CW00749859

12996. 20 Dek. 1912    13449.    13338. 20. Dek. 1912.

13728. 23. Abc. 13. 12727. 28. Cen. 13.    22. Dek. 1912.    13454.    Cepe6 13505. 2. IV. 1913.
Золоt 13334. 13. Cen. 1913.

ПЛАТИНА.

13331. 27. XI. 1912    13211. 7. VI. 1913    13265 7. VI. 1913

# FABERGÉ

## HIS MASTERS AND ARTISANS

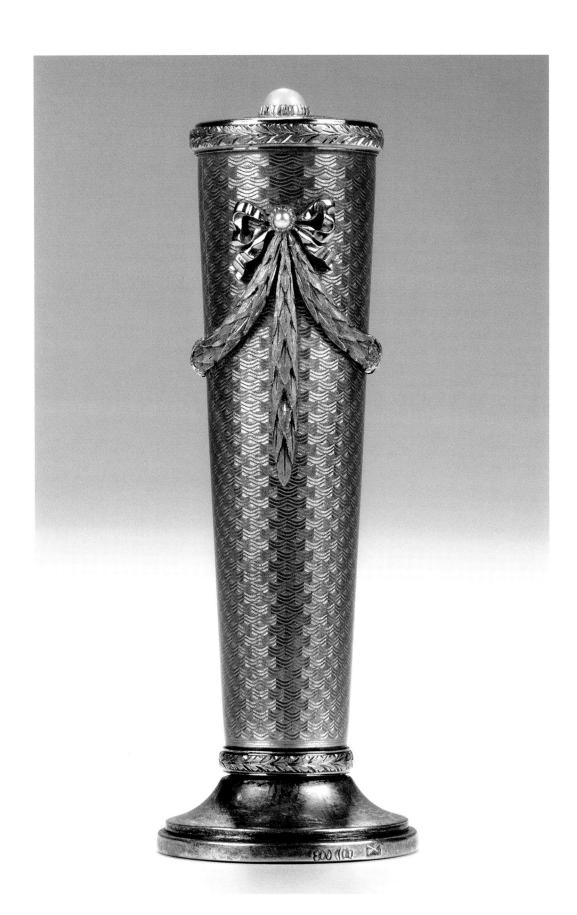

ULLA TILLANDER-GODENHIELM

*his masters*
*and artisans*

UNICORN

Published in 2018 by
Unicorn, an imprint of Unicorn Publishing Group LLP
5 Newburgh St,
London
W1F 7RG
www.unicornpublishing.org

Text © Ulla Tillander-Godenheilm

All rights reserved. No part of the contents of this book may be reproduced, stored
in or introduced into a retrieval system, or transmitted, in any form or by any means
(electronic, mechanical, photocopying, recording or otherwise), without the prior
written permission of the copyright holder and the above publisher of this book.

Every effort has been made to trace copyright holders and to obtain their permission
for the use of copyrighted material. The publisher apologises for any errors or omis-
sions and would be grateful to be notified of any corrections that should be incorpo-
rated in future reprints or editions of this book.

ISBN 978-1-911604-20-4

10 9 8 7 6 5 4 3 2 1

Design and layout by Jukka Aalto · Armadillo Graphics
Image editing and digital restoration by Timothy F. Boettger

Printed in Finland by Grano

◁◁ *A cylindrical desk seal in varicolour
gold, pearls, and enamel. Fabergé, Henrik
Wigström, St Petersburg, made after
1903. Height 7.2 cm. The piece formerly
belonged to King George II of the Hellenes
(reigned as King of Greece from 1922–24
and 1935–47). The silver matrix to the seal,
added later, shows George II's crown.*
Courtesy of Collection Mirabaud

*The sketches seen on the end-papers
are from the second stock book
of Henrik Wigström.*
National Archives of Finland, Helsinki

# Contents

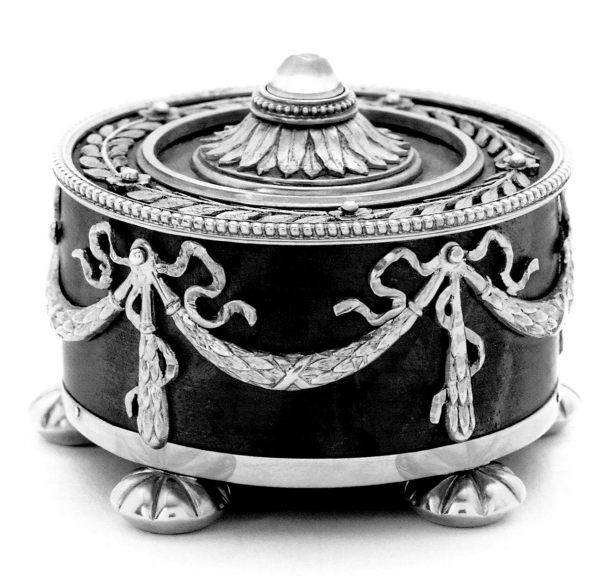

# Contents

*A jewelled gilt silver mounted birchwood bell push, with the pushpiece of a single moonstone.*
*Diameter 4.2 cm. Fabergé, Henrik Wigström, St Petersburg, made between 1899 and 1908.*
COURTESY OF CHRISTIE'S

Carl Fabergé is arguably the most famous goldsmith who has ever lived, and his posthumous reputation is amplified with each passing year. It is a strange paradox: the more removed we become from his time and his life, the more we know about the short flowering of Fabergé's genius and the business that fostered it. It lasted just the few fleeting decades between 1882 and 1917.

The Russian Revolution changed everything, and irrevocably. Society under the Tsars had certainly been unequal and unfair, but at least it was well-regimented, with a place for everyone and everyone in his place. However, in the aftermath of the uprisings of 1917, the old order and culture quickly spiralled into chaos. Survival was often the foremost priority, and needless to say the luxury goods emporiums became redundant and went under. With its all too obvious connections to the Russian Court, the House of Fabergé was one of the first to go, and its founder with it. Carl Fabergé retreated to Lausanne in Switzerland, leaving his business behind, and just three years later, in 1920, he died aged 74.

In the ensuing years, the Communist regime became more and more insular and eventually the "Iron Curtain" was dropped on the outside world. As far as Western historians were concerned, it might as well have been a blackout curtain, for they were left in virtual darkness for decades.

Even though the House of Fabergé was undoubtedly the largest business of its sort, with four branches in Russia, one in London, and connections as far afield as India and Thailand, its glory faded fast. In 1937, just 20 years after the business closed its doors, Fabergé's creations were described in the British press as "unrecognisable and virtually unsalable". Fashion had a part to play in this demise, and the clean geometric lines of Art Deco reigned supreme: it seemed all things *fin de siècle*, including Fabergé's wares, were distinctly passé.

If few remembered this remarkable business, and if Soviet Russia was by this time effectively sealed off from the rest of the world, then the situation was compounded by a dearth of knowledge about Fabergé, both the man and his trade. His work alone was left to speak for itself. The witty animal carvings and beautiful flower studies, the exquisite jewellery, and the improbable Imperial Easter Eggs became silent witnesses on their own account. Their only champions were the loyal customers of the past, who remained deeply nostalgic about Fabergé and the society that nurtured him. Little by little, however, came the first light and a new dawn.

In 1933, Henry Bainbridge published his memoirs under the title *Twice Seven*, and about half of the material was devoted to his time as manager of the House of Fabergé branch in London. Sixteen years later, in 1949, Bainbridge published the first monograph on the subject, entitled *Peter Carl Fabergé – Goldsmith and Jeweller to the Russian Imperial Court*. Despite the shadow of the Iron Curtain, Bainbridge was able to piece together a mosaic of facts about Fabergé from personal reminiscences and meagre external evidence drawn from the objects themselves: makers' marks, dedication inscriptions, and the like.

If Bainbridge focused on Carl and on his exciting and exacting clientèle, things changed with the next book devoted to Fabergé, published only four years later, in honour of the Coronation of Queen Elizabeth. This was A. Kenneth Snowman's seminal *The Art of Carl Fabergé*. It lived up to its title, being less about the man and more about the objects created in his name. It seemed thereafter that

the source material had all but completely dried up, and subsequent publications relied heavily on secondary sources, in what was virtually an archival desert.

Eventually, in 1979, the thirst for fresh information was quenched by the recently-discovered London ledgers published in *Fabergé - Court Jeweler to the Tsars*, by Géza von Habsburg-Lothringen and Alexander von Solodkoff. Here scholars, museums, and collectors were introduced to a source of fresh information about every aspect of Fabergé's work and patronage that was, by default, a social history of the contemporary elite.

At the same time as this remarkable discovery was revealed, Ulla Tillander-Godenhielm, the author of the meticulous text contained in these pages, was conducting her own research in her native Finland. Nobody had better credentials to do so, for Ulla belonged to a dynasty of jewellers, founded in 1860 in St Petersburg, who were not only contemporaries of Carl Fabergé in Russia but competitors for the patronage of Emperor Nicholas II, his family, and the Imperial Court.

After the Revolution of 1917, the Tillander family moved from St Petersburg and re-established their distinguished jewellery business in Helsinki. It was there at Tillander's that contemporary jewellery continued to be made to the exacting standards of the past, and where a deep sense of heritage was maintained. For instance, Ulla's father, the late Herbert Tillander, was a respected jewellery historian and gemologist, and the culmination of his life's work came in 1996, when he published *Diamond Cuts in Historic Jewellery 1381-1910*.

Established family connections, comprehensive language skills, and above all her own unique charm facilitated Ulla's research. She discovered that her family members were not by any means alone in returning home after the Russian Revolution – a number of Fabergé's Finnish craftsmen had done the same, and it was their descendants on whom Ulla Tillander-Godenhielm focused her attention. Some of the first fruits of her research were to be seen in 1980 at the Museum of Arts and Crafts in Helsinki, at an exhibition celebrating the 120th anniversary of the Tillander family firm. "Fabergé and His Contemporaries" was a triumph: scholars and enthusiasts alike were enthralled by what they saw and read in the catalogue.

Since then there have been many books and catalogues on the endlessly beguiling subject of Fabergé, but Ulla Tillander-Godenhielm's original research and her various publications remain a standard to which all her peers aspire. In the pages that follow, the author not only pays eloquent tribute to Carl Fabergé and his exquisite creations, but also throws new light on the workings of his firm and on the lives of the craftsmen who contributed so much to its luminous fame.

*A gem-set figurine of a seated magot by Carl Fabergé, carved from bowenite and decorated with scarlet enamel, rose-cut diamonds, rubies, and natural pearl drops. The head and hands are counter-balanced and articulated, moving up and down at the slightest touch. Even the magot's tongue, suggested by a single ruby, lolls from the mouth when the head rocks. Fabergé's inspiration for this uniquely compelling object derives from similar figures made by the Meissen porcelain factory in the 18th and 19th centuries. St Petersburg, before 1903.*
PRIVATE COLLECTION. PHOTOGRAPH COURTESY OF WARTSKI, LONDON

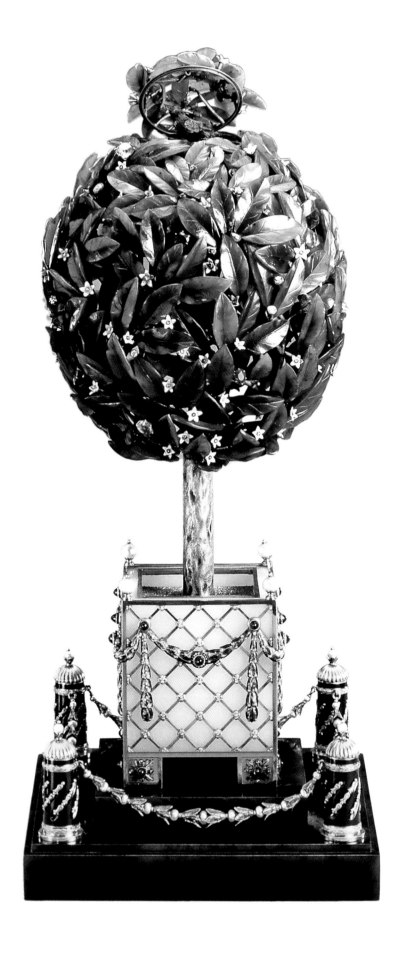

The life-stories and careers of a remarkable array of men and women – the master gold- and silversmiths of the House of Fabergé – are presented in this book. Singled out to work at the very crux of the business, they are therefore very much part of the success story of Carl Fabergé, the legendary St Petersburg jeweller in the late 19th and early 20th centuries.

The majority of these craftsmen hailed from regions not very far from St Petersburg; from the Baltic Governorates and above all Finland, then a Grand Duchy of the Russian Empire. Poor farm hands and craftsmen, unable to support their large families during times of famine and lack of work, sent their children to St Petersburg which offered boundless opportunities for employment and advancement. The youngsters seized their chance and travelled to the thriving metropolis, where they signed on as apprentices. Through hard work and resilience, they qualified as master gold- and silversmiths. Carl Fabergé, who had a particularly keen eye for skill and talent, gave them the opportunity to set up independent workshops to supply his growing business.

It will quickly become clear to my readers that most of the biographies covered in this book relate to the Finnish-born craftsmen. The simple explanation for this imbalance is the lack of sources on the masters hailing from other parts of the Russian Empire.

At the time of the 1917 Russian Revolution, the Finnish masters and their families returned to their former homeland. They all took pride in having had the good fortune of working for the eminent court jeweller. Fortunately for us, their recollections and anecdotes from years of work in St Petersburg were kept alive by fond repetitions to their children and grandchildren. Family photograph albums, memories, original histories, personal papers, and correspondence – all items of great value in the documenting of their lives and work today – were preserved for posterity.

In the late 1970s, the idea was born to arrange an exhibition celebrating the 120th anniversary of our family firm, A.Tillander. The jewellery business was founded in St Petersburg by my great-grandfather Alexander Tillander. The exhibition *Fabergé and His Contemporaries* was presented in 1980 at the Museum of Arts and Crafts in Helsinki (now the Design Museum). In great measure it was a quite exceptional event, for many of our lenders – mostly private collectors in Finland – were original customers (or the direct descendants of original customers) of the House of Fabergé in St Petersburg, or were the descendants of Fabergé's workmasters. The exhibition curators struck up close contacts with this latter group, since the families of the former workmasters, journeymen, and employees were delighted to open their family archives and albums and to share their memories. Many of the surviving family members remain close personal friends of mine to this day.

*The Orange Tree Egg (also known as the Bay Tree Egg) is a small mechanical orange tree in flower given by Emperor Nicolas II to his mother, the Dowager Empress Maria Feodorovna, as an Easter gift in April 1911. It is made of gold, Siberian nephrite, green and white enamel, white onyx, diamonds, rubies, amethysts, citrines, pearls, agates, and – in the small songbird surprise activated by a lever hidden in the foliage – natural feathers. The lever itself is of gilt silver. Fabergé, Henrik Wigström, 1911. Height 27.3 cm (closed) and 29.8 cm (opened). Fabergé charged the Emperor 12,800 roubles for the Orange Tree Egg.*

PHOTO BY LARRY STEIN © THE FORBES COLLECTION, NEW YORK.
FABERGÉ MUSEUM, ST PETERSBURG. THE LINK OF TIMES CULTURAL AND HISTORICAL FOUNDATION

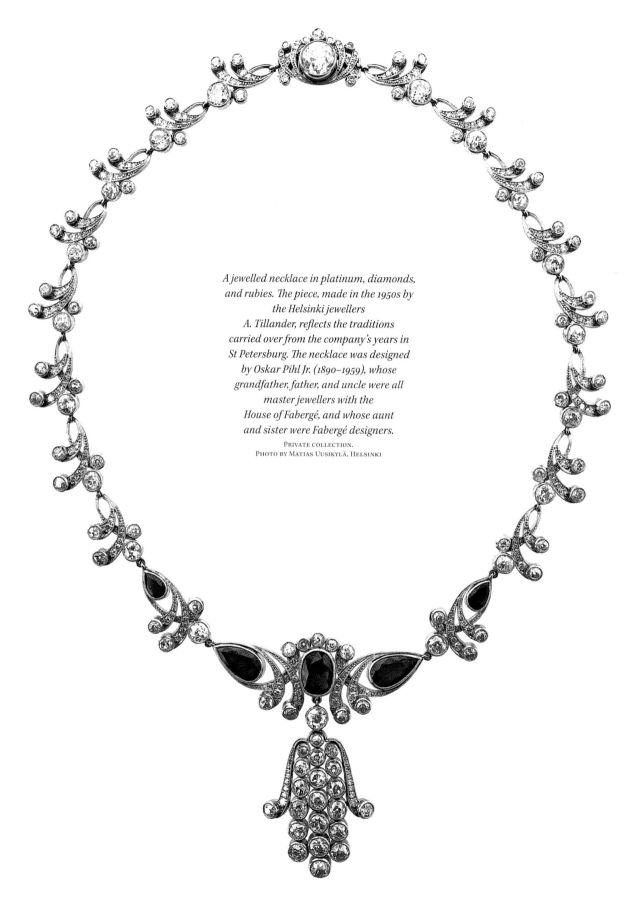

*A jewelled necklace in platinum, diamonds, and rubies. The piece, made in the 1950s by the Helsinki jewellers A. Tillander, reflects the traditions carried over from the company's years in St Petersburg. The necklace was designed by Oskar Pihl Jr. (1890–1959), whose grandfather, father, and uncle were all master jewellers with the House of Fabergé, and whose aunt and sister were Fabergé designers.*

Private collection.
Photo by Matias Uusikylä, Helsinki

Several of the children of Fabergé's workmasters were still living. in the 1970-80's, and it is with great fondness that I recall happy hours spent with the sons and daughters of Fabergé's well-known masters. Many of them had glowing memories of their daily work in the ateliers. Henrik Wigström's daughter Lyyli, who for fifteen years was the close assistant of her father, shared her vivid recollections. From her childhood she remembered how she accompanied her father to the Imperial Stables to check the precise colouring of the Coronation Coach, to help the master enameller Alexander Petrov find the exact shade of raspberry red needed for the miniature version of the coach, the surprise contained in Fabergé's fabled 1897 Coronation Egg.

With Wigström's granddaughter Anni Sarvi, I visited the family dacha at Ollila on the Karelian Isthmus, now part of the Russian Federation. Anni recalled childhood summers when her beloved grandfather was still alive. We rummaged through the entire house (today a children's summer retreat), from cellar to attic, looking for traces of the old days. Shortly before our visit to Ollila, an extraordinary stock book, containing some 1,000 watercolour designs of objects made in the workshop of Henrik Wigström, had been discovered languishing on a Finnish bookshelf. The important historical find, now in a private collection, was published in 2000 under the title "Golden Years of Fabergé". See the *References*. Anni Sarvi remembered clearly how as a little girl, in the attic of this very house in Karelia, she had leafed through huge piles of folio-sized volumes filled with beautifully-coloured drawings of objets d'art, all produced in her grandfather's workshop. Anni and I earnestly hoped we might somehow unearth the rest of the trove, hidden away in a dusty corner of the attic. Needless to say, there was no trace of them.

In 2007, however, I happened to locate a second of these lost volumes. It had been brought to the National Archives of Finland in Helsinki by "persons unknown", without any reference to the Wigström workshop or to the House of Fabergé. Illustrations from this second stock book are shown on the endpapers of the present volume.

Warm personal memories of the Pihl and Holmström families are still very much alive. The two younger brothers of Alma Pihl were central to the Tillander family firm: master jeweller Oskar Woldemar was our long-time designer, while Georg was the company accountant. One of the great ironies of my life is that at the time I did not understand their family had at their fingertips all the answers to the many questions which I still have today. Fortunately, the niece of the three siblings, Lydia Pihl, made a point of listening to the reminiscences of her aunt Alma and uncles Oskar and Georg. She kindly passed these on to me in detail.

My steadily growing interest in the lives and work of these extraordinary goldsmiths has later resulted in close contacts and friendships with members of the Aarne, Armfelt, Hollming, Nevalainen, Nykänen, and Väkevä families.

In 2008, the Helsinki publishing house Tammi offered me the chance to write a book about Fabergé, focusing on his Finnish workmasters. This obviously triggered a new impulse to be in touch with the descendants, by this stage mainly the great-grandchildren of the masters. Writing the book was a delight! It offered the pleasure of spending hours on end to discuss details never brought up before and looking at recent discoveries in the treasure troves of the respective family archives. The book was reprinted in a revised 2011 edition.

Two important members of the Fabergé team are only referred to in passing in the current book: Fabergé's Chief Designer Franz Birbaum and Fedor Rückert, the master of Russian enamels, who collaborated with Fabergé in his Moscow branch from 1887 to 1914. Excellent and comprehensive biographies have been published on both of these masters. Birbaum's life has been documented in 1997 by a group of authors including Tatiana Fabergé, the great-granddaughter of Carl Fabergé, and in 2016 by Valentin Skurlov *et al.* Rückert's life and work has been presented in a magnum opus by Tatiana Muntian in 2016. See the *References*.

The descendants of the masters and I are grateful to have been given the opportunity of returning to the topic, now in English and under the aegis of Unicorn Publishing Group. This English version of the book on the workmasters was reworked to accommodate the broader international audience. It is my hope the reader will take pleasure in being introduced to the extraordinary creative talents behind the scenes at the House of Fabergé, the masters and artisans whose maker's marks adorn the marvellous Fabergé items we admire in salerooms and exhibitions the world over.

Ulla Tillander-Godenhielm
Helsinki, January, 2018

1842   Gustav Fabergé (1814–1893) establishes himself as a goldsmith and jeweller at 11, Bolshaya Morskaya in St Petersburg. He had qualified as a master goldsmith in 1841. Master's mark unknown. He collaborates with the master silversmith Johann Eckhardt (active 1820s–1850), whose workshop is at the same address. Master's mark unknown.

1846   Birth of Gustav's son, Peter Carl (Carl Gustavovich) Fabergé. Hiskias (Hesekiel) Pöntinen [after 1879 Hiskias Pendin] (1823–1881) works as a journeyman with Gustav Fabergé.

1848   Hiskias Pöntinen qualifies as a master goldsmith and jeweller. Master's mark [ HP ]. He becomes workmaster and business partner of Gustav Fabergé.

1849   Johann Alexander Gunst (active 1849–72) collaborates with Gustav Fabergé. Master's mark [ JG ].

1850   Johann Eckhardt dies.

1856   Theodor Ringe (1824–94) becomes a master goldsmith. He starts his collaboration with Fabergé. Master's mark [ T.R ].

1857   August Holmström (1829–1903) qualifies as a master goldsmith and jeweller and begins his lengthy collaboration with Fabergé. Master's mark [ AH ]. Stefan Väkevä (1833–1910) begins his collaboration with Fabergé, having secured his master silversmith's certificates in 1856. Master's mark [ S.W ]. Carl Fabergé is apprenticed to Hiskias Pöntinen. Wilhelm Reimer (d. circa 1898) begins his collaboration with Fabergé. Master's mark [ W.R ].

1858   Erik Kollin (1836–1901) works as a journeyman with August Holmström.

1859   Anders Mickelsson (1839–1913) qualifies as a journeyman, possibly under Holmström.

1860   Gustav Fabergé moves to Dresden. Pöntinen, assisted by master goldsmith Walery (Valery Andreyevich) Zaionchkovsky, takes over the running of the business. Zaionchkovsky's master's mark unknown.

1860–66   Formative years of Carl Fabergé in Dresden, Frankfurt, Paris, and London. He returns to St Petersburg in 1866.

1864   Isaac Abramovich Rappoport, after the early 1890s known as Julius Rappoport (1851–1917), trains with the master silversmith Scheff in Berlin.

1867   Anders Mickelsson earns his master's certificate and becomes part of the Fabergé team. Master's mark [ AM ].

1868   Erik Kollin becomes a master goldsmith. Master's mark [ EK ].

1870   Erik Kollin opens his workshop and works exclusively for Fabergé. The enameller N.N. Killender starts work for Fabergé.

1872   Carl Fabergé assumes responsibility for the firm. Erik Kollin is appointed Fabergé's head workmaster.

1874   Edward Wilhelm Schramm (1850–c.1899) qualifies as a master goldsmith and begins his collaboration with Fabergé about this time. Master's mark [ ES ]. Antti Nevalainen (1858–1933) is apprenticed at Holmström's workshop. Gabriel Nykänen (1854–1921) is possibly also apprenticed at Holmström's.

1876–79   August Hollming (1854–1913) works as journeyman in St Petersburg, possibly in Holmström's workshop. In 1879 he receives his papers as a master goldsmith and opens his own workshop at 35, Kazanskaya. Master's mark [ A*H ].

1878   Mikhail (Mikhail Evlampievich) Perkhin (1860–1903) is apprenticed under Erik Kollin.

1880   Viktor Aarne (1863–1934) works as a journeyman in Holmström's workshop. He qualifies as a master goldsmith in Tampere, Finland in 1890. Master's mark in Finland [ JVA ].

1881   Hiskias Pendin ( formerly Pöntinen) dies.

1882   Agathon Fabergé (1862–1895), Carl's younger brother, joins the firm as a designer. Fabergé moves across the street to 16, Bolshaya Morskaya.

**1884** Isaac Abramovich Rappoport is recognised as a master silversmith and opens a workshop. Master's mark [ I.P. ]. The lapidary workshop of Carl Woerffel (Karl Fedorovich) (1846-after 1917) enters into cooperation with Fabergé. Mikhail Perkhin earns his spurs as a journeyman, possibly still under Kollin.

**1885** Antti Nevalainen becomes a master goldsmith, opens a workshop, and enters into cooperation with Fabergé around the year 1890. Master's mark [ A.N ]. The enameller N.N. Killender resigns from Fabergé.

**1886** Mikhail Perkhin qualifies as a master goldsmith, possibly under Kollin. Master's mark [ М.П. ].

Friedrich Moritz (Fedor Ivanovich) Rückert (1851–1918) opens his workshop in Moscow. Master's mark [ Ф.Р. ].

**1887** Fabergé opens his Moscow branch in partnership with Henry 'Allan' Talbot Bowe. A showroom (торговый зал) is opened in San-Galli's House at Kuznetsky Most. Oscar Pihl (1860–1897) qualifies as a master goldsmith and jeweller under his father-in-law August Holmström. Master's mark [ OP ]. He is appointed head of the Moscow jewellery workshop. Henrik Wigström (1862–1923) qualifies as a master goldsmith. Master's mark [ H.W. ].

**1888** Mikhail Perkhin is appointed head workmaster of Fabergé at the end of the year. He takes up his position in January 1889.

**1889** Gabriel Nykänen becomes a master goldsmith. He opens his own workshop. Master's mark [ GN ].

**1890** Julius Rappoport ( formerly Isaac Abramovich Rappoport) becomes Fabergé's head silversmith in St Petersburg about this time. The enameller Vasily (Vasily Vasilievich) Boitsov (1864-after 1917) starts work with Fabergé. Fabergé's Moscow silver workshop opens at 4, Bolshoy Kiselnyi Pereulok. Alfred Thielemann (1870–1910) qualifies as a master goldsmith (possibly a few years later). Master's mark [ AT ].

**1891** Viktor Aarne returns to St Petersburg and opens his workshop. He works under contract with Fabergé until 1904. His master's mark in St Petersburg is [ BA ]. Konstantin (1867–1902) and Alexander Väkevä (1870–1957) qualify as master silversmiths around this time. They both work for their father Stefan Väkevä. Master's marks [ K.W ] and [ A.W ]. Albert Holmström (1876–1925) starts training with his father August.

**1893** Gustav Fabergé dies. Franz (François) Birbaum (1872–1947) is employed by the House of Fabergé as a designer.

**1894** Theodor Ringe dies. His widow Anna Ringe (1840–1912) takes over the workshop, assisted by the master goldsmiths Vladimir (Vladimir Viacheslav) Soloviev and Anders Mickelsson. Soloviev's master mark [ BC ]. Anna Ringe's widow's mark [ AR ].

**1895** Agathon Fabergé dies. Franz Birbaum becomes head designer. Alfred Thielemann (c.1870–1910) starts his collaboration with Fabergé. Alexander (Alexander Fedorovich) Petrov (d. 1904) is employed as Fabergé's head enameller. His two sons Dmitry and Nikolay work with him. Alina Holmström (1875–1936) starts training with her father August Holmström. August Hollming is now under contract with Fabergé, having previously worked independently. Gabriel Nykänen begins to work for Fabergé around this time.

Fabergé's Moscow store moves to the corner building at No. 4, Kuznetsky Most and Neglinnaya. Master goldsmith Gustav Heinrich (Gustav Gotfridovich) Jahr produced objects of vertu for the Moscow store between 1895 and 1908.

**1897** Oscar Pihl dies.

**1898** Wilhelm Reimer dies about this time. Master goldsmith Andrey (Andrey Gerasimovich) Gurianov takes over his workshop. Gurianov's master's mark [ АГ ].

**1901** Fabergé's new premises at 24, Bolshaya Morskaya are completed. The workmasters Mikhail Perkhin, August Holmström, August Hollming, and Alfred Thielemann move into the atelier wing. Fabergé's Odessa branch opens. Erik Kollin dies. His workshop is listed until 1910 in the name of his widow Henrika Eleonora Kollin (1841–c.1920).

**1902** Konstantin Väkevä dies. His widow Jenny Väkevä (1878–1971) acquires the widow's mark (in active use 1902–17) [ J.W. ].

**1903** Mikhail Perkhin dies. Henrik Wigström takes over his workshop.  August Holmström dies. His son Albert succeeds him as head jeweller. Master's mark [ AH ] (taken over from his father). Fabergé's London branch opens.

**1904** Hjalmar Armfelt qualifies as a master gold- and silversmith. Master's mark [ ЯА ]. Viktor Aarne sells him his workshop, and Armfelt joins Fabergé as a workmaster. Aarne establishes himself in Vyborg, Finland. Master's mark in Finland [ JVA ]. Alexander Petrov dies. His son Nikolay (Nikolay Alexandrovich) Petrov (d. 1918) succeeds him as head enameller. The enameller Vasily Vasilievich Boitsov resigns from Fabergé in 1905.

**1906** Fabergé's Kiev branch opens. Väinö Hollming qualifies as a master goldsmith. Master's mark [A*H], the same as his father.

**1907** Master goldsmith Fedor (Fedor Alexeyevich) Afanasiev (1870-after 1927) becomes a collaborator of Fabergé. Master's mark [ ФА ].

**1908** Hardstone carvers Peter Kremlev (Peter Mikhailovich) (1888-after 1938) and Peter Derbyshev (Peter Mikhailovich) (1888–1914) take over the lapidary work from Carl Woerffel. Vladimir Soloviev and Anders Mickelsson take over Anna Ringe's workshop.

**1909** Julius Rappoport retires. The First Silver Artel is formed on Rappoport's initiative and with his help. His former workers make up the staff. Fabergé continues to collaborate with them. Mark [ ICA ]. Vladimir Soloviev becomes a sub-contractor of Fabergé.

**1910** Alfred Thielemann dies. His widow Elisabeth, née Körtling, takes over the workshop and continues to work for Fabergé. Widow's mark [ ET ]. Stefan Väkevä dies. He is succeeded by his surviving son Alexander. Alma Pihl (1888–1976) starts her training with her uncle Albert Holmström.

**1911** Fabergé's Kiev branch closes.

**1913** August Hollming dies. His son Väinö takes over the workshop. Master's mark [ A*H ] (taken over from his father). Anders Mickelsson dies. The First Silver Artel is wound up.

**1914** World War I breaks out. Many of Fabergé's craftsmen are called to the front. Stone carver Peter Derbyshev is killed in action. Väinö Hollming resigns. He opens a new workshop at 3, Gorokhovaya. Rückert's Moscow workshop closes.

**1916** Julius Rappoport dies. Hjalmar Armfelt moves into the former Hollming premises at 24, Bolshaya Morskaya.

**1917** Fedor Rückert dies. Fabergé's London and Odessa branches are shut down.

**1918** The House of Fabergé closes its doors in November.

**1920** Carl Fabergé dies in Switzerland.

*The image shows the first stock book of*
*Henrik Wigström, and a number of loose sheets*
*containing signed sketches and designs by Wigström.*
PHOTO BY HARRI KOSONEN, HELSINKI

## GUSTAV FABERGÉ

The Fabergés are an old French Huguenot family, dating back to the 17th century. The Huguenots, as history tells us, were French Reformed Protestants, hailing mainly from the north of the country and emerging in the 16th century. The Reformation tenets of Martin Luther rapidly gained ground in France, spreading despite the intense hostility shown by the French monarchy and the Roman Catholic Church. By the middle of the 16th century, there were some 400,000 Huguenot supporters in France, found among all social classes. A series of bloody conflicts ensued from 1562, known as the "Huguenot Wars" or the French Wars of Religion, and the civil strife divided France into two hostile camps.

The situation appeared to be resolved by the Edict of Nantes of 1598, when the French Protestants were granted almost complete freedom to practice their religion. The bitter discord between Protestant and Catholic factions nevertheless repeatedly threatened to re-ignite into new violence, and in 1685 Louis XIV revoked the Edict of Nantes, declaring Protestantism illegal in the country.

This led to around 200,000 of France's most hard-working and skilled citizens choosing to flee the persecution that followed, regardless of strict prohibitions on their leaving the country. French trade and industry were dealt a heavy blow for decades to come.

Carl Fabergé's ancestors left from Picardy in Northern France, a region known in the 17th century for its large Gothic cathedrals and magnificent châteaux, reminders of its long and rich history and the presence of a population skilled in building and craftsmanship. The family sought refuge in the region around Schwedt an der Oder, in what is now Brandenburg in north-eastern Germany. Local records speak of a French tobacco farmer in the district, one Jean Favry. A century later, around 1800, a master carpenter named Peter Favry or Peter Favrier surfaces in the idyllic coastal town of Pärnu [Ger. Pernau] in Livonia, then a part of the Russian Empire.

Peter's youngest son, Gustav, was born in 1814, and at an early age he sought work as an apprentice goldsmith in the Russian capital St Petersburg. He secured his first apprenticeship with the master goldsmith Andreas Ferdinand Spiegel (1797-1862), who hailed originally from Tallinn [then known as Reval] in Estonia. Spiegel had in turn learned his trade in his home town and later moved (in the 1820s) to the more lucrative milieu of Petersburg, where he established himself as a master jeweller. After spending some years learning his craft with Spiegel, Gustav Favry was accepted

*Carl Fabergé at his workbench, examining precious stones.*
PHOTO BY HUGO ÖHBERG DATES FROM THE 1890S. COURTESY OF WARTSKI, LONDON

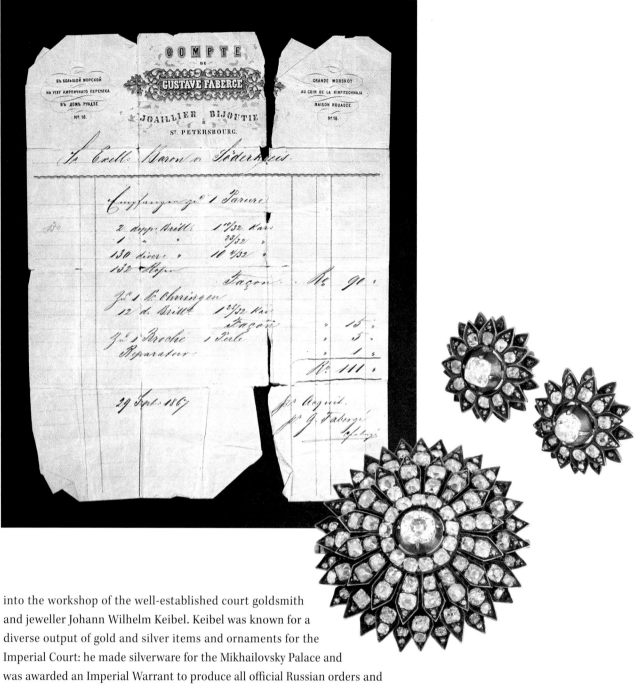

into the workshop of the well-established court goldsmith and jeweller Johann Wilhelm Keibel. Keibel was known for a diverse output of gold and silver items and ornaments for the Imperial Court: he made silverware for the Mikhailovsky Palace and was awarded an Imperial Warrant to produce all official Russian orders and decorations for the Chapter of the Imperial and Royal Orders.

Gustav clearly landed on his feet: he duly received his master goldsmith's papers and a few years later – in 1842 – he was able to rent workshop and sales premises at No. 11, Bolshaya Morskaya, a street right in the heart of St Petersburg, just off the main thoroughfare, Nevsky Prospekt.

The young master, who had by this stage changed his name to Fabergé, also put down roots and started a family. His bride was Charlotte Maria, daughter of the Danish artist Karl Jungstedt. Peter Carl Fabergé (also known as Carl Gustavovich Fabergé), the central figure of this volume, was born four years later, on May 30th, 1846.

*A gold and diamond brooch and matching earrings; the stones mounted in silver. Gustav Fabergé, St Petersburg, 1861. The jewels come with their original presentation case and this invoice, in German, dated September 29th, 1861. The buyer was the Finnish jurist and member of the Senate of Finland, Baron Carl Emil Cedercreutz (1806–1869).*
PRIVATE COLLECTION. PHOTO BY KATJA HAGELSTAM

## HISKIAS PENDIN

It did not take long before Gustav Fabergé needed a business partner and a workshop manager, and he found one such in Hiskias Pöntinen (1823–1882). As it happens, Pöntinen (he later changed his name to Pendin, and is widely known as such in the literature) proved to be rather more: he became Gustav's close friend and confidant, and above all he took on the task of the first master to the young Carl Fabergé. Aside from this, Hiskias was quite a personality in his own right, with very endearing traits that are noted in many amusing anecdotes passed down through the Fabergé family.

Hiskias – or more formally Hesekiel, the name with which he was baptised – was born in the parish of Ristiina, close to Mikkeli, in central Finland, on May 3rd, 1823. He was the son of farmer Mauno Ristonpoika Pöndin and his wife Anna Maija (née Korpelainen). At the tender age of ten years, the boy was despatched to St Petersburg to learn a trade. The usual reasons for such young lads to be sent off to the great metropolis to the east were hard times at home, large families with too many mouths to feed, and no prospects locally for any kind of professional training or earning a livelihood. It took courage and endurance aplenty for these boys to leap into the unknown like this. They were barely out of short trousers, in all probability were unable to read or write, and naturally they only spoke the language – in this case Finnish – they had learned at their mother's knee.

Hiskias was one of those who survived and thrived. He was initially apprenticed to a maker of eyeglasses, but he discovered before long that spectacles were not his metier. What he wanted to become was a goldsmith. We do not know for certain to whom he was apprenticed, but an educated guess would be that it was the same Wilhelm Keibel with whom the slightly older Gustav was working by this time. After eight years of education and supervision, Hiskias Pöntinen was already a talented journeyman. In 1840, the parish records of the Evangelical Lutheran Church of St Mary in Petersburg identify Hiskias as a jeweller. Two years on, and Gustav Fabergé, by now himself established as an entrepreneur, offered his young and clearly gifted colleague a share of his business.

We have only the sketchiest of details of that first goldsmith's outlet at No. 11, Bolshaya Morskaya, but it is nevertheless clear that Pöntinen – as workmaster – was responsible for production, while Gustav ran the business side of matters. As was the custom in those days, the master and entrepreneur's home was "over the shop". Consequently, Carl Fabergé – just like the other children of goldsmiths and jewellers – saw the goings-on in his father's workshop at close quarters and from a very early age indeed. He may also have been given small tasks to complete as a child. This was quite natural, and was all part of a desire to nurture in the child an interest in taking up the family profession. In the case of Carl Fabergé, the yen to follow in his father's footsteps was formed early, and Hiskias Pöntinen was instrumental in this. We know that Pöntinen was specifically the one who taught the younger Fabergé the rudiments of the goldsmith's trade. In the Fabergé family annals, Pöntinen is described as a genial, good-hearted, and cheery sort, with a healthy and positive outlook on life. He apparently carried with him from home the somewhat skewed sense of humour often associated with people from Finland's Savo region.

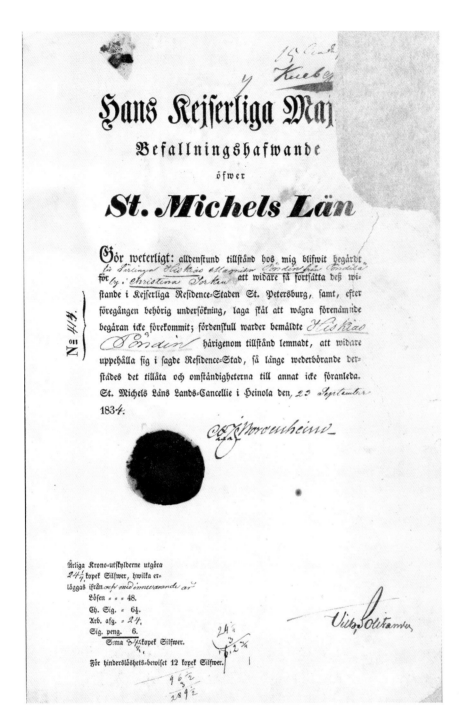

*His Imperial Majesty's Governor for the Mikkeli Province of the Grand Duchy of Finland agrees to the granting of an extended residence permit in St Petersburg for apprentice goldsmith Hiskias Pöntinen (later Pendin). The permit is dated September 23rd, 1834.*
NATIONAL ARCHIVES OF FINLAND, HELSINKI

In any event, Hiskias took Carl under his wing and gave his full attention to teaching the young man all he knew. He helped his gifted and malleable pupil to use his imagination and made sure that Carl understood the importance of quality in workmanship. Carl Fabergé was eternally grateful to his first mentor, and in his turn he assisted Hiskias's son Albert when he embarked on a career in medicine. Carl Fabergé's oldest son Eugène has reported that these early years of training at Hiskias's elbow left a massive impression on his father, precisely because of the extraordinarily receptive moment: Carl was a child, soaking up ideas and experiences like a sponge.

*A gold brooch set with a large faceted amethyst. Gustav Fabergé, St Petersburg, 1860s.*

© THE FORBES COLLECTION, NEW YORK. PHOTO BY JOSEPH COSCIA, JR.

Eugène Fabergé had one family tale about Pöntinen/Pendin, which demonstrates the disarming and charming lack of affectation in the man – Hiskias was his own self; he never put on airs for anyone, regardless of station. On one occasion, the wife of a wealthy merchant came into the Fabergé store to look at a pair of earrings. After a couple of days' mulling it over, she came back to the shop and said that regrettably she couldn't consider buying them, as she felt she was too old and long in the tooth to wear such extravagant jewels. Hiskias, who had his own peculiar brand of logic when it came to cajoling a customer into making a purchase, replied – without the slightest thought of sounding mean-spirited: "But my dear lady, just imagine what you will look like without ear-rings - like a cow without a bell!"[1]

Another tale of Pöntinen that has come down to us refers to a member of the Russian Imperial Family (precisely whom it was is not known), who was quite interested in the goldsmith's art and expressed a desire to learn something of it. He came to Gustav Fabergé's store and said he wanted to buy the tools essential for a basic grounding in working with gold. Pöntinen drafted the list, and included in it a small arsenal of implements and utensils, including hammers, and punches for chasing, engraving, and sinking and suchlike, and then he added a stout leather strap as a last item. The Princely Customer's eyebrows rose at the sight of the strap, and he confessed that he could not see where it might be useful. Pöntinen replied: "Your Imperial Highness, rest assured that this is the first and most indispensable of all the tools we have; not one apprentice has learned even the rudiments of the goldsmith's art without recourse to the strap."[2] One can imagine this is a fair reflection of Pöntinen's brand of Savo gallows humour.

Only a few items from Gustav Fabergé's early production have survived to the present. What has come down to us nevertheless indicates that the workshop was making gold ornaments very much at the cutting edge of contemporary fashion: wide bangles, gold brooches and necklaces, belt buckles, medallions, and earrings in the Rococo Revival style, as well as jewellery set with diamonds and other precious stones. This happily coincided with a resurgence of interest in all things Rococo in St Petersburg's fashionable circles – the more extravagant and florid the better. The jewels showed off the power of colours, with a rich, bright palette of precious stones, pearls, and enamel.

Gustav Fabergé and his business partner Hiskias Pöntinen found no shortage of willing buyers for their wares, and were soon able to hire additional workmasters. The first such was Wilhelm Reimer, (see p. 56). Working with Gustav Fabergé were also two Baltic-German masters, master silversmith Johann Eckhardt [until 1850] and Johann Alexander Gunst [until 1872]. In 1857, the business embarked on collaboration with the Finnish jeweller and goldsmith August Holmström (1829–1903), a master specialising in jewellery. August became one of the most faithful servants of the Fabergé name, and was the Fabergé head jeweller until his death, almost half a century later. (See p. 39).

In 1850, Hiskias Pöntinen married a girl from his home district in Finland's Savo. She was Anna Helena (1823–1885), and was the daughter of landed farmer Mauno Juhananpoika Pöndin and his wife Maria Antintytär (née Ootrain). By the sound of it, the bride and groom were quite closely related through the male line. They had five

children: Maria Helena (1850–1874), Alexandrine (b. 1874), Karl Alexander (b. 1857), Albert Johan (b. 1861), and Voldemar (b. 1865). The Pöntinens flourished, as can be seen from a glance at how the three boys turned out: Karl trained for a singing career, Albert studied medicine, and Voldemar became a military officer. Albert graduated as an M.D. in 1885, and he later became the Fabergés' family physician, and indeed he seems to have provided medical care for *most* of the Finnish ex-pat community living in St Petersburg. We nevertheless know little or nothing of what happened to the boys in later life. Even though the Pöntinens must have spoken Finnish at home, their ties to Finland did not survive very long. After the death of their parents, all the children registered themselves with the German Lutheran Congregation in Petersburg. By this stage all had the surname Pendin, which Hiskias had formally adopted back in 1879.

Hiskias Pöntinen/Pendin died in 1881, and he was undoubtedly active until shortly before that year, when he was diagnosed with advanced cancer of the liver. By that time, however, Hiskias was fully convinced that his pupil Carl Fabergé had a glittering future ahead of him.

*A medallion or brooch in gold, pearls, and diamonds. Gustav Fabergé, Wilhelm Reimer, St Petersburg, c. 1860. Diameter 4.5 cm. The presentation case is original.*
Courtesy of Christie's

# Carl Fabergé

## FORMATIVE YEARS

There is no disputing that the business of Gustav Fabergé and his partners was flourishing, since in 1858, when Carl was 12 years of age, his father enrolled him in the Annenschule, one of the finest and most expensive schools in St. Petersburg, with a German curriculum and all the teaching carried out in German. This proved to be a rather short-lived project, however, as Carl spent only three terms in this illustrious establishment, from 1858 to 1859.

In 1860, Gustav decided to move his entire family to Dresden, and he left Hiskias Pöntinen to take care of the workshop with the assistance of the goldsmith Walery Zaionchkovsky, who had a shop almost next door, across the street at No. 20, Bolshaya Morskaya.

So, what prompted Carl's father Gustav Fabergé to move to Dresden? He was, after all, only 46, and he had had the business barely eighteen years. To use an automotive metaphor, the firm was "nicely run in", any teething troubles were long gone, and it had acquired a loyal customer base that could provide Fabergé with the sort of income to sustain the good life in the attractive capital of the Kingdom of Saxony. Ill health certainly played no part in the move, for Charlotte Fabergé delivered a second son, Agathon (1862–1895), two years after the family had settled in Dresden.

Carl Fabergé continued his education in Germany, now at the *Handelslehranstalt*, a Dresden business college. Thereafter his father sent him off to Frankfurt am Main to train in the workshop of the jeweller Joseph Friedman.[3] While in Frankfurt, Carl also learned the noble art of fencing, and became quite a skilled exponent of the sport. Next came England, where Carl spent some months learning the language. He lodged in a boarding house, and in keeping with family tradition he was soon entrusted with the honorary task of carving the Sunday joint of roast beef. He was also permitted to prepare the salad, according to his own extremely esoteric recipe.[4] Together with his good friend Julius Butz, son of the eminent St Petersburg court jeweller Alexander Franz Butz, Carl undertook the European "Grand Tour" experience, with stops in Florence and in Paris, where he also attended courses at Schloss's Commercial College. A year later, in 1866, Carl Fabergé returned to St Petersburg. By this stage, he was 20 and was full of ideas for the future and bursting to show off his professional abilities.

After a further six years spent honing his skills in the family workshop, he was ready to take over responsibility for his father's business. In 1872, Gustav Fabergé and his partner Hiskias Pöntinen handed over the reins to young Carl Fabergé. An entirely new era in the company's history was about to begin.

At this juncture, it might be worth pausing to ask just how Carl Fabergé became so staggeringly successful at what he did. How was he so gifted and so deeply steeped in the history of the goldsmith's

art and its ancient techniques? The scanty CV we have for Carl's early years provides no answers. We only begin to get a glimpse when we look more keenly at all the places where the young journeyman had studied and hung his hat.

Gustav Fabergé may have chosen to resettle in Germany, but he had by no means lost interest in his business in St Petersburg. The opposite is true: he made quite sure that both his boys followed in his footsteps. And he could hardly have done better at it. Dresden was an ideal milieu for learning the goldsmith's art, and Gustav was an excellent mentor in his own right. The Dresden region had a rich history of mining and quarrying dating back to the 15th century. Varieties of quartz and chalcedony – agate, jasper, carnelian, and many others – in the most wonderful and exotic colours were quarried from the nearby Erzgebirge (literally: "ore mountains"), and the art of cutting and polishing stones had long been held in high esteem locally.

*A snuffbox in gold and spectrolite (a gemstone variety of labradorite feldspar), by Johann Christian Kayser, 1792.*
COURTESY OF THE STATE HERMITAGE MUSEUM, ST PETERSBURG

### SOURCES OF INSPIRATION

One of the great attractions of the city was – and still is – the *Grünes Gewölbe* (The Green Vaults) treasure chamber located in the palace of Elector of Saxony Frederick Augustus (1670–1733), often known as Augustus the Strong. Most uncharacteristically for the time, Augustus shaped his private chambers into a public museum between 1723 and 1730, opening up an astonishing collection of treasures and riches displaying the talents of Europe's best craftsmen from the Middle Ages, the Renaissance, and particularly the Baroque. The rooms are heaving with gold and silver artefacts and ornaments, precious objects fashioned from gems, decorative minerals, carved ivory, amber, mother of pearl, coconuts, nautilus shells, and even ostrich eggs, along with the most fabulous enamelled works, bronze statuettes, and pieces in glass and carved wood – more than 3,000 masterpieces on show. Carl Fabergé had a gift for drawing, and there can be no doubt he would have spent a good part of his time with his sketch pad in this royal treasure trove.

*A snuffbox in gold, silver, and moss agate, set with diamonds. Fabergé, Henrik Wigström, St Petersburg, 1899–1908. Diameter 4.9 cm.*
PHOTO BY OWEN MURPHY.
COURTESY OF THE CHEEKWOOD BOTANICAL GARDENS & MUSEUM OF ART, NASHVILLE, TENNESSEE.
THE MATILDA GEDDINGS GRAY FOUNDATION COLLECTION.
THE PIECE IS ON EXTENDED LOAN AT
THE METROPOLITAN MUSEUM OF ART, NEW YORK

Among the incredible items in the *Grünes Gewölbe* are several that have directly inspired Carl Fabergé in his own production: bowls and basins, snuffboxes, and trophies with ornate golden handles, small stone figures of humans and animals, ornamental mantle-clocks and mechanical toys. One of the most astonishing and fantastical of all the items on show is the dazzling *"Royal Household at Delhi on the Occasion of the Birthday of the Grand Mogul Aurengzeb"*, made by Elector Augustus's court jeweller Johann Melchior Dinglinger and his workshop. This tour de force of the Baroque goldsmith's art – essentially a sumptuous enamelled and jewel-encrusted diorama depicting the birthday celebrations – was made between 1701 and 1708. Dinglinger built the structure, roughly 140 cm wide, 60 cm high, and 114 cm in depth, with the help of his two brothers and 14 artisans from the studio. It was not a commission from the Elector, but produced entirely on Johann Melchoir's own initiative and aside from his many obligations as principal court jeweller.

The flamboyant Baroque artefacts displayed in the rooms of the *Grünes Gewölbe* were the source material that Carl Fabergé frequently returned to in his later designs. Throughout Carl's long career as a jeweller, the Elector's magical treasure trove stayed in his mind as a boundless source of inspiration.

*A bell push, decorated with a small elephant and howdah. Gold, bloodstone (heliotrope, a variety of chalcedony), ruby, enamel, diamonds. Fabergé, Mikhail Perkhin, St Petersburg, end 19th century. Height 6.8 cm.*
COURTESY OF HILLWOOD ESTATE, MUSEUM & GARDENS. ESTATE OF MARJORIE MERRIWEATHER POST, WASHINGTON DC. PHOTO BY E. OWEN

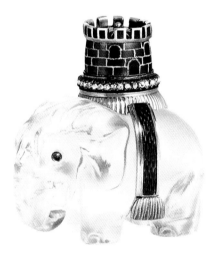

*An elephant and castle howdah, in carved rock crystal, gold, diamonds, enamel, with cabochon ruby eyes. Fabergé, Mikhail Perkhin, St Petersburg, made between 1899 and 1908. From the collection of King George I of the Hellenes, who reigned as King of Greece from 1863–1913. George I was a Danish prince by birth, and the miniature figurine has probably been inspired by the Danish Order of the Elephant (Elefantordenen), formally established in 1693.*
COURTESY OF CHRISTIE'S

The few months in 1864 that Carl spent in England were naturally not confined to his lodgings. He explored the London sights and would certainly have marvelled at the treasures from the ancient world in the British Museum – the famous Elgin Marbles from the Parthenon in Athens and the vast collections of Grecian vases, amphoras, and urns, not to mention the Egyptian stele we know as the Rosetta Stone. We can also be confident he would have visited the recently-established South Kensington Museum (formally opened in 1857, and known from 1899 as the Victoria & Albert Museum), which received its first design donations from the very first "World's Fair", the Great Exhibition of 1851, held in Hyde Park in Joseph Paxton's magnificent glass & cast-iron Crystal Palace. The idea behind the new museum was to assemble collections of the applied arts of the time: ceramics, glassware, textiles and costumes, sculpture, furniture, silverware and jewellery, as teaching material and to provide an example for the nation's handcraft and design industries. The South Kensington Museum was in turn an example for a similar establishment set up in St Petersburg, the Baron Alexander von Stieglitz Museum of Decorative and Applied Arts, which was opened in 1878 in the premises of Stieglitz's Central School of Technical Drawing, the alma mater where most of Fabergé's own artists received their training.

Carl Fabergé and his friend Julius Butz spent time in Florence in 1864. They saw the Cattedrale di Santa Maria del Fiore and its brick dome engineered by the brilliant architect Filippo Brunelleschi (actually a goldsmith by training), the fabulous gilded bronze doors to the Baptistery of St John by Ghiberti and Pisano, the sculptures by Benvenuto Cellini (the famous master goldsmith), examples of the exquisite enamel work of the Florentine goldsmiths, and of the Italian Renaissance cameo artists. All this naturally left a lasting impression on the two young Petersburg goldsmiths.

Carl arrived in Paris in 1865. Aside from lectures at Schloss's Commercial College, he naturally had the opportunity to make a closer acquaintance with the culture and arts that were to have the greatest impact on his own language of form, namely the Rococo and Neo-Classical styles emanating from 18th century France. We can also be sure he went to the Musée du Louvre to see the infinite treasures there. At that time, the famous Galerie d'Apollon housed much of the "Joyaux de la Couronne de France", those Crown Jewels that had survived the French Revolution, including a stunning rock-crystal vase from the reign of Louis XIV.

Fabergé naturally also visited Versailles and he would certainly have acquainted himself with the fabulous Campana Collection,[5] the sale to France of which was at that time a hot topic of conversation in Parisian art circles. The Emperor Napoleon III had bought a large part of the collection for four and a half million French francs, and it was put on display, initially at the Palais de l'Industrie on the Champs-Élysées and subsequently in the Louvre. The collection included around 1,000 Etruscan gold ornaments, diadems, necklaces, bracelets, torques, fibulae for fastening cloaks, and earrings, gathered by Giampietro Campana from his excavations in Etruria and the Romana Campagna. This fabled corpus of ancient gold jewellery became perhaps the greatest of all sources of inspiration for the goldsmiths of the day, and Carl Fabergé was no exception. In 1882 he presented his collection of "archaeological revival" jewellery at the Pan-Russia Exhibition and received his first public recognition, at the very highest level.

## The Return to St Petersburg

In 1866, following his return to St Petersburg and after joining his father's firm on Pöntinen's watch, Carl Fabergé got the idea of continuing his explorations of the European goldsmith's art under his own direction. One could scarcely have imagined a better place for this endeavour than St Petersburg. The Hermitage Treasury of the Winter Palace at the time housed one of the finest collections of fashioned gold items and jewellery in Europe.[6]

We do not know precisely how the young jeweller managed to get himself introduced to the Hermitage curators. It is plausible to imagine it happened with the assistance of Alexander Franz Butz, father of Carl's friend Julius. Butz Sr. was not merely a court jeweller, but also an Appraiser of the Cabinet of His Imperial Majesty. How it all took place is secondary: in any event, for fifteen years from 1866 Carl Fabergé assisted the Hermitage in the care and management of its priceless collection of antique gold pieces. In this he was offered an incredible opportunity to handle these exquisite items and to examine them in every detail. As a training ground and laboratory for an ambitious goldsmith and jeweller, this was beyond perfect.

The directorate of the Imperial Hermitage Museum also entrusted Fabergé with complex repair and restoration work on archaeological artefacts – jewels and other works of art. In a letter dated May 25th, 1884, the then Curator of the Department of Classical Antiquities Ludolf Stefani writes to the Hermitage Director Alexander Vasilchikov, full of praise for the work carried out – *pro bono* – by the young goldsmith:

> Mr Fabergé has consistently taken part in all manner of technical research work, some of it most laborious, embracing a large body of items in the Hermitage Archaeological Collections. Through his meticulous examinations, he has regularly and with great reliability been able to identify the materials of the pieces in the museum collections. In this way, he has provided the most valuable assistance in the correct cataloguing of these items. When we take delivery of discoveries from the annual excavations under the aegis of the Imperial Archaeological Commission, I have always been able to call upon Fabergé in his capacity as an expert and skilled professional, and in the re-creation from shards and fragments of a historically accurate artefact. Mr Fabergé has been known to spend days on end in the pursuit of these demanding tasks, repairing broken pieces and restoring them to their original form. Now these brilliant jewels from Ancient Greece are the pride of our Hermitage. For all that, his contribution has gone unnoticed and unrewarded. Despite the considerable investment of his time in the service of the Hermitage, at no stage has Fabergé presented an invoice for work carried out. To the best of my understanding, to date he has equally not received any official commendation for the work he has undertaken on behalf of the Empire.[7]

## The Hermitage Jewels

Aside from his work on archaeological treasures, Carl Fabergé had the opportunity to examine 18th century precious items in the Hermitage collections. These pieces were very much to become a source of inspiration in his later designs and production.

*A pendant watch in gold and diamonds, with two cabochon "mecca stones" (sky-blue stained chalcedony), in its original presentation box. The watch movement is by Henry Moser & Cie. Fabergé, Albert Holmström, St Petersburg, c. 1910.*
Courtesy of Andre Ruzhnikov, London

*Two jewelled walking canes belonging to Empress Catherine II (Catherine the Great). Wood, gold, silver, diamonds, and guilloché enamel. The E monogram for Ekaterina (in Cyrillic) is prominent on the handle. St Petersburg, c. 1770.*
Courtesy of The State Hermitage Museum, St Petersburg

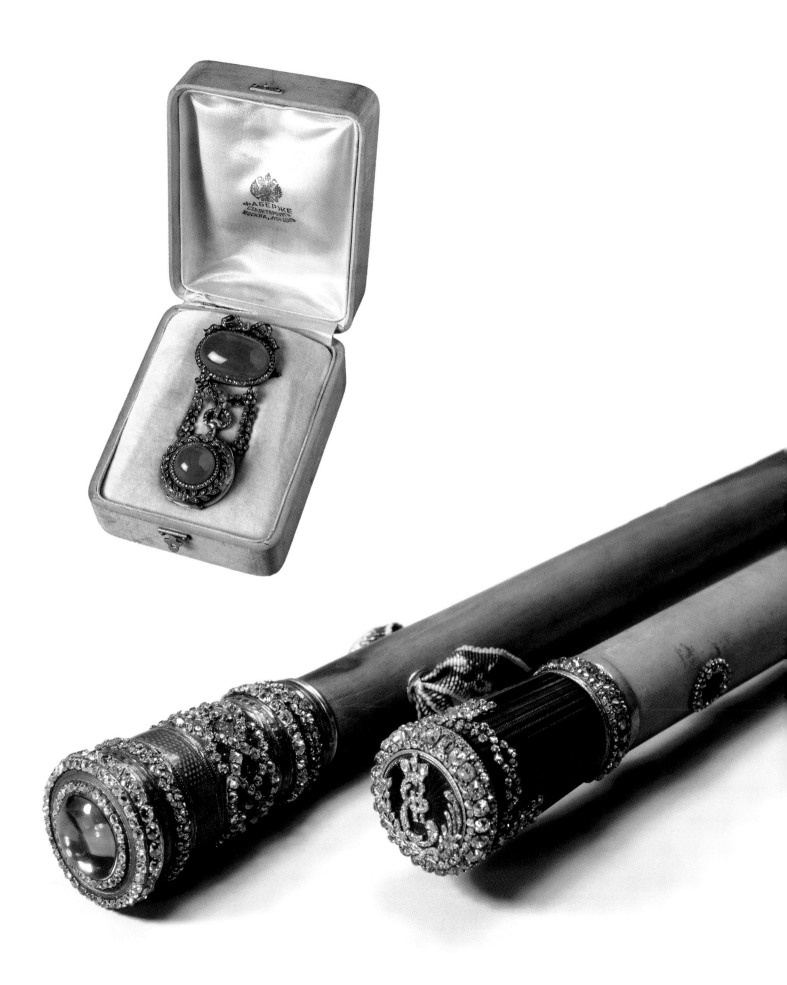

Empresses Elizabeth Petrovna (reigning from 1741–1761) and Catherine the Great (Catherine II, reigning from 1762–1796) were both given to luxury and were lovers of the arts, and they amassed vast collections of gem-encrusted snuffboxes and other precious ornaments. The snuffboxes occupy the lion's share of both rulers' collections of jewels, and display a dizzying array of shapes, sizes, materials, and forms of workmanship. In addition to their apparent use to keep snuff in, they were popular gifts. Hence they are often found with diamond-studded ciphers or with a miniature of the Empress's features. There are numerous snuffboxes made in the 1760s and 1770s using the same intricate *guilloché* technique that Fabergé would later make famous in his own gold and enamel work. The surface of the boxes is mechanically engraved using precise, repetitive patterns that can vary from geometrical figures to straight lines, wave formations, ribbons, zig-zag patterns, or a string of pearls effect. Bright translucent enamelwork and cameo imitations were all the rage in the 1770s and 1780s, and Fabergé unabashedly used them in his own designs a century later.

The boxes from the 1780s and 1790s often feature classical or neoclassical motifs – laurel wreaths, grape clusters and fruiting vines, strings of pearls, and egg and dart superbly chased in gold. This was precisely what Fabergé would later become so famous for in his designs. The Hermitage also boasted gold and enamel boxes of various descriptions with historical scenes painted in the enamel, enamelled medallions set with precious stones, with images of cupids, or portraits, or allegorical designs extolling the Empresses and their administrations.

Many other objects caught Fabergé's eye and stayed with him in his later designs, among them jewellery pieces set with precious stones, gem-studded pocket watches with lavishly ornamented chains, necklaces and pendants, rings, diamond-encrusted swords, mechanical toys, miniature figurines, walking canes, elegant parasol handles, pill-boxes, decorative boxes for candies or confectionery items, Easter Eggs, and vases. Jérémie Pauzié (1716–1779), the French-Swiss diamond expert and jeweller to the courts of Elizabeth Petrovna and Catherine the Great, was also known for his stunning kaleidoscopic "flower arrangements" of diamonds, emeralds, rubies, sapphires, and other precious stones. For balls or other formal occasions, these bouquets might be worn as brooches, but by day they were set in a vase of rock crystal with its own "water" of polished rock crystal.

The Hermitage contains one fabulous and quite unique item that simply leaves the viewer in awe. It is the Peacock Clock, a huge "automaton" or mechanical timepiece manufactured by the British clocksmith and entrepreneur James Cox in 1780. Catherine the Great's favourite Prince Grigory Potemkin had heard of Cox's magnificent mechanisms. Knowing the Empress's predilection for *jouets mécaniques* of this sort, he ordered up a clock that would definitely impress her.

The Cox timepiece-automaton that arrived in St Petersburg in 1781 did not disappoint: it was made of gilded bronze and boasted a peacock, an owl, and a cockerel (all birds redolent with symbolism in art history) in an oak tree, as well as a clock dial secreted in the cap of a large mushroom. When the clockwork goes into action on the hour, small bells chime in the gilded cage housing the owl (emblem of night, darkness, and wisdom) before the peacock – symbol of the cosmos, the sun, the moon, and resurrection – spreads its tail and spins around, tail feathers still wide apart, so the

*A study of cornflowers and stalks of oats, in engraved gold, rock crystal, rose-cut and brilliant diamonds, and enamel. Fabergé, St Petersburg. No maker's marks, but dates from c. 1910. Height 18.5 cm.*
ROYAL COLLECTION TRUST /
© HER MAJESTY QUEEN ELIZABETH II

*A jewelled bouquet of flowers by Catherine the Great's legendary Court Jeweller Jérémie Pauzié, in a rock crystal vase. Gold, silver, and a kaleidoscopic array of precious and semi-precious stones, including diamonds, emeralds, rubies, sapphires, amethysts, topazes, and aquamarines. St Petersburg, 1740s. Height 19.0 cm.*
COURTESY OF THE STATE HERMITAGE
MUSEUM, ST PETERSBURG

viewer can see the bright silver underside of the feathers, representing the glow of the moon. It then turns back to us, with the same feathers now showing in burnished gold at the same instant as the cockerel announces the rising of the sun. The Peacock Clock presents a life-affirming image, diametrically opposed to the normal symbolism associated with clocks, namely that of death and the fleeting nature of our existence.

Carl Fabergé used the spellbinding Peacock Clock as inspiration for one of his Imperial Easter Eggs (the Peacock Egg, 1908, see pages 121–123). Another intriguing piece by James Cox, the 1773 automaton entitled the Silver Swan, gave the young Fabergé further ideas for his own production when he saw it on display at the Paris World's Fair [Exposition universelle d'art et d'industrie] of 1867.

As mentioned earlier, in 1872 Carl Fabergé took over the running of his father's business in St Petersburg. He was 26 years of age at this point. We know little or nothing of his first years in charge, but it seems probable that things proceeded initially along the existing lines. It is also very possible that his father's partner and good friend Hiskias Pöntinen acted as a "minder" to the younger man, not out of jealousy or spite so much as because the business was running very smoothly indeed, and the old master felt that, for now at least, there was no need to tweak things or to bring in too many new-fangled ideas. This could also help to explain how Carl was able to devote quite so much of his time to the Hermitage in these early years.

## MARRIAGE AND FAMILY

In 1872 Carl Fabergé married Augusta Julia Jacobs, daughter of Gottlieb Jacobs, a manager at the Imperial Furniture Workshop in the city. The couple had five boys, one of whom sadly died in infancy. All four surviving siblings were artistically gifted. The oldest was Eugène Gottlieb (1874–1960), then came Agathon Theodor (1876–1951), Alexander Julius (1877–1952), and Nicholas Leopold (1884–1939). The boys were given a good education. Three were enrolled at the renowned and venerable Petrischule ( founded in 1709), which had a stellar academic reputation, while Agathon went to the private F. I. Wiedemann Gymnasium. On completion of their formal education, the boys went on to various arts institutes. Eugène studied at the Royal Prussian Academy in Hanau, and Alexander at Baron von Stieglitz's Central School of Technical Drawing, from whence he undertook further studies in Geneva. Both Eugène and Alexander worked as artists in their father's company after their graduation. Agathon trained as a precious stones specialist and was later appointed as an appraiser to the Cabinet of His Imperial Majesty. Carl's youngest son Nicholas also received an education as a designer, and he subsequently worked at the Fabergé outlet in London.

## A THRIVING ENTREPRENEUR

By the turn of the century, Fabergé had emerged as the most successful jeweller in all Russia. He employed, directly and indirectly, more than 500 skilled craftsmen, artist-designers, and clerical and sales staff. The turnover of the business was comfortably greater than any of his rivals, and his name was known almost all over Europe. From 1887 onwards, he had branch outlets in Moscow, including a showroom, a workshop crafting fine jewellery and a factory making silverware and cutlery. From 1901 a shop

*A snuffbox in gold, silver, diamonds, and enamel, with a miniature portrait of Catherine II on the lid. Made in St Petersburg by Jean-François-Xavier Bouddé, c. 1780. Diameter 7.3 cm.*
COURTESY OF THE STATE HERMITAGE MUSEUM, ST PETERSBURG

*An Imperial presentation snuffbox in gold, diamonds, and enamel, featuring a portrait of Emperor Nicholas II. Fabergé, Henrik Wigström, St Petersburg, made between 1908 and 1911. Diameter 8.5 cm. The piece in question was a 1911 gift from the sovereign to Prince Friedrich Hermann Heinrich of Solms-Baruth.*
PRIVATE COLLECTION, SWITZERLAND. PHOTO COURTESY OF JAKOB GRAF VON MOY.

*James cox's celebrated peacock clock automaton.*
COURTESY OF THE STATE HERMITAGE MUSEUM, ST PETERSBURG

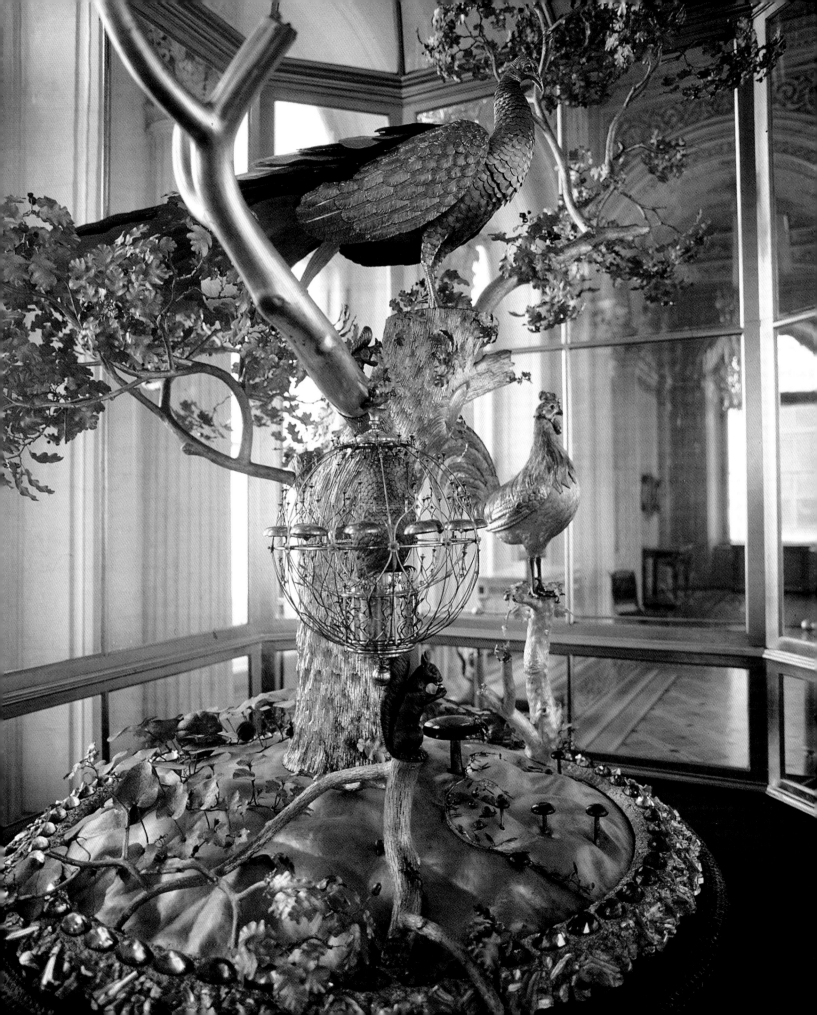

and workshop were added in Odessa, and from 1903 a retail branch in London. A similar outlet in Kiev followed in 1906.

In the wake of his success as an entrepreneur, Carl Fabergé was officially recognised. In 1885 he was appointed Purveyor to the Imperial Court. In 1890 he was granted hereditary honorary citizenship and was appointed Appraiser of the Cabinet of His Imperial Majesty. A supplier to almost all the courts of Europe, as well as that of Siam, he was officially named Jeweller to the Court of Sweden and Norway in 1897. He received several decorations: the Order of St Stanislas 3rd Class (1889), the Order of St Anne 3rd Class (1892), and the Order of St Stanislas 2nd Class (1896).

In 1900, Carl participated in the Paris World's Fair, and at the urging of Nicholas II he put on display fourteen of the dazzling Imperial Easter Eggs, miniature copies of the Russian Imperial Regalia, exquisite "flower arrangements" in gold, silver, pearls and rose-cut diamonds, and an assortment of jewels and personal luxury items. The public and the jury members alike were wowed by the Fabergé stand. Carl was given the honorary title of Maître by the Paris Guild of Master Goldsmiths, and President Émile Loubet of France formally bestowed on him the Legion d'Honneur. In 1910, he was granted the honorific titles of Manufacturing Counsellor and Court Jeweller.

By the end of the century, the old premises at Bolshaya Morskaya (initially at No. 11, moving in 1882 to No. 16) had already become too cramped for comfort. Workshops were scattered around the city, which greatly hampered the production process. Altogether too much time and energy was going into keeping lines of communication open and into toing and froing between the various locations. It was essential to put the entire organisation on a more efficient footing. To this end, in 1898 Carl Fabergé purchased a property one block down from the old address and launched a major construction project that led to the completion of a modern and purpose-built headquarters. At its opening in 1901, Fabergé's new home was in fact the first commercial complex of its kind anywhere in Russia, introducing a quite novel concept: all the company's core operations were now housed under the same roof.

The new address was 24, Bolshaya Morskaya. The Gothic Revival facade on the four-storey building gave onto the street and was clad in pale grey Finnish granite. The display windows on the ground floor were framed by three stout columns, again hewn out of Finnish red granite. The ground floor was laid out as a large salesroom with counters and glass display cases around the walls, in which the greater part of the standard assortment was placed, in their presentation boxes. The space was designed with display in mind, such that the customer could walk in easily and see all the latest wares at a glance.

Carl Fabergé's own office was directly adjacent to the main ground-floor showroom. From there he had a view out to the sales area, and could spring into action if some particularly important customer chanced to come through the doors. The floors over the showroom contained the company's offices, and the artists and designers had their studio space on the top floor of the building. The property also housed a reference library of works on the arts and the jewellery branch. Nearly every volume that had been written about the goldsmith's trade and the cutting and polishing of gemstones could be found on the shelves, and the library was naturally at the disposal of the employees.

*An egg-shaped cup in chased gold, ivory and eggshell, attributed to Master Goldsmith D of St Petersburg, and dating from c. 1780. The cup is part of an Easter dinner service. Height 10.9 cm. The cup served as a model for Fabergé's Blue Ribbed Egg (see p. 83).*
COURTESY OF THE STATE HERMITAGE MUSEUM, ST PETERSBURG

*A snuffbox in varicolour gold and red enamel on a guilloché ground. The portrait miniature of Louis XIV mounted on the lid is inside a diamond-set foliate frame. Andreas Ferdinand Spiegel, St Petersburg, 1856. Gustav Fabergé, Carl's father, learned his trade as an apprentice in Spiegel's workshop.*
COURTESY OF SOTHEBY'S

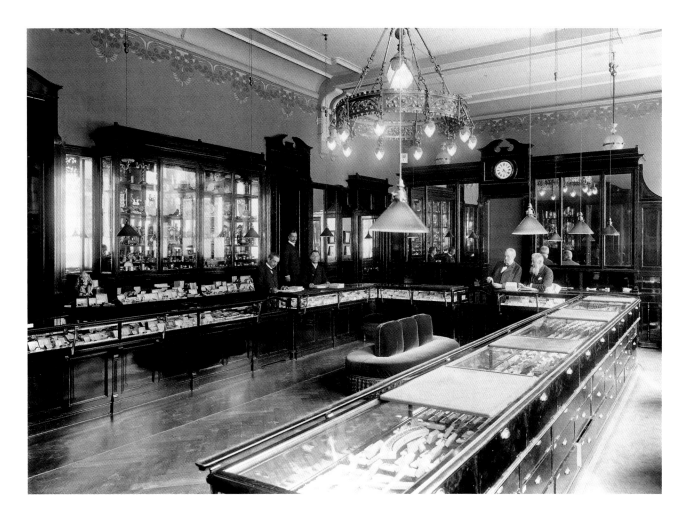

*The Fabergé flagship store at No. 24, Bolshaya Morskaya. The jewels and other small items are in their presentation boxes in the glass-covered counters, while larger pieces are on show in the glass display cases around the walls. Carl Fabergé's own office and studio was directly behind the wall of the salesroom itself. The photo is believed to date from 1910.*
<small>COURTESY OF WARTSKI, LONDON</small>

In keeping with the old guild traditions, Carl Fabergé also furnished his own spacious suite of fifteen rooms in the building for himself and his family. The same traditions were upheld for the home of the head workmaster: his apartments looked onto the inner courtyard and were directly connected to his workshop (see in more detail in the chapter covering Henrik Wigström).

## THE WORKSHOPS

Scaling up the output called for efficient manufacturing processes, and the key decision was taken to outsource production. The workmasters of the various workshops were supported to become independent entrepreneurs. Offering the masters ownership of their workshops within a system of close collaboration was an inspired idea. It afforded many advantages, both for the House itself and for the individual workmasters, securing long-term cooperation among the parties involved. For the master, there was the assurance of a steady outlet for his production, quite apart from the attraction of captaining his own ship, as it were. Long before the modern concept of "industrial democracy", its prototype was in play at Fabergé. Curiously enough, it bloomed during the reign of the greatest autocracy the world has ever known.

The recruitment and training of craftsmen was an important charge given to the workmasters. They were also responsible for the quality of their workmanship

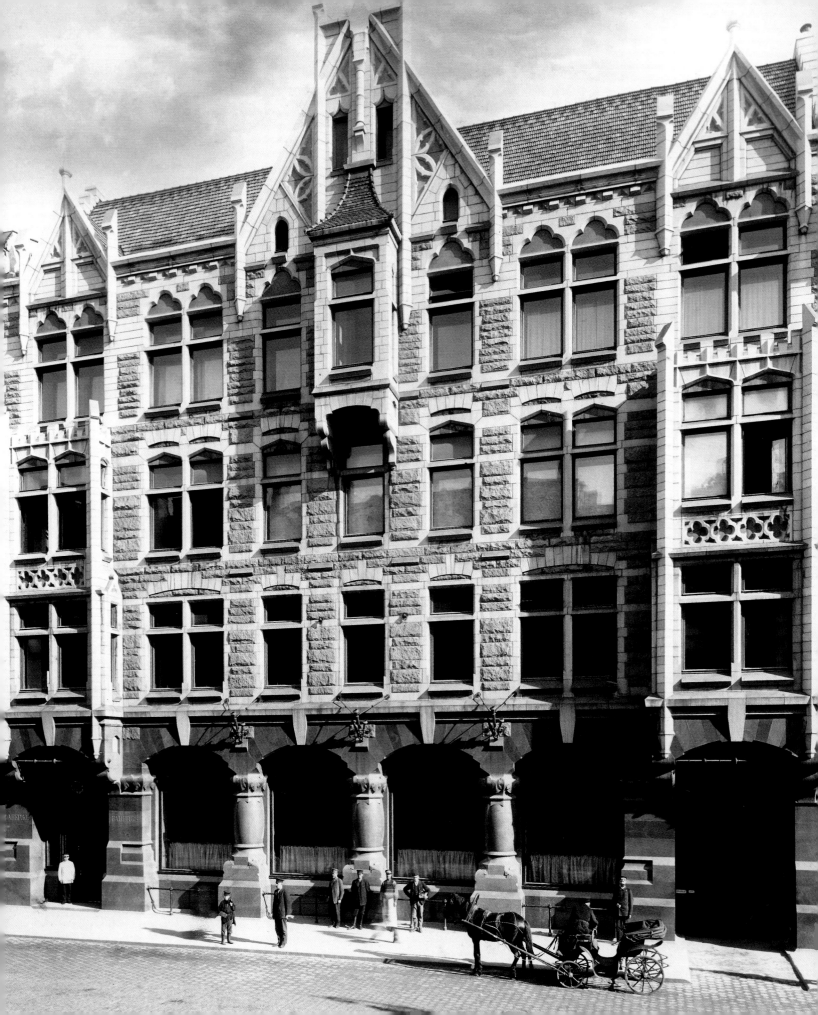

*Exterior of the House of Fabergé premises at No. 24, Bolshaya Morskaya. The building was designed by the architect Carl Schmidt and was completed in 1901. The façade is of pale grey Finnish granite, and the three stout columns framing the display windows are also of Finnish granite.*
COURTESY OF WARTSKI, LONDON

and for guaranteeing delivery schedules. In return, they were granted the right to mark their wares with their own initials. Outsourcing liberated Fabergé's management from the burden of trivial day-to-day problems. These included difficulties in recruiting suitable apprentices and journeymen, and the chronic problem of keeping the skilled ones on the staff roster. The owners' creative time was thus not frittered away on "unproductive" matters.

The workshops were in the five-storey courtyard wing of the building. The premises occupied by the head workmaster were on the second floor (this was Perkhin's realm until his death in 1903, and thereafter Henrik Wigström's). Directly below this, on the first floor, was the workshop of August Hollming. On the death of Hollming, his son Väinö took over the family workshop. Fabergé was, however, not overly pleased with Väinö's work, and his contract was consequently not renewed. In 1916, the premises were offered to Hjalmar Armfelt.

The third floor housed the jewellery workshop, in other words the domain of the head jeweller August Holmström, and from 1903 of his son Albert. Underneath the eaves on the fourth floor were the quarters of workmaster Alfred Thielemann. There was a connecting passage between the office building and the workshops, which facilitated daily contacts between the various company units.

On the ground floor, also in the courtyard wing, was the atelier of Fabergé's master case makers. Between the years 1896 and 1911, it was managed by the widow of the master. The basement housed one of the enamelling workshops.

On the flat roof of the building there was a greenhouse in which plants and flowers, including tropical flowers, were grown during the summer months. These were used as models for the flower studies created by Fabergé.[8]

The other masters had their premises outside of the Fabergé building, albeit that most were within easy walking distance of Bolshaya Morskaya.

*Architectural drawing showing the five-storey workshop wing of the House of Fabergé at No. 24, Bolshaya Morskaya. For the division of the floors, see the text.*
RUSSIAN STATE HISTORICAL ARCHIVE, ST PETERSBURG

# August Holmström

ugust Wilhelm Holmström (1829–1903) was chief jeweller to the House of Fabergé for a total of forty-six years, and it was in his atelier that the major jewellery production was carried out. He had joined the firm during Gustav Fabergé's time, and he served together with the company founder for three years before Gustav moved to Dresden. Holmström also worked for more than two decades with Gustav's business partner and friend Hiskias Pöntinen. Among the many youngsters training in Holmström's workshop, under his watchful eye, were the future master goldsmiths Erik Kollin, Viktor Aarne, Antti Nevalainen, Anders Mickelsson, and Knut Oscar Pihl, who was to become his son-in-law. Against this background, Holmström can rightly be considered the firm's 'good and faithful servant'.

Holmström was born in Helsinki on October 2nd, 1829. He was the only child of the journeyman stonemason Henrik Holmström and his wife, Maria Christina Ahlborg. For an only child to leave home may initially have caused a problem within the family. It is therefore believed that August started out by training in his father's craft. By the age of sixteen, however, he had apparently had enough of laying bricks and decided the stonemason's profession was not for him. He decided instead to try his luck in St Petersburg, the fabled city of endless opportunity.

In August 1845, August arrived in the Russian capital and signed apprenticeship papers with the master jeweller Herold, whose workshop acted as a sub-contractor to the big retail shops along Nevsky Prospekt. Also apprenticing under Herold was another Finnish boy, by the name of Johan Fredrik Hammarström (1832–1867). The two youngsters received their journeyman papers one after the other, Fredrik in 1849 and August in 1850. Hammarström maintained his lead, becoming a master goldsmith in 1853. However, four years later, after becoming a master himself, August purchased Hammarström's workshop. Shortly after this, he was appointed chief jeweller at Fabergé.

*The "Empress Joséphine" Tiara, studded with diamonds, mounted in silver and gold. The central pear-shaped diamond is flanked by one cushion-cut and three briolette-cut diamonds. The diamonds are linked with the thinnest "knife-wire" connections, making the stones appear to be invisibly suspended. Fabergé, August Holmström, St. Petersburg, c. 1890. Breadth 13.2 cm.*

*The nickname for this iconic piece derives from the story of the three briolette diamonds, allegedly gifted by Emperor Alexander I to Empress Joséphine (1763–1814), after her divorce from Emperor Napoleon I of France. Alexander paid her several visits at the Château de Malmaison outside Paris. The briolettes passed down through the family and returned to Russia with the Empress's grandson Maximilian de Beauharnais, 3rd Duke of Leuchtenberg. In 1839, he married Grand Duchess Maria Nikolaevna of Russia, eldest daughter of Emperor Nicholas I.*

COURTESY OF THE MCFERRIN COLLECTION, HOUSTON, TEXAS

*August Holmström, Master Jeweller
of the House of Fabergé.*
FROM THE COLLECTION OF LYDIA PIHL

*Hilma Holmström (1850–1925),
wife of August Holmström.*
FROM THE COLLECTION OF LYDIA PIHL

There was a certain pattern in the lives and careers of young master craftsmen such as August. Not long after establishing himself as an independent entrepreneur, with a workshop of his own, the young man married. A master craftsman was greatly in need of a good wife – someone willing and able to assist her husband in his work. She was expected to take care of a sizeable household in the rooms over the workshop, to which not only her own children belonged, but also a company of adolescent apprentices. Holmström followed the established pattern, marrying almost as soon as he received his master's certificate. His seventeen-year-old bride, Maria Sofia, was the daughter of the Imperial Court watchmaker Welen, based in Gatchina, on the outskirts of St Petersburg. The marriage regrettably ended in divorce in 1866. It may have been that the young wife was not best suited to the challenges of a frenetically busy workshop. In any event, in 1868 August married for a second time, to Hilma Rosalie Sundberg (1850–1925), daughter of the Finnish-born coppersmith Carl Johan Sundberg.

The couple had a total of eight children, including Fanny Florentina (1869–1949), who married the master goldsmith Knut Oscar Pihl, Alina (1875–1936), who became a jewellery designer, and Albert Woldemar (1876–1925), who succeeded his father as Fabergé's chief jeweller. In the next generation, Fanny and Knut Oscar's daughter Alma Pihl became a hugely talented designer, while their son Oskar Woldemar trained under Albert Holmström and later worked as a designer with A. Tillander in Helsinki.

Henry Bainbridge says of August Holmström:

I cannot place Holmström except on the very top rung of the Fabergé ladder. No jeweller in Europe could beat him, but he was much more than a setter of precious stones... Not only did he succeed in turning out objects of jewellery for personal adornment and jewelled objects in the way of Imperial Easter Eggs and their 'surprises', and of the finest quality, but he was equally successful in goldsmithery, pure and simple. For example, it was he who made the tiny gold model of the armoured cruiser Pamiat Azova, exact in every detail of guns, chains, anchors, and rigging, in which Nicholas II, when heir to the throne, made his voyage round the world. This model is the 'surprise' in the Imperial Easter Egg, made in jasper and ornamented with chased gold and diamonds in the Louis XV style, which the Emperor presented to his mother.[9]

*The document confirms that the bricklayer's son August Wilhelm Holmström has been granted a six-month residence and work permit for St Petersburg. The pass was granted by the Governor of Mikkeli Province on February 8th, 1844. It is not known to whom Holmström was originally apprenticed in Mikkeli.*
NATIONAL ARCHIVES OF FINLAND, HELSINKI

*A diamond-shaped cabochon almandine garnet brooch, with a gold frame set with diamonds. Fabergé, August Holmström, St Petersburg, c. 1890.*
COURTESY OF JOHN ATZBACH, REDMOND, WASHINGTON

*An Imperial presentation bijou. Gold, rubies, diamonds, and enamel. The piece bears the monogram of Grand Duchess Maria Pavlovna ("the Elder", 1854–1920). Fabergé, August Holmström, St Petersburg, made between 1899 and 1903.*
FABERGÉ MUSEUM, ST PETERSBURG. THE LINK OF TIMES CULTURAL AND HISTORICAL FOUNDATION

*A knot-shaped brooch in yellow gold, cabochon sapphires, and a single rose-cut diamond. Fabergé, August Holmström, St Petersburg, c. 1890. The piece was a gift to Erika Gustafsson from Princess Maria Victorovna Bariatinskaya (1858–1942), one of Empress Alexandra's maids of honour. Miss Gustafsson was in turn lady's companion to Princess Maria in St Petersburg.*
PRIVATE COLLECTION. PHOTO BY KATJA HAGELSTAM

*A brooch in gold, platinum-silver, diamonds, sapphires, and rubies. Fabergé, August Holmström, St Petersburg, made between 1899 and 1903.*
COURTESY OF JOHN ATZBACH, REDMOND, WASHINGTON

Pendant (stock number 89043), brooch (stock number 91002), and earrings (stock number 93780). In gold and platinum-silver, each with rose-cut diamonds and cabochon "mecca stone" (sky-blue stained chalcedony) drops. Fabergé, August Holmström, St Petersburg, c. 1900.

©FABERGÉ MUSEUM, ST PETERSBURG. THE LINK OF TIMES CULTURAL AND HISTORICAL FOUNDATION

A pendant in gold, diamonds, and baroque pearls. Fabergé, August Holmström, St Petersburg, 1890s.

PRIVATE COLLECTION. PHOTO BY KATJA HAGELSTAM

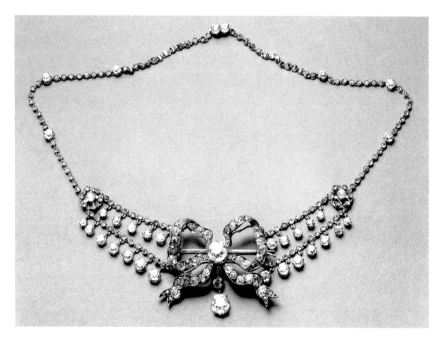

◁ A necklace in gold, silver, and diamonds, with a detachable ribbon-bow brooch. Fabergé, August Holmström, St Petersburg, 1892. This piece was ordered by Anna Sinebrychoff, wife of the Finnish-Russian brewing magnate Pavel Sinebrychoff, to be given to their eldest daughter Maria (b. 1852) on her 40th birthday.

PRIVATE COLLECTION

▷ A necklace in gold, silver, and diamonds. Fabergé, August Holmström, St Petersburg, 1894. This piece was ordered by Anna Sinebrychoff for her second daughter, also Anna (b. 1854), as a 40th birthday gift.

PRIVATE COLLECTION. PHOTO BY KATJA HAGELSTAM

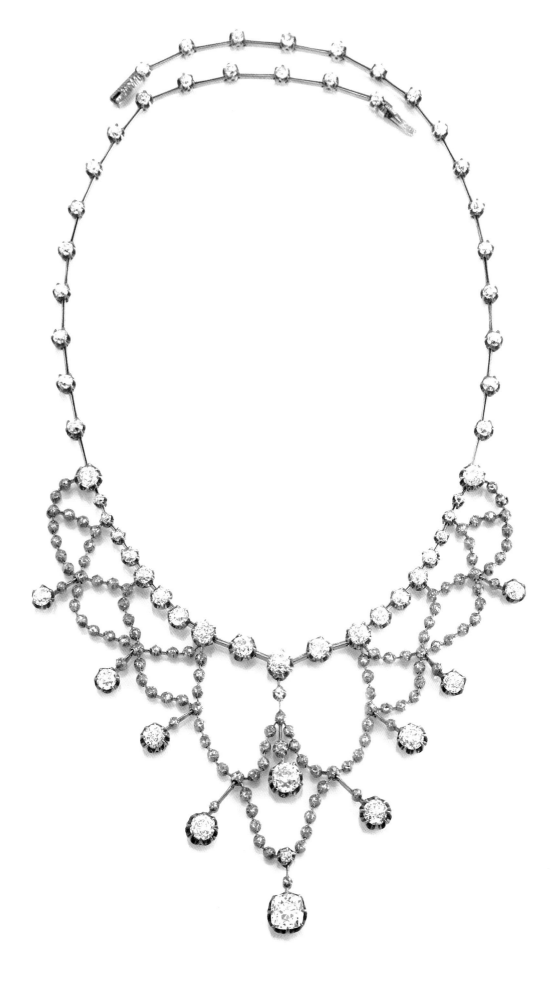

*Four gold, enamel, and diamond buttons. Fabergé, August Holmström, St Petersburg, c. 1899.*
COURTESY OF THE INDIA EARLY MINSHALL COLLECTION, CLEVELAND MUSEUM OF ART, CLEVELAND, OHIO

*Cufflinks in gold with enamel and cabochon sapphires. Fabergé, August Holmström, St Petersburg, made between 1899 and 1903. Diameter 2.5 cm.*
COURTESY OF BONHAMS

*Cufflinks in gold and diamonds. Fabergé, August Holmström, St Petersburg, c. 1890. Diameter 1.7 cm.*
COURTESY OF BONHAMS

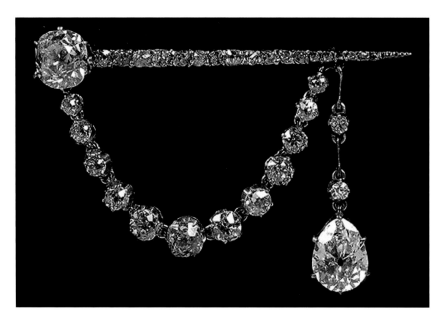

◁ *A gold, platinum-silver and diamond-set brooch with a pendant pear-shaped diamond. Fabergé, August Holmström, St Petersburg, made between 1899 and 1903.*
COURTESY OF JOHN ATZBACH, REDMOND, WASHINGTON

▷ *A four-colour gold and moss agate miniature Louis XVI clock and thermometer. Fabergé, August Holmström, St Petersburg, c. 1890. Scratched stock number 43985.*
COURTESY OF SOTHEBY'S

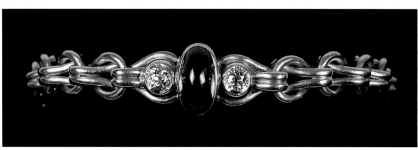

◁ *A bracelet with gold links, diamonds, and a cabochon sapphire. Fabergé, August Holmström, St Petersburg, 1890s.*
COURTESY OF JOHN ATZBACH, REDMOND, WASHINGTON

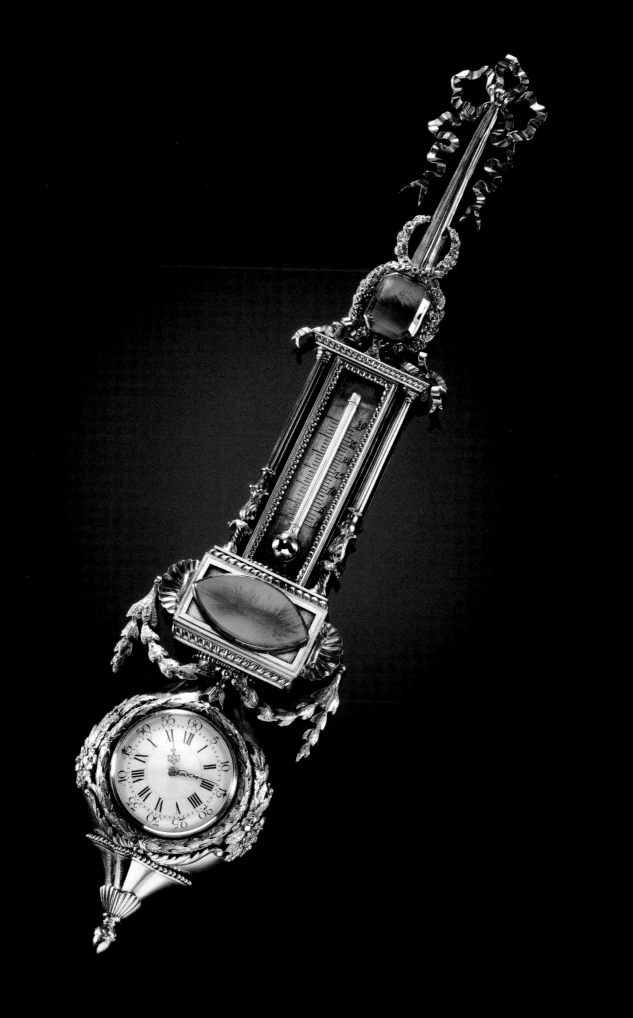

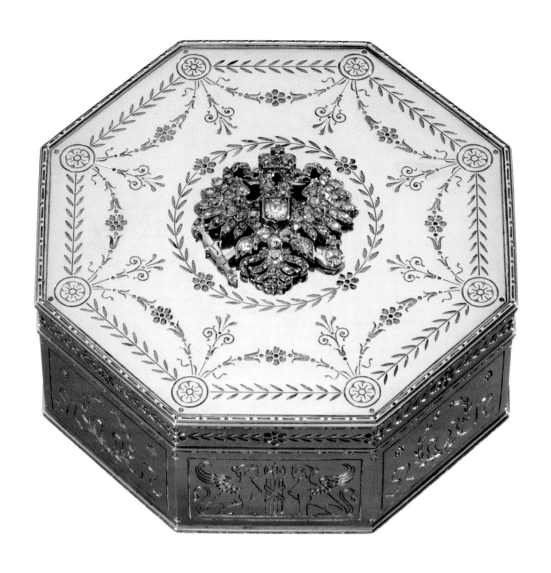

Aside from the incredible quantity and variety of commissioned jewellery and items made for stock, Holmström created several quite extraordinary custom pieces.

Two, possibly even four of the earliest Imperial Easter Eggs, given by Alexander III to his wife Empress Maria Feodorovna, were produced in the Holmström workshop. One was the Third Imperial Egg, made for Easter 1887. Until its dramatic rediscovery in 2014, this was among the eight lost Imperial Easter Eggs.[10] The jewelled and ridged yellow gold egg contains a surprise of a watch by Vacheron Constantin. The Easter Eggs of 1888 (the missing Cherub Egg with a Chariot) and of 1889 (the Nécessaire Egg, once again missing) may well also have been made under Holmström's guidance.[11] The chief workmaster Erik Kollin, who would have overseen the production of these important commissions, had been replaced in 1889 by the young master goldsmith Mikhail Perkhin. Even though young Perkhin was a skilled craftsman in his own right, he was still in the process of being "run in". Whatever the case with these two pieces, the pale-green bowenite Diamond Trellis Egg made for Easter 1892 was indisputably made under the supervision of August Holmström. (See p. 50).

A further well-known masterpiece from Holmström's workshop is the miniature set of the Imperial Regalia (in 1:10 scale), created in collaboration with the silversmith Julius Rappoport and the stone carver Carl Woerffel. The facsimile coronation crown, orb, and sceptre are made of gold, platinum, silver, diamonds, sapphires, and rubies. Precise in every tiny detail, the set is a genuine pièce de résistance of the goldsmith's art, and was among the objects Fabergé sent to be exhibited at the Exposition Universelle in Paris in 1900.

August Holmström, Fabergé's Grand Old Man, worked actively in his studio right up until his death. He died with his boots on at the age of seventy-four in 1903,

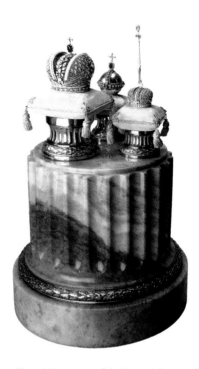

*The miniature set of the Imperial Regalia. See the text on the right.*
THE STATE HERMITAGE MUSEUM, ST PETERSBURG

◁ *An octagonal Imperial presentation box in red gold, engraved and set with diamonds and rubies, and displaying the Russian Imperial double-headed eagle topped with a crown. Fabergé, August Holmström, St Petersburg, c. 1899.*
COURTESY OF HILLWOOD ESTATE, MUSEUM & GARDENS. ESTATE OF MARJORIE MERRIWEATHER POST, WASHINGTON DC. PHOTO BY E. OWEN

◁ *A gold-mounted silver and guilloché enamel dagger-form paper knife and pencil holder. Fabergé, August Holmström, St Petersburg, c. 1900–1903. Scratched stock number 13826. This was a birthday gift, and came originally from a royal collection. The hand-written card in the Fabergé presentation case reads: "Von Motherdear zum Geburtstag, 11th Oct. 1906".*
COURTESY OF COLLECTION MIRABAUD

*The Holmström family gathered at Hilma Holmström's home (Hilma is seen at front right), around 1915. Seated next to Hilma, from right to left, are: her eldest daughter Fanny Florentina Pihl, an unknown family friend, daughter Alina Holmström-Zverzhinskaya, an unknown family friend, and Hilma's grandson Georg Pihl. Standing in the back row, from left to right, are: Hilma's grandson Artur Pihl, Alina's husband Evgeny Vasilievich Zverzhinsky, Hilma's granddaughter Alma Pihl-Klee, Hilma's grandson Oskar Pihl, and Alma's husband Nikolay Klee.*
FROM THE COLLECTION OF LYDIA PIHL

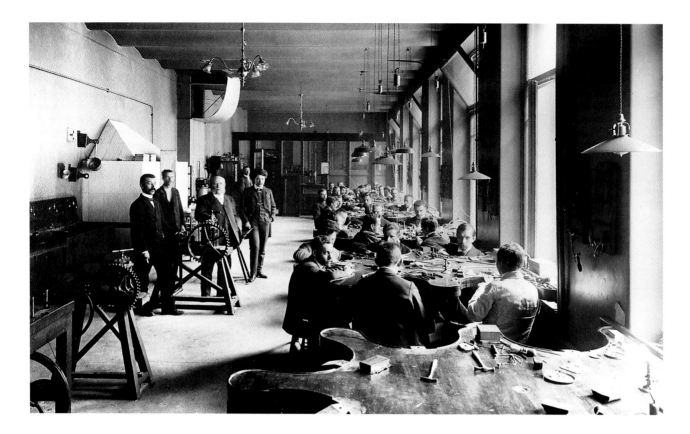

in St Petersburg. In his lifetime, he had witnessed the modest shop of Gustav Fabergé become one of the world's leading jewellery firms. And he himself had risen from being a simple mason's son from the Grand Duchy of Finland to recognition as one of the most talented and revered jewellers in the industry.

*The photograph shows the August Holmström Workshop in 1902.*
COURTESY OF THE ALEXANDER FERSMAN MINERALOGICAL MUSEUM IN MOSCOW, UNDER THE RUSSIAN ACADEMY OF SCIENCES.

### AUGUST HOLMSTRÖM'S WORKSHOP

August Holmström, at the age of seventy-three, stands imperiously third from the left, and diagonally behind him over his left shoulder is his son and successor, the young master jeweller Albert Holmström, 26, striking an elegant pose and dressed in the latest fashion.

At this stage, the workshop employed nearly fifty journeymen and apprentices. At the back, behind the glassed partition wall, was the office in which new projects were assigned and the precious metals and stones were weighed before being distributed to the craftsmen.

On the empty workbench in the foreground, one can see a variety of jeweller's tools: a hammer, a saw, a putty stick, and a small brush for sweeping the filings into the leather pouches below. More tools hang neatly from leather straps on the wood panelling between the windows.

On the left-hand wall are the kilns, which were heated with gas, a relatively new innovation at this point. The gas-pipe is visible running along the wall. Standing on the floor are two rolling mills with large cogwheels. One was used to create decorative edges on pieces of jewellery, and the second produced gold wire to a desired thickness.

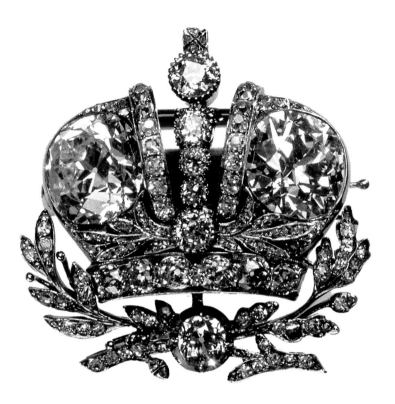

The House of Fabergé received a veritable avalanche of important commissions in advance of the Coronation of Nicholas II and his wife Alexandra in May 1896. On the momentous day of the Coronation, all 15 Grand Duchesses of the Romanov Dynasty received from Their Imperial Majesties the gift of an opulent diamond brooch in the form of an Imperial Crown.

The costliest of the brooches were presented to the highest-ranking ladies, both by pre-eminence and seniority of tenure: Grand Duchesses Alexandra Iosifovna (widow of Grand Duke Konstantin Nikolaevich), Maria Pavlovna (wife of Grand Duke Vladimir Alexandrovich), Maria Alexandrovna (wife of Duke Alfred of Saxe-Coburg and Gotha), and Olga Konstantinova (Queen consort of King George I of Greece).

The brooch illustrated here was the gift to Grand Duchess Anastasia Mikhailovna (wife of Grand Duke Friedrich Franz III of Mecklenburg-Schwerin). Two further brooches have survived and are likewise in collections of family members of the original recipients.

Some of the brooches were set with pearls, rubies, emeralds, or sapphires. They ranged in price from 6,850 to 1,100 roubles, with the aggregate total cost reaching 66,892 roubles. In fact, as many as 18 brooches were made, with three remaining in stock at the Cabinet of His Imperial Majesty.[12]

*Grand Duchess Anastasia Mikhailovna's Coronation gift from Emperor Nicholas II. Gold, silver, 84 brilliant-cut diamonds with a total weight of c. 17 carats, and 80 rose-cut diamonds. August Holmström, Fabergé, (56 zolotnik), scratched stock number 1032. Height 3.6 cm.*

COURTESY OF HER ROYAL HIGHNESS PRINCESS ELISABETH OF DENMARK. PHOTO RAUNO TRÄSKELIN

This beautiful egg was the 1892 Easter gift from Alexander III to his wife Empress Maria Feodorovna. The egg is carved from the pale apple-green form of the serpentine group mineral known as bowenite, which is an attractive substitute for jade.

Deposits of bowenite are found in several places around the world, including Afghanistan, China, New Zealand, South Africa, and the United States.[13] The stone was named in the 1850s, in honour the American chemist and mineralogist George Thomas Bowen (1803–1828).

Bowenite is seen as a symbol of friendship, love, and gratitude. In that respect it was a fitting metaphor for an Easter gift. Whether the symbolism of the stone was known to Fabergé is not clear, but he certainly favoured the mineral, commissioning his lapidarians to sculpt a huge array of objects in bowenite. Of these, his menagerie of miniature bowenite animals is especially delightful.

The 1892 Imperial Easter Egg is encased by a skillfully crafted trellis of minute rose-cut diamonds. The workmanship is a true showpiece of the jeweller's hand; the task of crafting it had obviously been entrusted to the chief jeweller, August Holmström.

A large brilliant-cut diamond is set at the apex of the egg. The surprise, only recently rediscovered, is a miniature figure of an elephant carved in ivory and almost identical to the badge of the Danish Order of the Elephant. The Egg was originally supported on an elaborate base consisting of three silver cherubs, now regrettably lost. The cherubs are thought to symbolise the sons of the Imperial couple. The Diamond Trellis Egg can be seen on the top shelf of Empress Maria Feodorovna's showcase at the 1902 charity exhibition held in the von Derwies Palace in St Petersburg. (See p. 129)

*The Diamond Trellis Egg from 1892 is of gold (marked 72 zolotnik), silver, pale green translucent bowenite, with a trellis of rose-cut diamonds. Fabergé, August Holmström, St Petersburg. Height 10.8 cm. Fabergé's invoice from April 1892 indicates a price to Emperor Alexander III of 4,750 roubles for this Easter gift to his wife, Empress Maria Feodorovna.*
COURTESY OF THE MCFERRIN COLLECTION, HOUSTON, TEXAS

*Long thought to have disappeared, this is the jewelled elephant automaton made as the 'surprise' for the 1892 Diamond Trellis Egg. The item is described in Fabergé's original invoice and in an inventory of Imperial Easter Eggs made by Fabergé in the collection of Maria Feodorovna. In terms of the detail – the tower, the cross on the elephant's flanks, the mahout perched on the elephant's head - the piece is almost identical to the badge of the Danish Order of the Elephant, the most senior order of chivalry in Denmark. Maria Feodorovna was the former Princess Dagmar of Denmark. The elephant is wound with a key through a hole hidden beneath the diamond cross on one side. It walks on ratcheted wheels and rocks its head up and down. Ivory, gold, diamonds, enamel, brass, and nickel. Fabergé, Mikhail Perkhin, St Petersburg, 1892. The maker's marks, only recently discovered, are hidden under the removable 'roof' of the tower.*
ROYAL COLLECTION TRUST/ © HER MAJESTY QUEEN ELIZABETH II

The Fabergé chain bracelet in the illustration features an artificially-coloured sky blue chalcedony cabochon, popularly called a "mecca stone". Fabergé frequently used chalcedony in his designs, especially in brooches, bracelets, pins, and cufflinks, and usually in combination with small rose-cut diamonds. The stone is enchanting, resembling a glittering drop of water. A simple, inexpensive gemstone set in handmade jewellery was in perfect accord with Fabergé's philosophy. For him, design and workmanship were what gave jewellery its real value, not costly materials.

*Empress Alexandra Feodorovna (r.) and her confidante Anna Vyrubova, née Taneyeva. The photograph is taken from Anna Vyrubova's own album.*
COURTESY OF THE DESIGN MUSEUM, HELSINKI

Empress Alexandra Feodorovna commissioned the bracelet as a gift for her protégée Anna Vyrubova, née Taneyeva (1884–1964), who spent twelve years (1905–17) in close association with the Imperial Family as Alexandra's companion and friend. The Empress called the bracelet 'The Tear', saying it symbolised the infinite tears Anna and she had shed together.

Anna writes in her memoirs:

The diagnosis of the boy's [Tsesarevich Alexey Nikolaevich, heir apparent to the throne] illness was a terrible blow both to the Emperor and the Empress. The Empress's health suffered, and she could not stop blaming herself for being the cause of his complaint. The Emperor aged significantly on this very day, and those close to him could not help but notice that he was grieving the future of his son on an unremitting basis.

I so well remember that outstandingly beautiful child; he looked like a cherub with his golden locks and his amazingly large, insightful eyes. He looked absolutely healthy, but developed large swelling bruises from the slightest nudge. The heir was protected in all possible ways, but being a lively child, he could not avoid getting small wounds, which caused laments, tears, and tremendous pain... I cannot count the hours I have spent in the company of Her Imperial Majesty in the quiet white nursery next to the bed of the small heir to the throne.[14]

At the outbreak of the Russian Revolution and following the abdication of Emperor Nicholas II, Anna Vyrubova was forcibly separated from her patrons and supporters. She was arrested and imprisoned several times, and after her release she went into hiding from her Bolshevik persecutors, together with her mother. The two women were helped to safety, escaping in 1920 across the ice-covered Gulf of Finland on a sledge.

Anna subsequently lived forty-four years in exile in Finland. She had close contacts with the monks of the Orthodox monastery of Valaam (Valamo), and was herself ordained as a nun. Having been disabled and confined to a wheelchair following a railway accident in 1915, Anna could not be received at the Lintula Holy Trinity Convent, in Kivennapa on the Karelian

The bracelet is of gold, with a pale-blue tinted cabochon chalcedony or "mecca stone" as the centrepiece. The 56 zolotnik (14-carat) gold chain was by a Fabergé sub-contractor, the goldsmith Friedrich (Fedor) Rutsch. The jewel is believed to be the work of the Holmström workshop. Fabergé, Friedrich Rutsch, St Petersburg, made between 1899 and 1908.

NATIONAL MUSEUM OF FINLAND. PHOTO BY KATJA HAGELSTAM

Isthmus. She became a non-resident member of the Convent, and had to promise in her nun's oath to pursue a lifelong adherence to certain Lintula rules and obligations.

During her early years in Finland, Anna encountered the philanthropist Baroness Matilda Wrede (1864–1928), who was a known benefactor of prisoners. Matilda had already begun visiting inmates in Finnish prisons in the 1880s, but was forced by the authorities to discontinue this activity in 1913. She then began to assist Russian refugees in Finland. As a gesture of friendship and gratitude, Anna gave the Empress's bracelet to Matilda Wrede.

Anna Vyrubova's last resting place is in the cemetery of the Helsinki Orthodox Congregation. Flowers often decorate her modest grave, brought there by unknown individuals. They are Russian visitors, who stop by to pay their respects to her and many other well-known Russians who fled their country during the troubled years of the Revolution.

T his exquisite gold basket was Empress Alexandra Feodorovna's favourite object. It took pride of place on the writing desk in her fabled Mauve Room at the Alexander Palace at Tsarskoye Selo. It was presented to her in 1896, when the Imperial couple visited the trade fair at Nizhny Novgorod. The base of the basket is engraved with the inscription: 'To Her Imperial Majesty, Empress Alexandra Feodorovna, from the Ironworks Management and Dealers in the Siberian Iron Section of the All-Russia Industrial and Art Exhibition, in the Year of 1896'.

Lilies of the valley were the young Empress's flower of choice, and the Siberian industrialists had been very shrewd in seeking out this preference, in order that their gift might particularly delight her. It is entirely possible the donors asked Carl Fabergé for advice when planning their offering. This incredibly fine piece was made in the workshop of August Holmström. It is very naturalistic, and one can well imagine the artistic team working on it with a bouquet of freshly picked and fragrant flowers before them for inspiration. The stone cutter Carl Woerffel most probably had an actual leaf as a model when carving the fine green nephrite leaves seen here. Holmström's skilled goldsmiths created the flowers from small freshwater pearls. They have lobes of rose-cut diamonds, a small detail not found in the real flowers, but one that adds to the luxury of the piece. The soft bed of moss is made from fine brownish gold threads. The gold basket is modelled after wicker varieties still in everyday use in Nordic households today.

*The basket and its flowers are of gold, silver, nephrite jade, freshwater pearls, and diamonds.*
*Fabergé, August Holmström, St Petersburg, 1896. Height 19 cm, breadth 21.5 cm.*

PHOTO BY OWEN MURPHY. COURTESY OF THE CHEEKWOOD BOTANICAL GARDENS & MUSEUM OF ART, NASHVILLE, TN., THE MATILDA GEDDINGS GRAY FOUNDATION COLLECTION. THE OBJECT IS ON EXTENDED LOAN AT THE METROPOLITAN MUSEUM OF ART, NEW YORK, NY.

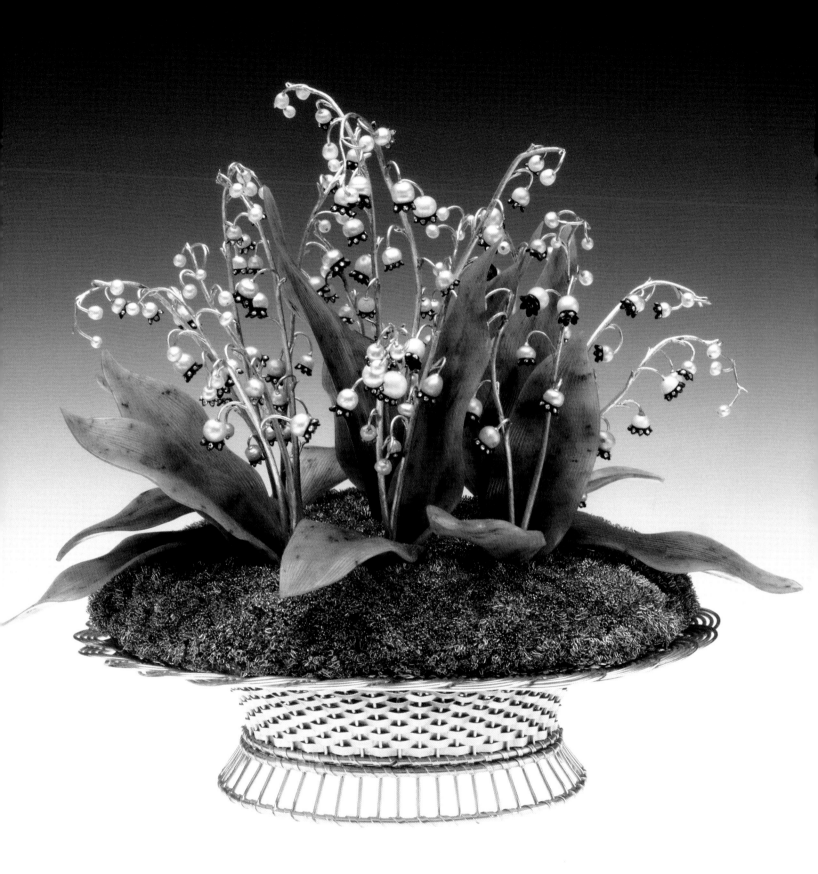

# Wilhelm Reimer

Master Goldsmith Wilhelm Reimer (d. circa 1898) was born in Pernau (Pärnu in Estonian), a small Livonian town on the coast of the Gulf of Riga, some sixty-eight miles (110 km) south of Reval (known today as Tallinn). Gustav Fabergé also hailed from this ancient Hanseatic harbour, which at the time was part of the Russian Empire. It has been suggested the two of them were related, in that Wilhelm's father was married to Gustav Fabergé's sister. Gustav Fabergé would in other words have been Reimer's maternal uncle, but it has not been possible to verify their family ties.[15]

Reimer was one of the early collaborators of Fabergé, along with Johann Eckhardt, Johann Alexander Gunst, and August Holmström. It is not known exactly in which year he started working for Gustav, though it was possibly in 1857, the year Holmström joined the team. Reimer qualified as a master goldsmith in the early 1860s and could thereafter apply for permission to establish a workshop of his own. There was space enough for him to set up in the backyard of the Jacot House at 11, Bolshaya Morskaya. This was the address at which Gustav Fabergé had both his salesroom and his "in-house" workshop, headed by Hiskias Pöntinen (later Pendin).

Master Goldsmith Rudolf Augustovich Thielemann, the father of Alfred Thielemann (see p. 205), also rented space in the same yard. The concentration of various masters' workshops at the same addresses was and still is a customary practice of a particular trade, and an indicator of smooth collaboration between them.

In 1882 the House of Fabergé, by this time headed by Carl Fabergé, moved its salesroom and workshop across the street to 16, Bolshaya Morskaya. The lease at No. 11 being now discontinued, Wilhelm Reimer moved into the backyard of 2, Bolshaya Morskaya, which was state-owned property occupied by the Ministry of Finance. Rudolf Thielemann stayed on at 11, Bolshaya Morskaya, and his workshop was still listed there in 1895.[16]

Reimer's production consisted of jewellery and small enamel and gold objects. Very few examples of his work have survived. It is therefore difficult to establish whether he was solely working for Fabergé or whether he might have worked for others as well. It is, however, known that he remained a collaborator of Fabergé until just a few years before his death. Master Goldsmith Andrey Gurianov, who possibly had worked for Reimer for some years, took over his workshop in 1898.

For an illustration of a piece by Reimer. (See p. 24)

In 1858, Wilhelm Reimer married Marie Charlotte Friedrike Reimers (1839–1882).[17] Based on her German name, the bride could well also have had her roots among the German-speaking Livonians.

# Theodor & Anna Ringe

Friedrich Theodor Ringe (1824–1894), another master goldsmith with roots in Germany, was born in Riga, Latvia, at the time a part of the Russian Empire. Ringe worked for the House of Fabergé as an independent goldsmith, but presumably was not under an exclusive contract, which would have required him to work solely for Fabergé.

It is not known where and with whom Ringe trained, nor the date when he was certified as a master goldsmith. According to Leonard Bäcksbacka, the eminent specialist on St Petersburg goldsmiths, Ringe was active in his own workshop from 1856.[18] It is nevertheless possible he may have earned his master's papers earlier.

In 1866, Ringe married Anna Karlovna, née Lapping (1840–1912), who hailed from Latvia.[19]

Ringe's production consisted of small enamelled objects in gold and silver: cigarette boxes, wax seals, parasol- and cane handles, thermometers, bonbonnières, and items of jewellery, such as belt buckles and egg pendants.

Theodor Ringe died on November 11th, 1894. His widow Anna Ringe (1840–1912) assumed responsibility for her late husband's workshop and continued the production in the same genre – and with much the same clientele – for the next fourteen to sixteen years. Upon taking over the workshop herself, she was granted a "widow's mark" [AR]. Widow's marks were issued to the wives of well-established workmasters, even though they were not trained in the profession themselves, on condition that the production was overseen by a master goldsmith. In Anna Ringe's case, she was assisted by two masters, Vladimir Soloviev and Anders Mickelsson, both collaborators of Fabergé. (See pp. 189 and 193)

Anna Ringe sold her family workshop in 1908 – or possibly a year or two later – to Soloviev and Mickelsson.

*A cigarette case. Gold, ruby, plaque of moss agate. Fabergé, Theodor Ringe, St Petersburg, c. 1895.*

© FABERGÉ MUSEUM, ST PETERSBURG. THE LINK OF TIMES CULTURAL AND HISTORICAL FOUNDATION. PHOTO BY ANDREY TEREBENIN

# Andrey Gurianov

Andrey Gerasimovich Gurianov (d. after 1917) is known to have been active as a goldsmith until the fall of the Russian Empire in 1917. Gurianov was yet another of the many independent master goldsmiths whom Fabergé plied with work.

On the death of Wilhelm Reimer in 1898, or possibly a few years before this, Gurianov took over Reimer's atelier at No. 2, Bolshaya Morskaya. This may be an indicator that Gurianov had trained and subsequently worked for Reimer for some years prior to taking the reins in his workshop.

The above hypothesis is supported by the fact that Gurianov was welcomed into the circle of Fabergé's sub-contractors at the turn of the century, but it is not known to what extent he actually worked directly for the House of Fabergé. A search of auction records from 1934 to the present yielded approximately 80 items marked with the initials [А.Г].[20] Of these, just two objects – a photograph frame and a small bowl – are stamped with Gurianov's master's mark next to the Fabergé mark and can thus be positively identified as commissioned by Fabergé.

Based on the above research, it can be concluded that Gurianov's production consisted of small objects of art and vertu such as guilloché enamel photograph frames, bowls, dishes, bell pushes, cigarette cases in either gold or silver, and jewellery items, such as brooches, cufflinks, and egg pendants. Gurianov's design signature mirrors that of the House of Fabergé.

*A silver and guilloché enamel bell push, the top with a circular silver well, surmounted by a push-piece with a spread eagle-form finial. Fabergé, Andrey Gurianov, St Petersburg, made between 1899 and 1908. Diameter 7.6 cm.*
COURTESY OF CHRISTIE'S

# Edward Schramm

Master Goldsmith Edward Wilhelm Schramm (1850- c.1899) had German roots, but there is no information on his place of birth, nor on where he trained. In 1874, Schramm qualified as a master goldsmith and opened his own workshop. Shortly after this, he entered into collaboration with Fabergé.

In that same year, 1874, the young master also married; his bride was a Russian girl named Elena Zacharova.[21]

Edward Schramm remained an independent master throughout his professional life. He was unusually skillful, mastering complex and intricate techniques, and he also had an eye for the styles in vogue during his time, such as Art Nouveau and Japonisme, which he gave his own personal touch. It comes as no surprise that he received commissions from the foremost jewellers of St Petersburg, among them Fabergé and Bolin.

His production included cigarette cases, at the time a hugely popular item, and exquisite small gold objects, such as pill boxes and bowls, often with a hammered finish.

*A jewelled dish. Gold (72 zolotnik), rose-cut diamonds, cabochon sapphires and rubies. Edward Schramm, St Petersburg, made before 1899. Scratched stock number 24870. Diameter 10.8 cm.*

*The dish, designed in the Art Nouveau style, is chased with swirling rocaille, acanthus foliage, and flower heads set with cabochon stones, the centre with a flower spray set with rose-cut diamonds.*

Courtesy of The Woolf Family Collection, London

# Erik Kollin

In 1870, the Fabergé business was expanded through the addition of a workshop headed by the Finnish goldsmith Erik Kollin. Kollin was no newcomer on the scene, but had already spent 12 years working for Fabergé under the direction of master jeweller August Holmström, and had demonstrated that he was a more than capable craftsman in gold. He received his formal master goldsmith papers in 1868, and within two years he opened up his own workshop at No. 9, Kazanskaya, not far from the Fabergé establishment on Bolshaya Morskaya. Carl Fabergé saw the wisdom of maintaining Kollin's services, and consequently a deal was struck with the newly-minted master goldsmith that he would work exclusively under contract to the firm. In a couple more years, Kollin was appointed as chief workmaster to the Fabergé operation.

Erik August Kollin was born in 1836, on Holy Innocents' Day, December 28th, in the parish of Pohja, west of Helsinki. His father was a tied day-labourer from Kastbacka, then part of the estates of the sizeable Brödtorp Manor, which in those days was owned by the Hisinger family. Baron Johan Hisinger, head of the family, was an innovative individual, and the first major landowner in Finland to recognise the advantages of sub-soil drainage on his fields. He brought in experts from Scotland to get started on the process, which undoubtedly made heavy demands on the agricultural labourers bound to the Hisinger estates, including Erik Kollin's father Karl Gustav Kollin. It is possible that Erik, too, may have had to help his parents on the land from an early age, and that it was only when he reached his teens that an agreement was reached such that the son would not follow in his father's footsteps. In any event, Erik Kollin was a teenager when he left – we do not know the precise date – for the larger town of Tammisaari to learn a craft.

Erik was fortunate to land in the workshop of the gold- and silversmith Alexander Palmén, who had been a master in the town since 1849. After spending a few years apprenticed to Palmén, in 1858 Kollin secured a travel pass to St Petersburg, where he registered himself with the congregation of St Catherine's Church. He was by this time 22 years of age, and he immediately entered the service of August Holmström, who had been appointed chief jeweller to Fabergé by Gustav Fabergé one year prior to this.

*A bonbonnière in the shape of an Easter egg. Red gold and agate.*
*Fabergé, Erik Kollin, St Petersburg. c. 1886. Height 11 cm.*
PRIVATE COLLECTION. PHOTO BY KATJA HAGELSTAM

Carl Fabergé and Erik Kollin embarked on close cooperation from 1879, when Count Sergey Stroganov, the founder and chairman of the Imperial Archaeological Commission, suggested that modern facsimiles of a selection of the archaeological jewels and ornaments in the Hermitage collections be produced in Russia. Emperor Alexander III gave his approval to the project, and the contract for copying the pieces was given to Carl Fabergé. As we have seen already, these ancient jewels had become more than familiar to Fabergé over recent years. Two years of intensive work with Kollin resulted in the delivery of an impressive collection of 40 pieces.

Fabergé expended a great deal of time and energy on his "archaeological revival" designs throughout the 1880s. The collection was launched at the Moscow Pan-Russia Exhibition of 1882, and two years later it went on show at the Metropolitan Museum of Art in New York City. The collection took a gold medal at the Nuremberg Fine Arts Exhibition of 1885. Two years on, and Fabergé was showing off the jewels at the Great Northern Exhibition in Copenhagen.

The popular Russian weekly *Niva* spotlighted Fabergé's collection in an issue that appeared some months after the opening of the Moscow exhibition (*Niva*, 40/1882). The article notes that with his archaeological revival designs, Fabergé gives the entire jewellery branch a welcome artistic shot in the arm.

Mr. Fabergé has succeeded in refashioning the art of the ancient Greeks. His showcase at the Moscow Exhibition provides some superb examples of the breadth and diversity of these creations. In addition to various smaller pieces – rings, bracelets, and earrings – the eye was inexorably drawn to two wondrous sets of jewellery. Particularly noteworthy is the set whose original pieces can be dated back to the Age of Pericles [5th century B.C., Pericles was the most eminent statesman in Athens from 461–429 B.C.]. When looking at these jewels, one can catch a glimpse of the way in which Grecian goldsmiths must have worked some 2,000 years before our day. The craftsmanship in these pieces is so outstanding that it requires a magnifying glass to be able to detect every tiny detail. Seven master craftsmen were engaged for 120 days in the making of just one necklace. If the work were to be carried out by a single master, it would require no less than twelve years and four months. This explains, perhaps, the price of 3,000 roubles attached to the necklace, or the 400 roubles asked for the pair of earrings. It is also noteworthy that as we examined the earrings, we caught sight of some minute specks in one ornamental figure, and a magnifying lens revealed that each of these was in fact formed of three infinitesimally small globules of granulated gold. The Greeks themselves had no access to such powerful lenses, so one can only imagine that their masters must indeed have had remarkably sharp eyesight.

The *Niva* text continues:

Over a period of twelve years, the Fabergé enterprise – whose workshops have been active since 1842 – has managed to train rigorously enough skilled gold-smiths that the company was able to bring this collection of facsimiles to the Moscow Exhibition – a collection that has been greatly marvelled at by the public

*The document from His Imperial Majesty's Governor of the Nyland Province certifying an extended residence permit in St Petersburg for the apprentice gold- and silversmith Erik Kollin, dated January 26th, 1859.*
National Archives of Finland, Helsinki

*A Scythian-style ropework gold bracelet with lion's head terminals. An example of Carl Fabergé's "archaeological revival" collection. Fabergé, Erik Kollin, St Petersburg, 1880s.*
Photo by Joseph Coscia Jr. © The Forbes Collection, New York. Fabergé Museum, St Petersburg. The Link of Times Cultural and Historical Foundation

*A sketch for a lion's head bangle from the second stock book of Henrik Wigström.*
National Archives of Finland, Helsinki

*A bar brooch in gold, with circular terminals with beading and filigree in the Scythian style, in its original leather presentation case. An example of Carl Fabergé's "archaeological revival" collection. Fabergé, Erik Kollin, St Petersburg, 1880s.*
Courtesy of Stockholms Auktionverk, Stockholm

◁◁ *An enamelled goblet in gilt silver (vermeil), rock crystal, and enamel. Erik Kollin, St Petersburg, before 1901. Erik Kollin left Fabergé c. 1889 to work independently. He died in 1901. Height 8.8 cm.*
Courtesy of Collection Mirabaud

◁ *A seal in two-colour gold and nephrite. Erik Kollin, St Petersburg, c. 1896. Height 6.3 cm. The item belonged to the collection of King George I of the Hellenes.*
Courtesy of Christie's

▷ *An assortment of items made from Siberian nephrite. At the back, in its original case, a nephrite paper knife, c. 1900. The attached label notes it was a gift to Queen Alexandra from Richard Curzon, 4th Earl Howe. Curzon was Alexandra's Lord Chamberlain from 1903 to 1925.*

*From left to right: A dish in nephrite, two-colour gold, rubies, diamonds, and guilloché enamel. Fabergé, no master's marks, St Petersburg, made between 1899 and 1908. A dish in nephrite, two-colour gold, and rubies. Erik Kollin, St Petersburg, made between 1899 and 1901. A postage stamp box in nephrite and gold with cabochon rubies. Fabergé, no master's marks, St Petersburg, c. 1900. A pen-rest in nephrite, gold, rose-cut diamonds, and pearls. King George V is said to have kept this pen-rest, with its mistletoe decoration, on his desk at all times. Fabergé, no master's marks, St Petersburg, made between 1899 and 1908.*

*At front, a crochet hook in nephrite, gold, guilloché enamel, and seed pearls. Fabergé, no master's marks, St Petersburg, c. 1900. Queen Alexandra is known to have bought a crochet hook from the London branch of the House of Fabergé in 1909. A pen, presumably from a desk set, in nephrite, gold, rose-cut diamonds, and cabochon rubies. Fabergé, Mikhail Perkhin, St Petersburg, made before 1899.*
Royal Collection Trust /
© Her Majesty Queen Elizabeth II

◁ *A cigarette case in gold and pink rhodonite. Erik Kollin, St Petersburg, early 1890s. The rhodonite was carved at the Ekaterinburg Imperial Lapidary Manufactory. The lid has a relief monogram of Emperor Alexander III.*
Courtesy of The State Historical And
Cultural Museum in The Kremlin, Moscow

*A gold and carved agate "charka" or vodka cup (the "charka" is also an obsolete Russian unit of liquid measure, c. 125 ml) with cabochon sapphire in the handle. Fabergé, Erik Kollin, St Petersburg, made before 1887. Stock number 40748. Height 5 cm.*

COURTESY OF COLLECTION MIRABAUD

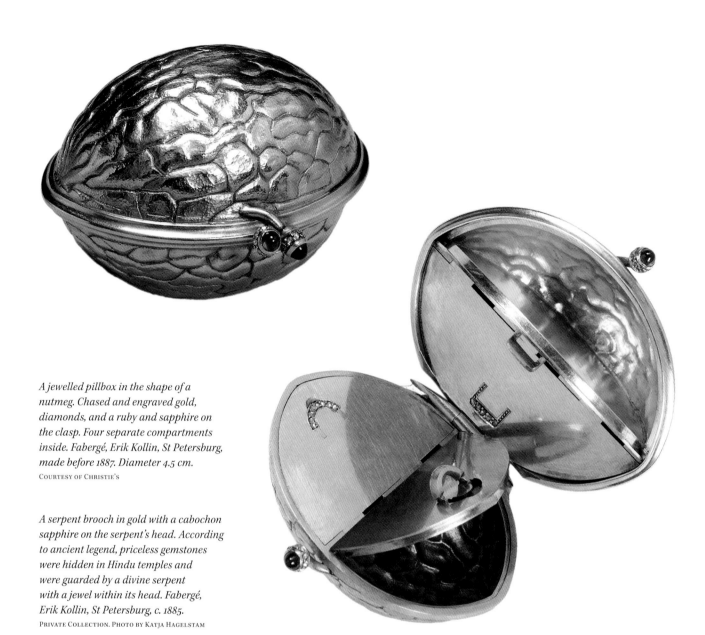

*A jewelled pillbox in the shape of a nutmeg. Chased and engraved gold, diamonds, and a ruby and sapphire on the clasp. Four separate compartments inside. Fabergé, Erik Kollin, St Petersburg, made before 1887. Diameter 4.5 cm.*
COURTESY OF CHRISTIE'S

*A serpent brooch in gold with a cabochon sapphire on the serpent's head. According to ancient legend, priceless gemstones were hidden in Hindu temples and were guarded by a divine serpent with a jewel within its head. Fabergé, Erik Kollin, St Petersburg, c. 1885.*
PRIVATE COLLECTION. PHOTO BY KATJA HAGELSTAM

*A watch fob or chatelain, in three links. In gold and incorporating graduated gold coins dating from the late 18th century (Catherine II). The fourth, smaller coin depicts Empress Elizabeth, who ruled Russia from 1741 to 1762. Fabergé, Erik Kollin, St Petersburg, made before 1887.*

COURTESY OF HILLWOOD ESTATE, MUSEUM & GARDENS. ESTATE OF MARJORIE MERRIWEATHER POST, WASHINGTON DC. PHOTO BY E. OWEN

and also singled out for praise by Their Imperial Majesties. Her Imperial Majesty further did Mr Fabergé the honour of acquiring from him a pair of gold cufflinks shaped like cicadas, ancient Greek symbols of good fortune.

Practically the only preserved examples of the original 1882 collection – the lion's head bracelets – are beautifully finished, and we can assume the same to be true of the remainder of Fabergé's archaeological revival work. Exactly how Carl managed to pass his expertise on to his workmaster Erik Kollin is an intriguing question. Their collaboration must really have been very dynamic in nature. It is quite feasible that Kollin was also given an opportunity to handle and examine the Hermitage material at first hand. The project was, after all, a very significant undertaking for the entire Fabergé enterprise.

It is probably fair to argue that Fabergé's drive towards making jewellery in the archaeological revival style has had the effect of "typecasting" Erik Kollin's output as a whole. Nearly everything that was produced in the Kollin workshop does point to the craftsmen's being specialised in recreating the archaic – the art of the goldsmiths of the ancient world. This goes for the subjects chosen, the forms, and even the particular alloy of gold the workshop favoured. The serpent motif, so beloved among the ancient artists, surfaces often in Kollin's brooches, in cane or parasol handles and grips, and in ornaments. The coiled serpent is a symbol of covert power and of dynamism.

But it is once again only fair to say that alongside the manufacture of these jewels modelled on ancient artefacts, Kollin's output does include completely new designs – small decorative items, bowls, *kovshes*, basins, boxes for caramels or confectionery, and egg pendants fashioned from beautiful Siberian semi-precious stones such as pink quartz, agate, heliotrope, or bowenite. These items display elegant cast gold inlays, handles, knobs, feet, and bases, and are also often decorated with cabochon gemstones. A very distinguished clientele was apparently also eager to snatch them up, at least to judge by the more than a dozen such items that can be found in the Royal Collection in the U.K. They were gifts from members of the Russian Imperial Family to their royal relatives in England.

By 1889, Erik Kollin was no longer chief goldsmith to the Fabergé business. Once again, it is unclear precisely why Kollin was replaced by the young Mikhail Perkhin, a gifted but still very inexperienced master goldsmith. Likewise, we do not know to what extent Kollin might have been a difficult partner for Fabergé to work with. Is it possible that Fabergé felt Kollin was getting staid and set in his ways? We will never know Carl's motives.

Kollin carried on as an independent master goldsmith after his formal parting of the ways with Carl Fabergé, and indeed the evidence suggests he actually continued to do work for the House of Fabergé, as well as for other retail jewellers, among them the Imperial Purveyor I.E. Morozov. Kollin's workshop was located at No. 9, Demidov Pereulok, today Grivkova Pereulok. After Erik's death in 1901, the business was in the hands of his widow Henrika Eleonora Kollin, née Backman (1841-c.1920). The company name is listed in St Petersburg address directories several years after the master's demise. Parish records indicate that the Kollins had no children.

This was the first egg of fifty made by Fabergé for the Imperial family. It was Alexander III's Easter gift to his wife, Empress Maria Feodorovna, in 1885. It was most likely made in the workshop of Erik Kollin, possibly in cooperation with August Holmström.[22]

The shell of the Hen Egg is of white matte enamel to give the impression of a real egg. It twists open to reveal a "yolk" crafted in a warm gold alloy. The yolk likewise twists open to reveal a small hen in varicoloured gold with beautifully chased plumage and ruby eyes. Originally there was a miniature diamond replica of the imperial crown and a small ruby pendant (now lost) inside the hen.

The Empress was overjoyed with her gift. The obvious pleasure it gave her prompted the Emperor to commission a similar lavish gift each year thereafter. These added up to ten outstanding creations, the last being that for Easter 1894, the year of the Emperor's untimely death. (For the 1894 Renaissance Egg, see p. 80). From then onwards, until the fall of the Russian Empire, Fabergé created two Imperial Easter Eggs per year, commissioned by Emperor Nicholas II: one for his mother the Dowager Empress and one for his wife, Alexandra Feodorovna.

In the biography of Alexander III's youngest daughter, Olga Alexandrovna (1882–1960), we can get a personal glimpse of the Easter celebrations of the august family. The biography was published in 1964 by the Greek-Canadian author Ian Andrew Vorres, who was a neighbour of the Grand Duchess in a suburb of Toronto during the last years of her life. Vorres was at the time a young journalist, who clearly won the friendship of the elderly Olga Alexandrovna. His text is based on what he was told, and is interspersed with delightful quotations:

> The second landmark of the year came at Easter, its festivities being enjoyed all the more because they followed seven weeks of rigorous abstinence – not only from meat, butter, cheese, and milk, but from any form of entertainment. The Grand-Duchess's dancing lessons were suspended during Lent. There were no balls, concerts, or weddings. The period was called Veliky post (The Great Fast) and the name fitted.
>
> Beginning with Palm Sunday, they went to church morning and evening. Easter Eve brought the first breath of freedom. … Olga, no longer considered a baby, stayed up. For the great midnight service, which lasted more than three hours, she was dressed as for a great court occasion: an empearled kokoshnik on her small head, the embroidered veil falling down to her waist, the silver brocade sarafan and a kirtle of cream satin. Full court dress, known as zautreniya, was worn by all attending the service.
>
> 'I can't remember if we ever got tired, but I do remember how we all waited, breath suspended, for the first triumphant "Christ is risen", chanted by the combined Imperial choirs.'
>
> Snow might lie thick and firm outside, but the words ended the winter. Big and small annoyances, disappointments, anxieties, all vanished at that first "Christ is Risen". Everybody in the church stood, a lit candle in hand. All gave themselves up to that triumph. The rigours of Lent behind them, the Emperor's children ran into the banqueting hall for the traditional zazgovlenye where delicacies forbidden since Carnival Sunday awaited them.
>
> 'And on the way we kept stopping every minute to exchange the traditional three kisses with butlers, footmen, soldiers, maids, anyone we met on the way.'

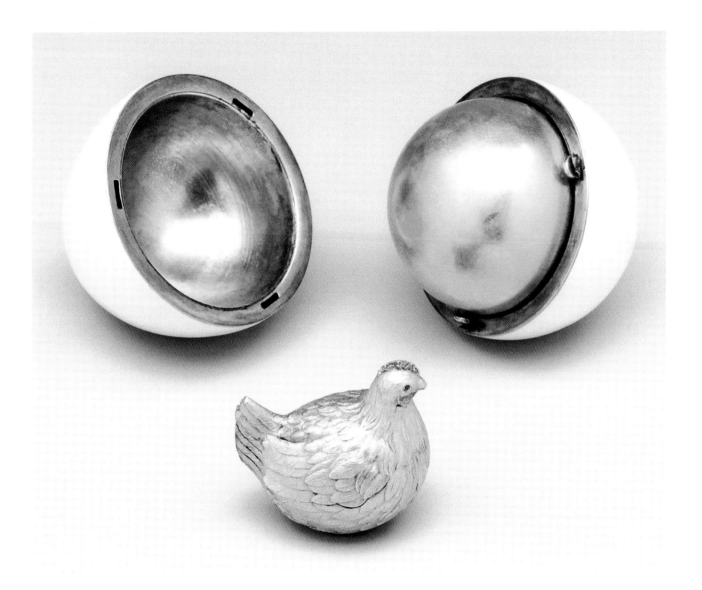

*The exterior of the Hen Easter Egg is of gold and opaque white enamel, and it opens to reveal a "yolk" in matte gold. The yolk contains a small vari-coloured gold hen with ruby eyes. The hen, too, opened to reveal a miniature gold and diamond crown and a ruby pendant, both now lost. No master's marks. Length 6.4 cm. The yolk is 4cm in diameter, and the chicken 3.5 cm.*

PHOTO BY JOSEPH COSCIA JR. © THE FORBES COLLECTION, NEW YORK. FABERGÉ MUSEUM, ST PETERSBURG. THE LINK OF TIMES CULTURAL AND HISTORICAL FOUNDATION

Easter Sunday was no day of rest for the Imperial family. It began with a reception in one of the great halls of the palace of Gatchina. The Emperor and Empress stood at one end of the hall and the courtiers, then the entire staff, each in turn, approached them to receive the traditional Easter greetings and an egg, which was made of porcelain, jasper, or malachite.[23]

The morning following the midnight service was when the Fabergé Easter Egg was presented. Its design had been kept a closely-guarded secret. On Easter morning, Carl Fabergé travelled from St Petersburg to Gatchina bearing the precious gift. The same ceremony was repeated for ten years until the Emperor's death.

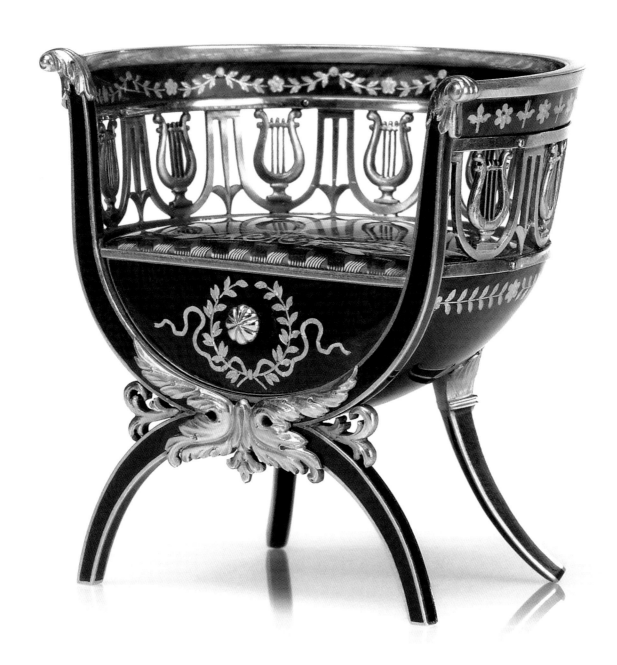

# Mikhail Perkhin

Carl Fabergé's second chief workmaster Mikhail Evlampievich Perkhin (1860–1903) is described as a phenomenal, prodigious talent. During his time at the helm, the Fabergé operation took a quantum leap forwards.

Perkhin was born on May 22nd, 1860 (*o.s.*), in the small village of Okulovskaya in White Karelia, on the shores of Lake Onega, at a distance of 264 miles (426 km) from St Petersburg. Mikhail's father, Evlampy Arsenevich (d. 1877), was a farmer belonging to a special class of peasants called *obelnyi* (*obelnye krestiane*). These peasants were descendants of individuals who had rendered singular services to the monarch and were thus exempt from taxes and duties. The *obelnyi* peasants were centred in the Olonets Governorate, in the districts of Petrozavodsk, Povenets and Vytegorsk. Evlampy and his wife Anna Trefilovna, who in the 1860s adopted the surname of Perkhin, had through hard work and their privileged status secured a good standard of living. Their home was a spacious log house in the Karelian style, built by Evlampy himself with the help – as was the custom in the Russian countryside – of family members and friends from the local village.

As a child, Mikhail spent a lot of his time in the village church, which became very important for his later life. These Orthodox churches in small villages scattered around the countryside were the sole source of education for the peasant class, before any form of schooling was introduced into the Russian Empire. The local clergy were, as a rule, the only lettered persons in the village. The deacon of the Okulovskaya congregation, Father Matvey Mattheus, was Mikhail's godfather. Matvey was intrigued by the inquisitive mind of his godson and took him under his wing. It is presumed Father Matvey not only taught the boy to read and write, but also guided him in the basics of the Orthodox religion. Mikhail Perkhin remained a fervent believer all his life.[24]

The village churches, albeit simple, gave the congregation a view into the world of the arts. The decorative features of sacred art – the iconostasis and the icons, framed and protected by *oklads* of precious metal, skillfully embossed, enamelled, and set with colourful semi-precious stones – were the work of proficient metal craftsmen, goldsmiths, and painters. Young Mikhail Perkhin was inspired by the beauty of the art and crafts in his village church of St Nicholas. As a child, he had

*A bonbonnière in gold and red enamel, fashioned to look like a miniature "fauteuil en gondole" in the French Empire style, and with a pull-out front drawer. Fabergé, Mikhail Perkhin, St Petersburg, made before 1903. Scratched stock number 1920. Height 5.7 cm. This piece belonged to Grand Duchess Maria Pavlovna (1854–1920), who was married to Grand Duke Vladimir Alexandrovich, younger brother to Emperor Alexander III.*

PRIVATE COLLECTION. PHOTO COURTESY OF WARTSKI, LONDON

already learned how to handle metalworking tools, possibly with the help of the local blacksmith. It therefore comes as no great surprise that Mikhail decided his future vocation would be that of the goldsmith.

At the age of 18 in 1878, Mikhail resolved to leave home for St Petersburg and to find a master goldsmith willing to provide him with an apprenticeship. He succeeded, and the goldsmith in question was Fabergé's first head workmaster, Erik Kollin. At Kollin's workshop, Carl Fabergé noticed the youngster's natural ability and his aspirations to become a master goldsmith in time. Perkhin earned his proficiency as a journeyman in 1884, and he collected his master craftsman's papers two years later in 1886, giving him the right and opportunity to open his own workshop.

In 1884, while still a journeyman, Perkhin married 17-year-old Tatiana Vladimirovna Finikova, whose father, Vladimir Iakovlevich Finikov, was head workmaster of the renowned court jeweller C.E. Bolin. It is quite possible young Perkhin trained with his future father-in-law for a period of time during his seven-year apprenticeship, and it was in Finikov's workshop that he became acquainted with his future bride.

At the end of 1888 Fabergé stepped in and appointed Perkhin his head workmaster, to replace Kollin. With his new workmaster-in-chief installed at the beginning of 1889, Carl Fabergé was in a position to revamp the entire product assortment in a large way. For the changes that he had in mind, he needed skilled and progressive craftsmen who would not cling to tried and tested old ways. Fabergé had long played with the idea of creating a completely new line in jewellery, throwing caution to the winds and discarding all the old and familiar designs. At this point in the late 1880s, Petersburg jewellers inclined towards gaudy ornamentation and large, expensive gemstones. A business would thrive through the sale of extravagant pieces, dripping with diamonds, rubies, sapphires, and emeralds. Fabergé's novel idea was to manufacture luxury gift items that placed design and peerless craftsmanship above the value of the materials themselves. The artist Franz Birbaum (1872–1947), who served the business from 1893 and subsequently became the senior designer for the House of Fabergé, has left written recollections that add greatly to what we know of the running of the company. This is how he summarises the new approach:

> The design thinking was to preserve the style of past centuries, but to apply it to objects very much of the present. In lieu of the old snuffboxes, there were cigarette cases and compacts, and in place of decorative objects with no earthly purpose, we produced table clocks, ink bottles, ashtrays, bell-pushes, and so on.[25]

Together with Perkhin and the company's talented young artists – one of whom was Carl's younger brother Agathon (1862–1895) – Fabergé forged his new art handicraft idiom. Production was ramped up from one year to the next, and every year the results were more impressive. The constantly expanding customer base at home and overseas eagerly devoured the new pieces and cried for more. The catalogue had a panoply of gold and silver items, decorated with enamel or various minerals, and the designers kept turning out new models from an apparently bottomless well of the imagination. From here onwards, Fabergé's production began also to include small

*Master Goldsmith Mikhail Perkhin.*
Archive Image

*Mikhail Perkhin's workshop, 1902. Chief Workmaster Perkhin, with a bushy beard, stands on the left in the centreground. Slightly further back on the right, behind the journeyman in a white apron, stands Henrik Wigström, Perkhin's closest assistant.*
Courtesy of Wartski, London

*A jewelled silver cigar box in the shape of a Russian helmet; a gift from Emperor Nicholas II to his cousin, Kaiser Wilhelm II of Germany. Fabergé, Mikhail Perkhin, St Petersburg, c. 1902. The item is visible on the second workbench in the photograph above.*
Courtesy of Museum Huis Doorn, Netherlands

*The jewelled, varicolour gold-mounted and enamelled "Rothschild Egg", with a clock and gold cockerel automaton. Fabergé, Mikhail Perkhin, St Petersburg, 1902. The clock, too, is visible on the second workbench in the photograph above. For the story of the object. (See p. 82)*
Courtesy of The State Hermitage Museum, St Petersburg. 'Photo by Christie's'

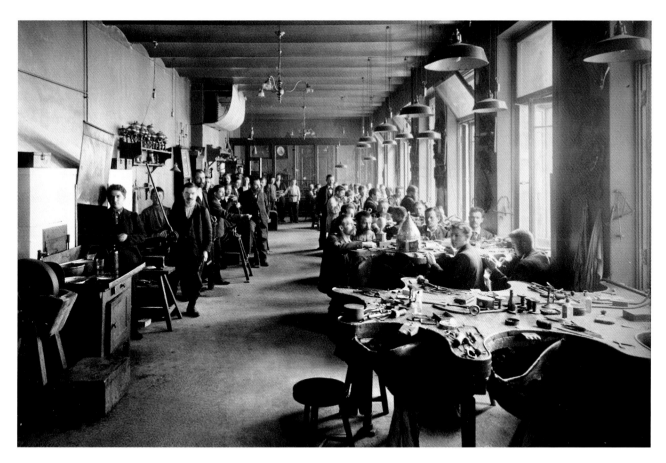

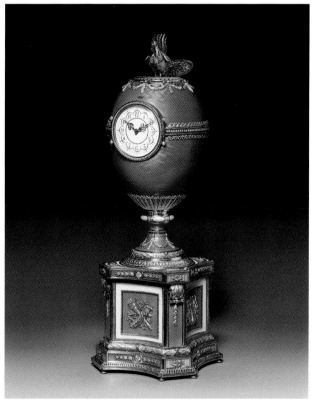

animal figures, and flower arrangements made from decorate minerals and precious stones.

Carl Fabergé has described the design process in his own words. In an interview published in January 1914 in the short-lived "beau-monde" lifestyle magazine *Stolitsa I Usadba* ("Capital and Country Estate", 1913–1917), he notes: "It is obvious that if my business is compared with such as Tiffany & Co., Boucheron, or Cartier, then these jewellers can offer a great deal more in prized and precious items than can Fabergé. One might easily find from their catalogue a necklace with a price of one and a half million roubles. But they are retail jewellers; they are not jewellery artists. A piece that is costly for the sole reason that it is swimming in brilliant cut diamonds and natural pearls, this is of only passing interest to me."

Throughout the fourteen years that Perkhin served as head workmaster to Fabergé, he was under almost unimaginable pressure. It was in his workshop that the very finest commissioned pieces were manufactured, and yet the craftsmen under Perkhin were also turning out phenomenal quantities of "off-the-shelf" items for sale. This was a laboratory and a testbed of sorts for new technical solutions and innovations, while at the same time production was supposed to be going at full steam. Quite naturally the strain took its toll, and Perkhin's health began to suffer. There were rumours that he was mentally unstable, but it is more likely that his problems were caused by unremitting stress and over-exertion. He died on August 28th, 1903, at the very pinnacle of his career and at the age of just 43 years.

The demise of his head workmaster Mikhail Perkhin, barely two years after the firm had moved into the new premises at 24, Bolshaya Morskaya, was a tremendous blow to Carl Fabergé. He had not anticipated the loss of this brilliant craftsman, whom he had supported in many ways, helping and also motivating him personally. In 1891, Perkhin had thus been accepted as a Merchant of the 2nd Guild, and in 1899 he was granted Personal Honorary Citizenship. The latter honour was recognized as an official Imperial Award. Those eligible to become personal honorary citizens were prominent merchants and industrialists. In creating this new estate, the government of Imperial Russia sought to bring about a commercial upper middle class with an improved legal and social position. Honorary citizenship did not, however, replace the traditional merchant guilds, but became an elect class within them.

Perkhin was crucial for Fabergé in another way, in that he followed the Orthodox faith. Most of the firm's workmasters were Evangelical Lutherans, as was Carl Fabergé himself. But the clientele were generally Orthodox adherents. Hence it was of primary concern to have an Orthodox master who understood and could interpret the culture of Orthodoxy. It was helpful not only in the decoration of religious objects, but also in understanding the cultural context in which they belonged.

*A gem-set gold cup, with cabochon star sapphire and rose-cut diamonds on the arched handle. Fabergé, Mikhail Perkhin, St Petersburg. Made between 1899 and 1903. Height 5.5 cm, length 6.5 cm.*
COURTESY OF THE WOOLF FAMILY COLLECTION, LONDON

*A hinged bonbonnière in carved citrine, gold, and rose-cut diamonds, shaped to resemble an apple. Fabergé, Mikhail Perkhin, St Petersburg, made c. 1900. Stock number 3496. Height 3.5 cm. Emperor Nicholas II and his wife Empress Alexandra Feodorovna bought this bijou from the House of Fabergé at Christmas in 1900.*
COURTESY OF SOTHEBY'S

*A jewelled magnifying glass in two-colour gold and diamonds, and with a pearl finial. Fabergé, Mikhail Perkhin, St Petersburg, c. 1896. Stock number 57966. Length 9.4 cm.*
COURTESY OF SOTHEBY'S

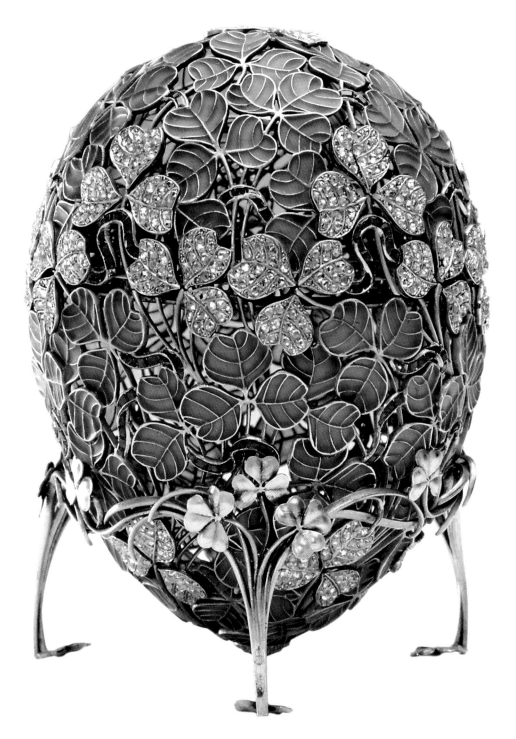

The Clover Leaf Imperial Easter Egg. Gold, platinum, rubies, rose-cut diamonds and enamel. Fabergé, Mikhail Perkhin, St Petersburg, 1902. The Clover Leaf was Nicholas II's 1902 Easter gift to his wife Empress Alexandra Feodorovna. A large proportion of the delicate clover leaves are rendered green in a very demanding enamel technique known as "plique-à-jour". The remaining leaves are "pavé set" with rose-cut diamonds (a paving-stone setting, the diamonds being so tightly set that the metal framework is invisible). The body of the egg is encircled by a narrow, meandering "ribbon" of calibré-cut rubies. A cabochon ruby and diamond cluster is set at the point of the egg. The four-legged stand repeats the clover-leaf motif in gold. The egg opens to reveal – around the openwork rim of the lower part – a repeated pattern of the Empress's cipher (AΘ), the Imperial crown, clover leaves, and – once – the year 1902. Overall height, including stand, 9.8 cm. The Easter Egg's surprise, since lost, was a four-leaf clover with miniature portraits of the Imperial Family's four daughters: Olga, Tatiana, Maria, and Anastasia. (See p. 132)

COURTESY OF THE STATE HISTORICAL AND CULTURAL MUSEUM IN THE KREMLIN, MOSCOW

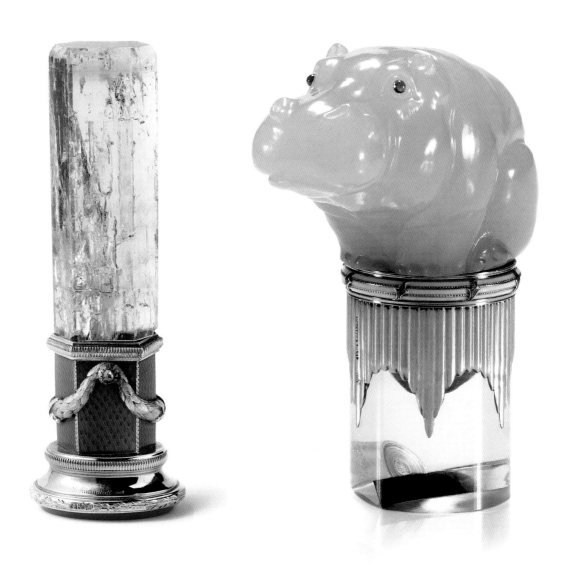
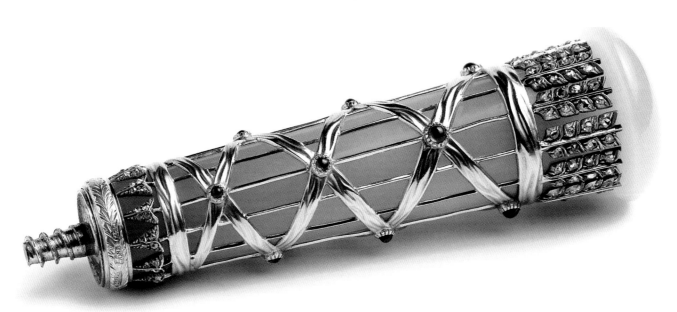

◁◁ *A hand seal in two-colour gold, with a Siberian green beryl crystal, diamonds, and guilloché enamel. Fabergé, Mikhail Perkhin, St Petersburg, c. 1896. Stock number 6799. Height 6.4 cm. The piece was formerly in the collection of King George I of the Hellenes.*
COURTESY OF CHRISTIE'S

◁ *A jewelled cane handle in bowenite, gold, enamel, and rock crystal; the bowenite carved into the shape of a sitting hippopotamus, with the eyes set with rubies. Fabergé, Mikhail Perkhin, St Petersburg, c. 1900. Height 6.4 cm.*
COURTESY OF THE MCFERRIN COLLECTION, HOUSTON, TEXAS

▷ *A cigarette case in two-colour gold and translucent white enamel, with a cabochon ruby pushpiece. Fabergé, Mikhail Perkhin, St Petersburg, late 1890s. Scratched stock number 2102A. Length 10 cm.*
COURTESY OF SOTHEBY'S

▷ *A jewelled tubular cigarette case in gilt silver, moss agate, rose-cut diamonds, and pale mauve guilloché enamel, with a rose-cut diamond thumbpiece. Fabergé, Mikhail Perkhin, St Petersburg, made between 1899 and 1903. Length 9.2 cm.*
PRIVATE COLLECTION. IMAGE KINDLY PROVIDED BY ALEXANDER VON SOLODKOFF

▷ *A triangular gem-set electric bell push in gold, pink topaz, rubies, pearls, and guilloché enamel. Fabergé, Mikhail Perkhin, St Petersburg, 1902. This piece was made as a gift from Grand Duchess Xenia Alexandrovna (sister to Emperor Nicholas II), to Olga, Queen consort of the Hellenes. Olga was the former Grand Duchess Olga Konstantinovna of Russia, and was herself cousin to Xenia's father, Alexander III.*
COURTESY OF WARTSKI, LONDON

◁ *A jewelled two-colour gold and bowenite parasol handle, designed to resemble a quiver of arrows; the arrow heads and flights set with diamonds, and the quiver with cabochon rubies. Fabergé, Mikhail Perkhin, St Petersburg, made between 1899 and 1903. Length 10 cm.*
COURTESY OF WARTSKI, LONDON

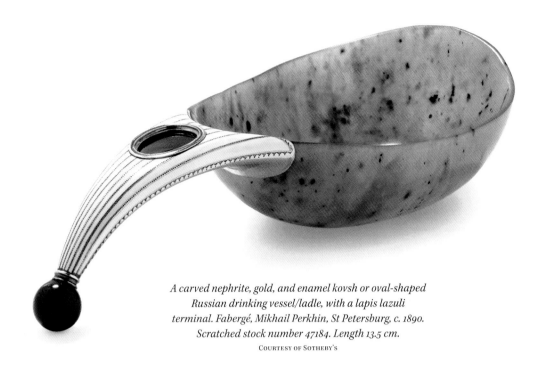

*A carved nephrite, gold, and enamel kovsh or oval-shaped Russian drinking vessel/ladle, with a lapis lazuli terminal. Fabergé, Mikhail Perkhin, St Petersburg, c. 1890. Scratched stock number 47184. Length 13.5 cm.*
COURTESY OF SOTHEBY'S

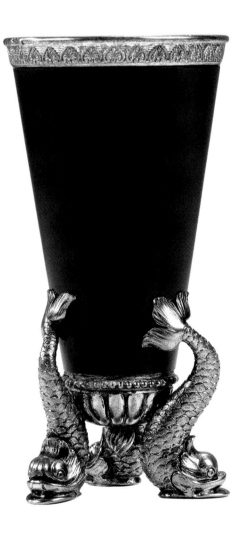

◁ *A vase in gold and smoky quartz. Fabergé, Mikhail Perkhin, St Petersburg, made before 1899. Scratched stock number 51542. Height 7.5 cm.*
COURTESY OF COLLECTION MIRABAUD

▷ *A vase in embossed silver gilt and jasper. Fabergé, Mikhail Perkhin, St Petersburg, made before 1899. Scratched stock number 59132. Height 7.5 cm. The three legs are sculpted to represent stylised dolphins.*
COURTESY OF COLLECTION MIRABAUD

An enigmatic egg by Fabergé, made in the workshop of Mikhail Perkhin, was entered into the sales ledger of the jeweller Alexander Tillander in Helsinki at the end of August, 1921. The jeweller made no comment on the provenance of the object in his ledger. Tillander had close ties with the émigrés fleeing Russia via Finland, several of whom had earlier been his customers in St Petersburg. His inventory books are filled with references to objects and jewellery purchased from those in need of ready money.

The egg in question, of royal blue enamel, is encased in gold reed and foliate motifs on a twisting gold pedestal base, and it is topped with a miniature imperial crown set with sapphires and diamonds. The egg was sold with a "surprise", a small aquamarine-hued agate rabbit with ruby eyes.

The design of the egg is modelled after three egg-shaped cups, part of an Easter service made in St Petersburg in 1780, now in the collection of The State Hermitage Museum.[26] All three cups stand on a gold-ornamented ivory base. The first is made of gold and glass; the second is of gold, foil, and glass, and the third is of gold, ivory, and eggshell. (see p. xxx)

A small sketch of the egg is shown next to the entry recording its purchase – from a gentleman by the name of Bagge-Petersén – for 1,500 Finnish markka (roughly USD 550):

"*1921 Augusti 29 | 41054 | Stort Ägg, guldornament på blå emalj botten. Månstensfigur [sketch] Fabergé Bagge-Petersén | Faktura 1500 | Vikt 148 | Netto 1500 –*"

(1921 August 29th | 41054 | Large egg, gold ornaments on blue enamel background. Moonstone figurine [sketch] Fabergé Bagge Petersén | Invoice 1500 | Weight 148 (grams) | Net 1500 –).[27]

Three years later, Tillander sold the egg for 3,000 Finnish markka (c. USD 1,100) to an antique dealer from Budapest named Herr Popper, together with cufflinks decorated with the Imperial Crown. The sum was rather trifling, given that Tillander sold a simple gold cigarette case of similar weight at much the same time for some 6,000 markka.

*A detail of a page from the ledgers of Alexander Tillander's store, showing a small sketch of the egg, and the price the jeweller paid for it.*
FROM THE AUTHOR'S OWN ARCHIVES

*The Blue Enamel Ribbed Egg is of green, yellow, and red gold (marked 56 zolotnik), sapphires, diamonds, agate, rubies, and translucent blue enamel. Fabergé, Mikhail Perkhin, St Petersburg, made before 1899. Scratched stock number 44255. Height 11 cm on its pedestal. The egg is 5 cm in diameter and weighs 148 g. For the inspiration behind this object, see the egg-shaped wine cup dating from c. 1780. (See p. 34)*
OWNED BY THE ESTATE OF THE LATE STAVROS NIARCHOS, PARIS

| | | | | | | | | | | |
|---|---|---|---|---|---|---|---|---|---|---|
| | 21 | 41052 | 103. Perlor 44 35 – läs av S B⁵ N 15256 | | 14126 | | 20000 | | 20000 |
| Augusti | 2 | 41053 | Portecigarette [sketch] refflad pol. 14 Cᵗ 1 Saphir Cab | | inköpt | 50 | 50 3000 | 145.8 | 3100 |
| | 29 | 41054 | Stort Ägg, guldornament på blå emalj botten. Månstensfigur [sketch] Fabergé Bagge-Petersén | | | | 1590 | 148. | 1500 |
| September | 27 | 41055 | Böes prönjul 18 kar. ⁷/2 Saphir Cab. | | acift | | 900 | 45 | 900 |
| | | 41056 | guld etui, slåt; polerad, 14 kar. m. 1 Saf. Cab. | | inköpt | 50 | 1000 | 84.6 | 1650: |

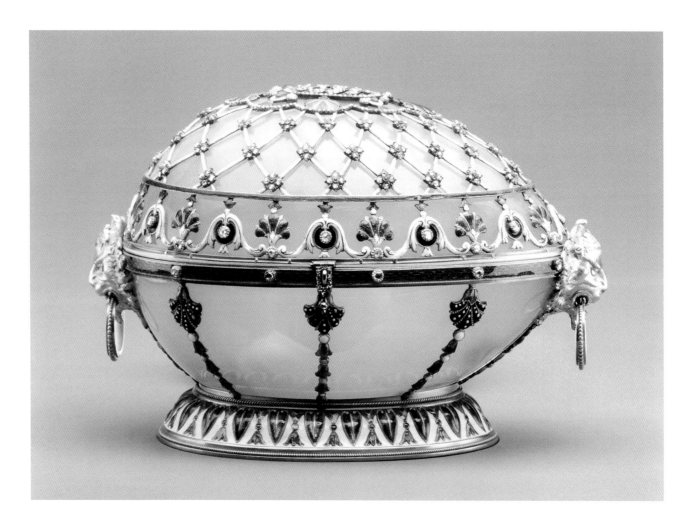

The Renaissance Egg of 1894 was the last Imperial Easter Egg given by Alexander III of Russia to his wife Empress Maria Feodorovna. The Emperor died unexpectedly later the same year.

The egg is of translucent milky-white agate, with a trellis of gold, studded with diamonds, rubies, and enamel in shades of green, red, blue, black, and white. Fabergé, Mikhail Perkhin, St Petersburg, 1894. Marked 56 zolotnik. Height 13.3 cm, with base. The whereabouts and nature of the egg's "surprise" remain a mystery. The invoice price of the egg was 4,750 roubles.

PHOTO BY JOSEPH COSCIA, JR. © THE FORBES COLLECTION, NEW YORK. FABERGÉ MUSEUM, ST PETERSBURG. THE LINK OF TIMES CULTURAL AND HISTORICAL FOUNDATION

The model for the Renaissance Egg. This enamelled Renaissance-style casket, by the 18th century master goldsmith Le Roy of Paris, was made of quartz, gold, and diamonds. Carl Fabergé would certainly have seen the item among the artefacts in Grünes Gewölbe (The Green Vaults) during his youth in Dresden.

COURTESY OF GRÜNES GEWÖLBE, STAATLICHE KUNSTSAMMLUNGEN, DRESDEN. PHOTO BY JÜRGEN KARPINSKI

This cigarette case is a rare survival of a personal gift from Empress Maria Feodorovna to her beloved husband Emperor Alexander III. The engraved inscription "Gatchina, 28th October 1890" in Maria Feodorovna's handwriting on the inside of the lid was the date of the 24th wedding anniversary of the Imperial couple.

Two-colour gold (72 zolotnik). The body is enamelled, with alternating stripes, translucent steel blue over a hatched guilloché ground. Bright-cut gold borders, the outer borders with chased green gold acanthus leaves. Silk tinder-cord and vesta compartment. Fabergé, Mikhail Perkhin, St Petersburg, 1890. Length 12 cm.
PRIVATE COLLECTION. PHOTO BY KATJA HAGELSTAM

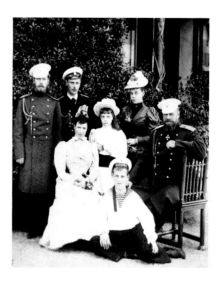

Emperor Alexander III with his family at their summer retreat of Livadia in the Crimea. This photograph, taken in May 1893, is among the last images of the entire family together, for Alexander died in the fall of 1894.
PRIVATE COLLECTION

Madame Béatrice Ephrussi (née de Rothschild), the granddaughter and heiress of Baron James Mayer de Rothschild, founder of the French branch of this famous banking family, presented this wondrous egg-shaped table clock and automaton to her future sister-in-law Germaine Alice Halphen in 1902, on her engagement to Béatrice's younger brother Édouard.

It is not known how Madame Ephrussi got the idea for such a magnificent gift. Members of the English branch of the Rothschild family were good customers of Fabergé's London branch, but it was opened only in 1903. It is quite possible Béatrice saw the fourteen Imperial Easter Eggs that Fabergé displayed at the Exposition Universelle in Paris in 1900. Information about precisely which Easter Eggs were on show has not survived. We do know seven of them: the Danish Palaces Egg (1890), the Pamiat Azova Egg (1891), the Diamond Trellis Egg, (1892), the Egg with Revolving Miniatures (1896), the Coronation Egg (1897), the Lily-of-the-Valley Egg (1898), and the Pansy Egg (1899). It is also conceivable that Carl Fabergé took this opportunity to show Mme Ephrussi an image of the Cockerel Egg, Nicholas II's Easter gift to his mother in 1900. The Rothschild clock bears many similarities to this egg: a central dial surrounded with seed pearls and the surprise cockerel that rises from beneath a small hatch at the top. One can well imagine her discussing this piece with Fabergé and placing an order on the spot for a similar one of her very own.

*The table clock and automaton known as the Rothschild Egg. The clock is also visible in the 1902 photograph of the Mikhail Perkhin workshop on page 73. Varicolour gold, silver, translucent pink guilloché enamel, seed-pearls, and pearls. Fabergé, Mikhail Perkhin, St. Petersburg, 1902 (inscribed "K. Fabergé, 1902" on the base). The gold fineness is 56 zolotnik and silver 88 zolotnik. Height 27 cm (closed), 31 cm (open, with the diamond-set cockerel raised). Weight 3,645 g.*
COURTESY OF THE STATE HERMITAGE MUSEUM, ST PETERSBURG. PHOTO BY CHRISTIE'S

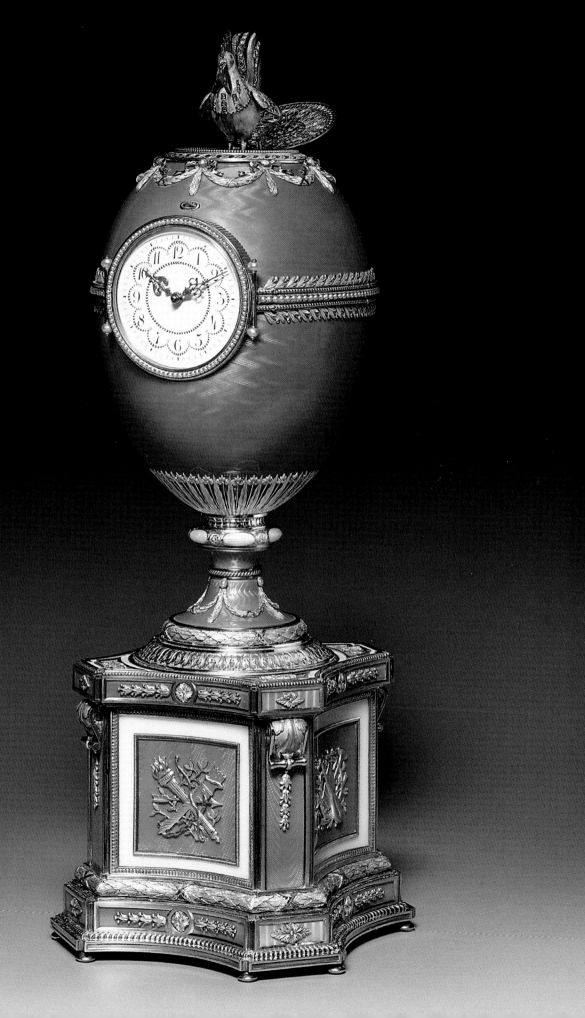

This opulent and diminutive decorative *objet de fantasie*, the sole purpose of which was to delight its owner, is just so representative of Fabergé's oeuvre. It was made in the workshop of Mikhail Perkhin in or around 1900, and it depicts an 18th-century sedan chair, the mode of transport for elegant ladies of the era, when it would have been carried by two liveried porters.

It is in the Louis XVI style, which had become popular again at the turn of the century, and it exhibits all its typical elements. The walls, roof, and doors are enamelled in translucent pink over a sunburst guilloché ground, and they feature beautiful enamel decorations: a torch and quiver, the attributes of Cupid; an artist's palette; musical instruments, and a basket of flowers. These are all suspended from ribbons and encircled with wreaths. Each corner of the roof is ornamented with a *thyrsus*, a staff associated with Dionysus (Bacchus) and his followers, a common neoclassical motif.

A small handle opens the door, the hinges of which are cleverly concealed behind the fasces on the right. The fasces, Etruscan in origin, consisting of a bound bundle of wooden rods (sometimes including an axe with its blade emerging), were adopted by the Romans and carried by lictors (civil-servant bodyguards) before magistrates (elected officials) who held *imperium*.

The windows are made of thinly cut rock crystal and engraved with valances. The interior and seat are of mother-of-pearl.

The first owner of this sedan chair was the rubber magnate Maximilian Othmar Neuscheller (1860–1919), a prodigiously wealthy industrialist from St Petersburg. The Neuscheller family belonged to the new St Petersburg business elite and were, like the Nobels, good Fabergé customers. All of life's significant events were commemorated with gifts purchased from the jeweller's sales-room on Bolshaya Morskaya.

Neuscheller's residence was on Kamennyi Ostrov, which at that time was home to fashionable villas with large gardens. It was featured in the January 30th, 1917 issue of *Stolitsa i usadba* (Town and Country). The article is effusive in its description of the home:

> The interior is extremely elegant. It is all flowers, greenery, and the kingdom of light. The large winter garden, the windows of which face south, is filled throughout the day with sunshine. The other first floor rooms are located around a beautiful central white music hall.

The house was full of the most precious antiques and art objects, including a number of Canova statues, furniture signed by the famous French *ébéniste* André Charles Boulle, Baccarat chandeliers, antique porcelain, and Flemish tapestries. It is by no means hard to imagine this exquisite pink sedan chair in such a setting.

---

*Varicolour gold (72 zolotnik), rock crystal, mother-of-pearl, translucent salmon pink enamel on a sunburst guilloché ground. Fabergé, Mikhail Perkhin, St Petersburg, made between 1899 and 1903. Scratched stock number 2707. Height 9 cm. Width (max) 5.3 cm.*
Private Collection. Photo by Katja Hagelstam

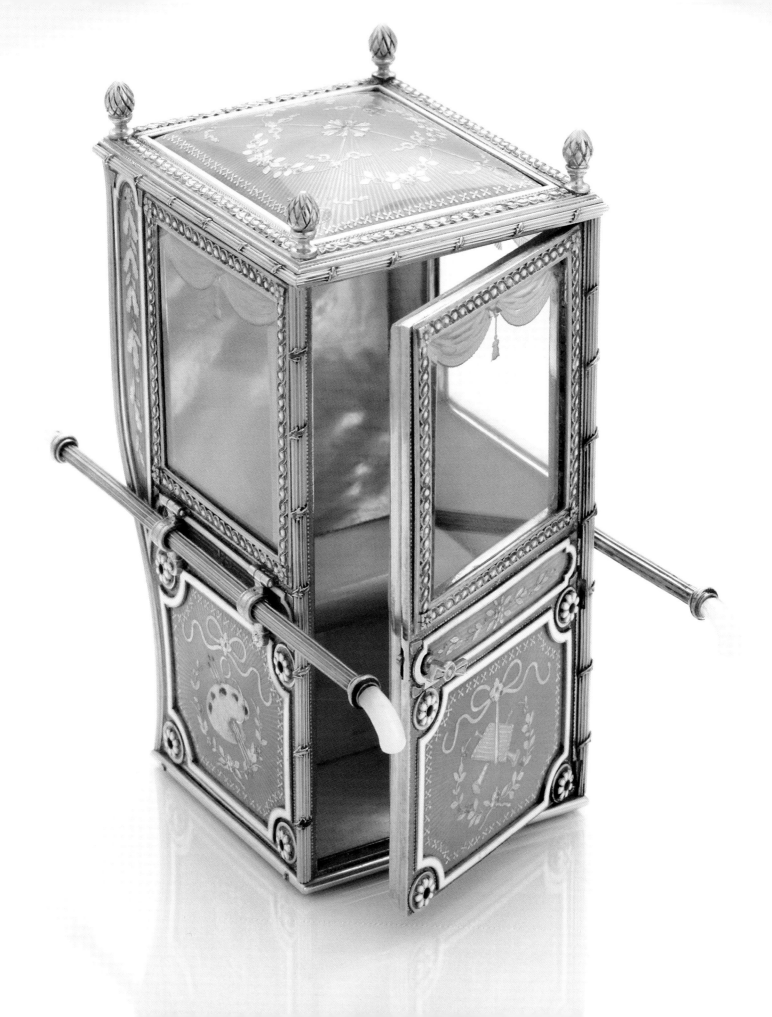

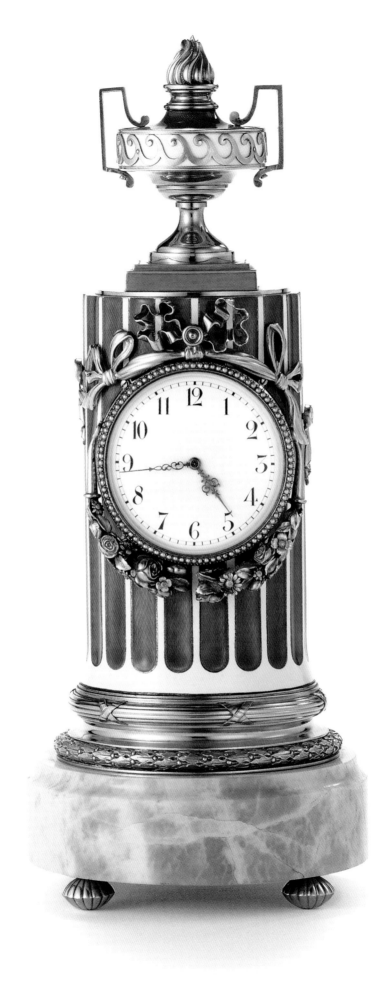

# Henrik Wigström

On the death of Mikhail Perkhin in 1903, Henrik Wigström became Fabergé's head workmaster, and he retained this role until the company was wound up in 1918. Prior to 1903 Wigström had been Perkhin's chief assistant and right-hand man. During his fifteen years as head workmaster, Wigström was responsible for the most demanding segment of the House of Fabergé's production. Altogether twenty of the fifty Imperial Easter eggs were made under his direction. It was on Wigström's watch that the company enjoyed some of its greatest triumphs. The name of Fabergé was by this time well-known and hugely respected, and the company's luxury gift items were popular almost all over the world.

Henrik Wigström was born in the Finnish coastal town of Tammisaari[28] on October 2nd, 1862. His father August Wig, later Wigström, had the good fortune to be taken up as a bonded fisherman by the Mayor of Tammisaari. Being the mayor's fisherman did not pay well, and consequently August took part-time work as a housepainter and member of the town's night watch. The poor wages were compensated somewhat by being employed by the most influential figure in the town, and when the position of parish sexton became vacant in 1853, August Wigström got the job. The new sexton had been in the post only a year or two when he was widowed, with two young daughters to care for.

To be able to work to make ends meet, August had to find a new bride. A year on from the death of his first wife, August married again, to Wendla Forsman (1824–1910). This union produced four more children: Wendla Victoria (1860), the future master goldsmith Henrik Immanuel (1862), August Emil (1864), and Ernst Wilhelm (1868). The family was nevertheless dogged with ill-luck. August Wigström himself died far too young, and in 1873 Wendla was left alone with four children between the ages of five and thirteen.

Shortly after the sexton's death, the town's parish council met and declared that the late August's family were living in "destitute circumstances". The council duly awarded the widow and children a year's grace, carrying with it the obligation to find and hire a temporary replacement. In other words, Wendla Wigström was to receive her late husband's salary for a calendar year and was entitled to remain in the official sexton's lodgings for the same time. In any event, Wendla's position as a single parent was still hardly an enviable one. In order to eke out a living, she applied to the local

*A column-form desk clock, in varicolour gold, pearls, marble, and enamel. Fabergé, Henrik Wigström,*
*St Petersburg, c. 1903. Height 21 cm. The clock movement carries the signature of Hy. Moser & Cie., No. 25479.*
PRIVATE COLLECTION. PHOTO BY WARTSKI, LONDON

magistrates for a licence to distil and sell spirits, but the request was rejected. For the oldest of her four children, 13-year-old Wendla and 11-year-old Henrik, the turn of events meant an abrupt end to their childhood.

### Henrik – the Apprentice

Henrik had the good fortune of securing an apprenticeship with the goldsmith and silversmith Petter Madsén in his home town. Madsén had experience from St Petersburg, having had his own workshop there, dating back roughly a quarter of a century. He returned to the Grand Duchy of Finland in 1861, with great plans in mind. Together with the goldsmith Werner Elfström, who had left Petersburg at the same time, he bought six undeveloped plots in Tammisaari and applied successfully for permits to build and operate a plant manufacturing luxury items. Production got started well enough, but collaboration between the two men not so much: Elfström soon sold his share to his partner Madsén and gradually drifted back to St Petersburg.

In falling in with Madsén, Henrik Wigström learned the basics of his craft from a master who was not only energetic and successful but also blessed with a much broader vision than the average small-town jeweller. Petter Madsén's production was made up of household silver and tableware, and for the most part it was sold to customers in St Petersburg. It is no surprise that the young apprentice became both curious and eager to explore the opportunities that might be waiting for him in the large metropolis next door. After two years as Madsén's apprentice, the master's former partner Werner Elfström offered Henrik Wigström a similar position at his workshop in St Petersburg, and in September 1875, at the age of just thirteen, Henrik packed his belongings for the trip east. The documents relating to Henrik's move to Petersburg have survived, and they indicate that by this time – in the 1870s – an underaged boy would no longer be despatched to the big city without some safeguards. In addition to a certificate of no impediment and a travel pass issued by the regional government, written permission for the move had to come from the applicant's parent or legal guardian. It was also mandatory to report to the authorities within three days of one's arrival.

Henrik had to be in possession of indenture documents, in which the contracting master pledged that in addition to formal tuition, the child would have lodgings, food, and clothing on his back. Aside from this, the master was to ensure that the apprentice would register with some local congregation, would attend Sunday School, and would in time be confirmed. These necessary regulations had been gradually introduced after decades of less-than-desirable experiences among the Finnish children who had settled in St Petersburg. Until a semblance of order had been brought to this aspect of the migration eastwards, vicars and other clergymen in Finland and Sweden alike had protested about the worrying traffic in minors to St Petersburg. A good many of the stories had ended tragically. Underage and inexperienced girls who sought work in Petersburg as maidservants (the term used in the day) could easily find themselves as working girls of another sort, in the city's brothels. Young lads turning up without an apprenticeship position could instead be coerced into doing hard labour in factories – for many teenagers it was a short and brutal career-path. The clergy were also constantly complaining that many young

*Henrik Wigström at the age of 13, shortly after his arrival in St Petersburg.*
Wigström Family Album

*Formal consent from Henrik Wigström's legal guardian, his mother Wendla, that her son may travel to St Petersburg to be apprenticed to a goldsmith. Her pledge is as follows:*

I hereby confirm that my underage son Henrik Immanuel has my consent to travel to St Petersburg, accompanied by Miss Marie Winblad, janitor's daughter, in order to take up an apprenticeship with Gold- and Silversmith Werner Elfström.

Tammisaari, 8th Day of September 1875

*Wendla Wigström signs the consent with her mark, a cross leaning at an angle, and the shoemaker G.A. Holmberg witnesses the document.*

*Henrik Wigström is not sent off to Russia alone. The 13-year-old boy is accompanied by Miss Maria Winblad, who provides her formal pledge (on the same consent document) that she will look after Henrik's welfare in St Petersburg.*

Herein I do commit myself to accompany the underage boy Henrik Immanuel Wigström to the premises of Entrepreneur Werner Elfström in St Petersburg, and thereafter to care for the child's welfare until he shall attain the age of fifteen years, confirmed here by my hand.

Tammisaari, 8th Day of September 1875.
Maria Winblad

*In this document dated January 21st, 1877, His Imperial Majesty's Governor for the Uusimaa Province of the Grand Duchy of Finland grants an extension to Henrik Wigström's residence permit for St Petersburg. The Governor has incorrectly described Henrik's late father's profession as gamekeeper or forest ranger, rather than sexton.*

*Henrik Wigström's indentureship agreement, written and signed by his prospective master, the goldsmith Werner Elfström.*

Herein I do declare myself competent to take as apprentice the son of the deceased sexton Wigström (given name unknown) and to oversee his development both physical and spiritual, to wit his attendance at Sunday School and Preparation for the Sacrament of Confirmation, to provide him with clothing, board, and lodging, and to teach him the trade of goldsmith in as far as his understanding and comprehension do permit.

St Petersburg, this 25th Day of August (6th Day of September) 1875.

Werner Elfström

Master Goldsmith

The shoemaker G.A. Holmberg is by this hand charged with acquiring for the above-mentioned boy all necessary documents and permits, etc. for his travel.
W.E.

National Archives of Finland, Helsinki

boys and girls were not showing up to Sunday School, and hence they received no written or oral learning whatsoever.

### The Leap into the Unknown

According to the stories passed down in the Wigström family, the youngster Henrik had no fears about his great leap into the unknown. As did most in his home town, he spoke Swedish, but that was the limit of his language skills. He was innocent enough to believe that even if the language of Russia was Russian, the Russians nevertheless "thought in Swedish". The family still recalls that Henrik's luggage for the journey consisted of not more than a single simple wooden valise of 30 × 40 cm, containing a spare shirt, a pair of trousers, and two markka in Finnish money.

Henrik's daughter Lyyli Wigström recalled often having heard her father tell of how the early years in Petersburg were no bed of roses. The work of a goldsmith's apprentice was hard, the days were long, and the metropolis, the language, and the entire milieu felt strange. An apprentice's tasks included sweeping up in the workshop, cleaning the tools of the trade, running errands, and generally being at the beck and call of the master. There were times when the lad was so exhausted he was close to falling asleep leaning on his broom.

Henrik was nevertheless fortunate in spending his first years in the service of a Finnish master, where the working practices were not completely unfamiliar, relative to things back home. It was also undoubtedly a relief for the young man that the goldsmith's wife, too, was Finnish. Workshops in those days were closely connected with the private quarters of the master himself, so the spouse would have had a significant role as a mother-figure for the young apprentices. Admittedly, much of the long working day was spent sitting beside the master goldsmith at the workbench, which is where the pupils gradually acquired the skills of the trade.

During the nine years that Henrik Wigström was with Elfström, he developed into a gifted goldsmith, taking his journeyman's papers and thereafter preparing for his master's examination. By this stage, the need arose to find work that was more in keeping with his skills and with a better salary, for the young journeyman had encountered his destiny, in the shape of 18-year-old Ida Johanna Turunen (1866–1911) from Kuopio. Ida had left Finland for St Petersburg four years earlier, in search of work as a nanny. It is possible she arrived on a vessel owned by her father, Pietari Turunen, who was the skipper of a boat hauling cargo on the lake waterways from Kuopio to Petersburg.

The banns were read out for the future bride and groom in the Finnish Lutheran congregation of St Mary's in Petersburg, where the two of them had first met and where they were eventually married in October 1884. Ida and Henrik had four children: Anna Lyyli (b. 1885), Hellin Maria (b.1888), Henrik Wilhelm (b. 1889), and Yrjö (b. 1891). Of this quartet, the daughter Lyyli and son Henrik worked in their father's workshop after they finished their schooling.

In 1884, Henrik Wigström got to know an important person in his life: Mikhail Evlampievich Perkhin. The two men were almost of an age – Perkhin was the older by barely two years. Perkhin saw in Wigström both an adept worker and a kindred spirit, and offered him a position when he became head workmaster of Fabergé in

*Henrik Wigström at around 16 years, as a journeyman goldsmith.*
Wigström Family Album

*Ida and Henrik Wigström shortly after their marriage, in St Petersburg, 1884.*
Wigström Family Album

*The young Master Goldsmith
Henrik Wigström.*
WIGSTRÖM FAMILY ALBUM

*Henrik Wilhelm "Poju" ("Boy")
Wigström, his father's assistant and
the future master goldsmith.*
WIGSTRÖM FAMILY ALBUM

*The Wigström children. From left to right:
Yrjö, Henrik Wilhelm ("Poju"), Hellin, and
Lyyli. The children grew up living next
to their father's studio, and both Lyyli
and Henrik joined the family firm.*
WIGSTRÖM FAMILY ALBUM

1889. The pair worked side by side for the best part of fourteen years. Quite apart from the strong professional bond that emerged, the two families became close: Mikhail Perkhin and his wife Tatiana Vladimirovna were godparents to the Wigström children.

### FABERGÉ'S NEW HEAD WORKMASTER

On the death of Perkhin in 1903, ownership of the workshop passed to Wigström, with no money changing hands. It is not clear precisely how this all occurred, but we do know that Wigström had no need to go into debt to get into the driving seat. The matter was discussed extensively among Wigström's professional colleagues, perhaps with just a dash of envy surfacing here and there. From the perspective of the House of Fabergé, there was no other solution in sight – Henrik Wigström was the right individual to take over the reins at the workshop and to become the head workmaster. We can also be quite sure that Perkhin's descendants were not left high and dry. Undoubtedly, they were compensated for the loss without Fabergé making any great song and dance about it.

Henrik Wigström was 41 when he stepped into the head workmaster's shoes. It goes without saying that this brought a host of changes to his life and that of his family. The family moved into the Fabergé office complex, to the apartment set aside for the head workmaster. The residence faced the workshop wing of the building across the courtyard, but from the kitchen door there was direct access to the workshop. For Ida Wigström, too, her husband's new position meant some significant changes. The master was responsible for the care of the underage apprentices, and his wife was therefore obliged to keep them fed and watered. The Wigström household, with four children still living at home, was now swelled by several young lads, who ate their meals in Ida's kitchen and slept in a dormitory furnished specially for them.

At this juncture, the career paths of the Wigströms' own children became a topical issue. Their oldest, Lyyli, had in fact come into the picture earlier, in the latter years of Mikhail Perkhin's tenure, after she had finished her formal schooling. She was a quick-witted, intelligent, and all-round talented young woman. Before very long she was the one who handled the day-to-day clerical errands in the workshop. Lyyli's tasks included the daily distribution of the individual goldsmiths' work-packs, the so-called "iron strongboxes" in which pieces-in-progress were kept overnight, locked away in the workshop safe. Lyyli was also charged with the important job of managing the workshop's jewel stock. When gems were required for a particular piece being worked up, Lyyli made sure that the right stones were available. These were ordered up from the Fabergé central gemstone depository.

Within the Wigström family, it was taken for granted that the eldest son would learn his father's trade, to take his place at the helm in due course. Henrik Jr., known in the family simply as "Poju" (Boy), was therefore articled as an apprentice as soon as he had finished school at sixteen. Ten years later, in 1915, Henrik Jr. had his master goldsmith's papers and was his father's closest aide in the workshop management.

The House of Fabergé flourished, and output expanded steadily despite the uncertain times that threatened Imperial Russia, including the naval humiliations of the Russo-Japanese War of 1904–05 and a succession of grave political upheavals on the home front, climaxing in the outbreak of World War One. With sales booming,

the pressure on Wigström's workshop was particularly intense. There was no way of physically expanding the space, and yet production had to be ramped up several times over. This placed huge demands on the workmaster, on his managerial skills, and not least on his ability to lead and motivate his team of craftsmen.

It is not easy to imagine how this would have happened in practice. A stroke of luck, however, has left us with a first-hand description of the way things were. It was written by one Jalmari Haikonen (1896–1989), who worked for Henrik Wigström as a journeyman engraver between the fall of 1915 and the early spring of 1918. His lively report takes us right into the heart of the routines at the workshop. We first learn how the young journeyman finds his new employment:

> One morning I got wind of a vacancy at Fabergé from two journeymen at the Wigström workshop. They urged me to go and show my face. One Saturday in October, around breakfast time, I went to see the workmaster Henrik Wigström. I explained what it was I'd been doing for Jaggard.[29] Wigström said he knew the firm and the work it did. He said his workshop needed help in that line.
>
> Come in on Monday!
>
> And so it was that in October 1915, at 8 o'clock on the Monday morning, I stepped through the double doors of the world-famous jewellers Fabergé with the firm intention of starting work as an engraver under the tutelage of Master Henrik Wigström. The Wigström workshop was on the second floor. The main studio was spacious and well-lit. There were eight workbenches, and a total of 28 journeyman craftsmen. I was initially given the simpler ornamentation and engraving tasks. Thereafter, I gradually began to get pattern work, models drawn by the artists. It was often gold cigarette cases, on which I had to engrave simple or more complex designs, which would then be enamelled in a variety of colours. Sitting opposite me was an older man, a Russian engraver in his late forties, Apashikov by name. He had been with the firm for all of 23 years. Apashikov gave me advice and hints whenever I needed them. Around the walls there were plaster casts of all the ornamental flowers, and leaves, and whorls and suchlike, all larger than in life, so that you could examine the designs and patterns in greater detail.
>
> Workmaster Wigström showed me a few cigarette cases and asked if I thought I was qualified to do the work.
>
> Yes, but I am not able to draw such things.
>
> Well now, our artists will see to that.
>
> I told him I had done similar work for Jaggard, and he said he knew all about that. Consequently, they were not afraid to give me quite demanding pieces to work on from an early stage. Further, the salary I received, within a couple of months of my starting there, was twice that of the master at my former employer. Jaggard's asked me to come and explain to them what the reason was. I reported that I was doing the same work as before, but it was more valuable. The golden rule was that there should be no haste, to ensure that the results would be exactly as required. Fabergé's clients were of the most demanding type: princes and dukes, the aristocracy, foreign monarchs, potentates, and very wealthy patrons. Just before I arrived at Fabergé, they had delivered a massive consignment of jewels

*Front and rear views of a cigarette case from Henrik Wigström's second stock book (Plate 107). This was a 1914 commission from Princess Cécile Murat, as a gift for her gentleman friend Charles Luzarche d'Azay. Green gold, platinum, diamonds, and enamel. The lid features an enamelled antelope skull motif in green. The crescent moon is in platinum and is a pointer to the C of Cécile, the present-giver. The Arabic script on the other face has been interpreted as Cécile once again. The text is in platinum and is set flush into the surface of the case. The actual case has survived and is in the Musée des Arts et Métiers in Paris.*
<small>NATIONAL ARCHIVES OF FINLAND, HELSINKI</small>

13979 40ck. 1913.

*Sketches for the cigarette cases shown on the right, included in Henrik Wigström's second stock book. The case above is depicted on Plate 105, the lower one on Plate 103.*
NATIONAL ARCHIVES OF FINLAND, HELSINKI

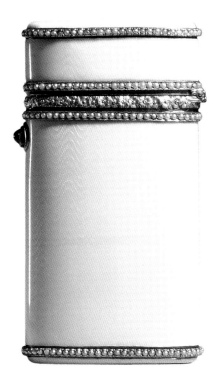

*A lady's cigarette case in gold, gilt silver, pearls, and translucent white guilloché enamel, with a ruby-set pushpiece. Fabergé, Henrik Wigström, St Petersburg, 1911. Stock number 25058. Height 8.4 cm. London import marks from 1913. Lady F.E. Smith, wife of the 1st Earl of Birkenhead, bought this case from Fabergé's London store in June 1916, for £50.00. The case is today part of The Khalili Collection of Enamels of the World; its catalogue number is FAB-312.*
COURTESY OF THE KHALILI FAMILY TRUST

*A lady's gilt silver and guilloché enamelled cigarette case. The central moss agate panel is edged with rose-cut diamonds. Thumbpiece with rose-cut diamonds. Fabergé, Henrik Wigström, St Petersburg, 1913. Length 9 cm. London import marks from 1913.*
COURTESY OF THE MCFERRIN COLLECTION, HOUSTON, TEXAS

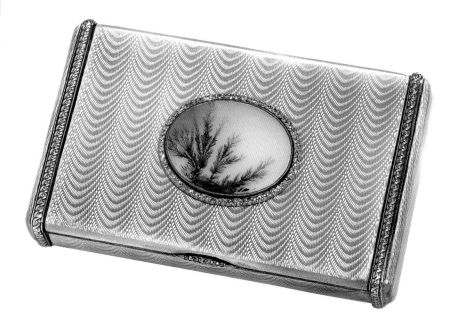

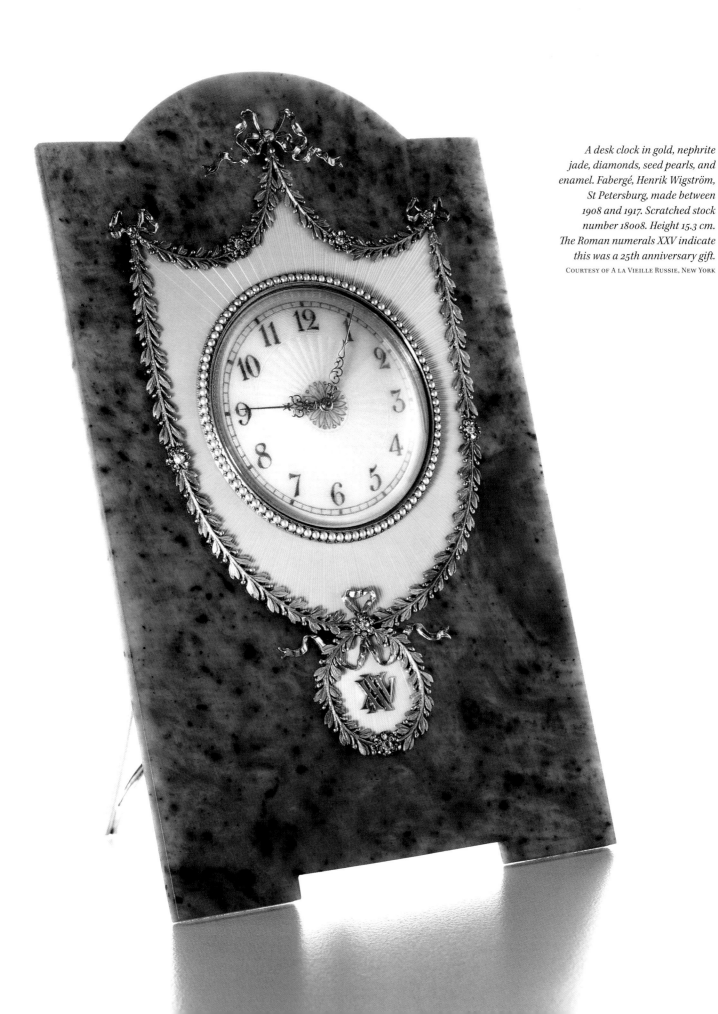

A desk clock in gold, nephrite jade, diamonds, seed pearls, and enamel. Fabergé, Henrik Wigström, St Petersburg, made between 1908 and 1917. Scratched stock number 18008. Height 15.3 cm. The Roman numerals XXV indicate this was a 25th anniversary gift.

Courtesy of A la Vieille Russie, New York

*A gold and enamel bonbonnière or candy box in the Renaissance style. Fabergé, Henrik Wigström, St Petersburg, 1913. Scratched stock number 24307. Diameter 4.5 cm. London import marks. The drawing for this particular box is found in the first stock book of Henrik Wigström, Plate 215. The sketch bears the production number 13279.*

© Fabergé Museum, St Petersburg. The Link of Times Cultural and Historical Foundation

*A matchsafe or vesta case in gold, moss agate, and rose-cut diamonds. Fabergé, Henrik Wigström, St Petersburg, made between 1903 and 1908. Length 8.7 cm.*

Courtesy of Sotheby's

*A cigarette case in gold, gilt silver, rose-cut diamonds, and translucent white guilloché enamel. Fabergé, Henrik Wigström, St Petersburg, made between 1908 and 1917. Scratched stock number 21724. Length 9 cm. London import marks.*

Courtesy of Sotheby's

*A vesta case in gilt silver and translucent golden yellow enamel over wavy engine-turning. Fabergé, Henrik Wigström, St Petersburg, made between 1903 and 1908. Length 5.4 cm.*

Courtesy of Sotheby's

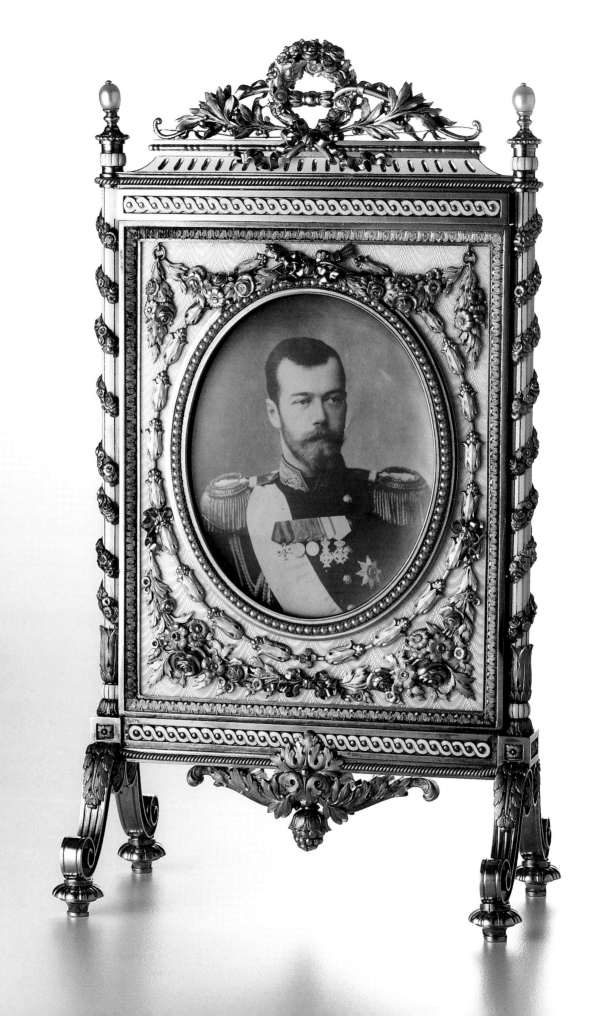

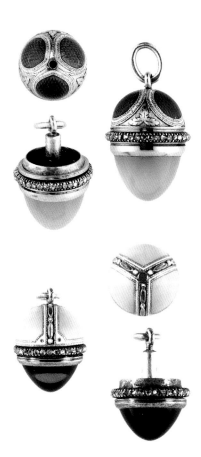

*A miniature pendant egg that also serves as a small perfume dispenser. Varicolour gold, "mecca stone", rose-cut diamonds, and enamel. Fabergé, Henrik Wigström, St Petersburg, made between 1903 and 1908.*
COURTESY OF THE MCFERRIN COLLECTION, HOUSTON, TEXAS

*Another miniature pendant egg that also serves as a small perfume dispenser. Varicolour gold, amethyst, diamonds, and enamel. Fabergé, Henrik Wigström, St Petersburg, c. 1910. Height 2.5 cm.*
COURTESY OF THE MCFERRIN COLLECTION, HOUSTON, TEXAS

◁ *A double-sided "firescreen" photo-frame in varicolour gold, platinum, pearls, and enamel. The two faces show portraits of Nicholas II and Empress Alexandra. Fabergé, Henrik Wigström, St Petersburg, made between 1908 and 1917. Height 18 cm.*
COURTESY OF THE MCFERRIN COLLECTION, HOUSTON, TEXAS, PHOTO BY A LA VIEILLE RUSSIE, NEW YORK

and other items for the court of the Siamese Royal Family. These pieces must have cost a veritable fortune.

On one occasion, a certain French princess wished to give her beau a suitably magnificent cigarette case. She travelled far and wide and could not find a maker to match her very specific demands. The case had to be of gold, with an image of Crimea in the enamelling that was so much in the life that it would positively exude all things Crimean. The lady in question turned to the Fabergé representative in London. The response was that the commission might be too difficult.

Please do try, for money is no object to me.

London contacted St Petersburg. In Petersburg, the wisest hands and heads were set to the task. They took up the challenge – and they succeeded! The princess got her wish. One cannot deny a woman anything.[30]

The year turned. 1916. In the Wigström workshop, ten craftsmen were engaged permanently on turning out gold cigarette cases. There were several models and shapes, mostly in 14-karat gold, sometimes 18-karat, and in different colours. We could have as many as forty cases lined up waiting to be engraved or otherwise worked. There was the guilloché work, then we engravers touched up the marks from the engine turning as necessary, and we did the hand finishing. The polishers would provide the final touch by hand. One of them was a man with a head of snow-white hair. He told me he had come to the House in his twenties, and he was now 82 years of age. He said he was happy with his lot. And I'm sure he was.

At the workbench behind me there was one 72-year-old whose sole task was silver repoussage. Month after month he was hammering away, embossing this hugely complex tray for tea-glasses. Henri Wigström [Henrik Jr., the 30-year-old son of workmaster Wigström] had told me when I started that I could go around all the work-stations if I wished, to see what was being done, because there were a good many Finns working here, too.

There were four stalls in the toilet. Once I was seated in there when the workmaster himself happened to need the facilities. Noticing somebody scrambling up and out of the stall, he insisted that there was no call to hurry, as the rule of "a time for everything" applied in the lavatory as much as elsewhere.

Sometimes Henri Wigström would beckon me to come with him:

- Come, Mr Haikonen, we'll go to the first floor to have a look at how Jalmari [Hjalmar] Armfelt's ciselure is going.

The master silversmith Armfelt was only too happy to show me their working methods for chasing silver. Henri Wigström was even so gracious that he had arranged with the sales staff that I might cross the courtyard to have a peek into the salesroom when the coast was clear; when the management were at lunch, for instance. That was quite an experience. I got to see so many treasures.

When some special and particularly elaborate item had been completed by the experts in the various departments, either for sale or as a private commission, and after it had been placed in a fine presentation case of its own, then the custom and culture at Fabergé was for the managing director and one or other of the workmasters to go around the departments and workbenches, showing the finished item to everyone. This was another exemplary gesture, in my view.

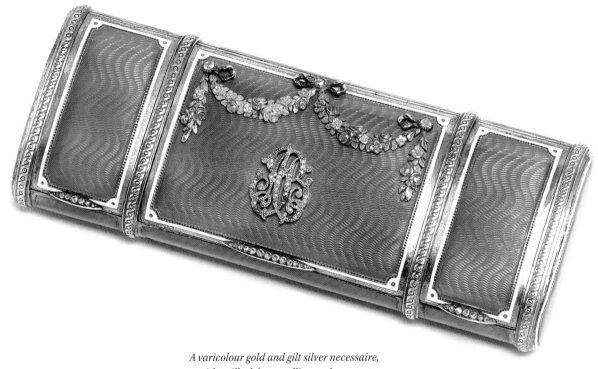

*A varicolour gold and gilt silver necessaire, with guilloché enamelling and rose-cut diamonds. Fabergé, Henrik Wigström, St Petersburg, c. 1910. Length 10 cm.*

COURTESY OF THE MCFERRIN COLLECTION, HOUSTON, TEXAS

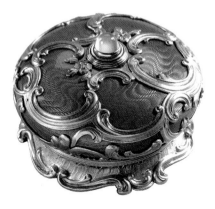

*A small bonbonnière fashioned in the shape of a doge's cap (corno ducale), in yellow enamelled gold, with rubies, emeralds, diamonds, and seed pearls. Fabergé, St Petersburg, made between 1899 and 1908. Scratched stock number 6659. Height 3.6 cm.*

COURTESY OF THE WOOLF FAMILY COLLECTION, LONDON

*A "cushion form" gold and translucent rose enamel bell push by Wigström in Rococo style, uncharacteristic for the master goldsmith. The pushpiece is a moonstone. Fabergé, Henrik Wigström, St Petersburg, made between 1908 and 1917. French import marks. Diameter 5 cm.*

COURTESY OF SOTHEBY'S

*A pillbox in the shape of a doge's cap, with a translucent oyster enamel, engraved, and with gold bands set with rose-cut diamonds, sapphires, seed pearls, emeralds, and square-cut rubies. Fabergé, Henrik Wigström, St Petersburg, c. 1908. Scratched stock number 15741. London import marks from 1908. Height 3.5 cm.*

COURTESY OF SOTHEBY'S

◁◁◁ A sumptuous example of a "salt chair", a type of salt cellar common in Russian households. Gold, Siberian nephrite, seed pearls, and enamel. The nephrite seat is hollowed out to hold the salt. The hinged lid of the seat and the backrest of the Louis XVI style "chair" are decorated with sepia and opalescent transparent enamel over a guilloché ground, to produce the effect of fine brocades. Fabergé, no master's mark visible, St Petersburg, 1915.
COURTESY OF THE INDIA EARLY MINSHALL COLLECTION, CLEVELAND MUSEUM OF ART, CLEVELAND, OHIO

◁ The front view of the "salt chair" as shown in the first stock book of Henrik Wigström (Plate 205). The production number of the piece is 12417 and the date of completion May 26th 1915.
PRIVATE COLLECTION

◁ A necessaire in varicolour gold, gilt silver, and enamel. Fabergé, Henrik Wigström, St Petersburg, 1912. Length 12 cm. Scratched stock number 22549. Bears the "JA" monogram of the original owner. A sketch of this same necessaire is to be found in Henrik Wigström's first stock book, Plate 197. Its production number is 12243 and the completion date is August 18th, 1912.
COURTESY OF SOTHEBY'S

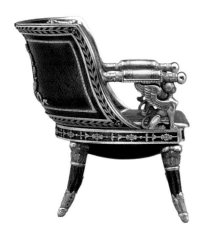
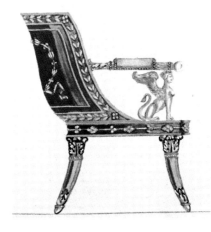

◁◁◁ A miniature armchair bonbonnière in "Empire" style. The seat slides forward to reveal a tray for bonbons. Gold and enamel, with the legs given a guilloché ground to simulate the look of mahogany. Fabergé, Henrik Wigström, St Petersburg, 1911 or 1912. Height 4.8 cm.
PHOTO BY LARRY STEIN © THE FORBES COLLECTION, NEW YORK. FABERGÉ MUSEUM, ST PETERSBURG. THE LINK OF TIMES CULTURAL AND HISTORICAL FOUNDATION

◁ A sketch for the miniature armchair in Henrik Wigström's first stock book, Plate 207. Undated, but items on this page relate to 1911–12 production.
PRIVATE COLLECTION

At the beginning of 1916, we marked a very special event. The Wigström workshop produced a cigarette box in platinum, ordered personally by the Emperor, Nicholas II. I saw the work being done. The piece weighed around half a kilogramme, and in the middle of the lid was Nicholas II's cipher, writ large, with many large diamonds, and at the four corners the Romanov double-headed eagle, with wings spread and again filled with large diamonds. It was the Emperor's gift to his uncle [sic], Grand Duke Nikolay Nikolaevich, the army commander-in-chief. We had the chance to inspect the finished cigarette box in its presentation case. A magnificent gift. We estimated among ourselves that it must have cost 50,000 gold roubles. [31]

When it comes to the working practices at Fabergé, Jalmari Haikonen could scarcely have imagined the value of the information he was passing on in his personal memoirs. It is well worth taking a closer look at what he had to say.

His description of how he got the position at Wigström's in the first place demonstrates very clearly how independently the various Fabergé workshops operated. The workmaster or workshop manager handled all personnel questions directly. He hired employees, and fired them or let them go as necessary. Since the workmaster was ultimately responsible for the quality of the work leaving the premises and for adherence to delivery schedules, it was also important that he kept a close eye on what his staff were doing. This was by no means always an easy ask in a working environment where the employees' backgrounds, their age and experience, and their nationalities were all rather diverse. Alcohol was another factor: drinking was a real issue among the artisans of the St Petersburg workshops. Life was not easy, and one did not have to look far to find solace from the mouth of a bottle. We can also read of this problem from Alexander Tillander's annual reports. His journeyman goldsmiths could be away from their bench for several days, or even weeks, after going on a bender.[32]

The increasing political ferment in Russia at the time hardly helped with personnel concerns. On Carl Fabergé's side, it was a smart move to let his workmasters handle these questions. Rather than having to grapple with such thorny problems, the management could concentrate wholeheartedly on things that moved the business forward.

▷ *A diamond-set Imperial presentation box. Three-colour gold, brilliant and rose-cut diamonds, guilloché enamel, and a miniature portrait of Emperor Nicholas II painted by the court miniaturist Vasily Ivanovich Zuev (1870–c.1917). Fabergé, Henrik Wigström, St Petersburg, 1914. Length 9.8 cm. This example was a gift from the Emperor to privy counsellor and financier Artur Germanovich Rafalovich (1853–1921).*
ROYAL COLLECTION TRUST / © HER MAJESTY QUEEN ELIZABETH II

▷ *An Imperial presentation box. Varicolour gold, brilliant and rose-cut diamonds, guilloché enamel, and a miniature portrait of Emperor Nicholas II painted by Vasily Ivanovich Zuev. Fabergé, Henrik Wigström, St Petersburg, 1916. Length 9.5 cm. A gift from the Emperor (actually presented only after Nicholas II's abdication in 1917) to the French Minister of Foreign Affairs, Gabriel Hanotaux (1853–1944).*
ROYAL COLLECTION TRUST / © HER MAJESTY QUEEN ELIZABETH II

◁ *Sketches for the Imperial presentation boxes shown on the right. They are found in Henrik Wigström's second stock book. The box presented to Artur Rafalovich is on Plate 105, and the one to Gabriel Hanotaux on Plate 31. The sketches show the boxes in preparation, still not set with the miniature portraits.*
NATIONAL ARCHIVES OF FINLAND, HELSINKI

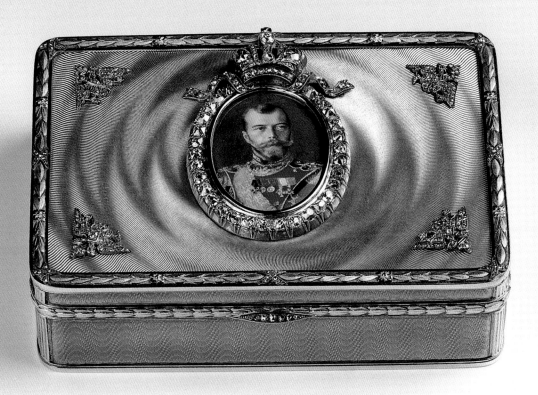

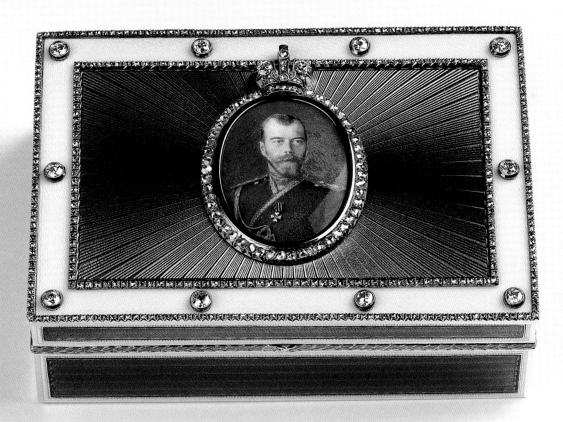

Russia had no pension system, and the problem of elderly or sickly employees was a sensitive question, about which we have little or no information. Haikonen does mention that Wigström's workshop had two older professionals, one of 82 and another of 72. The latter had apparently been banging away with a chasing hammer for months on end on a single smallish item. Even without more detailed reports, it would be easy to understand that a professional craftsman would not be "let go" simply on the grounds of advanced age. These old and trusted workers were able to hold on to their position, regardless of the fact that the workshop no longer really gained much value added from their services.

Haikonen also bears witness to the handling of the "workplace motivation" question. This was something that embraced the entire firm, and which can be seen to be very much ahead of its time. We read his account of the management performing a tour of the work stations displaying some particularly impressive item after the team had signed off on it. This was a simple yet strikingly effective way of boosting morale and creating a sense of shared achievement. This whole "team spirit" approach seems quite natural in our own society, but it was undoubtedly a novelty in the St Petersburg of the early 20th century.

Haikonen's text further paints the picture that the workshop artisans were grouped according to the tasks they performed. Those doing all-round goldsmith work would sit together around the same workbench, those whose task was to assemble parts into a whole sat at another table, and those doing chasing and repoussage work would be at a third. The stonesetting and engraving work was also carried out at different tables. In this way, the younger and less experienced journeymen could call on help from their older colleagues when required. Tried and tested tricks were passed on and learned across the workbench. This kind of daily contact among the craftsmen was of great importance in a studio milieu, where the tasks were performed as group-work. Wigström urged his younger staff members to make use of their elders and their experience, and encouraged them to wander around the workshop in order that they would see what others were doing, and how it was done. The workmaster also stressed time and again that precision was of the essence at Fabergé: the work was to be done carefully and accurately, with no pressures of the clock.

Andrey Pankratievich Plotnitsky,[33] one of Wigström's experienced goldsmiths, was interviewed in 1951 by the Parisian antiques dealer Léon Grinberg. Plotnitsky reports that he was once tasked with a very demanding piece, a unique cigarette box. It had been ordered by a wealthy customer who was a keen huntsman. The box was unusually large, and the motif to be chased into the lid was a complex forest landscape complete with peaks and gorges and waterfalls, and with wild game glimpsed through the stands of trees. The work was exhausting, and it was almost impossible to go at it except in short bursts. To rest his hands and his brain, Plotnitsky turned at regular intervals to simpler tasks, and his manager Henrik Wigström was in full agreement. He advised Plotnitsky to work on the cigarette box only when he was really fired up and at the top of his game. This was reflected in the time it took to complete the piece: it was three full years before the case was ready to be delivered to the customer.

The number of hours worked was not of crucial significance in the St Petersburg workshops, in an era when wage-levels were still very low. The average daily

*A pastille or pill case in gold, nephrite, and enamel, with diamond-set clasp. Fabergé, Henrik Wigström, St Petersburg, made between 1908 and 1917. Scratched stock number 20513. Diameter 5.2 cm.*
COURTESY OF COLLECTION MIRABAUD

*A triangular "vide-poche" (literally: a dish or tray in which to empty one's pockets). Gold, nephrite, diamonds, and enamel. Fabergé, Henrik Wigström, St Petersburg, Made between 1899 and 1908. Scratched stock number 11924. Length of each side 12.3 cm.*
COURTESY OF COLLECTION MIRABAUD

▷ *Bleeding heart. Gold, rock crystal (the vase), nephrite, rhodonite, quartzite. Fabergé, St Petersburg. No maker's marks, c. 1910. Height 19.0 cm.*
ROYAL COLLECTION TRUST /
© HER MAJESTY QUEEN ELIZABETH II

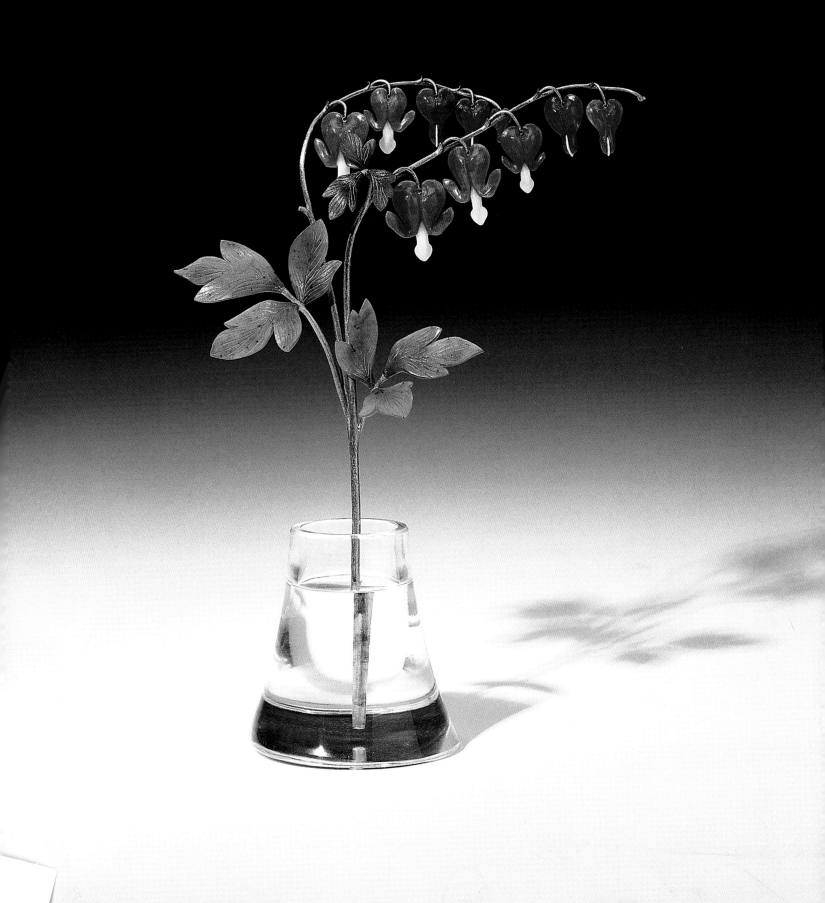

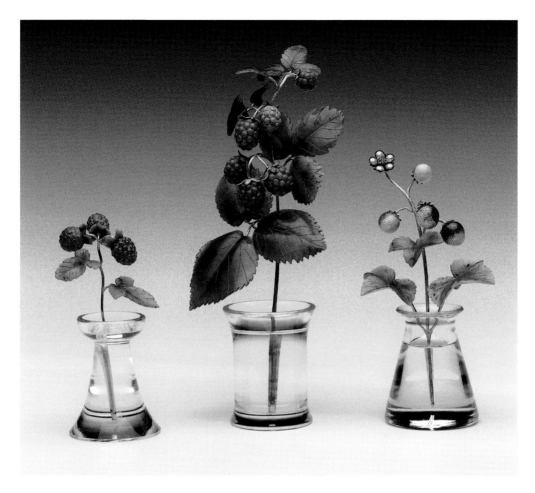

◁ *Raspberries and wild strawberries. The smaller spray of three raspberries is in gold, rock crystal, nephrite, and rhodonite. Fabergé, St Petersburg. No maker's marks, c. 1910. The larger raspberry arrangement is of the same materials, and once again there are no maker's marks, but the piece dates from c. 1910.*

*The spray of four wild strawberries is in gold, rock crystal, nephrite, and enamel, with pearls forming the petals of a fifth strawberry coming into bloom. Fabergé, St Petersburg. No maker's marks, c. 1910.*

ROYAL COLLECTION TRUST / © HER MAJESTY QUEEN ELIZABETH II

▷ *Wild roses, in gold, rock crystal, nephrite, and enamel, and with brilliant-cut diamond centres to the flowers. Fabergé, St Petersburg. No maker's marks, c. 1910.*

ROYAL COLLECTION TRUST / © HER MAJESTY QUEEN ELIZABETH II

301

303

◁ *Sketches from Henrik Wigström's second stock book. On Plate 301, at left is a sprig of cherry blossom "in a rock crystal vase". Below is a mock-orange or Philadelphus, a popular scented flower in Russia, and on the right a sprig of lilac. These sketches date from 1913, when the actual items were made. On Plate 303, clockwise from top left is a pansy in a vase made of rock crystal, a wild rose, two sprigs of mock-orange, and a cactus. These items were manufactured in 1916.*

NATIONAL ARCHIVES OF FINLAND, HELSINKI

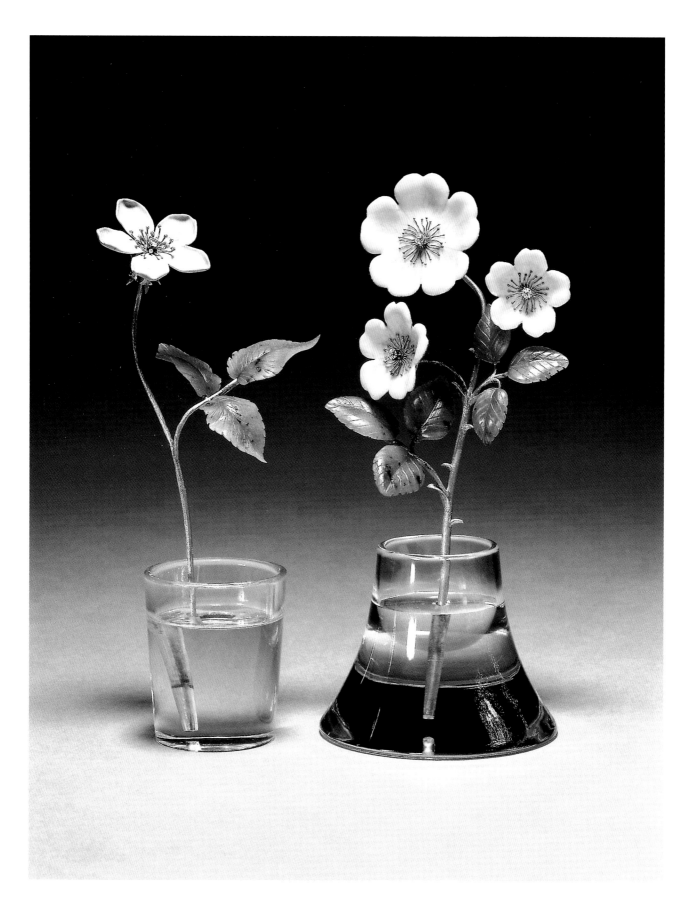

*Three puppies huddling together. Agate, set with rose-cut diamond eyes. Using a single piece of agate, the lapidarian has managed to exploit the material cleverly, such that the backs of the dogs are in a darker shade, while the area around the mouths and chins is appreciably lighter. Fabergé, St Petersburg, after 1908. Length 7.2 cm. The charming puppies were formerly in the collection of a member of the Nobel family in St Petersburg.*

COURTESY OF STOCKHOLMS AUKTIONSVERK, STOCKHOLM

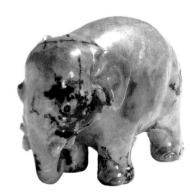

*Turtle. Carved bloodstone, with gold legs and head, inset with diamond eyes. Fabergé, St Petersburg, early 1900s. Stock numbers 5061 and 7009. Formerly in the collection of Nicholas II's sister, Grand Duchess Xenia Alexandrovna (1875–1960).*

COURTESY OF SOTHEBY'S

*Hippopotamus, seated. Rock crystal, with rubies for eyes. Fabergé, St Petersburg, early 1900s.*

COURTESY OF THE WOOLF FAMILY COLLECTION, LONDON

*Elephant, in rose-pink rhodonite. Fabergé, St Petersburg, c. 1908. Height 4 cm.*

COURTESY OF SOTHEBY'S

*A black-headed gull in agate, with gold legs and diamond-set eyes.*
*Fabergé, Henrik Wigström, St Petersburg, made between 1908 and 1917.*
Courtesy of Sotheby's

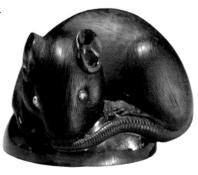

*A dormouse, in agate and with tail and ears encrusted with rose-cut diamonds. Fabergé, St Petersburg. Late 19th century. The mouse has been in the collection of Lord Ivar Mountbatten, cousin to H.M. Queen Elizabeth II.*
Courtesy of Collection Mirabaud

*A netsuke in the shape of a rat, in boxwood, with set eyes of brown bone and teeth of ivory. Signed by Ikkan (1817–1893, Nagoya School), Japan, 19th century.*
Courtesy of The Woolf Family Collection, London

*A mouse, carved and polished in netsuke style. Smoky quartz and diamonds. Fabergé, St Petersburg, early 1900s.*
Courtesy of The Woolf Family Collection, London

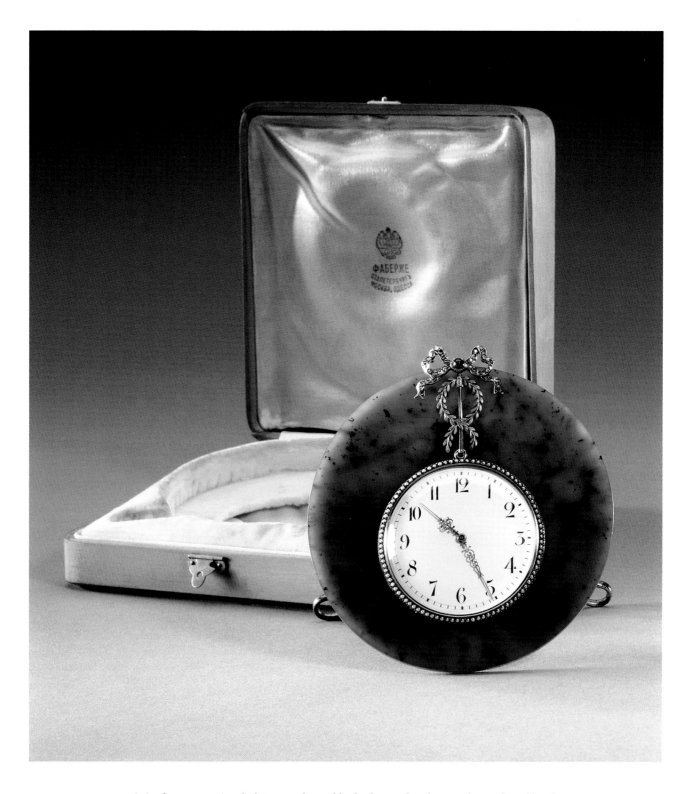

*A circular presentation clock in two-colour gold, gilt silver, and nephrite, with a seed pearl bezel, rose-diamond cresting, and a central cabochon ruby. Fabergé, Henrik Wigström, St Petersburg, made between 1903 and 1908. Height 10.8 cm. According to the Christie's auction listing from 2000, the clock was presented to a Captain Jones of the SS Sheikh by a grateful Emperor Nicholas II, in recognition of Jones's action in rescuing two shipwrecked Russian seamen during the Russo-Japanese War of 1904–05.*

COURTESY OF CHRISTIE'S

*Triangular desk clock. Gilt silver mounted enamel, with seed pearl bezel. Fabergé, Henrik Wigström, St Petersburg, made between 1908 and 1917. Height 12 cm.*
COURTESY OF SOTHEBY'S

*Desk clock in gold, silver and guilloché enamel. Fabergé, Henrik Wigström, St Petersburg, made between 1908 and 1917.*
COURTESY OF WARTSKI, LONDON

*Circular desk clock in silver and guilloché enamel. Fabergé, Henrik Wigström, St Petersburg, made between 1908 and 1917. Stock number 12357. Diameter 12 cm.*
COURTESY OF SOTHEBY'S

salary for a journeyman goldsmith who had his certificates was three roubles, while a craftsman with training and special skills could make as much as five roubles a day. This meant that an employee goldsmith's monthly salary, depending on skills and experience, could be between 80 and 130 roubles.[34] In busy periods, overtime brought the artisans welcome additional income. Of course, from our vantage point in the present it is hard to weigh the "value" of these sums and contemporary purchasing power, but it is clear that people did get by on these wages, and that the goldsmiths themselves regarded their earnings as "princely". As a rule, the journeymen in a goldsmith's workshop, with their lengthy training, were better paid than in a great many other sectors. To take one striking example, an unskilled labourer in the building trade would earn only 15 roubles a month.

Jalmari Haikonen came to the Wigström workshop amid the turmoil of the First World War. The fighting had been going on for more than a year, but it had no significant impact on demand at the House of Fabergé. In fact, quite the opposite is true. Alexander Tillander writes in the 1915 annual report for his own company that operations had most certainly not been adversely affected by the war's dragging on, for with every fall in the value of the rouble, customer demand for the goldsmiths' wares went up a notch. People were quite right in thinking that gold and jewels were a safe haven in troubled times.

## WIGSTRÖM'S PRODUCTION

By a most fortunate coincidence, two fine stock books with drawings of models from the Wigström workshop have survived to this day. They give us a snapshot of part of the workshop's output between 1911 and 1916. These are extensive volumes: the books contain drawings of roughly 1,200 pieces that were manufactured during this five-year period. The items are represented in their actual size, and the line drawings and watercolour work are so finely done that there is no mistaking the designs, or the materials used in the actual objects. Every tiny detail has been reproduced faithfully: the colour of the enamelling, the ornamentation, subtle differences in shades in the gold, the colour of the gemstones, and the type of cut that has been chosen. Practically all the drawings come with a date telling us when the item was made. A good many of the pieces presented in the albums have survived to the present, and whenever some piece that emerges for sale or at auction can be traced back to one of these album images, it generates whoops of delight among Fabergé scholars and enthusiasts around the world.

These books of drawings of finished works were reference albums – even portfolios, in a sense – for the use of the workshop staff. For posterity, they provide an excellent historical catalogue of what was produced by Wigström and his craftsmen.[35]

An inventory of the various objects included in the two books shows the diversity of the production assortment: cigarette boxes and cases, cigar boxes, snuffboxes, matchboxes, table lighters, cigarette holders, desk clocks, photograph frames, desk accessories for gentlemen and ladies; letter-openers, glue pots, calling-card cases, magnifying glasses, seals, electric bell-pushes, barometers, thermometers, trinket boxes, pillboxes, needle cases, *bonbonnières* for candies and confectioneries; vases, bowls, and *kovshes* (boat-shaped drinking vessels), ornate handles for canes, umbrel-

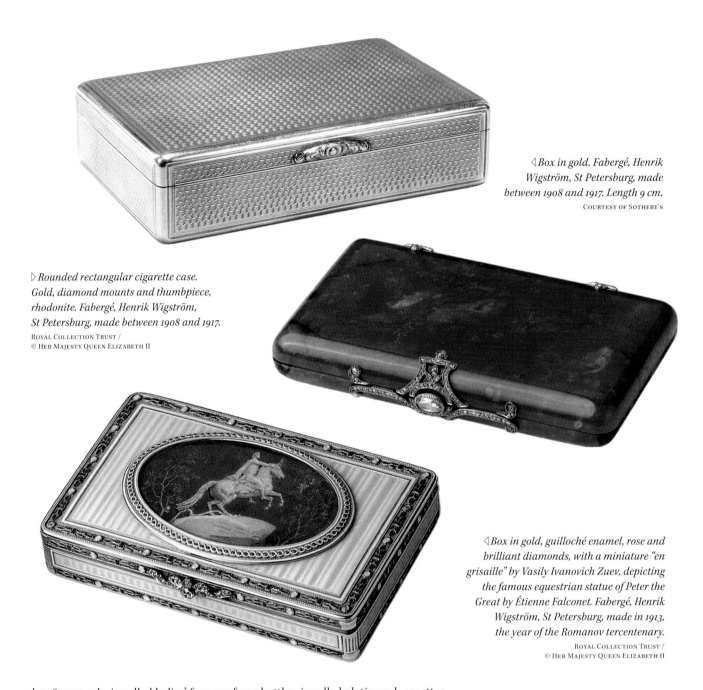

◁ *Box in gold. Fabergé, Henrik Wigström, St Petersburg, made between 1908 and 1917. Length 9 cm.*
Courtesy of Sotheby's

▷ *Rounded rectangular cigarette case. Gold, diamond mounts and thumbpiece, rhodonite. Fabergé, Henrik Wigström, St Petersburg, made between 1908 and 1917.*
Royal Collection Trust /
© Her Majesty Queen Elizabeth II

◁ *Box in gold, guilloché enamel, rose and brilliant diamonds, with a miniature "en grisaille" by Vasily Ivanovich Zuev, depicting the famous equestrian statue of Peter the Great by Étienne Falconet. Fabergé, Henrik Wigström, St Petersburg, made in 1913, the year of the Romanov tercentenary.*
Royal Collection Trust /
© Her Majesty Queen Elizabeth II

las, & parasols, jewelled ladies' fans, perfume bottles, jewelled platinum lorgnettes, evening clutch bags & vanity purses, coin purses, powder compacts, *nécessaires* for toiletries or sewing kits, a vast range of jewels and accessories (pendants, brooches, crucifixes, medallions, tie-pins, cufflinks, rings, bracelets, hat-pins, belt buckles, cloak clasps, thimbles, and the like), objets de vertu and bibelots such as miniature pieces of furniture; birdcages, animal- and human figures made of hardstones, and the famed flower arrangements, Easter eggs, and miniature Easter eggs.

The summary indicates that the emphasis in production at Wigström's was in small utility- and decorative items: the sort of pieces that would be scattered around affluent homes in keeping with the taste and decor of the time, and equally the sort of pieces that were ideal to give as luxury gifts.

▷ *An octagonal box in two-colour gold, gilt silver, guilloché and sepia enamel, with a rose-cut diamond-set thumbpiece and a miniature on the lid of Falconet's Peter the Great statue. Fabergé, Fedor Afanasiev, St Petersburg, made between 1908 and 1917. For Master Goldsmith Fedor Afanasiev. (See p. 207)*
Royal Collection Trust /
© Her Majesty Queen Elizabeth II

*Richly-jewelled snuff box in four-colour gold and enamel, with diamond-set Roman numerals to the lid, bordered by floral sprays. Chased gold garlands with diamond bows around the sides. Fabergé, Henrik Wigström, St Petersburg, made between 1908 and 1917. Diameter 7.1 cm. The item was clearly a 25th anniversary gift.*
COURTESY OF SOTHEBY'S

*Round box in gold, enamel, and sepia enamel. Fabergé, Henrik Wigström, St Petersburg. Possibly made in 1903 to coincide with the 200th anniversary of the founding of St Petersburg. The lid bears a painting in enamel of Falconet's equestrian statue of Peter the Great. The underside has an enamel painting of the Peter and Paul Fortress in St Petersburg.*
ROYAL COLLECTION TRUST / © HER MAJESTY QUEEN ELIZABETH II

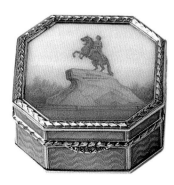

During Wigström's tenure as head workmaster, the neoclassical style made a comeback in fashionable circles. This suited Wigström down to the ground. As a Finn, leaning on the legacy of the so-called "Gustavian Style" that had come across from Sweden and enjoyed enormous popularity in Finland, he was quite at home in the stylistic monde of Louis XVI, which had raised its head once more within the House of Fabergé. The shapes were simple and classical in aspect, and the colours often pastels, such that it was a light and relatively understated look. By way of ornamentation, the standard repertoire almost always included laurel wreaths, grape & vine motifs, ovolo mouldings, or fan-shaped palmetto bands. Gradually the decoration became even more restrained, almost ascetic in nature. Already by this stage, the designs of many of the cigarette cases, for instance, betray traces of Art Deco and Modernism, styles that would not take serious hold in Western Europe until long after Fabergé's business had closed down.

Fabergé being jeweller to the Romanovs, the firm had a retainer with the Cabinet of His Imperial Majesty, under the Ministry of the Imperial Court. This involved the making of presentation items for official use, such as jewelled snuffboxes with the Emperor's portrait, his cipher, or the Romanov double-headed eagle on the lid, similar cigarette cases and boxes, jewelled photograph frames for the table-top (again with the Emperor or the Imperial Family depicted), and jewels and ecclesiastical items such as chalices and caskets. A great many of these commissions were crafted in Wigström's workshop.

In addition to all this, nearly every year, the workshop produced and delivered two of the fabled Imperial Easter Eggs. Two of them remained unfinished in Wigström's workshop – the eggs to be presented on Easter Saturday 1917. Emperor Nicholas II, however, abdicated a month before Easter came around.

## INGENIOUS IDEAS FOR RAISING PRODUCTION

While Wigström was head workmaster, the Fabergé operations expanded appreciably. Demand for the company's products was soaring, and it put pressure on the production capacity of the various workshops. Output had to be cranked up, but without compromising any of the things that the company name stood for: great design, unique models, and the most rigorous attention to quality. This called for much development work and an altogether new approach. The workmasters and the management put their heads together and came up with some ingenious ways of squeezing more out of the existing capacity. A single model would now become the basis for an entire series of pieces, whereas before it would have been a one-off item. By combining a suite of smaller elements, it was possible to make products that were unique, regardless of the fact that they were built around stock modules.

The idea as such was quite straightforward. Take the extremely popular Fabergé desk-clocks, for instance. The artists designed an entire series of basic models in different sizes and shapes. For each of these models, a flat plate surrounding the dial was turned out in gold or silver in series of perhaps a dozen – sometimes even more pieces. These plates were given a variety of engraving designs – again in series of a dozen or more – and then enamelled in a full palette of pastel shades. For each and every individual model, there would then be a whole series of different decorative

*Gum pot in varicolour gold, translucent pale blue guilloché enamel, with a cabochon moonstone finial knob. Fabergé, Henrik Wigström, St Petersburg, made between 1903 and 1908. Stock number 12635. Diameter 4.5 cm. Formerly in the Collection of King George I of the Hellenes.*
COURTESY OF CHRISTIE'S

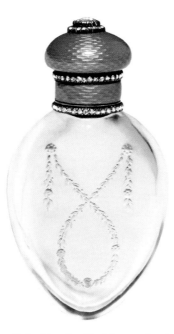

*Rectangular jewelled gold, silver, and enamel belt buckle. Leaf spray applications with diamond loops. Fabergé, Henrik Wigström, St Petersburg, made between 1903 and 1908. Stock number 14387. Height 6.3 cm.*
COURTESY OF SOTHEBY'S

*A jewelled gold and guilloché enamel and rock crystal scent bottle in amphora shape, with the pink enamelled hinged lid set with rose diamonds and a diamond finial. Fabergé, Henrik Wigström, St Petersburg, made between 1903 and 1908. Stock number 10612. Height 6 cm. Formerly in the Collection of H.R.H. Princess Margaret, Countess of Snowdon.*
COURTESY OF CHRISTIE'S

*Oval gold, silver, and guilloché enamel belt buckle. Fabergé, Henrik Wigström, St Petersburg, made between 1908 and 1917. Stock number 17129. Height 6.8 cm. The buckle was formerly in a European royal collection.*
COURTESY OF COLLECTION MIRABAUD

elements to be affixed – garlands, laurel wreath edging, or bands of flowering vines. When everything was made ready, a team of journeymen goldsmiths, each given their own specific task, would assemble the relevant bits and pieces and fix them together. This production batch might involve something like 200 desk-clocks, with the customer able to choose between five different colours, each with five different engraving patterns, five different garlands around the edges, five different floral vine motifs and rosettes. By combining these almost unlimited permutations, it was possible to manufacture several hundred such clocks, with no two perfect pairs. This kind of "mix and match" technique was a clever approach, and it allowed the House to raise production significantly without adding to the staff roster.

## EPILOGUE

Early in 1918, the House of Fabergé reached the end of its road. Jalmari Haikonen gives us a touching account of the day the workshop closed its doors for the last time.

*Master Goldsmith Henrik Immanuel Wigström in later life.*
WIGSTRÖM FAMILY ALBUM

> Then the work came to a stop, on all fronts, in all industries. Factories turned the machinery off and locked the doors. Private enterprise was made illegal, control of factories was handed to the soviets. Goldsmiths' and watchmakers' shops were expropriated, or they were robbed and looted. As a large business, Fabergé now had more than 300 workers unemployed. The new Bolshevik administration agreed with the former owners of businesses that they could withdraw from their bank accounts a sum equivalent to six weeks' wages for each of their employees. That's how it was that I, too, was given the equivalent of three months' salary. That was a lot of money.
>
> So, there we stood, the men from the Wigström workshop, with our wage-packets in our hands, dumbstruck and with aching hearts. We just stared around us like we were at a funeral. It was as though we'd lost a dearly beloved relative. And that was it, the end of the legendary House of Fabergé.

Henrik Wigström, like many of his colleagues, firmly believed the upheavals would be but a passing phase; that everything would get back to normal as soon as the war was over. That return to normality never did materialise.

At the age of 56, Henrik therefore had to abandon everything that was important to him: his life's work at Fabergé, his workshop, his home in St Petersburg, not to mention the assets and property he had earned through years of hard work. To guard against all kinds wilful damage or even arrest, the family had crossed the border into the former homeland, where they had a summer residence. Their idea had been to find a safe refuge from which to keep an eye on the situation, to wait patiently for the moment when life in Petrograd (the new name of St Petersburg) was back on an even keel and they could all go home and begin again. There at his summer villa in Terijoki, still on watch, Henrik Wigström died on March 14th, 1923.

The Coronation Egg was Nicholas II's gift to his wife, Empress Alexandra Feodorovna, on Easter Sunday in 1897.

The Imperial Couple were ceremonially crowned on May 14th, 1896 (*o.s.*) at the Uspensky Cathedral in Moscow. Nicholas was just twenty-eight years of age when he became the absolute ruler of one-seventh of the earth's land surface. Alexandra was four years his junior. Their coronation was observed with all the pomp and circumstance the Russian Empire had to offer. Representatives from the world's imperial and royal houses, together with a throng of other dignitaries, participated in the lengthy celebrations. Delegations despatched from every corner of the Empire gathered in Moscow to honour the new sovereigns.

Baron Carl Gustav Emil Mannerheim, later Finnish military commander and statesman, and ultimately the 6th President of Finland (from 1944 to 1946), was among those present. At the time, he was a young Chevalier Guard Lieutenant, participating in the formal coronation ceremony. Mannerheim gives us the following first-hand account:

A few days before the Coronation, the Imperial Couple arrived at the Kremlin from the Petrovsky Palace outside the city. Their entry was a magnificent spectacle. Riding in front of the Emperor and his entourage was the 1st Squadron of the Imperial Chevalier Guards, to which I belonged, serving at that time as leader of the 1st Platoon. The Empress and Dowager Empress rode in splendid state coaches each pulled by eight horses, followed by a convoy of 20 six- and four-team carriages. The streets were lined with stands, crammed with spectators in their Sunday best under a cloudless sky. Everything was indescribably colourful and resplendent.

The same can be said of the Coronation itself, which was loaded to the gunwales with ceremony in which I was personally involved. I happened to be one of the four hand-picked Chevalier Guards officers, who – together with the highest dignitaries of the Empire – formed a guard of honour at the Uspensky Cathedral, standing on the broad staircase that led to the enclosure of the Coronation dais with the two Imperial Thrones. The air was thick with incense. Furthermore, with a heavy sword in one hand and the "dove" in the other [officers of the Chevalier Guards

*The Imperial Coronation Egg is of varicolour gold, platinum, rubies, rock crystal, emeralds, translucent yellow enamel on a starburst guilloché ground, and portrait, brilliant, and rose-cut diamonds. Fabergé, Mikhail Perkhin, St Petersburg, 1897. Height of egg 12.7 cm. Henrik Wigström's name is engraved inside the shell of the egg. The Imperial Coach "surprise" is 9.3 cm in length.*

PHOTO BY JOSEPH COSCIA, JR.© THE FORBES COLLECTION, NEW YORK. THE FABERGÉ MUSEUM, ST PETERSBURG. THE LINK OF TIMES CULTURAL AND HISTORICAL FOUNDATION

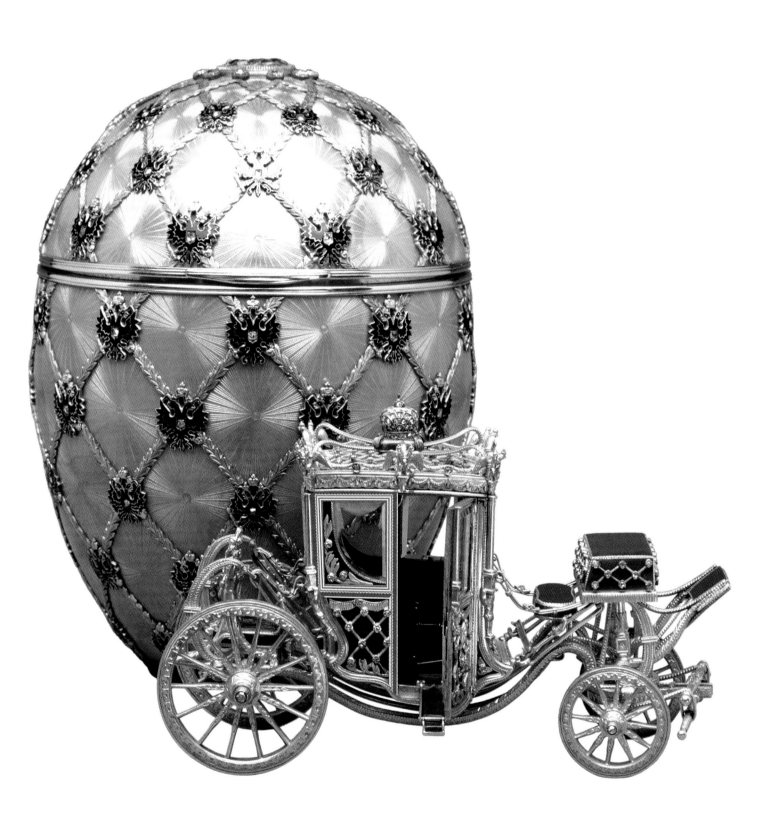

nicknamed their helmets "the dove"], we stood motionless from nine in the morning until half past one in the afternoon, when the Coronation was complete and the procession set off towards the Imperial Palace. In his ermine-lined gold brocade mantle, with the crown on his head, His Imperial Majesty walked under a canopy of honour borne by the General-Adjutants of the Empire, in front of and behind which marched the four Chevalier Guards officers, two ahead and two behind, swords still drawn in their hands.[36]

Fabergé played an important behind-the-scenes role in the coronation ceremonies. Countless gifts and decorations were required for the multitude of dignitaries and other guests, for whom Fabergé produced exquisite snuffboxes, diamond-set insignia, and lavish jewellery pieces.

Preparations for a very special Imperial Easter Egg commemorating the coronation had already started early in 1896. A group of goldsmiths was assigned for its manufacture. Henrik Wigström was given the task of creating the shell of the egg, and 23-year-old Georg Stein was charged with making the surprise, a miniature of Empress Alexandra's coronation coach.[37] The enamelling was done in the workshop of the newly appointed head enameller Alexander Petrov.

Fabergé and his designers saw Their Imperial Majesties' superb ermine-lined coronation robes, bearing the insignia of the double-headed eagle, as the obvious motif for the shell of the egg. The magnificent cloth-of-gold yellow of the robes, with its roots in an ancient coat of arms inherited from the Byzantine Empire, was the obvious colour for the enamel.

Transmitted to the surface of the egg, the design resulted in a magical, majestic creation. The shell is enamelled over a guilloché sunburst pattern and covered with a trellis-work of gold laurel leaves, the intersections of which are superimposed with the Imperial double-headed eagle, enamelled in black, the shields set with small diamonds. Under a portrait diamond on the top is the Empress's monogram AF in diamonds and rubies, and on the bottom, the year 1897 is visible through a smaller portrait diamond.

The jaw-dropping surprise, a precise replica of the Empress's ornate coach, is in yellow gold and translucent strawberry enamel, and is covered with diamond-studded trelliswork. The tyres are of platinum and the windows of polished rock crystal. Originally a small briolette-shaped emerald pendant (now lost) hung from a hook inside the coach. By his own account, Stein worked over a year on this piece, often up to sixteen hours per day.

The production of this important Easter gift also engaged members of the craftsmen's families. Henrik Wigström's daughter Lyyli remembered vividly how, at the age of eleven, she was permitted to accompany her father to the Imperial Stables, where she marvelled at the impossibly beautiful golden coaches. Wigström's visit was crucial, for he was to check the coach's interior in order to determine the exact shade of red enamel to be used.

And the price-tag for something that had occupied several goldsmiths for an entire calendar year? Fabergé's invoice to the Emperor has been preserved, and it shows he charged 5,650 roubles (including a glass display case priced at 150 roubles). This was a colossal sum of money, considering the average wage-levels of the time. A full general's annual salary ranged between 8,000 and 10,000 roubles. The young goldsmith Georg Stein stated he earned 5 roubles a day, which he considered appropriate, seeing as his previous employer, Edvard Kortman, paid him only 3 roubles a day.[38]

The Peacock Egg was Nicholas II's gift to his mother, Dowager Empress Maria Feodorovna, on Easter Sunday, April 13th, 1908.

It was made in the workshop of Henrik Wigström, and is one of the most technically demanding of all the Imperial Easter Eggs. It is also an excellent example of the cooperation between the different workshops of Fabergé. The master stone carver Carl Woerffel has cut the rock crystal shell so gossamer-thin, one would think it was window glass. It rests on an exuberant gold-plated rococo base crafted in the Wigström atelier. The surprise is a lavishly enamelled golden peacock automaton perched atop an engraved gold tree with flowers in enamel and precious stones. The turn of a gold key sets the mechanical bird in motion—it struts about, moves its head, and spreads its colourful tail feathers.

Fabergé's inspiration for this piece was the life-sized gilded mechanical peacock clock created by James Cox. It was, and still is, the special attraction of the Pavilion Hall of the Small Hermitage. (See p. 32)

Fabergé's Peacock Egg was many years in the making. There is an 1898 letter to the Minister of the Imperial Court and Domains, Baron V. B. Freedericksz,[39] from the head curator of the Hermitage, requesting permission for the Court Jeweller Carl Fabergé "and a craftsman mechanic" to examine the inner workings of James Cox's clock. The letter says that the jeweller is designing His Imperial Majesty's order for "a table decoration". The craftsman was probably the watchmaker Semen Lvovich Dorofeyev. According to Eugène Fabergé, Carl's eldest son, it took a full three years for Dorofeyev to complete this little peacock.[40]

Henrik Wigström's daughter Lyyli recounts that her father was utterly exhausted after the Peacock Egg was finally completed, just before the Easter weekend. He therefore decided to make a passage to London by steamship, reckoning the several days at sea would renew his strength. As she spoke English, Lyyli accompanied him on this voyage.

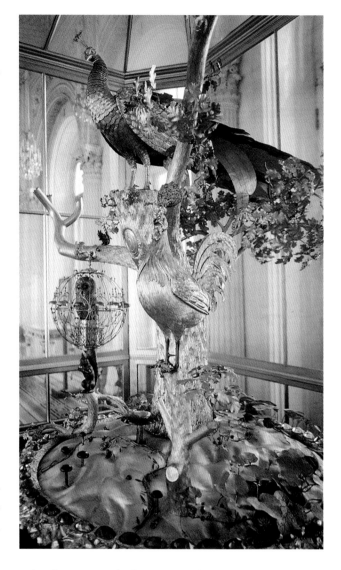

*Fabergé's inspiration for the 1908 Peacock Egg. James Cox's fabulous Peacock Clock from 1780.*
COURTESY OF THE STATE HERMITAGE MUSEUM, ST PETERSBURG

▷▷ *The Peacock Easter Egg. Rock crystal, gold, gilt silver wire, assorted precious stones (diamonds, rubies, etc.), and enamel (in the tree and the golden peacock automaton "surprise"). The fineness of the silver used was 91 zolotnik. Fabergé, Henrik Wigström, St Petersburg, 1908. Height of egg 19 cm. Length of the peacock 11 cm. The mechanical peacock was the work of clocksmith Semion Lvovich Dorofeyev. Fabergé's invoice to the Emperor for this egg was 8,300 roubles.*
COURTESY OF FONDATION ÉDOUARD ET MAURICE SANDOZ, LAUSANNE, SWITZERLAND

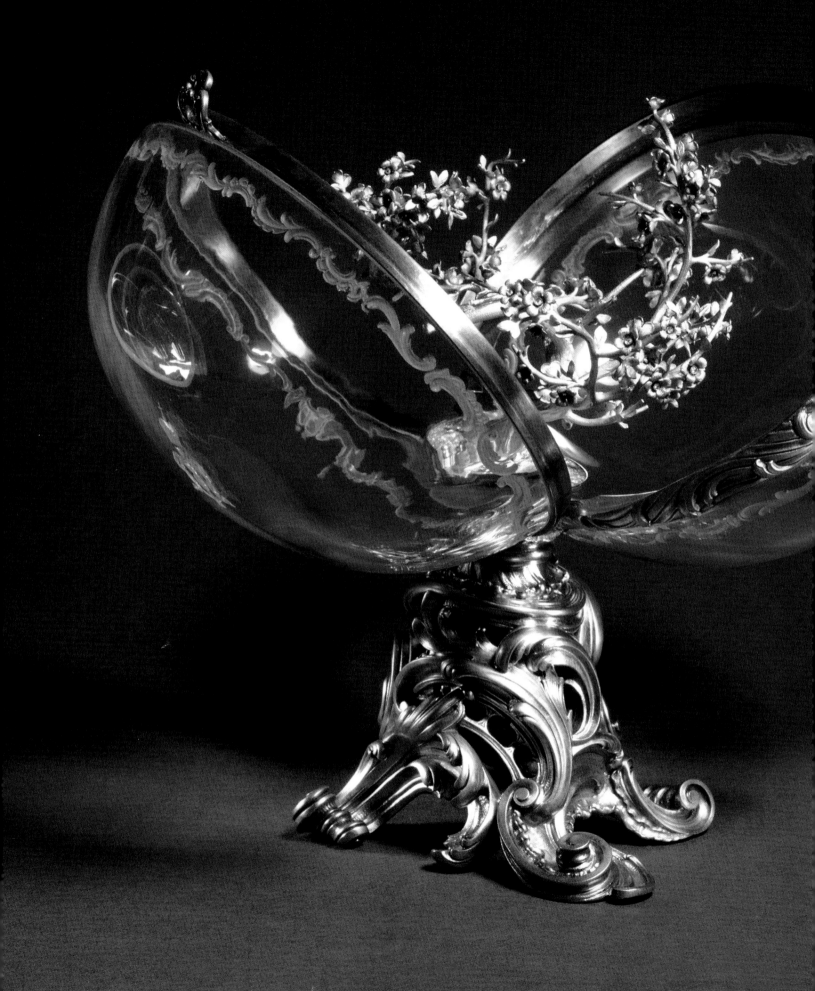

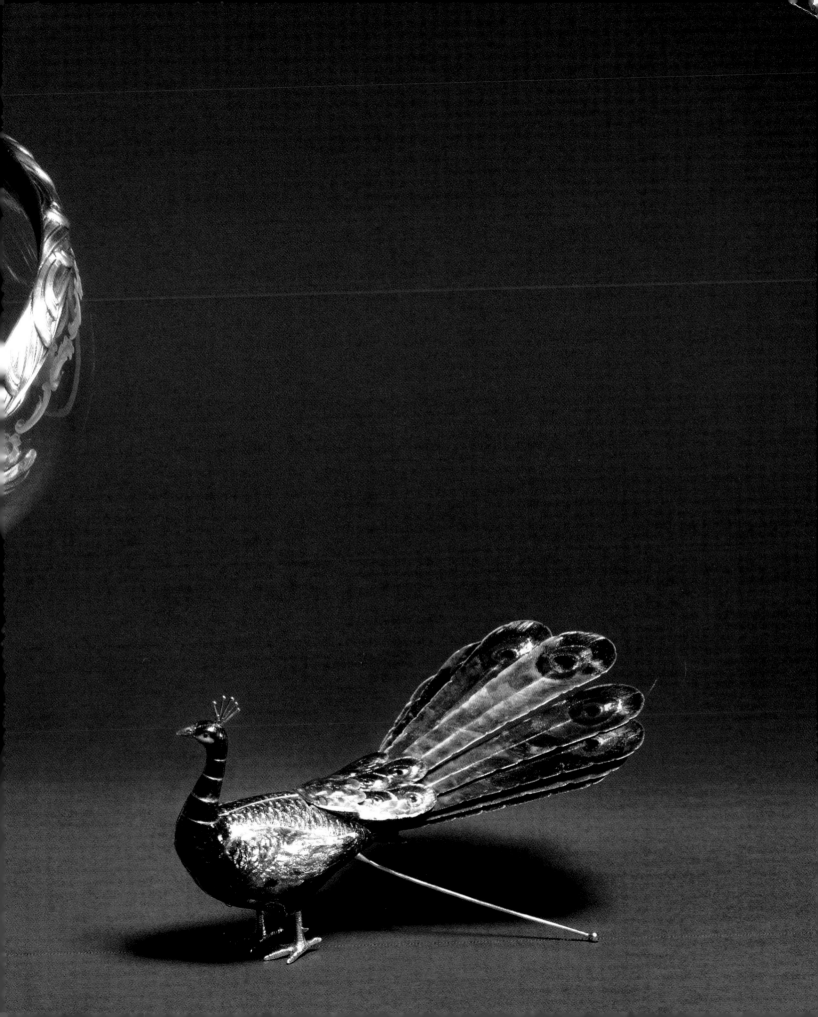

The surprise in this mauve-hued egg, Nicholas II's 1906 Easter gift to his mother Dowager Empress Maria Feodorovna, is a silver-plated gold swan on a lake of aquamarine.

"The egg opened up. Inside was a flower basket, the base of which was an unusually large aquamarine, serving as a lake. On the lake swam a swan made of platinum, gold, and precious stones. When a small button on the left was pressed, the swan silently swam, its shadow reflected on the aquamarine." This according to Agathon Fabergé, Carl's son, in an interview in *Suomen Kuvalehti* (an illustrated Finnish weekly) in 1935. The reporter, Väinö Joensuu, was so captivated by this creation that he entitled his entire piece "The Golden Swan Swimming on Waves of Aquamarine". In the article, Agathon recounts stories of the numerous objects created in his family's workshops. He has high praise for the Finnish craftsmen who made them.

There had been a two-year hiatus prior to the ordering of the 1906 eggs. Such extravagant gifts were not deemed appropriate in the context of the Russo-Japanese War and the 1905 Russian Revolution, despite the fact that 1904 had witnessed the joyous and long-awaited arrival of the heir to the throne, with the birth in July of the Tsesarevich Alexey Nikolaevich.

The swan surprise was modelled on James Cox's automated silver swan of 1773. It was exhibited in Cox's Museum in Spring Gardens, Charing Cross, London, where it was described as "a swan, large as life, of silver, fitted with mechanism, beating time with its beak to musical chimes, seated on artificial water, within reflecting mirrors; under the swan are waterworks—terminating at the top with a rising sun upwards of three feet in diameter; the whole eighteen feet high."[41]

Fabergé saw it when it was exhibited once again at the Exposition Universelle in Paris in 1867. He was familiar with Cox's work, as his famed mechanical peacock was part of the Hermitage collections. Cox's swan is now the biggest attraction at The Bowes Museum, Barnard Castle, in County Durham, England. It is controlled by three separate clock mechanisms made by John Joseph Merlin, a famous inventor of the time. While still in working order, due to their age, they are only set in motion once every day or two, at which time the swan begins to preen itself, extends its neck, and takes a fish out of the rippling water.

*Fabergé's inspiration for the 1906 Swan Easter Egg was another piece by the prodigious James Cox (1723–1800). Cox's Silver Swan is a life-sized clockwork automaton floating in a "stream" of glass rods, containing small silver fish. The bird turns its head left and right and preens itself, and then bends its neck to catch a fish from the water.*
COURTESY OF THE BOWES MUSEUM, BARNARD CASTLE, ENGLAND

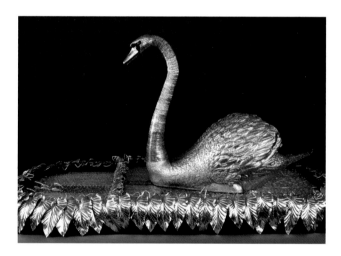

*The Swan Egg is of gold (56 zolotnik), matt opaque mauve enamel, and rose-cut and portrait diamonds.*
*The miniature mechanical swan surprise is of varicolour gold, silver-plated gold, and aquamarine. Fabergé, Henrik Wigström*
*(no maker's marks), St Petersburg, 1906. Height (egg) 9.9 cm, (swan) 5.5 cm. Price according to invoice was 7,200 roubles.*
COURTESY OF FONDATION ÉDOUARD ET MAURICE SANDOZ, LAUSANNE, SWITZERLAND

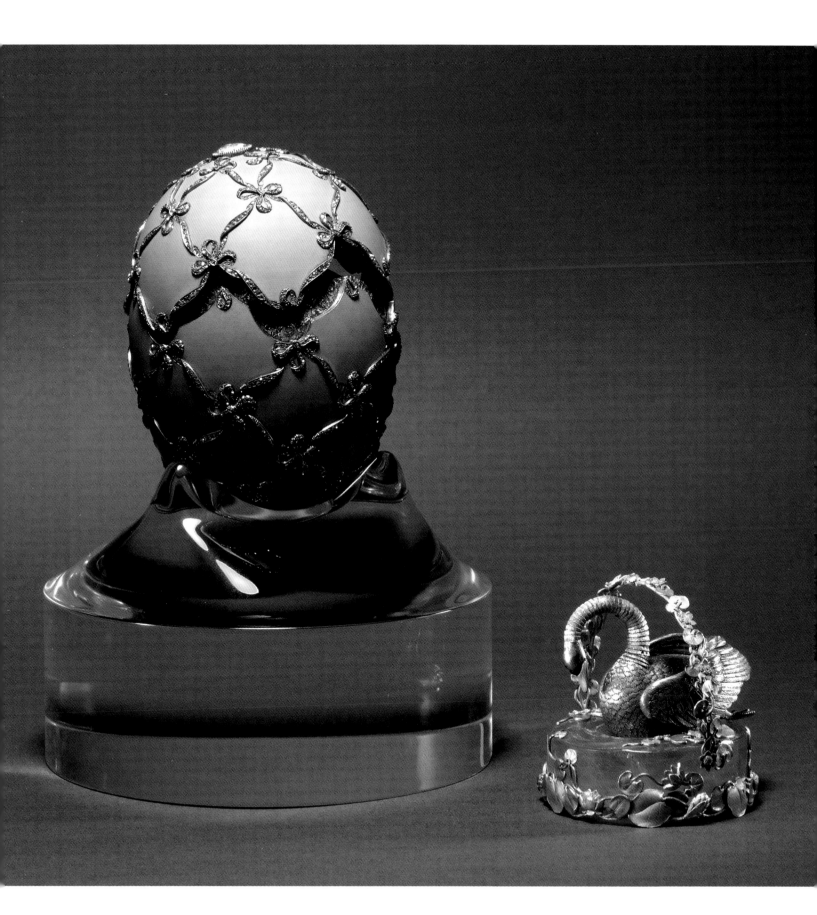

This was Nicholas II's 1912 Easter gift to his mother, Dowager Empress Maria Feodorovna.

The egg, made of gold and translucent emerald green and ruby red enamel, is ornamented with panels showing Empire-style military trophies and the Romanov heraldic double-headed eagle. It is signed Fabergé and bears the initials H.W. for Henrik Wigström. A drawing of the egg is found in the first stock book of Wigström. The delivery date noted therein indicates the egg was completed just two weeks before Easter.

In 1912, Russia celebrated the 100th anniversary of the "Patriotic War of 1812", in which Napoleon's Grande Armée of more than six hundred thousand men invaded Russia, supremely confident of victory. Alexander I's armies withstood the enemy's onslaught at the legendary – and horrendously bloody – Battle of Borodino and lived to fight another day, and those citizens of Moscow who had not already evacuated the city set fire to stores of food and other supplies, in order to prevent a French occupation. Napoleon ultimately had no choice but to retreat, suffering colossal losses. The defeat of Napoleon Bonaparte holds special significance for the Russian people to this day. It is a symbol of their indomitable spirit, and one of the finest historical examples of their bravery.

The egg's surprise is a folding screen consisting of six signed miniature paintings by Vasily Zuev. They depict the six regiments of which the Dowager Empress was honorary colonel-in-chief. Each member of the Imperial Family (males and females alike) was appointed honorary colonel-in-chief of one or more regiments. The practice dated from the time of Catherine the Great. At parades and ceremonies, the Empresses and Grand Duchesses wore specially-designed regimental uniforms. The regiments in this case are:

I   HIM Marie Feodorovna's Chevalier Guard Regiment (Кавалергардскій Ея Величества Государыни Императрицы Маріи Өеодоровны полкъ)

II  HIM's Life-Guards Cuirassier Regiment (Лейбъ-гвардіи Кирасирскій Ея Величества Государыни Императрицы Маріи Өеодоровны полкъ)

III HIM's Guards' Equipage [Naval Guards] (Гвардейскій экипажъ)

IV HIM's 2nd Pskov Life-Dragoon Regiment (2-й лейбъ-драгунскій Псковскій Ея Величества Государыни Маріи Өеодоровны полкъ)

V  HIM's 11th Chuguev Uhlan Regiment (11-й уланскій Чугуевскій Ея Величества Императрицы Маріи Өеодоровны полкъ)

VI HIM's 11th Siberian Rifle Regiment (11-й Сибирскій стрѣлковый Ея Величества Государыни Императрицы Маріи Өеодоровны полкъ)

The miniatures are framed with a narrow border of small diamonds and green enamel laurel wreaths. The hinges are in the shape of ancient Roman fasces in gold, bound with diamonds. On the reverse of each panel is the Dowager Empress's crowned cipher.

*A sketch of the Imperial Napoleonic Easter Egg in Henrik Wigström's first stock book, Plate 189. The production number is 13050 and the day of completion March 13th, 1912.*
PRIVATE COLLECTION

*The egg itself is of yellow gold, rose-cut diamonds, and emerald green and red enamel, with a velvet and satin lining. The miniature folding screen in six octagonal panels is of gold, platinum, rose-cut diamonds, and emerald green and opaque white enamel. The watercolours of Dowager Empress Maria Feodorovna's regiments are on ivory, and they are the work of court miniaturist Vasily Ivanovich Zuev. Fabergé, Henrik Wigström, St Petersburg, 1912. Height (egg) 11.8 cm. The price according to invoice was 22,300 roubles.*

PHOTO BY OWEN MURPHY. COURTESY OF THE CHEEKWOOD BOTANICAL GARDENS & MUSEUM OF ART, NASHVILLE, TN., THE MATILDA GEDDINGS GRAY FOUNDATION COLLECTION. THE EGG IS PRESENTLY ON EXTENDED LOAN TO THE METROPOLITAN MUSEUM OF ART, NEW YORK.

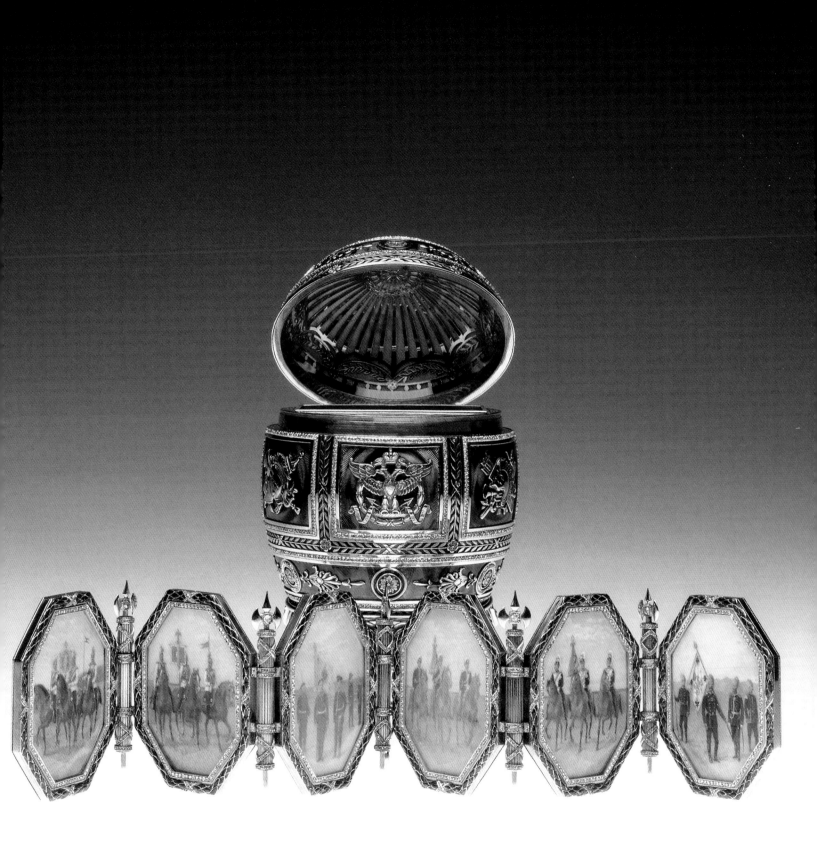

The Catherine the Great (or Grisaille) Egg was Nicholas II's gift to his mother, Dowager Empress Maria Feodorovna, on Easter Sunday, April 6th, 1914.

Two days after receiving it, the Dowager Empress wrote to her sister, Queen Alexandra of England:

He [her son Nicholas II] wrote me a most charming letter and presented me with a most beautiful Easter egg. Fabergé brought it to me himself. It is a true chef-d'œuvre, in pink enamel and inside a porte-chaise carried by two blackamoor bearers with Empress Catherine in it, wearing a little crown on her head. You wind it, and then the blackamoors walk; it is an unbelievably beautiful and superbly fine piece of work. Fabergé is the greatest genius of our time. I also told him: Vous êtes un génie incomparable.[42]

The egg was made in the workshop of Henrik Wigström, in the Louis XVI style. The shell is of varicolour gold ornamented in relief with popular motifs of the era: trophies, musical instruments, tools for artists and scientists, etc. These are interspersed with bowknots and sprays of leaves, set with tiny rose-cut diamonds. The principal decoration consists of a series of rectangular and oval panels with seed-pearl borders, featuring miniatures by Vasily Zuev painted *en camaïeu* on a pink guilloché enamel ground. The larger subjects are clearly inspired by the French painter François Boucher (1703–1770) and depict allegories of science and art. Four of the smaller oval panels portray cupids in various attitudes, each representing one of the seasons. The motif was certainly well chosen, as the entire piece reflects Empress Catherine's admiration for the fine arts and sciences.

Visible beneath the portrait diamond on the top are the initials of Dowager Empress Maria Feodorovna, and beneath a similar diamond on the bottom is the year, 1914.

The missing surprise, a miniature mechanical sedan chair with its "two blackamoor bearers" and crowned passenger, was apparently in gold and enamel, and possibly also set with jewels. One of the best craftsmen at the Wigström workshop, Andrey Pankratievich Plotnitsky was selected to work on the surprise. He made the mechanisms concealed in the figures of the bearers.[43] See the chapter of Wigström.

*The Catherine the Great Egg is of varicolour gold, diamonds (portrait & rose-cut), seed pearls, opaque white and pink grisaille enamel, and mirror glass. Portrait diamonds at top and bottom cover Maria Feodorovna's cipher and the year – 1914 – respectively. Fabergé (engraved under the lid), attributed to Henrik Wigström, St Petersburg, 1914. The miniatures are signed by Vasily Ivanovich Zuev. Height (without stand) 12.1 cm. The Egg was priced at 26,800 roubles.*

COURTESY OF HILLWOOD ESTATE, MUSEUM & GARDENS. ESTATE OF MARJORIE MERRIWEATHER POST, WASHINGTON DC. PHOTO BY E. OWEN

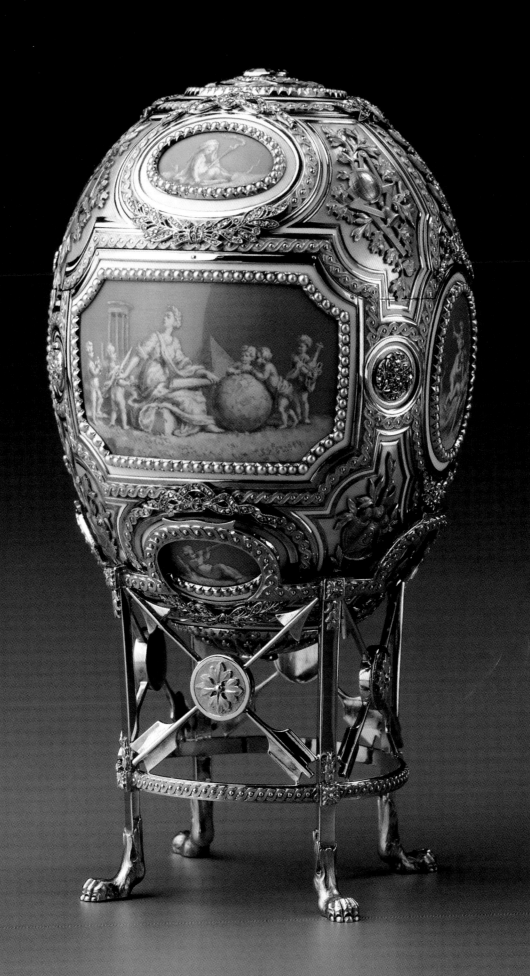

One day in the early spring of 1935, the master gold-smiths Heikki Kaksonen and Jakob Kock sat chatting in a Helsinki café with journalist Väinö Joensuu. They drifted back to St Petersburg and the time twenty years earlier, when both men had been employed in the Fabergé workshop of Henrik Wigström. They spoke of the incredible work that they had been doing. One particular item they remembered was an unusual gold cigarette case, the lid of which was ornamented with precious stones and a map of Southern Crimea.

The journalist Joensuu was fascinated by the master gold-smiths' story and wanted to know more. He contacted Agathon Fabergé, Carl Fabergé's son, who had fled to Finland after the Russian Revolution and was then living in Helsinki. Agathon agreed to be interviewed, and the piece was published in the Finnish weekly *Suomen Kuvalehti* in May 1935. Agathon also remembered this unique cigarette case:

I do not recall exactly who made it, but it truly was a unique piece of work. It was the Black Sea. The case was commissioned from us a few decades ago by an immensely rich gentleman named Konstantin Ushkov, who himself was an artist – he modelled the design – and whose maternal uncle was the magnate and "tea king" Alexander Kuznetsov. This uncle was, if that is possible, even richer than Konstantin, and in the Crimea, near the Baydar Gate, he owned a large estate called Foros, which was the most beautiful place I know

In those days, the draft proposal for the new railway line was such that it would have passed right through his land, and as soon as this lucrative – lucrative for him, at least – plan was in place, he made up his mind to expedite things a little and to "promote" the cause. Hard cash was unthinkable, but a gift one could always give. It had to be something special, and since the nephew Konstantin Ushkov had a good imagination, he was asked for help, and the case was commissioned.

On the lid was a geographically-accurate topographic map of the Crimean south coast, all in gold, along which the route of the planned new railway was marked

with small diamonds. The map's flash of wit was that the coastal cities were marked by precious stones whose names began with the same letter as the name of the city. Thus, for example, Yalta was marked with a large, beautifully polished jasper, Sevastopol with a sapphire, and so on.

However, the most difficult task was the representation of the sea, made of sapphires. To follow the shoreline, all the stones had to be specially cut so that the waves were symmetrical. The sapphires overlapped in an undulating pattern so that the darker and lighter coloured stones gave rise to a realistic wave effect. When the case was finally ready, it looked so much like the sea that one could smell the salt water…

Konstantin Ushkov's case was, to be fair, also suitable for holding cigarettes. At the end of the day, however, all was vanity of vanities.

In 1989, some fifty years after the interview, the Christie's auction house received an interesting jewelled cigarette case for sale. On the lid, projecting into the Black Sea, was a map of the Crimean Peninsula. It was a quite unique case, the likes of which the auction house experts had never seen before. Christie's and the antiques world at large debated long and hard over whether this case was a genuine Fabergé, as by this time numerous counterfeits were appearing on the market, and one had to be extremely cautious in such matters.

The case is stamped with the name Fabergé, and bears the master's mark of Henrik Wigström, H.W. The case sold for a high price to a private buyer, the auctioneers' estimate being 120,000–160,000 Swiss francs. The authenticity of the object was hotly debated even after the sale, and opinions were divided for and against.

There is no doubt that the Christie's case is one and the same item as described by Agathon Fabergé, Kaksonen, and Kock, and one can only lament that they were all long dead by the time the case came up for sale in Geneva.

Fast forward another twenty years, and yet more proof was unearthed that the case was in fact made by Fabergé. A stock book of drawings from the workshop of Henrik Wigström was discovered, completely by chance, at the National Archives

*Plate 103 of Henrik Wigström's second stock book shows the sketch of the Crimean box with its production number 13759 and date of completion, February 8th, 1913.*

NATIONAL ARCHIVES OF FINLAND, HELSINKI

*The Crimea cigarette case. Gold, brilliant and rose-cut diamonds, an assembly of square-cut sapphires to depict the waves of the Black Sea, bands of emeralds and rubies to illustrate the railways; a sapphire, diamonds, a ruby, and a topaz to mark out the cities and resorts along the coast. Fabergé, Henrik Wigström, St Petersburg, 1913. Height 9.5 cm.*

COURTESY OF CHRISTIE'S

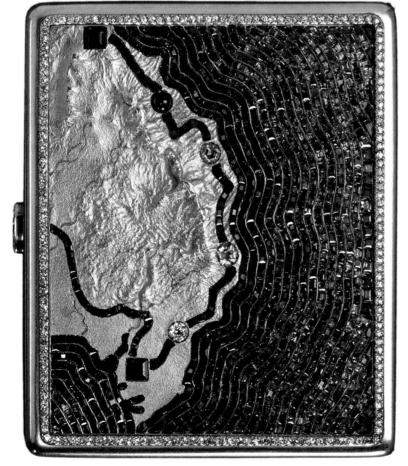

of Finland. On a page with drawings of cigarette cases made mostly in 1913, this very piece is illustrated.

The rectangular case with rounded corners is beautifully framed with closely set rose diamonds. The push-piece is decorated with a marquise-cut diamond. As Agathon Fabergé's description indicates, the sea is made of different shades of specially cut sapphires. The railway leading north to the capital of the former Taurida Governorate, Simferopol, is composed of a series of emeralds. The coast route, on the other hand, is a band of red rubies.

A square sapphire pinpoints Sevastopol, the base of the Russian Black Sea Fleet. The beautiful small towns and resorts of Balaklava and Foros are marked with diamonds. A colourless zircon is placed between Simeiz and Alupka, a cabochon ruby at Yalta, the fashionable watering-hole of the Czarist elite. The square amethyst at the far right designates the resort of Alushta, along the coast to the east.

The drawing in Henrik Wigström's album is otherwise identical to the actual cigarette case, but differs on two points: Foros, which Agathon Fabergé mentions belonged to the wealthy commissioner, is marked with a cabochon ruby; Yalta is a brownish-orange topaz, formerly called jacinth. Agathon Fabergé did observe that the precious stones should have the same first letter as the places they indicated. The drawing shows he in fact remembered correctly. Why the two stones have been replaced during the manufacture will forever remain a mystery.

### POSTSCRIPT

Agathon Fabergé's memory did falter slightly in matters of detail. However, this is not so very surprising, for he was recounting things from twenty years before, and he had lived through some quite dramatic events in the intervening decades. Based on new research, we now know the cigarette case was commissioned for the heir of the well-known industrialist Alexander Grigorievich Kuznetsov (1856–1895), owner of the large estate of Foros and one of Russia's largest tea producers. Kuznetsov's heir was his nephew, Grigory Konstantinovich Ushkov. This same Ushkov was closely involved with the project to build a coastal railway line connecting Sevastopol and Yalta, which would bring large numbers of tourists and guests to the watering holes and sanatoriums in the immediate environs of Foros. Ushkov managed to secure Imperial authorisation for the railway to be built, but the project was never realised, owing to the outbreak of the First World War.

*Agathon Fabergé (seated) with Henry Bainbridge in London in 1935, on the occasion of an exhibition of Russian works of art and bibelots, held in Belgrave Square. Around ten Imperial Easter Eggs were among the items on display. Agathon Fabergé is examining the translucent pink enamelled "Twelve Panels" Egg made – by Mikhail Perkhin – in 1899 for Barbara (Varvara) Kelch, wife of the wealthy Russian mining magnate Alexander Kelch. The piece is now in the Royal Collection of Queen Elizabeth II.*
TOPICAL PRESS AGENCY/GETTY IMAGES

*An exhibition showing objects by Fabergé from the collections of the Imperial Family was held in 1902 at the von Derwies Palace in St Petersburg. The exhibition was a charity event organized under the patronage of Empress Alexandra Feodorovna. We see two of the gilded showcases. The one in front displays Easter eggs and other treasures from Empress Alexandra's collections. The one in the background contains Easter eggs and other objects presented to the Dowager Empress Maria Feodorovna.*
THE STATE HERMITAGE MUSEUM, ST PETERSBURG

This interesting smokers' accessory was probably a palm-greasing gift to the director of the Southern Russian Railways – at least this can be inferred by reading between the lines of Agathon Fabergé's interview.

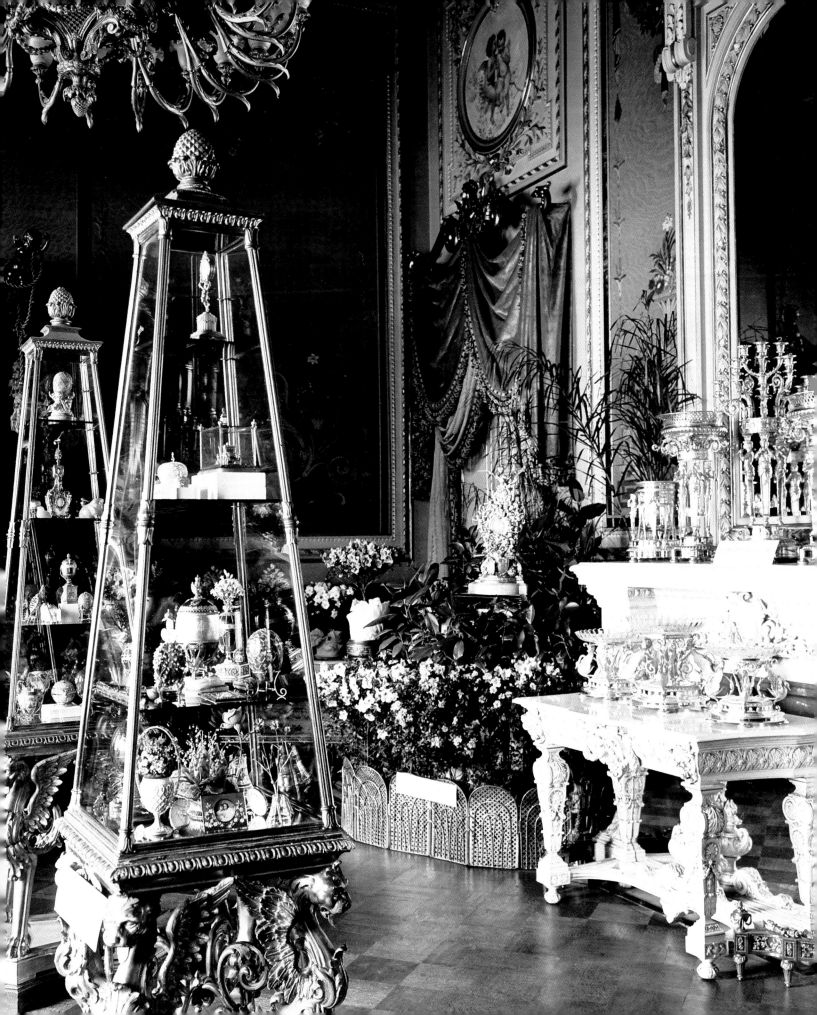

Thisvwas the most important engraving assignment I ever received – and the last one. It took me one and half months to complete it; this was at the end of 1917.

The above note was written by the master engraver and goldsmith Jalmari Haikonen on the back of a design sketch he had brought with him when leaving Russia after the Revolution (opposite page). It was a memento from the days he had been employed by Fabergé as a journeyman engraver in the workshop of its head workmaster, Henrik Wigström. (See the chapter of Wigström).

When writing this note, Haikonen could not, even in his wildest dreams, have foreseen the day he would set eyes on the actual object he had worked on so long ago.

In 1980, the jewellers A. Tillander celebrated their 120th anniversary with an exhibition entitled *Fabergé and His Contemporaries*, arranged at the Design Museum in Helsinki. It showcased hundreds of jewels and objects of art made by the gold- and silversmiths of St Petersburg during Fabergé's time, and was a true homage to the skilled craftsmen of the era. People stood in line for hours to get in. It was a great success, and everybody with a background in St Petersburg came to see it.

Jalmari Haikonen, then eighty-four years of age, was one of them. By chance, Dr Urho Kekkonen (1900–1986), the 8th President of Finland, honoured the exhibition with a visit at the same time. Haikonen was introduced to Kekkonen and proudly showed him his designs, which he had brought along for the occasion. As the two elderly gentlemen were admiring them, their eyes fell on a cigarette case in the glass display cabinet. It was the very same piece Jalmari Haikonen had worked on sixty-three years before. An unbelievable coincidence! How could the case have made its way to Finland?

*Jalmari Haikonen was a journeyman engraver with the House of Fabergé, under Henrik Wigström, from 1915–1918.*
COURTESY OF THE HAIKONEN FAMILY

The answer was very simple. It had come with its owner, an unknown Russian émigré. His initial N (H in Cyrillic) in diamonds decorates the lid. Alexander Tillander, well-known to the émigrés, had purchased it and sold it on to a Finnish collector.

*A cigarette case in gold, rose-cut diamonds, and enamel.*
*Fabergé, Henrik Wigström, engraving by Jalmari Haikonen, St Petersburg, 1917. Scratched stock number 41046.*
*Length 10 cm. The case is photographed on top of Haikonen's original working drawings.*
PRIVATE COLLECTION. PHOTO BY KATJA HAGELSTAM

This romantic egg was an Easter gift from Emperor Nicholas II to his wife Alexandra Feodorovna in 1907. The gold egg has a surface of translucent pale green enamel, latticed with rose-cut diamonds and decorated with opaque light and dark pink enamel roses and leaves in translucent emerald green. A portrait diamond is set at either end of the egg. The diamond on the top covers the cipher AF belonging to the Empress, but this monogram has regrettably been removed at some point. The diamond at the base reveals the date, 1907.

Fabergé's invoice for the Rose Trellis Egg, totalling 8,300 roubles, has survived and describes the lost surprise:[44]

*...a diamond chain with medallion and miniature of His Imperial Highness the Grand Duke Tsesarevich Alexey Nikolaevich...*

A gathering of the British and Russian royal families under King Edward VII and Emperor Nicholas II was arranged early in June 1908. They met in the Gulf of Finland, offshore from Reval (now Tallinn, Estonia), and the entire programme of the three-day visit took place aboard the spectacular luxury yachts on which the noble families had arrived. The two houses were closely related: Dowager Empress Maria Feodorovna was the sister of Edward's consort Queen Alexandra, her son Nicholas II was the Queen's nephew, and Empress Alexandra, a grand-

*Nicholas II and his wife Alexandra Feodorovna.*
ROYAL COLLECTION TRUST/
© HER MAJESTY QUEEN ELIZABETH II

daughter of Queen Victoria, was King Edward VII's niece. Hence the meeting was held with a relaxed protocol, and with lunches and dinners alternating onboard the royal yachts.

A delightful snapshot of the Russian Imperial couple has survived from the meeting. The relaxed, smiling faces of the Emperor and Empress reflect the convivial atmosphere of the visit. Fabergé scholar and researcher Annemiek Wintraecken of the Netherlands took a closer look at the jewellery Empress Alexandra is wearing: she saw the surprise from the Rose Trellis Egg - a long pendant necklace with a medallion, which under strong magnification reveals a miniature portrait of the two-year-old Tsesarevich Alexey![45]

It comes as no surprise that the Empress would wear this charming and very personal piece of jewellery when meeting with close family. Yet another Easter Egg surprise was detected by Ms Wintraecken in the snapshot: at the waistline, Empress Alexandra wears a jewel composed of four clover leaves. Could this be the surprise of the Clover Leaf Egg from Easter 1902, which according to its invoice contained a surprise consisting of four miniatures?[46]

The miniatures were obviously those of the daughters of the family: the Grand Duchesses Olga, Tatiana, Maria, and Anastasia. Every loving mother knows not to favour just one of her children, even though that child was the long-awaited heir to the throne. A jewel depicting her darling daughters would surely also have found a place on the Empress's elegant afternoon outfit.

See the Clover Leaf Egg on page 75.

*The Rose Trellis Egg opened up, showing the space for the missing necklace.*
COURTESY OF THE WALTERS ART MUSEUM, BALTIMORE, MARYLAND

*The Rose Trellis Easter Egg from 1907 is of gold, with translucent green and pink enamel, and a lattice of rose-cut diamonds. There are portrait diamonds set at each end. Fabergé, Henrik Wigström, St Petersburg, 1907. Height 7.7 cm.*
COURTESY OF THE WALTERS ART MUSEUM, BALTIMORE, MARYLAND

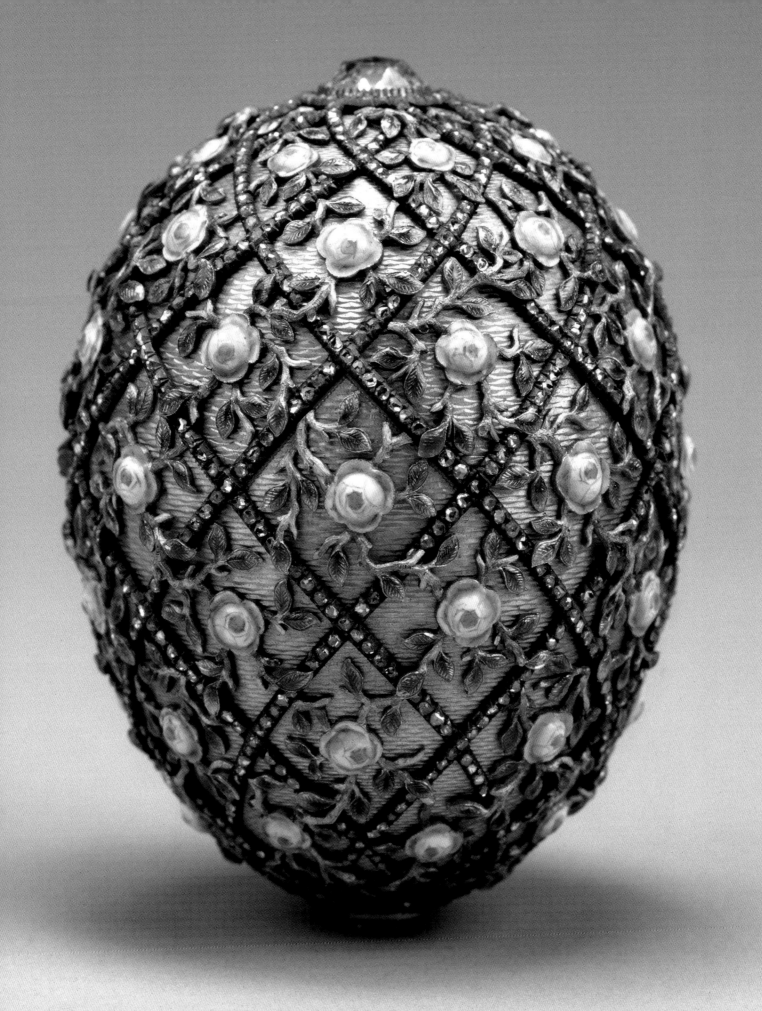

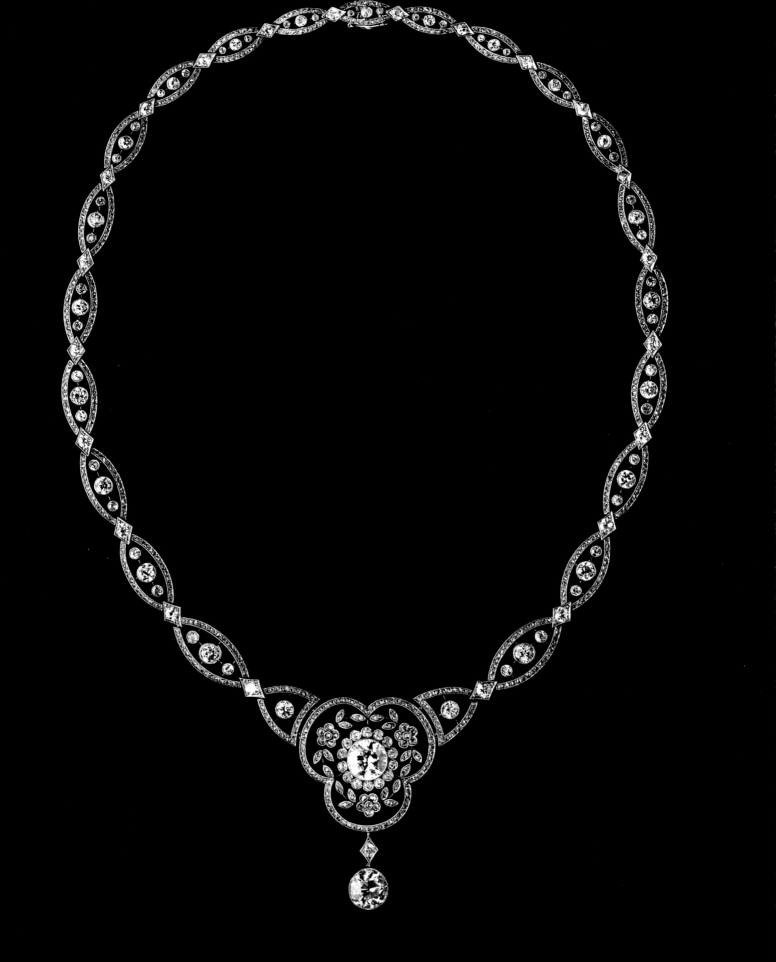

# Albert Holmström

A lbert Woldemar Holmström was born in St Petersburg on October 21st, 1876. He was the son of the master jeweller August Holmström and his wife, Hilma Rosalie.

After completing his schooling at the age of fifteen, he started his apprenticeship in his father's workshop, became a journeyman, and a few years later qualified as a master goldsmith and jeweller. Albert had long dreamt of a life as a performing musician. He played the violin, and was in fact rather accomplished on the instrument. Such fantasies of youth were nevertheless never going to be realised. His father's workshop was a lucrative family business, and it needed a capable heir. Family histories do not supply details of the battle between father and son over his choice of occupation, but the younger generation capitulated in the end.

It does not take much imagination to see just how different the two individuals were. August, the father, was very much a self-made man – he had worked hard all his life in order to secure and preserve his position as Fabergé's head jeweller. His son Albert was born with the proverbial silver spoon in his mouth. One can see from photographs of Albert that he was most fastidious about his looks and dress. He was indeed very fashionable, almost dandyish, decked out in his dazzling white shirt, tie, and sharply-tailored suit. Henry Bainbridge, head of Fabergé's London branch, writes about the Holmströms: "I never saw Holmström the elder, but the younger man I remember very well, having the appearance of a man about town, particular about his clothes."[47]

After his father's death, Albert Holmström nevertheless became the dynamic head the workshop needed. The business flourished, and an abundance of fine jewellery was produced while Albert was Fabergé's head jeweller. His workshop employed some sixty journeymen and apprentices during the good years. He was blessed with being able to have several talented craftsmen as assistants, thus reducing his workload. His closest associate was a master jeweller named Lauri Ryynänen, another Finn. Ryynänen had worked in the Holmström workshop since 1887, and he had qualified as a master at approximately the same time as Albert.

Albert Holmström also furnished a large office for himself, the likes of which none of the other Fabergé workmasters could boast. In a photograph of the office taken in 1912, one can see the master

*A necklace in platinum, gold, and diamonds. Fabergé, Albert Holmström, St Petersburg, 1911. The piece was a wedding gift on January 9th, 1916 to Baroness Sara Stjernvall, from her parents-in-law Lucy and Hendrik van Gilse van der Pals. Hendrik van Gilse van der Pals was a co-owner of Russia's large rubber goods enterprise Treugolnik. The family was an important customer of the House of Fabergé.*
COURTESY OF UPPSALA AUKTIONSKAMMARE, UPPSALA, SWEDEN

himself seated at his desk in a dark suit, brilliant white shirt, and immaculately starched cuffs. The workshop's two artists, Albert's sister Alina Holmström Zverzhinskaya and his niece Alma Pihl, have their desks next to the windows. The assistant artist, Albert's nephew Oskar Pihl, has a table on the workshop side of the picture. Alina's husband, Evgeny Vasilievich Zverzhinsky, then working as a bookkeeper-cashier for the firm, is seen surrounded by ledgers and an impressive stack of paper.

The output of Holmström's workshop was both extensive and diverse. Two splendid albums containing production sketches from the years 1909–15 have been preserved, and are now in the hands of the renowned London jewellers Wartski. They were rescued from probable loss by one of Holmström's journeymen, a gem setter by the name of Osvald K. Jurison.

The large album pages – more than 1,200 individual sheets – are full of drawings of jewellery representative of the output of the workshop. We find page after page of jewelled trinkets, tiaras, necklaces, bracelets, brooches, and pendants. They are an excellent time-capsule of the styles and tastes of the first decades of the new century. In addition to jewellery produced for stock and orders from private individuals, the albums also include descriptions and information about hundreds of objects that were made as official gifts for the Cabinet of His Imperial Majesty. A great many of the objects described were undoubtedly designed by the two artists of the workshop, Alina Holmström and Alma Pihl.

In his early twenties, Albert Holmström married one Sara Marshak.[48] This partnership foundered when Albert met a beautiful young pianist named Lidia Aleksandrovna Protsenko (1889–1974), who was the daughter of an infantry general, the Governor-General of Semipalatinsk, Alexander Iakovlevich Protsenko.

In the class-based society of Imperial Russia, it was extremely unusual for a craftsman such as Albert to marry the daughter of a high-ranking military officer. Lidia's father was a well-known personage, and his social circle mingled with many influential individuals. When the family moved to St Petersburg, frequent visitors

*Master Jeweller Albert Holmström (1876–1925).*
FROM THE COLLECTION OF LYDIA PIHL

*Lidia Holmström (née Protsenko), Albert's second wife.*
FROM THE COLLECTION OF LYDIA PIHL

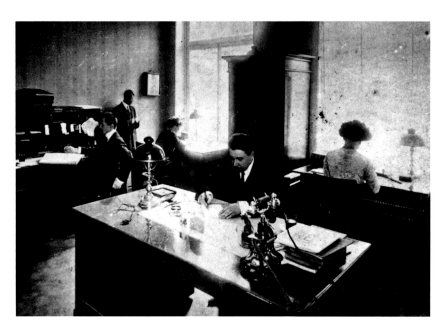

*Albert Holmström's office in 1912. See the text above.*
FROM THE COLLECTION OF LAURA RYYNÄNEN

in their home included the likes of the Emir of Bukhara. The young daughters of the family were so curious about this noble visitor from Central Asia that they waited on the dinner table, dressed up as servant girls.

A union across class lines demanded much from Albert. He had to provide his wife with the opportunity for a married life of leisure in keeping with her rank. The young couple moved into a twelve-room patrician apartment in St Petersburg, at 61, Kamennoostrovsky Prospekt. Albert later built a handsome house for his wife at Shuvalovo, on the banks of a lake close to her parents' home. The new house had two stories with turrets and large wings to each side, one of which accommodated a concert hall equipped with two grand pianos. The lady of the house arranged private recitals here. The other wing housed a large dining salon which could seat sixty people around the massive dinner table.

## After the Revolution

The Russian Revolution brought an abrupt end to the happy and carefree life that Albert Holmström and his wife had enjoyed. Their son Edgar was born in 1918, but life in Petrograd (St Petersburg's name from 1914 to 1924) became a hopeless struggle for the family.

When the House of Fabergé was shut down, Holmström tried for a time to work for the new administration. This part of Holmström's life is not documented in detail, but much is revealed by the fact that he attempted to adapt his workshop to

*Albert Holmström's workshop in the Fabergé building at No. 24, Bolshaya Morskaya. The workshop was on the 3rd floor of the courtyard wing of the premises, directly above head workmaster Henrik Wigström's quarters. The photograph is from 1912, when Holmström's foreman Lauri Ryynänen was marking twenty-five years with the firm. Albert Holmström is the standing figure on the left in the background, and Lauri Ryynänen is on the right.*
From The Collection of Laura Ryynänen

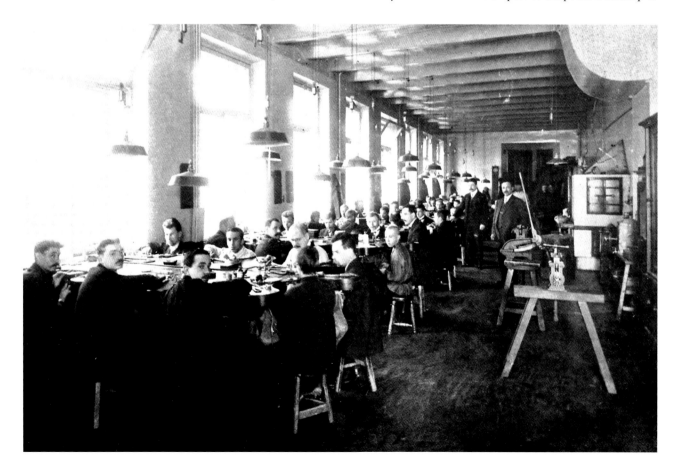

◁ *A pendant in platinum, rhodonite, and diamonds, pictured alongside the design sketch in Holmström's stock book, dated August 11th, 1911.*
Courtesy of Wartski, London

▷ *A pendant in gold, platinum-silver, with an aquamarine. The piece is by Albert Holmström from 1909. The text to the rendering on the left indicates the jewel can also be worn as a brooch. This dual-functionality was quite common in Fabergé jewels. The pin and eye/loop could be easily removed, as they were connected to the body of the jewel by a screw mechanism.*
Courtesy of Wartski, London

◁ *A brooch in gold, platinum, and diamonds. The rendering shows a variation on the theme, a pendant in the same design. Fabergé, Albert Holmström, St Petersburg, 1913.*
Courtesy of Wartski, London

▷ *A brooch surmounted by a diamond-set double-headed Romanov eagle, which indicates the jewel was an Imperial presentation gift. Gold, platinum, diamonds, and a panel of painted sepia enamel depicting classical female figures making offerings and praying at a temple. The jewel is set alongside the original sketch, which dates from 1911. Fabergé, from the Albert Holmström stock book.*
Courtesy of The McFerrin Collection, Houston, Texas, Photo by Wartski, London

◁ *A pendant and a sketched variant of the same in the stock book. Gold, rich lilac Ural amethyst, and rose-cut diamonds. Fabergé, Albert Holmström, St Petersburg. The rendering is dated March 1910.*
Courtesy of Wartski, London

*Кулонъ брошь* уп

1 акв. 42 4/32
175 брил. 225/
99 розъ à 2а

215 брил. 26/
въ цепочкѣ : 63 брил. 4 22/32

*Апрѣля 7* **Брошь**

5 брил. 14/12
69 брил. 113/
149 брил. 20/
10 розъ à 4у

*Живопись и эмаль*

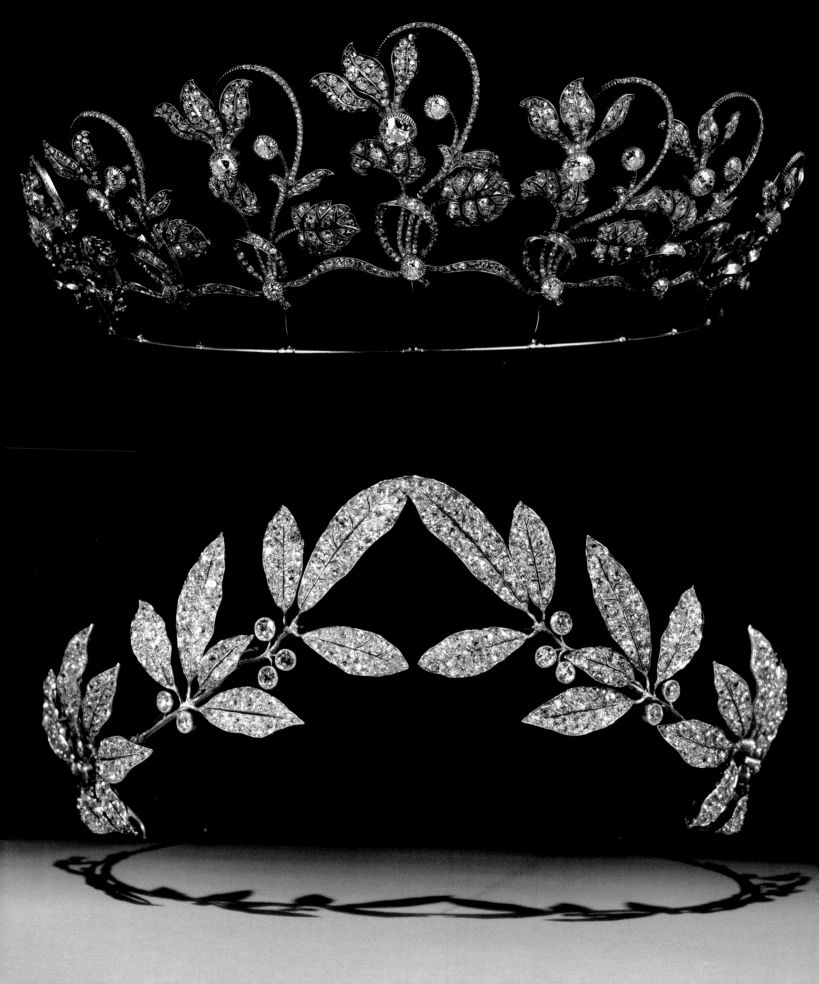

◁ *A tiara in gold, platinum, and diamonds depicting cyclamen flowers tied with a ribbon. The piece dates from 1903 and, ingeniously, it can also be worn as a necklace by removing the gold frame. Fabergé, St Petersburg, no maker's marks.*
COURTESY OF HER GRACE THE DUCHESS OF WESTMINSTER. PHOTO BY WARTSKI, LONDON

▷ *An Imperial presentation pendant bearing the cipher of Empress Alexandra Feodorovna. Gold, platinum, and diamonds. Fabergé, Albert Holmström, St Petersburg, 1909.*

*This pendant in Art Nouveau style was a gift from the Empress to Countess Augusta Lewenhaupt, the Chief Court Mistress to Victoria, Queen Consort of Sweden, on the occasion of the state visit to Stockholm by Their Imperial Majesties in 1909. There is a drawing of the pendant in the Holmström stock books. The original presentation case has also been preserved.*
PRIVATE COLLECTION. PHOTO BY PER-ÅKE PERSSON

◁ *The Myrtle Wreath Tiara is in red gold and diamonds, depicting myrtle leaves and berries. Fabergé, Albert Holmström, St Petersburg, c. 1906. The Tiara was purchased to mark the marriage of Hugh William Grosvenor and Lady Mabel Florence Crichton, which took place on April 21th, 1906.*
COURTESY OF HER GRACE THE DUCHESS OF WESTMINSTER. PHOTO BY WARTSKI, LONDON

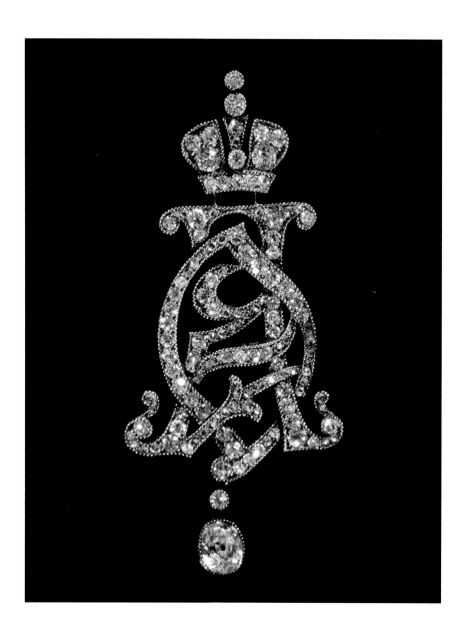

▷ *A brooch in gold and platinum-silver, set with a cushion-shaped diamond flanked by two pear-shaped diamonds and small rose-cut diamonds. Fabergé, Albert Holmström, St Petersburg, made between 1908 and 1917.*
PRIVATE COLLECTION.
PHOTO BY HASSE PETTERSSON / A. TILLANDER

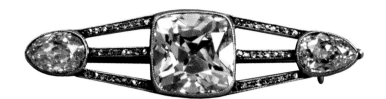

▷ *A gold and platinum-mounted diamond and carré-cut sapphire brooch. Fabergé, Albert Holmström, St Petersburg, c. 1910.*
PRIVATE COLLECTION. PHOTO BY KATJA HAGELSTAM

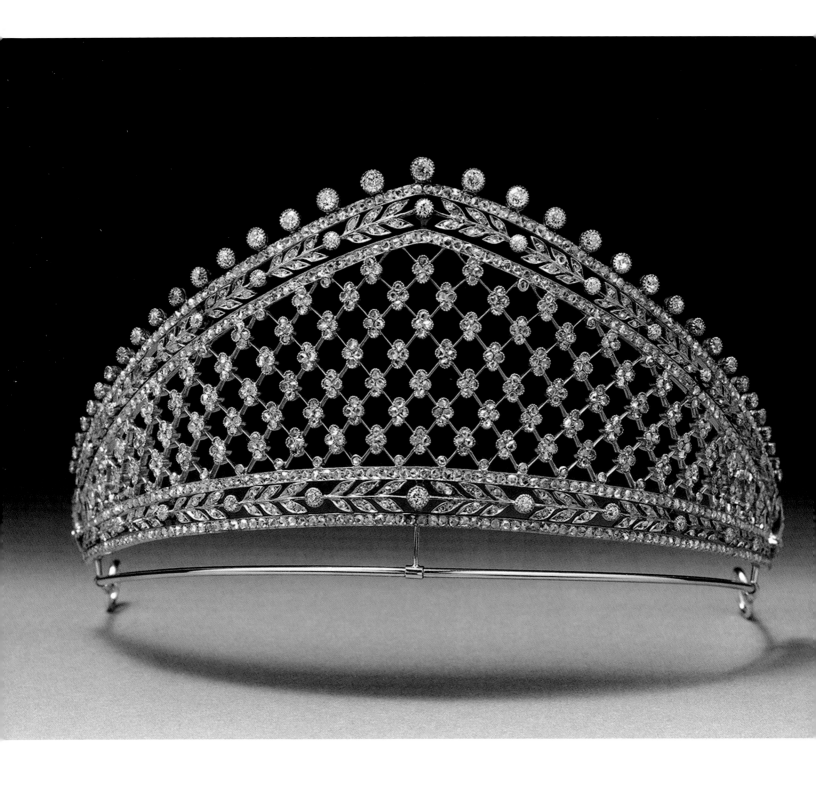

*A gold-mounted kokoshnik tiara composed of diamond-set forget-me-nots supported on
pierced openwork mounts, the border decorated with stylised laurels.
The tiara was presumably made in the workshop of Albert Holmström, St Petersburg, c. 1905.*

Courtesy of Wartski, London

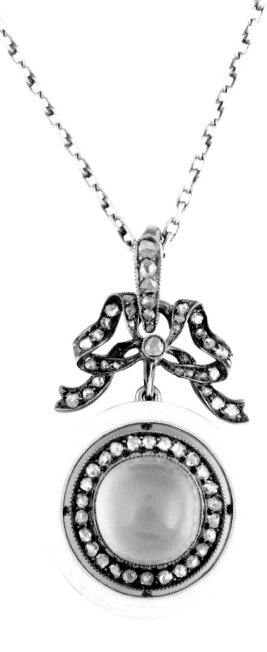

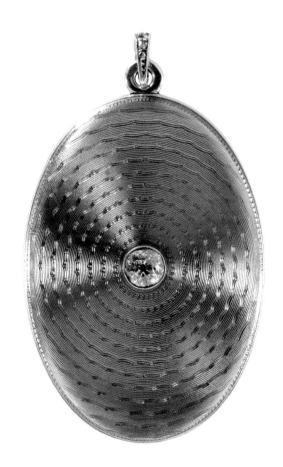

An oval locket in gold and translucent grey enamel
(concentric circles), centred with a diamond and with
a diamond-set pendant loop. Fabergé,
Albert Holmström, St Petersburg, 1908–17. Height 4.7 cm.
COURTESY OF SOTHEBY'S

A pendant in gold, diamonds, and cabochon
chalcedony "mecca stone". Fabergé, Albert Holmström,
St Petersburg, made between 1903 and 1917.
PRIVATE COLLECTION. PHOTO BY KATJA HAGELSTAM

the production of hypodermic syringes, even with his greatly reduced workforce. The attempt failed, however. According to Edgar, his father was imprisoned, along with many other private entrepreneurs.

Albert Holmström's son Edgar describes events after the revolution:[49]

Father applied for travel visas to Finland, but he was thrown into prison and taken to Moscow. Mother stood for two days on the street outside Litvinov's office[50] so as to get Father pardoned. On the return trip, Mother, who was dressed as a nurse, was forced to travel on a troop train with the soldiers. She stepped on a nail, and she came down with typhus and lay sick in bed for six weeks. All of us – Father, Mother, her siblings, and I – lived together in the same small room, but none of us caught the infection.

The winter was cold in St Petersburg, and Father burned furniture to keep us warm. It was cold even inside, and our shoes froze to the floor. The water pipes in the building froze so solid that the contents of the toilet had to be thrown out of the window. We made money to live on by selling furniture covers and the table linens. Then Father – a jeweller – went to work in the music library. We waited a whole year for travel permits, and our departure for Finland eventually took place in 1921, when I was three years old. [This was followed] by a period of quarantine in Tyrisevä and Kellomäki [two coastal towns on the Gulf of Finland, just over the old border, and now in Russia].

In Helsinki, we first lived in Kulosaari and then later in the centre, at Fabianinkatu 8. Father planned to open a jewellery shop in Helsinki together with some of his old colleagues, but he died of pneumonia in 1925.

Mother began working as a pianist; she gave concerts, performed on the radio, and so on.

But then the accident happened. She sliced her finger on some window paper and she got blood poisoning – followed by two months in the Salus Hospital in Helsinki. The middle finger of her left hand was left stiff, and the concerts ended there and then. She continued as a pianist in movie theatres, and later she worked in Gerda Alfthan's rhythm school and played for various women's exercise groups, about 500 people, in Helsinki. She gave piano lessons, including to the ballerina [Lucia] Nifontova, to the children of the Krogius family [an influential shipowner's family], and to others. She worked extremely hard.

In 1921, Albert Holmström did indeed establish a goldsmith's business at his home in Helsinki, along with Väinö Hollming. See Hollming's chapter. The intention was to continue producing jewellery. The two goldsmiths ran repeated advertisements in the daily newspapers with the words: "Long-serving C. Fabergé employees. Jewellers A. Holmström and W. Hollming will purchase gemstones, platinum, gold, and silver. Address - Fabianinkatu 8, Stairwell B, Apartment 10. Hours: 10–4."

This very modest operation ended with Albert Holmström's unexpected death. He passed away on April 16th, 1925. The general sense of malaise and hopelessness that this gifted master jeweller felt in his new and straitened circumstances almost certainly accelerated his far too early demise.

*A pendant in gold, platinum-silver, and rose-cut diamonds, with a central cabochon chalcedony ("mecca stone"). Fabergé, Albert Holmström, St Petersburg, made between 1903 and 1908. The Dowager Empress Maria Feodorovna bought this piece for 950 roubles in March 1911.*
Courtesy of Wartski, London

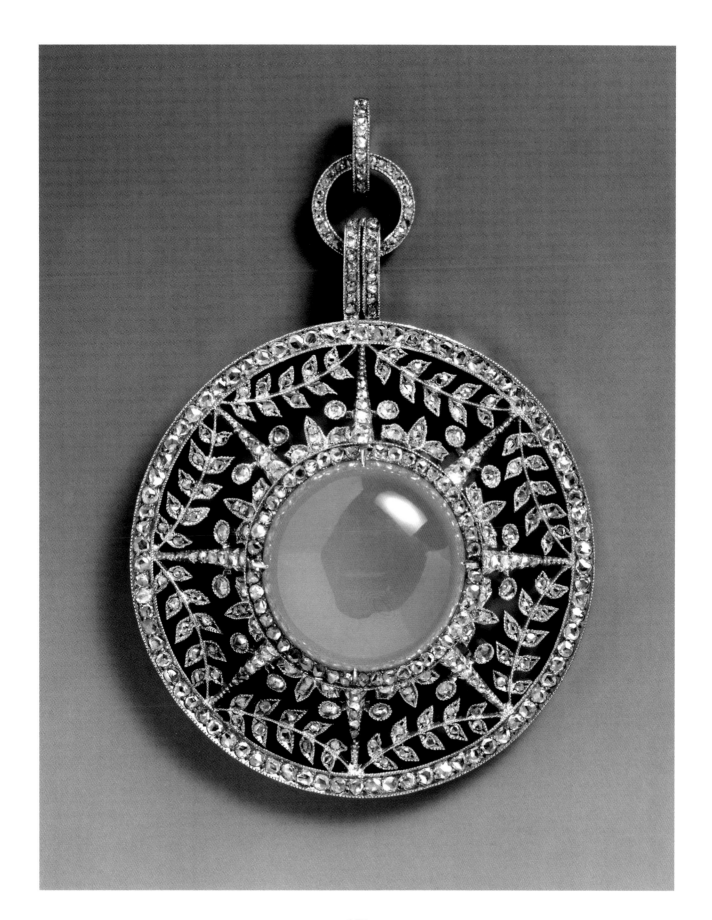

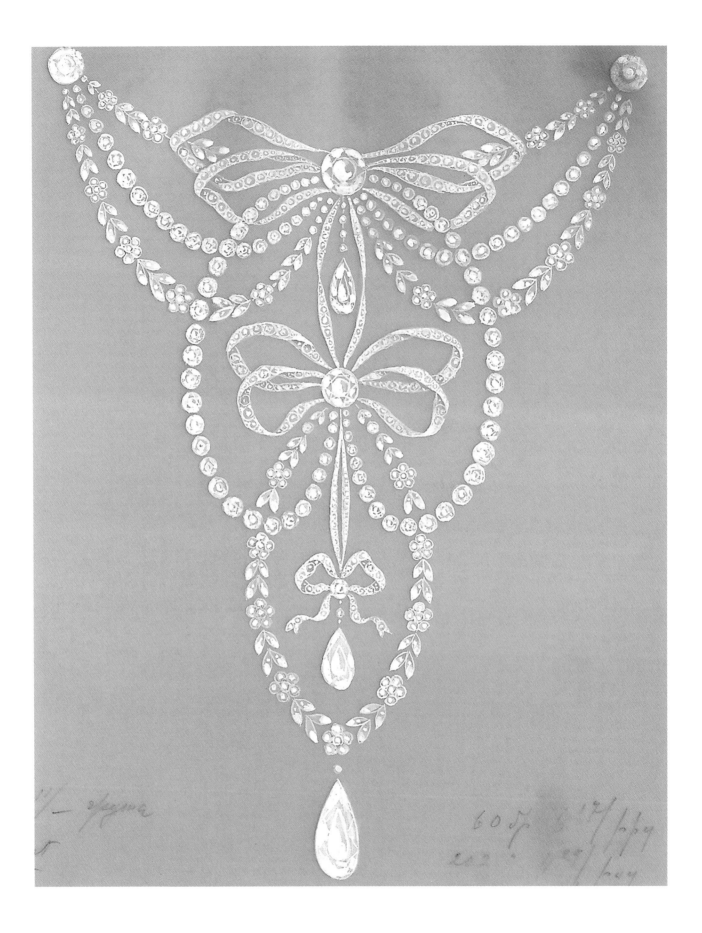

# Alina Holmström

H ilma Alina Holmström was the daughter of Fabergé's master jeweller August Holmström and his Finnish wife Hilma Rosalie Sundberg. She was born in St Petersburg on February 10th, 1875, and she died in Leningrad (as St Petersburg was then known) in 1936.

On completion of her schooling, Alina Holmström studied to become a jewellery artist, attending courses at Baron von Stieglitz's Central School of Technical Drawing as did many other Fabergé employees.

The family connection meant that Alina was able to begin work at a very early age as a full-time drafting apprentice in her father's workshop. She had a natural flair for drawing and a talent for fashioning extremely small details.

One album of Alina's jewellery illustrations has been preserved. After the Russian Revolution, it came to Finland with her nephew Oskar Pihl and was kept for decades in the Helsinki shop of the jeweller A. Tillander, where Pihl worked as a designer. Russian emigrants who engaged in second-hand retail trade often visited Oskar Pihl, and since the illustrations were of no use to him, he sold Aunt Alina's album for a trifling sum to a travelling salesman named Mikael "Mikko" Reppolt, who later resold the drawings. Nowadays Alina's album is in the collections of the New York antiques dealer A La Vieille Russie, which specialises in valuable rarities.

Browsing the album, one soon gets a picture of how skilled Alina was as a jewellery artist. The "garland" style or *style guirlande*, which came into fashion right at the end of the 19th century, stands out in the refined, ethereal, and stylish pieces that populate the album. There are necklaces, bracelets, diadems, and brooches, the majority of which were made of platinum. The dominant gemstone is the diamond.

Alina's daily routine was varied. Just as she was sitting, absorbed in her drawing, at her drafting table, she might be called to attend to a client in the shop downstairs. Alina herself reported that several of Fabergé's female customers were "somewhat difficult" and, if anything, were pampered to a fault. When their precious pearls had to be restrung, they expected the work to be done immediately, while they waited. The owners actually feared the employee might surreptitiously swap them for pearls of lower quality, and for this reason they wished to be on the premises while the work was

*A necklace in the "garland style", the fashion of the first decade of the new century. Designed by Alina Holmström. Platinum and diamonds. From the artist's own design book.*

COURTESY OF A LA VIEILLE RUSSIE, NEW YORK

being done. Alina could not imagine anyone coming up with such a scenario (that the girl stringing the pearls could be a common thief), as she thought well of everyone, and was always eager to serve and to please.

In 1903, Alina married Evgeny Vasilievich Zverzhinsky, who came to work as a clerk in the Holmström workshop after their marriage. He later found a more lucrative position as an insurance agent.

When the House of Fabergé closed down, the situation of Alina and her husband became desperate. They were out of work and soon understood that the two of them had no chance of obtaining official permission to move to Finland. Zverzhinsky was a Russian citizen, which prevented him from even applying for the right to leave the country. From the mid-1920s, the new Soviet regime actively blocked all personal contacts across its borders.

The Zverzhinskys endured life in Petrograd (from 1924 Leningrad) for some fifteen years. With the arrival of the political thaw of the 1950s, it came to light that Alina and her husband had not found a way of keeping themselves afloat through those hard times. Alina had died of starvation in 1936, while her husband's fate remains unknown to this day.

*Examples of jewels designed by Alina Holmström: bracelets and necklaces. Platinum and diamonds. From Alina Holmström's design book.*
COURTESY OF A LA VIEILLE RUSSIE, NEW YORK CITY

*Jewellery designer Alina Holmström, c. 1905. Alina, the belle of the Holmström family, poses behind her opulent ostrich feather fan, one of the accoutrements of every elegant lady of the epoch.*
FROM THE COLLECTION OF LYDIA PIHL

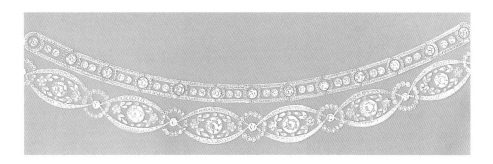

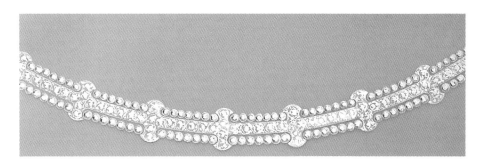

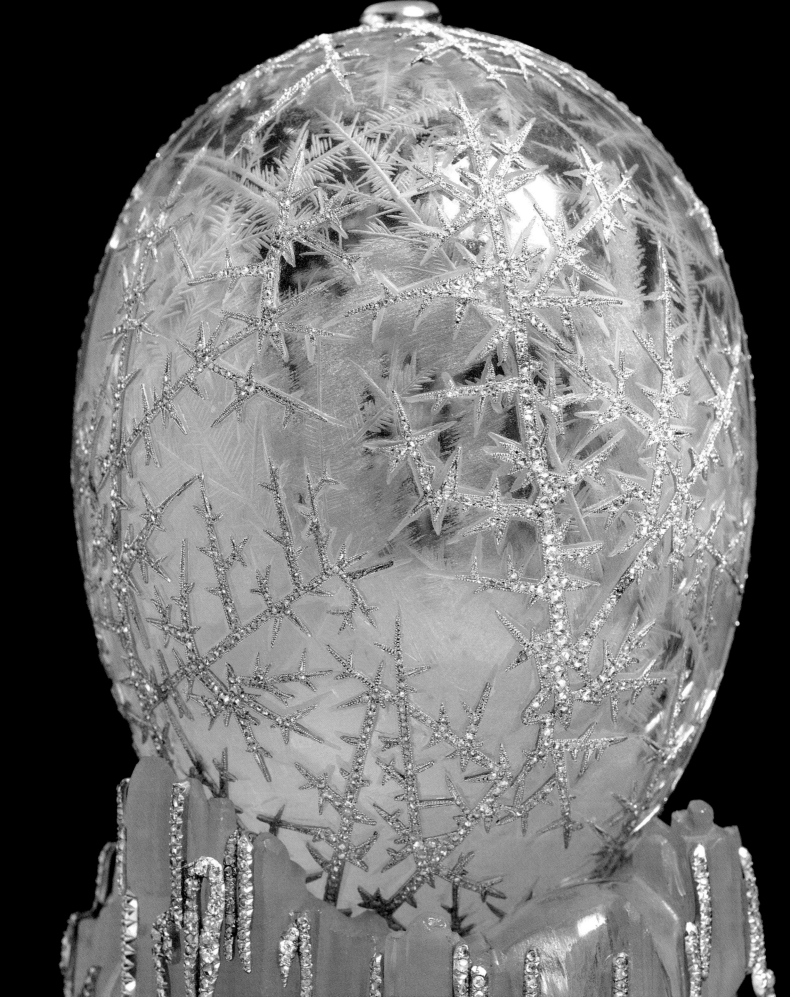

<p style="text-align:center; font-style:italic; font-family:cursive;">Alma Pihl</p>

lma Theresia Pihl (1888–1976) was a prodigiously talented designer who had already made an impressive career for herself by the age of twenty-five.

Alma was born in Moscow. Her mother was Fanny, daughter of the Fabergé jeweller August Holmström, and her father was the master goldsmith Knut Oscar Pihl. (See p. 259) The five Pihl children could thus call on excellent genetic credentials for making a go of the jewellery profession. The two eldest – Alma and her brother Oskar Woldemar – viewed their father's career as a natural choice for themselves as well.

The Pihl children lost their father at a very early age. The young widow Fanny returned to St Petersburg, and there the family lived in the safe environment of their grandparents' large and comfortable timbered villa in the attractive suburb of Shuvalovo. There, at the edge of the city, on the shores of what was known by the locals as "the second lake", the entire family congregated on Sundays (See photograph on page 47).

After attending preparatory school for a few years, Alma was admitted to the famed Annenschule, which Carl Fabergé had also attended. She was a gifted student and received the best possible certificate of graduation in 1906. Her drawing teacher was Eugen Jakobson (1877–1940), who had Swedish roots. Jakobson had graduated from Baron von Stieglitz's Central School of Technical Drawing, and he also worked as an artist for Fabergé. He is known to have given private pattern-drawing lessons to Alma.

Two years after her graduation, at the age of twenty, Alma was hired by her uncle Albert as a draughtsman trainee. It was the practice of the workshop at that time to draw as detailed a picture as possible of every item produced, for archival purposes. The drawings were life-size, and each would be accompanied by precise information about the gems used and the labour costs involved. This task gave the young trainee excellent on-the-job instruction and experience.

Alma quickly learned to calculate production costs and rose to the position of cost accountant in the workshop. In her few free moments, she sketched out her own ideas. When Uncle Albert saw her handiwork, he promptly took the sketches downstairs to the shop, returning triumphantly with news that everyone had thought them quite excellent and they had been ordered for the store's stock.

---

*The Imperial Winter Easter Egg, designed by Alma Pihl,*
*then just 25 years of age, was Emperor Nicholas II's gift to his mother,*
*the Dowager Empress Maria Feodorovna, in April 1913.*
PRIVATE COLLECTION. PHOTO: WARTSKI, LONDON

*Jewellery designer Alma Pihl.*
FROM THE COLLECTION OF LYDIA PIHL

*A frost-flower brooch in gold, platinum-silver, and rose-cut diamonds. This piece designed by Alma Pihl was commissioned by and produced for the Russian-born Swedish oil magnate and art collector Emanuel Nobel, who presented it as a gift to a bridesmaid at a family wedding. Fabergé, Albert Holmström, St. Petersburg, c. 1912.*

PRIVATE COLLECTION. PHOTO BY KATJA HAGELSTAM

*A "garden of frost-flowers" in a frozen window-pane. The artistic inspiration for Alma Pihl's winter jewellery collection.*

PHOTO BY REINO TURUNEN

And so began Alma's career as a jewellery designer. She was barely twenty-one years old and largely self-taught. She had not attended drafting school, nor had she done anything else specifically designed to lead to such a profession.

After two years of work and practice at her drawing table, a red-letter day dawned in young Alma Pihl's life. One January morning in 1911, she received her first independent design assignment. Dr Emanuel Nobel, the head of the family-owned Branobel oil empire and one of Fabergé's best clients, paid an urgent visit to his jeweller on Bolshaya Morskaya. He wanted to order forty small items of jewellery, preferably brooches, to be delivered on an accelerated schedule. The stipulations were that the design of the items should be completely new and that although fine materials were to be used in their production, they could not be costly. If the jewels were removed and if the rest of the item were melted down, the value of the constituent elements should be relatively trifling. The recipients were not to be able to understand the items as being bribes. Alma was being given an opportunity to win her spurs as a designer.

January is generally the coldest month in St Petersburg, and the draughty workshop's windows were covered in ice and hoarfrost. When the sun shone, the effect was dazzling, like a garden of exquisite frozen flowers. Alma's desk was next to one such window, and this sight inspired her to transfer the natural ice crystals into Dr Nobel's brooches. Ideas are sometimes closer to hand than we think! Alma drew six different brooch designs in her sketchbook, all of which had as their subject those sparkling "frost-flowers".[51]

The workshop leapt into action to produce thirty-seven brooches, six or seven of each frost-flower design. Copious numbers of tiny rose-cut diamonds were bead-set into an alloy of platinum and silver. The backs of the brooches and the pins were made of yellow gold. The result was a joy to the eye. Dr Nobel was completely sold, and he purchased exclusive rights to the design concept. After the first thirty-seven brooches, Nobel ordered a whole host of different frost-flower and snowflake jewelled items: necklaces, bracelets, pendants, and miniature eggs. These were presented as gifts to female guests at Nobel company dinner parties, when they were hidden in white linen napkins, or were distributed during large celebrations and family functions, for instance to bridesmaids at Nobel family weddings. They spread all over Europe and to North America, serving in these parts as beautiful reminders of Russia.

The success of Alma Pihl's frost-flower collection is exceptional for many reasons. In the first place, the designer was a young woman and self-taught. She did not fit the Fabergé mould, which demanded of its employees both education and lengthy experience. Furthermore, a female employee as such was a new departure within the company. Alma Pihl's designs also differed stylistically from the Neoclassical-influenced production for which Fabergé was hitherto famous. Alma's style was completely original and individual. Ice and snow motifs had rarely been used before, but the winter themes spoke to both the customer and to the delighted recipients of the gifts. Winter at its most beautiful, biting frosts with a pale sun playing across a field of snow – this was Alma Pihl's *hommage* to the grandeur of the hard northern winter.

The maturing of the idea can be observed in the Holmström workshop albums, and the popularity of the designs resulted in an ever-increasing production. In the early stages, Alma's creative joy practically gushes off the page. She feels she is creating something fresh and new, and obviously enjoys being able to bring her ideas to fruition. By 1915, however, the initial magic has gone, and the hoarfrost images suddenly become stereotypical. Alma grew bored with her theme and wished to develop her stylistic universe in new directions.

*Nikolay Klee (1879–1960), Alma Pihl's husband.*
From The Collection of Lydia Pihl

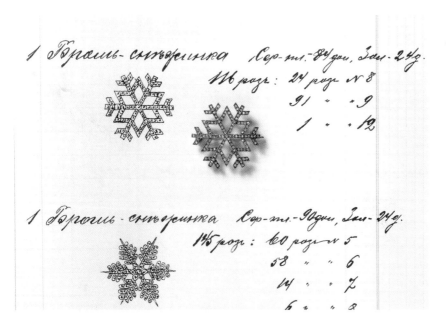

*A jewel and the stock book sketch for it. A frost-flower jewel in gold, platinum-silver, and rose-cut diamonds designed by Alma Pihl. Fabergé, Albert Holmström, St Petersburg, 1913.*
Courtesy of Wartski, London

*A winter-themed pendant designed by Alma Pihl, in gold, platinum-silver, rock crystal, and rose-cut diamonds. Fabergé, Albert Holmström, St Petersburg, 1913.*
PRIVATE COLLECTION. PHOTO BY KATJA HAGELSTAM

*A brooch set with a cushion-shaped aquamarine. Gold, platinum, and rose-cut diamonds, designed by Alma Pihl and made in the Albert Holmström workshop of the House of Fabergé in or around 1913. This piece belonged to Alma Pihl herself, and was her favourite item of jewellery.*
PRIVATE COLLECTION. PHOTO BY KATJA HAGELSTAM

*A snowflake brooch and ice-flower bracelet, both designed by Alma Pihl. Gold, platinum-silver, diamonds, and rock crystal. These items were commissioned by the regular Fabergé patron Emanuel Nobel. Fabergé, Albert Holmström, St Petersburg, c. 1913.*
PRIVATE COLLECTIONS. PHOTO BY KATJA HAGELSTAM

The tercentenary of the Romanov Dynasty in 1913 prompted the organising of large-scale celebrations in both St Petersburg and Moscow. At these events, the Emperor gave hundreds of jewelled gifts to his prominent guests – foreign crowned heads and other dignitaries who had come from around the world to take part in the festivities and to honour the head of the dynasty and his family. The Holmström production drawings also reveal Alma Pihl's role in the design of the tercentary jewellery. Themes were not chosen freely, but rather the forms followed directions handed down by the Cabinet of His Imperial Majesty. They had to have a connection with the Romanovs, and it was also to be metaphorically linked to the ruling family. Alma often spoke of the difficulty of attaching dynastic symbols to jewellery, particularly the double-headed eagle and the Monomakh's Crown, or as Alma somewhat irreverently referred to it, the "leather cap". The skullcap of Monomakh, dating from the 14th century, is made of gold, decorated with liberal filigree work, inlaid with rubies, emeralds, and pearls, and trimmed with sable.

Alma Pihl married in 1912, at the age of twenty-four. In her own words, she was "granted permission" to continue her work even after marriage, as she was "not a particularly skilled wielder of pots and pans in the kitchen".

Alma became acquainted with her future husband, Nikolay Klee (1879–1960), through her two younger brothers, Oskar and Georg. The three young men played tennis together. Nikolay was the son of Commercial Counsellor Wilhelm Klee, who hailed from Sortavala in Karelia, at the northern end of Lake Ladoga. The family had once owned the landmark Hôtel de l'Europe along the Nevsky Prospekt in St Petersburg, where Nikolay was born and grew up. Nikolay had a thorough business education and rose through the ranks to become manager of the St Petersburg office of the Kymi pulp and forest products company (nowadays the multinational pulp & paper giant UPM). Alma and Nikolay's wedding was celebrated in the summer of 1912, and the young couple moved into the Klee family home, where Nikolay's widowed mother lived alone.

The Russian Revolution brought Alma Pihl's promising career to a juddering halt. When Fabergé was forced to close its doors, Alma was left high and dry, without work. She began studying to become a German teacher, not least because as a seminary student she could receive a few more food coupons on her ration card. When the St Petersburg Kymi office was shut down, Nikolay was left to safeguard the company's interests single-handed. In 1919, Alma and Nikolay succeeded in obtaining passports to leave the country, but before they could pack up and go, Nikolay was detained and imprisoned for some time. During his gaol term, his passport expired, and it took until 1921 before a new document was issued.

In June 1921, Alma and Nikolay finally crossed the border into Finland. On July 1st, after two weeks of the mandatory quarantine, they were discharged and their final destination became the Kymi Mill in Kuusankoski, to the north-east of Helsinki. Nikolay was given a position at the Kymi head office, he handled the sales department's German correspondence, and was ultimately promoted to general counsel with rights to sign on behalf of the company. In 1927, Alma found a job as a drawing and calligraphy teacher at the mill complex's Swedish-language coeducational school, and she continued in this position for twenty-four years, until retiring in 1951.

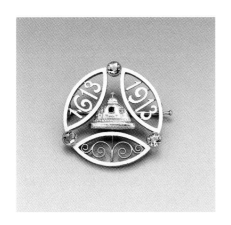

*An Alma Pihl brooch in gold, aquamarines, rubies, and diamonds, for the Tercentenary of the Romanov Dynasty. The central motif here is the "Monomakh's Cap" crown of the Russian autocracy. Fabergé, Albert Holmström, St Petersburg, 1913.*

Courtesy of Hillwood Estate, Museum & Gardens. Estate of Marjorie Merriweather Post, Washington Dc. Photo by E. Owen

◁△ *Renderings of brooches and pendants designed by Alma Pihl for the celebration of the Tercentenary of the Romanov Dynasty in 1913. The images are from Albert Holmström's stock books.*

Courtesy of Wartski, London

Alma never spoke of her design work at Fabergé. This may seem puzzling in our age of exaggerated self-assurance, but to her it was not a sign of mannered modesty, it was more a token of respect towards her former employer. Her work was a confidential matter and it remained so, never to be discussed outside the doors of the atelier.

Most of her students only heard afterwards – and to their great astonishment – who Alma Pihl-Klee really was. To her pupils, she was simply a lovely teacher whose artistry and drawing ability stirred admiration in young minds. They remember her as a warm, considerate, and refined person, whose speech had a soft foreign burr resulting from her years in Russia. They have described Alma in interviews as a small lady with sharp, peppercorn eyes, who was always friendly and good-natured. She gave her students the opportunity to create masterworks, but was also critical if they did not achieve their goals. While teaching, she waved her pen like a magic wand, adding a line here and a line there, miraculously changing their drawings into little works of art. With those strokes of the pen she breathed life into their work, creating shadows, tone, and depth. Alma was their most inspirational instructor. Everyone who remembers her is profoundly sorry that she never came to know how much her art was valued by posterity.

The albums from Albert Holmström's workshop (see p. 136) are an excellent source for the study of Alma's creations. They are liberally sprinkled with drawings of jewellery designed by her. Time and again in Alma Pihl's drawings, one's eye is drawn to the dynamism that marked her work. She was truly a child of her era, a product of the new century, who lived in an age when refreshing breezes were blowing through the arts and crafts. These fresh currents included Art Nouveau, Art Deco, and Modernism. As a jewellery designer, Alma Pihl was a pioneer in so many ways. Her drawings and her ideas could have easily been stamped twenty years later than they were. We can only guess what her work would have looked like had she been able to continue into maturity and middle age.

*The shape of things to come? A gem-set brooch in gold and platinum. The pierced frame is set with calibré-cut diamonds, rubies, blue and pink sapphires, emeralds, topazes, and green demantoid garnets to create a floral tapestry or mosaic effect. Design by Alma Pihl. Fabergé, produced in the St Petersburg workshop of Albert Holmström in 1913. Scratched stock number 97142. The brooch is clearly experimenting with the petit-point embroidery technique that was to achieve its full effect in the Imperial Mosaic Egg of 1914.*
Courtesy Of The Woolf Family Collection, London

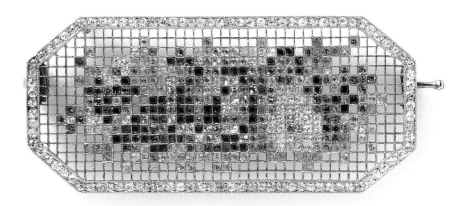

Dr Emanuel Nobel had reserved exclusive rights to Alma Pihl's winter-themed jewellery and decorative objects, but when a request came down directly from the throne, Nobel was happy to make an exception. There is scarcely any doubt that Carl Fabergé himself suggested Alma be afforded the opportunity to design the winter-themed 1913 Imperial Easter Egg. He gave Alma free rein, but pointed out that her creation must be in the shape of an egg and that it must contain a surprise.

This task may have been Alma's greatest challenge ever. The creation of the sketches for such a large custom order, getting the drafts approved, and the further development of the models into their final state, based entirely on her own ideas, was an opportunity to shine that would be granted only exceptionally rarely to a young and inexperienced artist.

This particular egg, the product of the feelings of a romantic young woman, reflects the budding spring and reawakening of nature. Alma considered it important that an Easter gift clearly express the idea of resurrection associated with the time of year. In Northern Europe, Easter falls at a moment when the winter snow and ice are gradually beginning to melt. The light is increasing after a time of darkness of nearly six months, during which the rays of the sun were only to be enjoyed for some six hours a day at best. However, over Easter, the sun often shines from a bright blue and cloudless sky.

The Winter Egg illustrates this time of year superbly. All residents of northern climes have seen the sort of thawing block of ice on which the Winter Egg stands. In March, small brooks released from winter's grip begin to ripple and burble, carving the sides of nature's ice sculptures. Droplets of water glisten like diamonds in the sun. The jewellers believed that Siberian rock crystal was the right material to depict ice. Cut as fine as can be, this lovely stone is almost as transparent as window glass; when engraved or etched, it becomes white.

At the end of April, when the northern sun has melted away the snow, a magical carpet of anemones appears in the forests and hollows. Few flowers are awaited so fervently in the north as are the white wood anemones. There is something heroic about these unassuming plants as they thrust up through the layers of dead leaves, after weathering the brutal winter cold. Alma's idea for the egg's surprise was totally charming: a small platinum wicker basket of these harbingers of spring, each made from a single piece of white quartz. The stamens are gold and the green centres demantoid garnets. The leaves are of green Siberian nephrite. The flowers are pressed into moss made of an almost brown alloy of gold. The hinged egg is crowned by a polished round moonstone, inscribed on the reverse with the year, 1913.

Although we do not have any written account of the Dowager Empress's reaction, we can be confident that she was delighted to receive her Easter gift. The Winter Egg also undoubtedly greatly pleased Emperor Nicholas II himself, since he was both deeply religious and a person who loved the great outdoors. We do not know whether Their Imperial Majesties' appreciation ever reached the ears of the young designer, the skilled jewellers, the goldsmiths, or the gem polishers who together had created this incredible object. It is possible that this did happen, for Alma was also asked to design an Imperial Easter Egg the next year, this time for Empress Alexandra.

*The Winter Egg itself is of platinum, rock crystal, 1,308 rose-cut and 360 brilliant diamonds, and a cabochon moonstone. The base is a block of melting ice, in rock crystal with rose-cut diamonds set in platinum "icicles". The trelliswork basket surprise is again in diamond-set platinum, with the wood anemones in carved white quartz, gold, nephrite, and demantoid garnets. "Fabergé, 1913" is engraved on the base of the basket. The basket alone is decorated with 1,378 rose-cut diamonds. Fabergé, Albert Holmström, designer Alma Pihl. The lapidary work on the egg was by Peter Mikhailovich Kremlev. Height (with base) 14.2 cm; height of egg 10.2 cm; basket 8.2cm. The price on the Fabergé invoice was 24,600 roubles.*
PRIVATE COLLECTION. PHOTO BY WARTSKI, LONDON

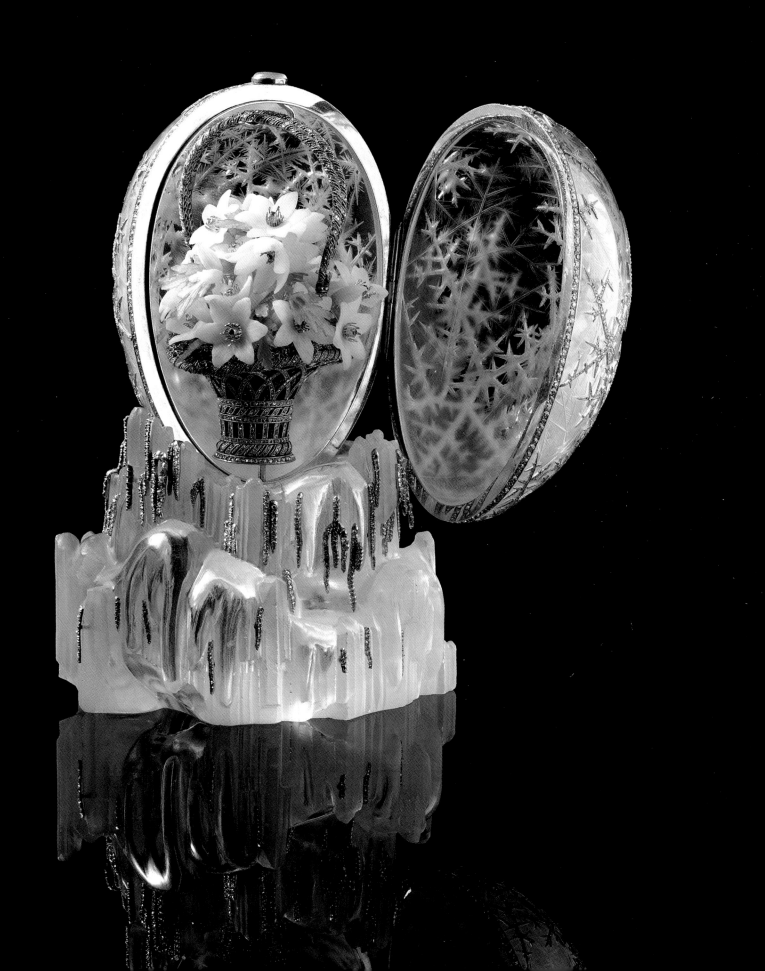

The success of the Winter Egg prompted Fabergé to give Alma Pihl the opportunity to present a design for the following year's Imperial Easter gift. In 1914, the assignment was Nicholas II's gift to his spouse, Alexandra Feodorovna.

Alma has herself noted that she weighed and considered options for a long time until the ultimate idea suddenly came to her. In her own words, this is how she got the notion for the design of the Mosaic Egg: "It was a winter night in 1913, and the family had sat down to spend the evening in the lamplight. I was lost in my own thoughts and mother-in-law was working on her colourful cross-stitch embroidery. When the light fell on the decorative sewing, the idea came to me in a flash: an Easter egg patterned with petit-point embroidery!"

Carl Fabergé approved the idea, and Uncle Albert began the technical execution in conjunction with his skilled artisans. Two small brooches were produced in the workshop in 1913, one round and one rectangular. (See illustration on page 157). These served as prototypes, as the craftsmen were exploring how to make the embroidery look realistic when it was constructed of metal

and gemstones. Fabergé's workshops planned the preparation of their large custom orders very meticulously indeed: the patrons would expect nothing less.

Alma Pihl's Mosaic Egg is tightly connected to Empress Alexandra Feodorovna, as she was known to enjoy relaxing with her embroidery. The egg itself is constructed of a platinum mesh, which corresponds to the metallic mock leno canvas used in petit point tapestry work. The framework is made of gold. The flower and foliage work in the six central panels is formed out of small, closely set, calibrated gemstones: red rubies, blue sapphires, green emeralds and garnets, yellow citrines, all of which are square cut, together with rose-cut diamonds, small pearls, and enamel. The egg is crowned with a round-cut moonstone, inscribed with the Empress's Cyrillic monogram.

As usual, a surprise awaits inside: on a stand, a small, oval medallion, the front face of which features the profiles of the children of Nicholas II and Alexandra – Olga, Tatiana, Maria, Anastasia, and Alexey – painted in pale sepia grisaille enamel. On the reverse side is a flower basket, also in pale sepia, edged with ornamentation formed from the names of the five children.

*The 1914 Imperial Mosaic Egg was Emperor Nicholas II's Easter gift to his wife Alexandra Feodorovna. Yellow gold, platinum, brilliant and rose-cut diamonds, rubies, emeralds, citrines, sapphires, green demantoid garnets, half-pearls, a cabochon moonstone, and opaque white and opaque pink enamel. The surprise is in gold, pearls, and translucent green and white opaque enamel, set with diamonds, with at its centre an oval plaque showing the five Imperial children in profile. Fabergé, Albert Holmström, designer Alma Pihl. The "G. Fabergé, 1914" engraving on the surprise is presumably an error. Height 9.2 cm. Height of miniature surprise 7.9 cm. Price: 28,300 roubles, making it one of the costliest of all the Imperial Easter Eggs produced by Fabergé.*

ROYAL COLLECTION TRUST / © HER MAJESTY QUEEN ELIZABETH II

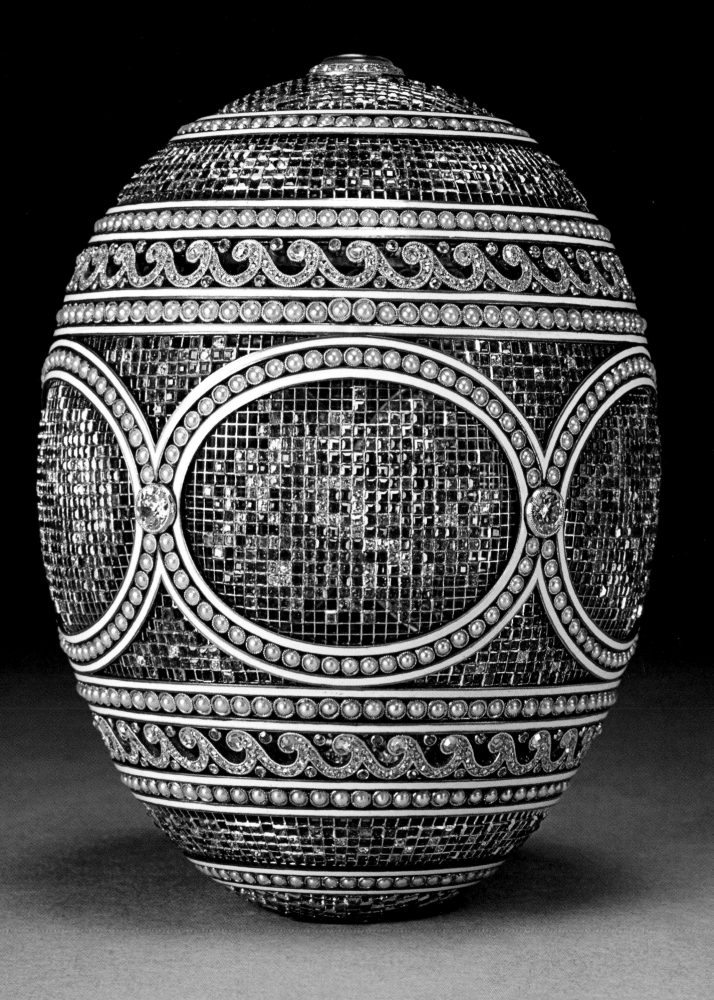

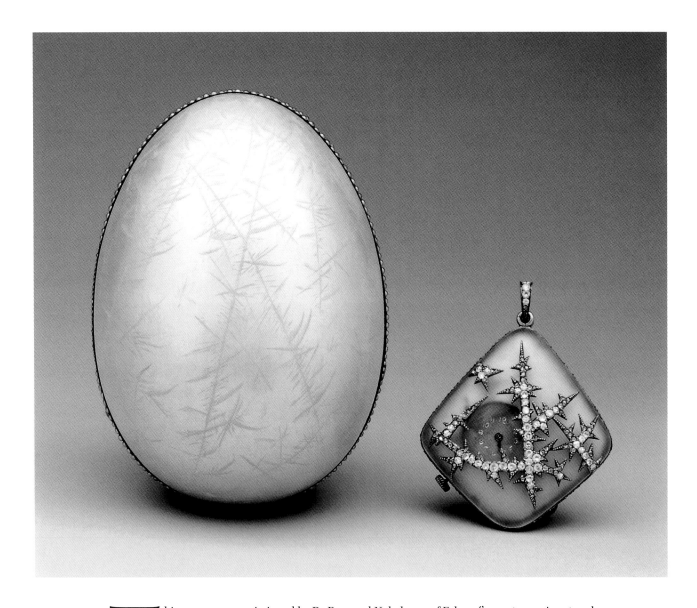

This egg was commissioned by Dr Emanuel Nobel, one of Fabergé's most prominent and loyal customers. It was most probably an Easter gift in 1914 to Emanuel's stepmother Edla Nobel, née Collin (1848–1921), with whom he was very close.[52]

In the stock book that is part of the Albert Holmström archive kept at Wartski, there is a sketch of the platinum pendant watch surprise. The drawing is dated March 6th, 1914.

*The Nobel Ice Egg (or "Snowflake Egg") is of platinum, silver, transparent and opaque white enamel layered over engraved frost crystals, and seed pearls, while the surprise of a tiny watch pendant is in platinum, rock crystal, and rose-cut diamond "frost crystals". Fabergé, Albert Holmström, designed by Alma Pihl. The egg is 10.2 cm in height, the clock 5 cm. Scratched stock numbers 23865 (egg) and 9829(0) (the clock).*

COURTESY OF THE MCFERRIN COLLECTION, HOUSTON, TEXAS

*Their Imperial Highnesses, Grand Duchesses Olga (left) and Tatiana Nikolaevna in a formal portrait from 1913, wearing necklaces designed by Alma Pihl. The jewels were produced in Albert Holmström's workshop.*

GETTY IMAGES. POPPER PHOTO

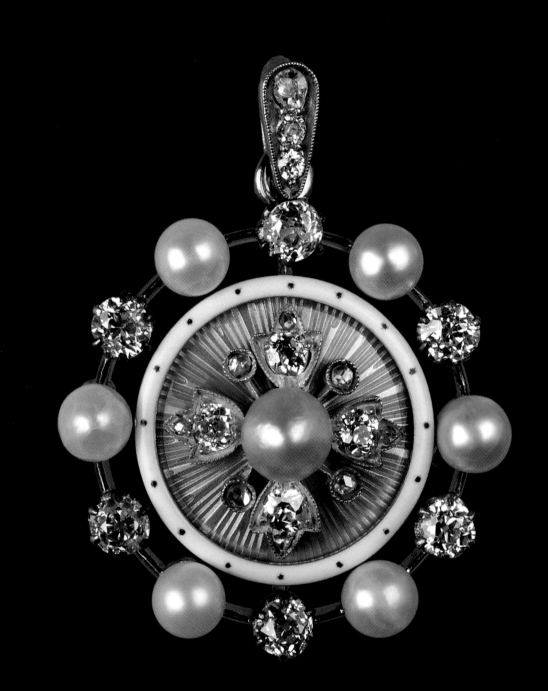

# August Hollming

ugust Fredrik Hollming (1854–1913) was born in Loppi, a rural municipality in Southern Finland known mainly for its superior potato crops (owing to the sandy soil in the area).

August's father Anders was supervisor of a sawmill. He and his wife Brita Katarina had a total of seven children.

Three of the Hollming sons trained as goldsmiths; August and his two brothers Anders (b. 1852) and Axel (b. 1857). August began his training in 1870 at the age of 16. He found his tutor in the Helsinki-based master gold- and silversmith Carl Fridolf Ekholm. Ekholm's workshop produced assorted luxury items, and tea- and coffee services in both precious and non-precious metals. The master worked with four journeymen and the same number of apprentices. August stayed with Ekholm for the entire length of his apprenticeship, six years in all.

Having qualified as journeymen, the three Hollming boys decided to try their luck as goldsmiths in St Petersburg. The life and career of August is well documented, but there is only scanty information to be had on his brothers Anders and Axel. Anders Hollming worked as a goldsmith in the metropolis for some ten years, but his place of work is not known. In 1882, he resettled in the Grand Duchy of Finland, along with his wife and two daughters. On his return, he worked as a goldsmith in the town of Hämeenlinna. The younger brother Axel met a tragic death at the age of just 37. He was attacked and killed by thieves at the railway station in Pargolovo on the outskirts of St Petersburg. Details of this sad incident are not known, nor anything of his family, but his young widow Xenia, the daughter of a Russian tailor, and their four small children were hardly left to their fate alone.

## AUGUST HOLLMING IN ST PETERSBURG

August Hollming was twenty-two on his arrival in St Petersburg in 1876. On April 23rd, his name was entered with the description "goldworker" in the parish register of the Finnish Lutheran Church of St Mary. It is likely that not long after his arrival in St Petersburg he came to work for August Holmström. The Holmström workshop was at the time Fabergé's "academy" or "hatchery" for talented journeymen. It was on Holmström's recommendation that young craftsmen in his workshop were sought out for demanding tasks.

*A circular pendant/brooch in gold, pearls, diamonds, and white opaque and pink guilloché enamel. Fabergé, August Hollming, St Petersburg, made between 1908 and 1913. Scratched stock number 81949. Diameter 2.8 cm.*

©THE FABERGÉ MUSEUM, ST PETERSBURG. THE LINK OF TIMES CULTURAL AND HISTORICAL FOUNDATION

Hollming qualified as a master goldsmith in 1879 and set up his own workshop in the backyard of No. 35, Kazanskaya. At the back of the shop there was space for the home of the master and his growing family. Kazanskaya was a street with a concentration of small workshops in the gold- and silversmith trade. The majority of these ateliers were so-called *odinochky*, in other words small shops owned by a master working on his own with one or two apprentices, serving as sub-contractors for larger manufacturers or retailers.

Each of these small workshops sought to have its own niche, whether it be basic gold work, chasing and repoussé, guilloché work, enamelling, setting of precious stones, chainwork, repairs, or stone cutting.[53] It is believed that Hollming, during his first decade as an independent master, was given commissions by several retailers, but the details are not known.

In 1885, Antti Nevalainen opened his workshop at the same address as Hollming. From 1889, Gabriel Nykänen had his atelier at No. 39, Kazanskaya, just a few steps away. The St Petersburg Assay Office, which provided assaying and hallmarking of precious items in gold, silver and platinum, as required by the Hallmarking Law of the Russian Empire, was conveniently located in the same street at No. 28.

Hollming worked at his Kazanskaya premises for a good twenty-two years. His collaboration with Fabergé, initially as an occasional sub-contractor, may well have begun shortly after he qualified as a master goldsmith in 1879. By the middle of the 1890s, he signed a contract to work solely for Carl Fabergé. Thereafter his entire production was made on order for the House of Fabergé. With the security that this arrangement provided, Hollming was able to increase his staff considerably to assist him in his work.

In 1901, when Fabergé's new headquarters at 24, Bolshaya Morskaya were ready to be taken into service, Hollming was offered the premises on the first floor of the workshop wing. He gave up his lease at Kazanskaya. His private home was after this at No. 1, Demidov Pereulok, today Grivkova Pereulok, just a few blocks away from the House of Fabergé.

*Master Goldsmith*
*August Hollming, c. 1880*
Courtesy of The Hollming Family

*Master Goldsmith August Fredrik Hollming*
*and Erika Gustava Abrahamsson were*
*married in St Petersburg in 1884.*
Courtesy of August Hollming's Family

## Family life

August Hollming had encountered his future wife soon after his arrival in St Petersburg. The two of them presumably met at the Finnish church. The two Evangelical Lutheran congregations of St Mary and St Catherine were gathering places for the young migrants from the Grand Duchy. The clergymen did their utmost to see to that the youngsters came to Sunday service each week. August's wife was Erika Gustava Abrahamsson (1856–1909), a crofter's daughter from Salo in Western Finland. She, too, had come to the metropolis with the aim of finding a brighter future than the one she could have hoped for at home. The couple married in 1876. The groom was twenty-two, his bride was twenty.

The Hollmings' first child, Lydia, born in 1877, died in infancy. Three sons followed: August Väinö (b. 1885), Arvid Alexander (b. 1887) and Yrjö Anders (b. 1890). According to the unspoken traditions of the trade, the eldest son Väinö was destined to follow in his father's footsteps, to train to be a goldsmith with the aim of taking over the family workshop. Son number two, Arvid, had a natural gift for business,

*The three sons of August Hollming. From left to right: Yrjö (b. 1890), Arvid (b. 1887), and Väinö (b. 1885). Väinö Hollming trained under his father with the aim of succeeding him as workmaster for Fabergé.*

*Photograph from St Petersburg, c. 1894*

Courtesy of The Hollming Family

and he became a successful builder and developer. The youngest son Yrjö sadly never found himself a calling. He is referred to as "the black sheep of the family" by later generations.

August Hollming was gradually able to craft a very comfortable standard of living for his family. He bought a plot of land in the popular resort of Terijoki on the Karelian Isthmus (nowadays Zelenogorsk in the Russian Federation). A spacious wooden house in two floors was soon built on the site. This was where the Hollming family could enjoy their leisure time, and it was also where Hollming himself preferred to live after being widowed in 1909.

During his active years, Hollming also found time for social activities.[54] One thing close to his heart was his work as a board member of the Finnish Temperance Society.

◁ *A brooch in gold, with settings in platinum-silver, diamonds, and a large central cushion-shaped Kashmir sapphire. Fabergé, August Hollming, St Petersburg, made between 1899 and 1908.*
COURTESY OF THE NOBEL FAMILY. PHOTO BY HASSE PETTERSSON

◁◁ *A moonstone and diamond pin, in gold, set with two cabochon moonstones with a diamond-set flower spray in the centre, Fabergé, August Hollming, St Petersburg, assay-mark 1899–1908. This piece was a gift from Empress Alexandra Feodorovna (née Princess Alix von Hessen-Darmstadt) to Grand Duchess Eleonore von Hessen und bei Rein, who became the second wife of Alexandra's older brother, Grand Duke Ernest Louis.*
COURTESY OF SOTHEBY'S

◁ *A pair of Imperial gold and cabochon sapphire cufflinks, each with the design of the double-headed eagle of the House of Romanov. Fabergé, August Hollming, St Petersburg, made between 1908 and 1913. Height 2.2 cm.*
COURTESY OF SOTHEBY'S

▷ *A pendant in gold, platinum, diamonds, and pearls. Fabergé, August Hollming, St Petersburg, c. 1907. Scratched stock number 78858. Length 8 cm. The pendant can also be worn as a brooch. According to the sales ledgers for Fabergé's London branch, the piece was sold in December 1907 to a Mr A. Parker, for £29.00.*
COURTESY OF BUKOWSKIS, HELSINKI

▷ *A brooch in gold and diamonds, formed as a swirling floral stem, with the flower bloom set with three brilliant-cut diamonds. Fabergé, August Hollming, St Petersburg, made between 1899 and 1908. Width 2.9 cm.*
COURTESY OF JOHN ATZBACH, REDMOND, WASHINGTON

◁ *Six decorative buttons in their original velvet-lined fitted holly wood presentation case. Gold and translucent turquoise guilloché enamel. Fabergé, August Hollming, St Petersburg, made between 1899 and 1908. Scratched stock number 68916. Button diameter 16 mm.*
COURTESY OF UPPSALA AUKTIONSKAMMARE, UPPSALA, SWEDEN

◁ *A bracelet in gold, moss agate, and rose-cut diamonds, joined with platinum curb link chains. Fabergé, August Hollming, St Petersburg, made between 1903 and 1913.*
COURTESY OF WARTSKI, LONDON

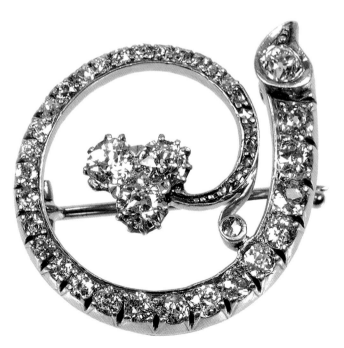

## Hollming's Production

Hollming was unquestionably a skilled goldsmith and jeweller. During the period from 1901 to his death in 1913, he worked with a staff of more than fifty craftsmen, a number close to that of the ateliers of both Wigström and Holmström. The workshop's output was consequently as staggering in quantity as that of his colleagues. His production consisted of a broad array of gold jewellery with precious stones and enamel, as well as gold boxes of many shapes and sizes, and an impressive collection of cigarette cases in gold and silver gilt.

Cigarette smoking was much in vogue during Fabergé's time, making the cigarette case an object of fashion – and soon enough a jeweller's bestseller, too. The invention of the cigarette lighter around 1911 changed the design of the cases, as the former tinder cords and match compartments were no longer required. The new generation of cases could be sleeker and lighter. Being an object of function, it was made to be used and not just to be admired. The clasps, the hinges, the adornments were designed with the owner's comfort in mind. Given the tremendous popularity of these objects, the designers at Fabergé enjoyed considerable scope for playing with almost innumerable permutations of both form and decoration.

*August Hollming's workshop in the Fabergé building at No. 24, Bolshaya Morskaya, in 1903. Hollming's workshop was on the first floor, directly below that of head workmaster Henrik Wigström. Hjalmar Armfelt moved into the premises in 1916. August Hollming is standing just left of centre in the middle ground of the photograph.*
Courtesy of The Alexander Fersman Mineralogical Museum in Moscow, Under The Russian Academy of Sciences.

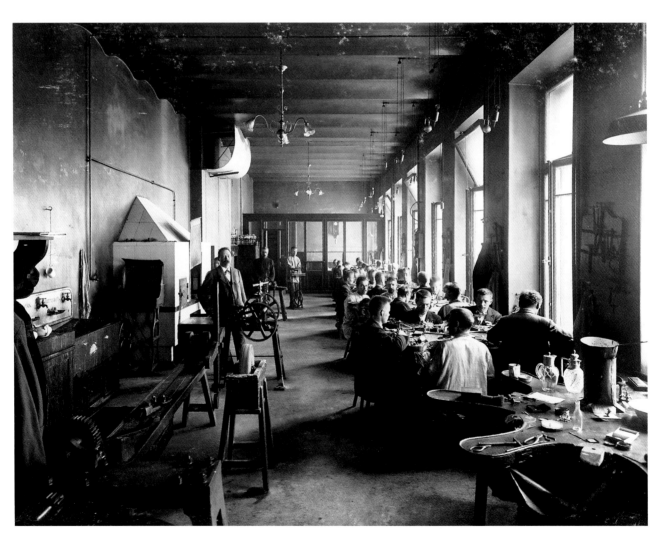

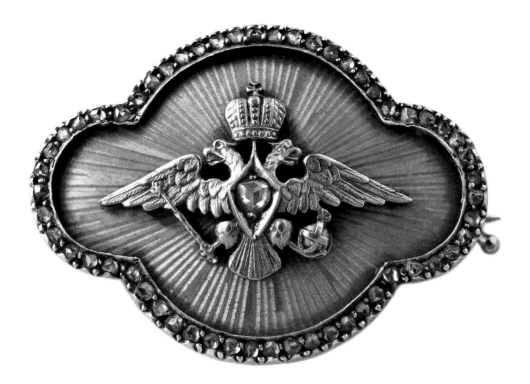

*An Imperial presentation brooch decorated with the Romanov double-headed eagle. Gold (56 zolotnik), diamonds, and guilloché enamel. Fabergé, August Hollming, St Petersburg, made between 1899 and 1903. Width 3 cm, height 2.2 cm. The original presentation case has survived, in red Morocco leather, with a gilded double-headed eagle on the lid. The brooch was presented in 1909 to the merchant Hioppi Peussa on the island of Koivisto (Björkö) in the Gulf of Finland. Peussa, a prominent figure in his community of some 6,000 inhabitants, was rewarded by the sovereign for 30 years of meritorious service.*
Private Collection. Photo Katja Hagelstam

Cigarette cases as Imperial presentation gifts were produced in huge numbers at Hollming's workshop. The majority featured the crowned Imperial double-headed eagle in a variety of designs from various historical periods.

Hollming's speciality in this department was enamelled cases. They were generally made of gold or silver gilt with elaborate guilloché patterns covering the entire surface. Silver was often used because *en plein* enamelling was technically more suitable on silver, and gilding applied because the guilloché pattern underneath the translucent layers of enamel appeared to better advantage with a gold surface.

An interesting decorative technique often seen in cases bearing the Hollming maker's marks was the *samorodok,* or gold nugget finish. The effect was obtained by bringing the metal plate almost to its melting point and then removing it quickly from the furnace. The sudden cooling shrank the plate and gave it the crumpled appearance of gold in its natural state. An example (by Gabriel Nykänen) can be seen on page 185.

Most of the jewellery made at Hollming's was specially designed to be sold in Fabergé's salesroom. Hollming did not have his own in-house designers as the Holmströms did. Designs for his production were provided by Fabergé's design ateliers, from 1895 headed by Fabergé's chief designer Franz Birbaum.

A good part of the jewellery production consisted of commissions from the Cabinet of His Imperial Majesty. These were usually small items of gold jewellery in a variety of forms: brooches, bracelets, cufflinks, and tie pins, set with Imperial emblems and small precious stones.

Hollming also produced a huge number of miniature eggs for Fabergé. These were in high demand, and literally thousands of them would be sold during Holy Week at Easter.

# *Väinö Hollming*

*Master Goldsmith
Väinö Hollming
(1885–1934)*
COURTESY OF THE
HOLLMING FAMILY

Having completed school at the age of 15, August Väinö Hollming (1885–1934) began his apprenticeship in his father August's workshop. After receiving his master's certificate in 1905 or 1906, Väinö was qualified to take over part of the responsibilities of the workshop. From 1909 onwards, August Hollming (now a widower) periodically took time off at his summer house in Terijoki, leaving the workshop in the care of Väinö and his indispensable Finnish-born journeyman Otto Hanhinen.

On August Hollming's passing on March 19th, 1913, Fabergé chose not to renew his contract with the Hollming workshop. It was obvious that the workshop was not the same with the old generation gone. Väinö Hollming therefore had to leave the premises at Bolshaya Morskaya. He set up a new atelier at No. 3, Gorokhovaya, a stone's throw from the Fabergé house, working there until 1917. In 1918, he is listed in the address book *Ves Peterburg* (All Petersburg) at No. 97, Ekaterininsky Kanal, still with the title 'master goldsmith'. Details about his work and his production in the new location have not survived.

Väinö Hollming was a keen yachtsman and himself the owner of a sailing boat. In 1905, he became a founding member and the treasurer of the Sestroretsk Yacht Club, with its clubhouse close to the estuary of the small Sestroretsk

*A jewelled lady's fob watch and brooch in Art Nouveau style, with a mistletoe motif. Gold, rose diamonds, pearls, and oyster guilloché enamel on a sunburst ground. Fabergé, August Hollming, St Petersburg, made between 1899 and 1908. Scratched stock number 73914. Height 6 cm. The watch is engraved inside the case: "Hy Moser & Cie, N14055". H. Moser & Cie supplied the majority of the movements used by Fabergé in his clocks and watches.*
COURTESY OF THE WOOLF FAMILY COLLECTION, LONDON

River, which flows into the Gulf of Finland. Members of the yacht club were successful businessmen, industrialists, and shipbrokers, so creating a helpful network for a goldsmith.

By 1921, Väinö Hollming was settled in Helsinki. To support himself, he established a goldsmith's firm in partnership with his peer Albert Holmström. The firm specialised in restorations and repairs of jewellery. The business was wound up in 1925, following the untimely death of Holmström. Väinö Hollming did not continue the operation on his own.

In 1925, Väinö Hollming married Milda Malmlund (1891–1931). It was both Milda's and Väinö's second marriage.[55] According to the bride's family, the newly-weds led a life of luxury, on borrowed money. An opulent three-storey summer residence was built on an island in the Turku Archipelago in Western Finland, and the couple entertained lavishly. Milda Hollming died of cancer in 1931, and Väinö himself passed on in 1934, tragically by his own hand in order to avoid the shame of looming bankruptcy.

In the summer of 1914, on the eve of the outbreak of the First World War, the Dowager Empress Maria Feodorovna was visiting her older sister Queen Alexandra in England. When hostilities were declared, Maria Feodorovna was prevented from returning by train to St Petersburg via Germany, which was the shortest route to the Russian capital. She therefore had to take a lengthy detour, some eleven hundred miles (nearly 1,800 km), through Denmark and Sweden, all the way up to Haparanda-Tornio, the twin towns at the border between Sweden and the Grand Duchy of Finland.

Word of Dowager Empress's enforced change of route was swiftly wired to the head office of the Finnish Railways Board. The Director General, Anders Ahonen, decided without hesitation that the Imperial Coaches, not used since the reign of Alexander II, were to be restored and sent directly to Tornio to meet the sovereign.

The young engineer Axel von Weissenberg was appointed to supervise the project. He kept a diary (still preserved in the family), in which the restoration work can be followed in detail.

For three days and nights, while the Empress's train was steaming northwards, the Imperial Salon, Dining Car, and Sleeping Cars were meticulously restored. An army of workers and craftsmen were delegated to the carrying out of this herculean task: a cleaning patrol, carpenters, painters, upholsterers, and railwaymen.

When the train arrived in Tornio, the Imperial Coaches were in a perfect state of readiness to receive their royal passenger, who was held in high esteem in Finland.

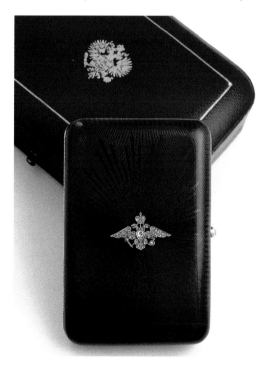

*This handsome cigarette case was a gift from the Dowager Empress Maria Feodorovna to one Anders Ahonen, then Director General of the Railways Board of the Grand Duchy of Finland. Gilt silver, rose-cut diamonds, and red guilloché enamel. Fabergé, August Hollming, St Petersburg. The case was made in 1911, a few years ahead of its presentation date in 1914 (information by Anna and Vincent Palmade). Scratched stock number 3102. Height 9 cm, width 6 cm.*

Courtesy of The Finnish Railway Museum, Hyvinkää, Finland. Photo by Katja Hagelstam

At the last moment, Axel von Weissenberg jumped off the train to pick a large bouquet of flowers for the Empress's salon. All he found growing on the railway embankment was willowherb (*Epilobium*) and various grasses; in other words, common or garden weeds. But the chivalrous young man figured a bouquet, regardless of what it contained, would be appreciated by Her Imperial Majesty. And so it was.

In gratitude for the wonderful arrangements, the men in charge of the work were presented with fine gifts. Ahonen received an elegant cigarette case in red guilloché enamel, decorated with an Imperial double-headed eagle in diamonds. The head of the railway workshops, Bengt Antell, was given a gold pocket watch by Buhré, likewise decorated with an Imperial eagle and fitted with a gold chain. Axel von Weissenberg received an identical pocket watch and the Order of Saint Anne, 3rd Class.

The happiest of all recipients of these generous gifts was Matti Taimio, the train's conductor. As there was no platform at the small station of Tornio, he had spontaneously grabbed the Dowager Empress in his arms and hoisted her onto the train! Weissenberg describes the incident in his diary: "In gratitude for his alert action, the Empress gave Conductor Taimio a gold fob watch, with which he was overjoyed. He could not stop debating and discussing what text was suitable to engrave on the watch."

All the thank-you gifts from HIM Maria Feodorovna have been preserved in the families of the recipients. Ahonen's cigarette case was recently purchased by the Railway Museum in Hyvinkää, Finland.

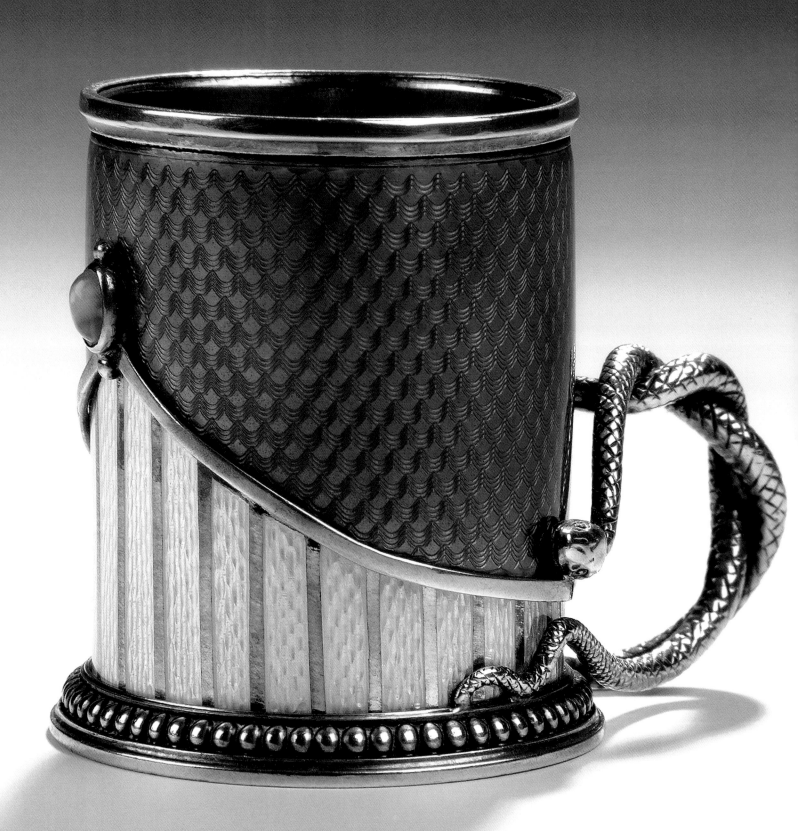

# Antti Nevalainen

ntti Nevalainen (1858–1933) was born in Pielisjärvi in Finland's Northern Ka-
relia. Both his parents – his father Juhani Nevalainen, a lodging farm labourer,
and his mother Margareta Valtonen – had their roots deep in the soil of the
same region.

As did so many other youngsters in these remote, rather deprived areas,
Antti realised he had to leave home to carve himself any kind of future. As for
so many others, St Petersburg was Antti's choice of destination. At the age of
16, in August 1874, he arrived in the great metropolis. Antti's name was soon listed in the St Mary's
parish register as a "goldworker", indicating that he had succeeded in finding apprenticeship with
a master goldsmith. His place of training was August Holmström's workshop, where he stayed until
he had become a journeyman.

In 1885, Antti qualified as a master goldsmith. Prior to obtaining his master's certificate he
had had seven years of apprenticeship and four more years as a journeyman. His dream was now
to establish himself as a self-employed craftsman. He found suitable rooms for his workshop in the
spacious backyard of No. 35, Kazanskaya. As was mentioned in the chapter on August Hollming,
Nevalainen therefore became the immediate neighbour of his fellow-countryman. The two of them
worked in adjacent spaces until 1901, when Hollming moved into Fabergé's workshop wing on
Bolshaya Morskaya.

It did not take long before Antti Nevalainen was welcomed into Fabergé's string of sub-con-
tracting master goldsmiths. Although the precise date when this took place is unknown, the
hook-up must have begun around the year 1890. Towards the end of the decade, Nevalainen was
assigned so much work that he needed an accomplished "deputy". He found excellent help in the
journeyman Hjalmar Armfelt, who worked with him for seven years, between 1897 and 1904. It is
assumed Nevalainen at the time employed c. 15 craftsmen, including a few apprentices.

Nevalainen turned out to be one of Faberge's most prolific producers of small-scale decorative
and utilitarian items made in gold, gilt silver, and silver, most often with guilloché enamel in a wide
palette of colours. There are often unusual combinations of materials in his work, such as silver with
faience, hardwood, and even polished granite, seldom used in art pieces or small functional objects.

*A parcel-gilt charka (vodka or tot cup), simulating a glass sitting in a glass-holder, enamelled*
*in blue over a waved guilloché ground, with the lower section in white opaque enamel. The*
*handle is of two entwined snakes, and there is a single cabochon moonstone decoration. Fabergé,*
*Antti Nevalainen, St Petersburg, c. 1903. Scratched stock number 7114. Height 4.1 cm.*
COURTESY OF COLLECTION MIRABAUD

*Master Goldsmith
Antti Nevalainen.*
COURTESY OF THE
NEVALAINEN FAMILY

*A kovsh in silver and translucent purple enamel over a guilloché ground, with a silver coin from 1747 (Empress Elizabeth of Russia) set in the handle. Fabergé, Antti Nevalainen, St Petersburg, made between 1899 and 1908. Scratched stock number 8255. Emperor Nicholas II acquired this small drinking vessel from the Fabergé store (for 55 roubles) as a prize to be awarded at a rowing competition held in Reval (now Tallinn, Estonia) in July 1902. Length 10 cm.*
COURTESY OF COLLECTION MIRABAUD

*A silver kovsh, with a silver coin from 1779 (bust of Empress Catherine II) set in the handle. Fabergé, Antti Nevalainen, St Petersburg, made between 1899 and 1908. Scratched stock number 5691. Length 11.5 cm.*
COURTESY OF COLLECTION MIRABAUD

*A kovsh in gilt silver and translucent pale blue enamel over a guilloché ground, with the handle set with a silver coin from 1747 (Empress Elizabeth). Fabergé, Antti Nevalainen, St Petersburg, made between 1899 and 1908. Scratched stock number 8255, the same as in the kovsh above. Emperor Nicholas II also acquired this drinking vessel (again, for 55 roubles) as a prize to be awarded at the above July 1902 rowing competition. It bears a later inscription: "5.VI.05. Ludwig Graf zu Pappenheim". Length 10.3 cm.*
COURTESY OF COLLECTION MIRABAUD

Nevalainen's bravura line was in small *kovshes, charkas,* and tankards in gold or gilt silver. Sometimes, to add to the richness of the object, an old silver or gold coin was set in the handle. These drinking vessels were excellent gift items, and they sold very well indeed, at least if we are to judge by the number of them still found in collections and auction catalogues. Other sell-out numbers included small bowls, tea-glass holders, and above all photograph frames, which Nevalainen produced for Fabergé in colossal quantities.

Decorative salt cellars were also in Nevalainen's production assortment. The bread and salt ceremony of welcome (Хлеб-Соль in Russian) was and still is a venerable Russian tradition, making salt cellars of all shapes and sizes a popular gift item. Bread and salt were given to newly-weds on establishing their first home, or by a host to respected guests as a display of hospitality, appreciation, and recognition. Hjalmar Armfelt relates in his reminiscences how deeply rooted and lovely the tradition was. The apprentices and journeymen greeted Armfelt with bread and salt on his first day as the new owner of Viktor Aarne's former workshop. (See p. 220)

Nevalainen was married in St Petersburg in 1884 to the Finnish-born Maria Karolina Liljerot (1860–1936). They had five children. Their son Arvid Nevalainen (1897–1963) became a watchmaker and opened a shop of his own in the fashionable resort town of Terijoki (today Zelonogorsk), at that time still part of Finland.

It is not known for how long Antti Nevalainen remained in the service of Fabergé. Neither parish records of the Finnish Lutheran Church of St Mary nor address registers indicate any changes in the master's career or life. But Anna and Vincent Palmade, who have done extensive research on the marking system of Fabergé, observed that there seem to be no objects signed by Nevalainen after the year 1910. Whether this means that the master resigned around that year is yet to be found out. What, however, is known is that Antti Nevalainen and his family relocated to Terijoki following the Russian Revolution, and it became their final resting place.

*A spherical gilt silver and translucent blue-grey guilloché enamel kovsh on ball feet. Fabergé, Antti Nevalainen, St Petersburg, c. 1900. Length 8 cm.*
COURTESY OF SOTHEBY'S

*A spherical gilt silver and apple green guilloché enamel kovsh with lobed handle and three ball feet. Fabergé, Antti Nevalainen, St Petersburg, made between 1908 and 1917. Scratched stock number 18501. Length 8 cm.*
COURTESY OF SOTHEBY'S

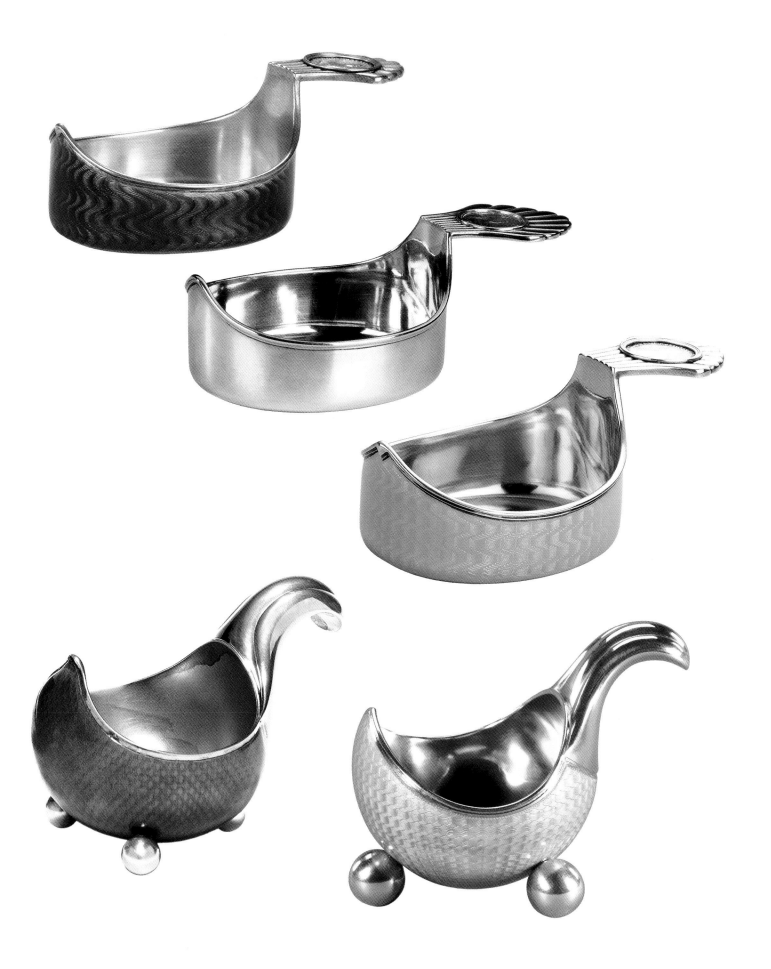

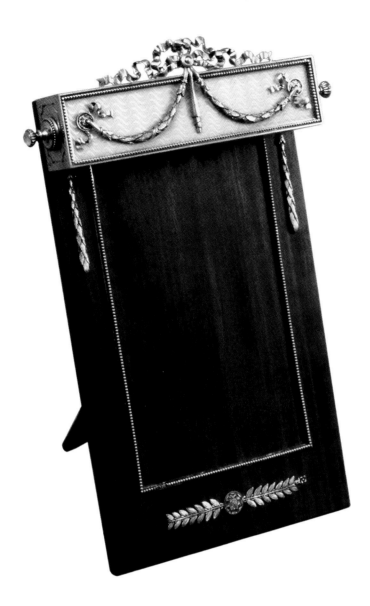

A Fabergé desk accessory – a holder for a notepad or calendar, in mahogany, gilt silver, and enamel. Fabergé, Antti Nevalainen, St Petersburg, made between 1908 and 1917. Scratched stock number 16134. The item belonged to Lieutenant-Colonel Alexander Nikolaevich Fenoult (1873–1954), a teacher in the Imperial Corps de Pages, a military academy for officer cadets, housed in St Petersburg's Vorontsov Palace. After the Revolution, he re-settled in Finland with his family. Fenoult assisted other Russian emigrés, and he was involved in the establishment of an old people's home for former Russians in Helsinki.
PRIVATE COLLECTION

A bellpush in gilt silver and enamel, with a cabochon sapphire pushpiece. Fabergé, Antti Nevalainen, St Petersburg, made between 1908 and 1917. Diameter 5.6 cm.
COURTESY OF COLLECTION MIRABAUD

A decorative square needle tray or vide-poche in silver and blue guilloché enamel. Fabergé, Antti Nevalainen, St Petersburg, 1899–1908. Size 8.2 cm.
COURTESY OF COLLECTION MIRABAUD

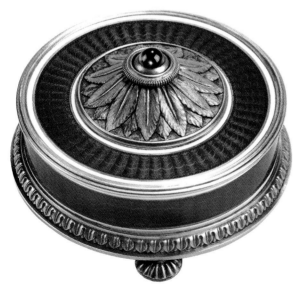

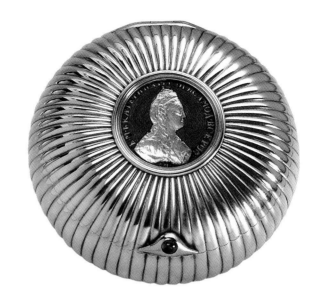

*A silver and guilloché enamel bonbonnière with a cabochon sapphire thumbpiece. The medallion in the centre of the lid has a bust of Empress Catherine II. Fabergé, Antti Nevalainen, St Petersburg, c. 1900. Scratched stock number 3176. Diameter 5.8 cm.*
COURTESY OF COLLECTION MIRABAUD

*A silver-mounted inkstand in the Empire style. Silver, red jasper, cut-glass, and (on the hinged lid) a silver coin from 1724 depicting Peter the Great. Fabergé, Antti Nevalainen, St Petersburg, made between 1899 and 1908. Scratched stock number 9358. Height 15.5 cm. Width 17.8 cm.*
COURTESY OF UPPSALA AUKTIONSKAMMARE, UPPSALA, SWEDEN

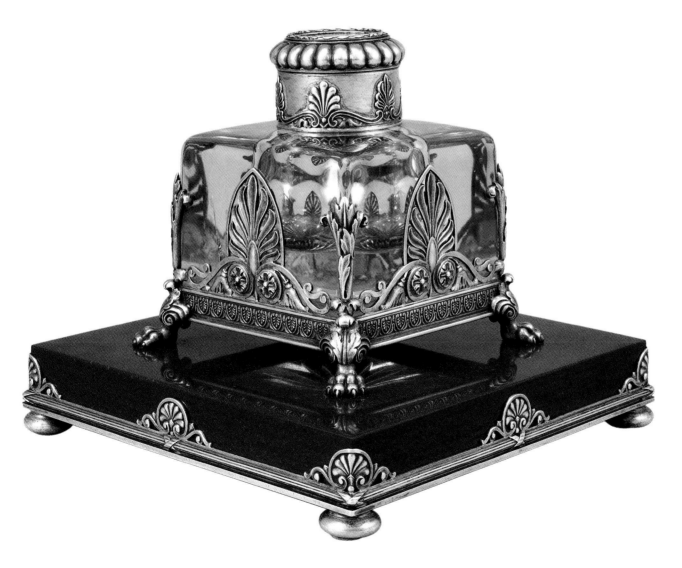

◁ *A waisted silver and translucent salmon pink guilloché enamel vodka cup. Fabergé, Antti Nevalainen, St Petersburg, made between 1899 and 1908. Scratched stock number 8738. Height 6.2 cm. The Russian inscription on the rims reads: "Neva Prize to 2-year-old 'Prince George', 3rd August, 1903."*
COURTESY OF COLLECTION MIRABAUD

▷ *A photograph frame, in curly Karelian birch, silver, and guilloché enamel. Fabergé, Antti Nevalainen, St Petersburg, made between 1899 and 1908. Scratched stock number 14132. Photo frames in various types of wood, often this kind of bird's eye birch, were a significant Fabergé product line. The frames were produced by skilled carpenters and joiners, and sometimes also by the house's Master Case Maker, Simo Käki. This example (original owner unknown) could conceivably have been a gift from Empress Alexandra Feodorovna to one of her relatives or close friends. The photograph is one of a series taken of Tsesarevich Aleksey Nikolaevich in 1907, at the age of three.*
PRIVATE COLLECTION. COURTESY OF WARTSKI, LONDON

◁ *A jewelled gilt silver* charka *on ball feet, with pink guilloché enamel, and rubies. The handle is in the form of a stylized toucan's head with a bear-claw beak and cabochon ruby eyes. Fabergé, Antti Nevalainen, St Petersburg, made between 1904 and 1908. Scratched stock number 11099. London import marks.*
COURTESY OF COLLECTION MIRABAUD

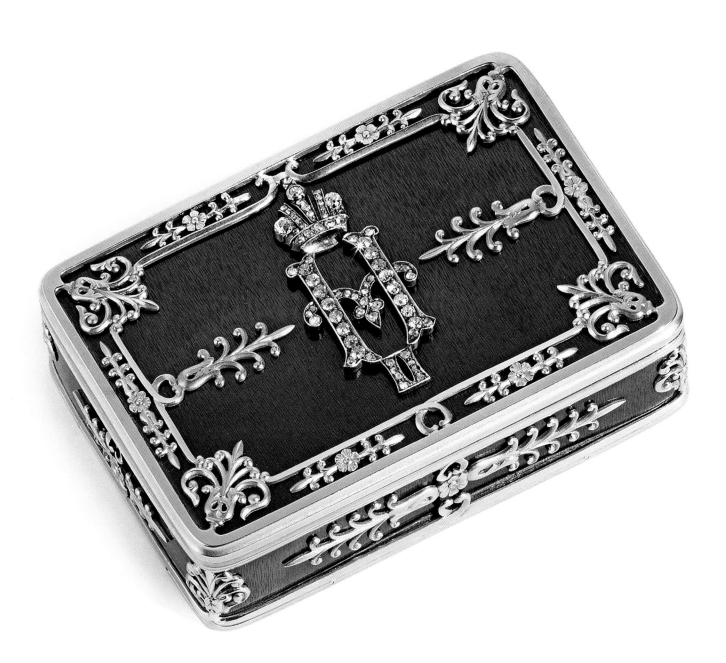

# Gabriel Nykänen

G abriel "Kaapro" Nykänen (1854–1921) was born in the village of Maavesi, close to Pieksämäki in Central Finland. His father Zachris "Sakari" Nykänen was a small farmer, and his mother's maiden name was Saara Pehkonen. Gabriel left home for St Petersburg, following the example of his older brother Matts. Matts Nykänen had by this time already reached the level of journeyman goldsmith, and he must have been content with his choice of trade, as he inspired his younger brother to follow in his footsteps.

We do not know with whom Gabriel Nykänen found apprenticeship, but it was presumably in one of Fabergé's workshops. As has been mentioned elsewhere, these were excellent "hatcheries" for young craftsmen later to be contracted with work for Fabergé. There are several classic examples of this process. Fabergé most certainly recognised the potential of Erik Kollin on seeing his work in the atelier of August Holmström. Henrik Wigström was the obvious heir to Perkhin's workshop, the two of them having worked in tandem for well over a decade. Hjalmar Armfelt's skills became known to Fabergé through his work for Antti Nevalainen.

Not much is known about Nykänen's persona. From his meagre *curriculum vitae*, the conclusion can be drawn that Gabriel was in no great hurry to pursue his career. His salvation, it appears, came in the person of the ambitious girl he married in 1880. She was Henrika "Hinni" Tuomala. Altogether nine children were born to the family, four of them while their father was still a journeyman with only a modest income.

At the age of thirty-five, in 1889, Nykänen finally earned his proficiency as a master goldsmith, which made it possible for him to open a workshop of his own. He did so that same year, and found premises at No. 39, Kazanskaya. Nykänen worked initially as a sub-contractor to several manufacturing and retail jewellers. By 1895, he had become part of Fabergé's team.

Gabriel's wife Henrika was an accomplished seamstress, and as witnessed by descendants of her customers, she was the driving force behind the family.[56] She opened her own fashion atelier

*A jewelled Imperial presentation snuffbox bearing the cipher of Emperor Nicholas II. Gold, diamonds, and enamel. Fabergé, Gabriel Nykänen, St Petersburg, made between 1908 and 1917. Width 8.5 cm. The snuffbox is enamelled in translucent purple over a wood-grained guilloché ground. The hinged cover is applied with a diamond-set crowned monogram of the sovereign. The cover and sides are mounted with cast and chased palmettes and flower heads within scrolled borders. The piece was presumably a diplomatic gift presented by Nicholas II on one of his state visits abroad, or alternatively a gift to a foreign dignitary visiting Russia.*
COURTESY OF CHRISTIE'S

next to her husband's workshop. This helped the family to secure a decent standard of living and to provide the children with a proper education. The oldest son, Vietti, having taken his baccalaureate in Vyborg, continued his studies at the Polytechnic Institute in Helsinki, and he graduated as an architect in 1907. The family also had a handsome summer home built on Lake Saimaa, across the border in Finland, where they spent their summer holidays.

Fabergé mainly supplied Nykänen with basic goldsmith work. Cigarette cases formed a sizeable part of his output. The models were predominantly classic, but with a great variety in design and decoration: some were simple, others boasted intricate chased and repoussé patterns; reeds, flutes, stripes, or festoons. There are also examples of the *samorodok* technique in Nykänen's production.

Most of the cigarette cases made by Nykänen were orders from the Cabinet of His Imperial Majesty. The House of Fabergé, being one of the main suppliers of objects

*A pectoral cross in gold and almandine garnet. Fabergé, Gabriel Nykänen, St Petersburg, early 1900s. The piece was an Imperial gift to Alexander Porozetsky, priest to the Orthodox Congregation of Kyyrölä, in what was then the Viipuri Province of the Grand Duchy of Finland. The area – on the Karelian Isthmus – was part of the territory ceded to the Soviet Union after World War II. Viipuri is now Vyborg.*
PRIVATE COLLECTION

intended as Imperial awards and presentations, had these items turned out by the workmasters in large numbers. During the first decade of the new century, the cigarette case had become one of the staple gift items handed down by the Empire.[57] More often than not, the cases would be topped with the Russian state emblem, the double-headed eagle.

One unusually important object to come out of Gabriel Nykänen's workshop is a snuffbox in gold and enamel bearing the cipher of Emperor Nicholas II. Objects with His Imperial Majesty's monogram or a miniature portrait were given only to highly-ranked personages, either Russian or foreign. It is not known to whom Nykänen's box was awarded. (See p. 182)

Gabriel Nykänen also produced other types of Imperial award objects, such as jewelled crosses to be worn by bishops and priests. Several fine examples of these have survived, still in their original red Morocco leather boxes.

*A jewelled gold Imperial presentation cigarette case, made using the samorodok or reticulation technique for a "nugget" effect. Gold, applied with a diamond-set double-headed eagle to one corner, and with a ruby thumbpiece. Fabergé, Gabriel Nykänen, St Petersburg, c. 1890. Length 9.5 cm. In its original red Morocco leather case, also with the Imperial eagle motif.*
COURTESY OF CHRISTIE'S

*An Imperial presentation cigarette case in gold, with a cabochon sapphire thumbpiece and diamond-set Romanov double-headed eagle on the lid. Fabergé, Gabriel Nykänen, St Petersburg, made between 1899 and 1908.*
© The Forbes Collection, New York.
Photo by Joseph Coscia, Jr.

*A cigarette case in gold, with a cabochon sapphire thumbpiece. Clearly a gift for a specific person, it is inscribed on the lid with the signatures and initials of those presenting it. Fabergé, Gabriel Nykänen, St Petersburg. Made between 1908 and 1917.*
Courtesy of Sotheby's

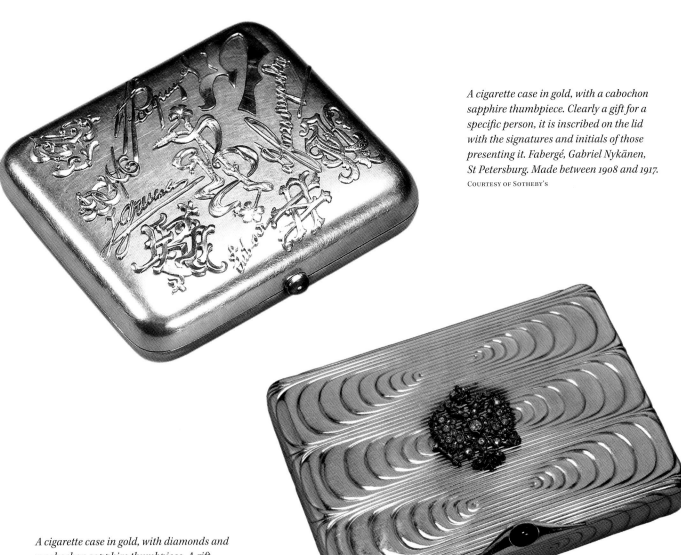

*A cigarette case in gold, with diamonds and a cabochon sapphire thumbpiece. A gift from Emperor Nicholas II to the Peterhof Palace physician, L.V. Ribalchenko. Fabergé, Gabriel Nykänen, St Petersburg, 1911.*
Courtesy of The State Historical and
Cultural Museum in The Kremlin, Moscow

*A pair of cufflinks in yellow and red gold, with ruby and diamond setting. Gabriel Nykänen, St Petersburg, early 1900s. Nykänen made these cufflinks for his own use.*

COURTESY OF THE DESCENDANTS OF GABRIEL NYKÄNEN. PHOTO BY KATJA HAGELSTAM

Kenneth Snowman, in his book *The Art of Carl Fabergé*, mentions that Gabriel Nykänen at some point was appointed head of Fabergé's Odessa workshop.[58] As evidenced by the parish registers at St Mary's, Nykänen nevertheless lived and worked in St Petersburg without interruption until 1917. On the other hand, Gabriel's nephew, the goldsmith Frans Botolf Nykänen, is known to have worked in Odessa from 1902 onwards.[59]

The year of 1912 brought turbulence to the Nykänen household. Gabriel changed address. His workshop and home from 1912 to 1918 was at No. 7, Stoliarnyi Pereulok, a street that is well known from the masterpiece *Crime and Punishment* by Fyodor Dostoevsky, published some four decades earlier. The protagonist of the book, the young student Raskolnikov, lived at No. 5, Stoliarnyi Pereulok. A newspaper clipping from 1865 reports that there were eighteen drinking establishments in the small street, which had a total of just sixteen houses.

Mrs Henrika Nykänen kept her atelier at the old address and rented an apartment for herself and the children across the river Neva on the "Petersburg Side" of the city. The Nykänen family seems by all accounts to have split up, but details of what happened have not survived.

Gabriel, now on his own, continued to work for Fabergé, but few objects bearing his marks have been found from the years 1912 to 1917. Whether this is an indication that things had taken a tragic downward turn we shall never know. In 1918, when life became unbearable in Petrograd, Nykänen managed to slip across the border to Finland. He settled in the town of Sortavala on the northern shores of Lake Ladoga, at that time part of Finland. A few years later, he moved to Helsinki, where he rented a small room in a block of flats in a working-class district. Gabriel Nykänen died on August 28th, 1921, without having reconnected with any of the members of his family. They had all sadly turned their backs on him, to the extent that the present-day descendants were not aware – until only very recently – of their ancestor's life and work in St Petersburg. Henrika Nykänen died on June 17th, 1934, having also spent the last years of her life in Finland.

# Anders Mickelsson

nders Mickelsson was born on January 8th, 1839 at Bölsbacka in the parish of Ruotsinpyhtää, Finland. His parents were Mikael Pettersson, a tenant farmer, and Ulrika Thomasdotter. On the Great Coastal Road between Turku and Vyborg, Ruotsinpyhtää was a mere one hundred and eighty miles (290 km) from St Petersburg.

At the beginning of 1852, the boy having barely turned thirteen, Anders's father applied for official permission for him to travel to St Petersburg. The teenager's passport was granted on March 9th in the same year. Where Anders did his apprenticeship is not documented, but seven years later, in 1859, he qualified as a journeyman at the age of twenty. He received his certification as master goldsmith and jeweller in 1867 and founded his own workshop that same year. No details about Mickelsson's workshop have survived, except for the name of one apprentice, a Finn named Antti Sivonen.[60]

Mickelsson worked for Fabergé as a sub-contractor, but not on a large scale. He made decorative and utility objects in gold, but his primary output consisted of small items of jewellery, indicating that he had indeed trained as a jeweller. It is possible that he worked as journeyman for August Holmström, which would explain how he subsequently came to be one of Fabergé's suppliers.

In 1908 Mickelsson purchased the workshop of Theodor and Anna Ringe at No. 12, Malaya Morskaya, in partnership with master goldsmith Vladimir Viacheslav Soloviev (see p. 193). Ringe's widow, Anna Karlovna Ringe (1840–1912), had managed her husband's workshop since his death in 1894, with the assistance of both Mickelsson and Soloviev. (See p. 57)

Mickelsson married Finnish-born Maria Helena Tiljander (1835–1907) in St Petersburg in 1863. They had four children, three daughters and one son. Their son, Viktor Mickelsson (1865–1912), became a watchmaker.

Anders Mickelsson died in St Petersburg on November 8th, 1913.

*Detail of the cigarette case shown on p. xxx.*
COURTESY OF CHRISTIE'S

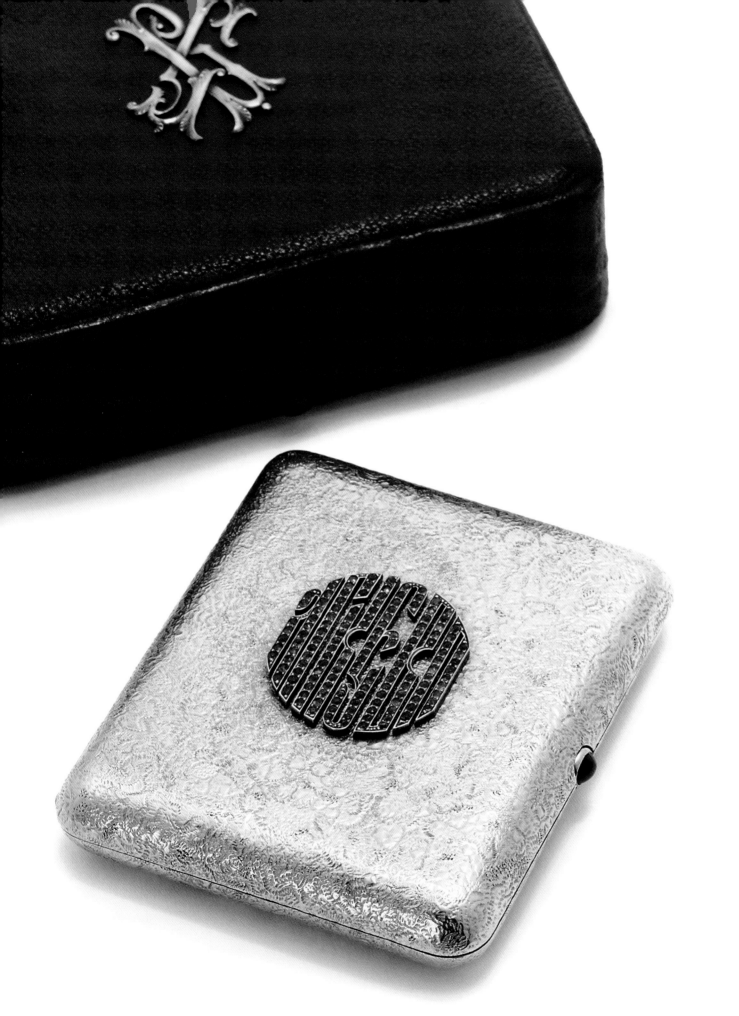

A jewelled gold cigarette case, with a cabochon sapphire thumbpiece and with rubies-set Cyrillic initials on the chased and engraved surface, spelling the transliterated LGKEVP, for "His [Imperial] Majesty's Lifeguards Cossack Regiment". Fabergé, Anders Mickelsson, St Petersburg, c. 1890. The presentation case is original, with the recipient's monogram S.V. (in Cyrillic letters). The cigarette case was a regimental parting gift for Semion Nikolaevich Varlamov, and is inscribed with the names of 33 donors, presumably fellow officers.
COURTESY OF CHRISTIE'S

An extended residence permit for St Petersburg granted by His Imperial Majesty's Governor for the Viipuri Province of the Grand Duchy of Finland. The permit, dated 31th July, 1852, is issued in the name of crofter's son Anders Mickelsson, born 8th January, 1839, and is valid indefinitely.
NATIONAL ARCHIVES OF FINLAND, HELSINKI

A brooch in gold, smoky quartz, diamonds, and enamel. Fabergé, Anders Mickelsson, St Petersburg, early 1900s.
COURTESY OF THE STATE HISTORICAL AND CULTURAL MUSEUM IN THE KREMLIN, MOSCOW

A jewelled paper knife in gold, with the handle set with sapphires, rubies, and diamonds. Fabergé, Anders Mickelsson, St Petersburg, late 1890s.
PRIVATE COLLECTION

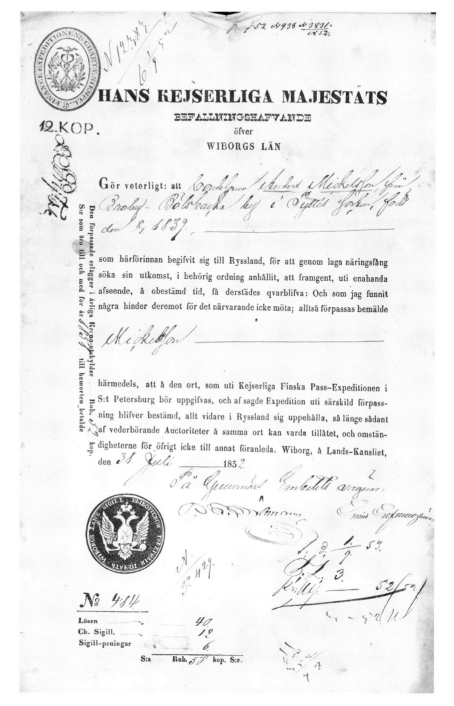

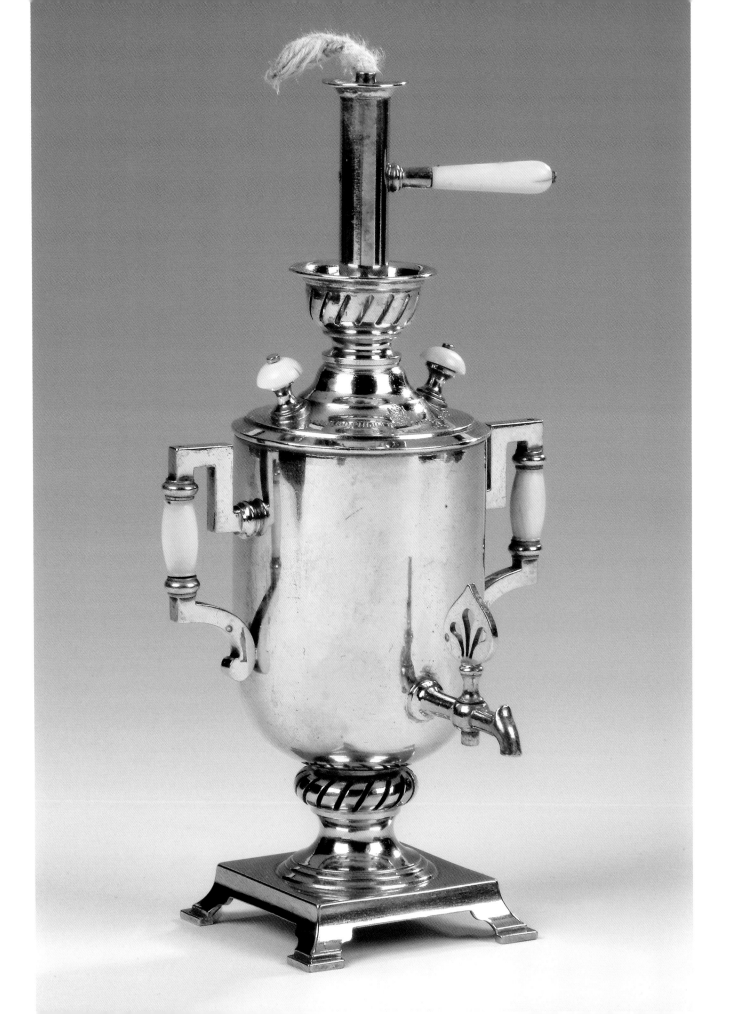

# Vladimir Soloviev

Vladimir Viacheslav Soloviev's birth and death dates are unknown to us. He was a master goldsmith with his own workshop at No. 33, Gorokhovaya. Soloviev's years as a master craftsman collaborating with Fabergé fell between 1909 and 1917.

On the death of master goldsmith Theodor Ringe in 1894, his widow Anna Ringe carried on her husband's business with the assistance of Soloviev and Anders Mickelsson. In 1908, the workshop passed into their hands. Mickelsson himself died in 1913, after which Soloviev was the sole owner of the former Ringe workshop.

Soloviev is known for small utility items - pencil holders or paper knives, for instance, in gold or silver, frequently with an elegant décor of guilloché enamel, most often in pastel colours. The holders were fitted for wooden pencils made by the renowned German pen and pencil manufacturer Faber ( founded in 1761; from 1900 Faber-Castell), which had opened a branch in St Petersburg in 1874. Soloviev's workshop also produced decorative scent bottles, cigarette lighters, and other items in the "Fabergé style".

*A miniature samovar table lighter. Gilt silver, ivory, tinder cord. Fabergé,*
*Vladimir Soloviev, St Petersburg, made between 1908 and 1917. Height 13.2 cm, width 6.9 cm.*
© FABERGÉ MUSEUM, ST PETERSBURG. THE LINK OF TIMES CULTURAL AND HISTORICAL FOUNDATION. PHOTO BY ANDREY TEREBENIN

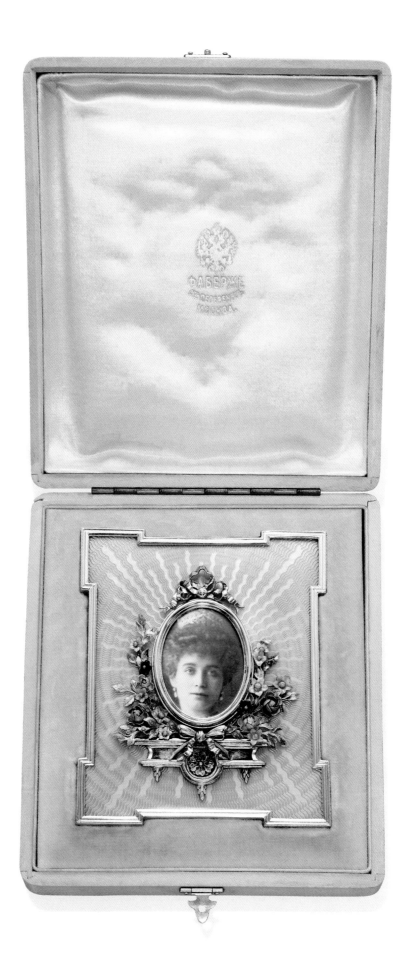

# Viktor Aarne

Johan Viktor Lindström, later known as Viktor Aarne (1863–1934), was born in the Finnish city of Tampere. He was the son of Johan Lindström, a carpenter (later a verger), and Anna Lovisa Brask.

After five years at an evening school, twelve-year-old Viktor was apprenticed to the master goldsmith Johan Erik Hellsten in Tampere. On completing his training with Hellsten, he moved 50 miles south to the town of Hämeenlinna, where in 1880 he qualified as a jour- neyman with the master silversmith Gustav Adolf Weckman (1823–1901). Weckman was known as a skilled craftsman. He primarily produced silver items such as coffee and tea services, although he also created small pieces of gold jewellery. Viktor thus acquired a solid grounding for his future career.

In 1880, now 17, Viktor decided to test his wings in St Petersburg. He was fortunate enough to be taken on as a journeyman in the workshop of August Holmström, where he was given the chance to try his hand at jewellery. In 1889 Viktor, full of lofty aspirations for his own future, applied to work with Mikhail Perkhin and was accepted as a "goldworker" in the new workshop. Perkhin had recently been appointed Fabergé's chief workmaster, which made his atelier the innovative hub of the House of Fabergé and thus the ideal place for a gifted learner.

Aarne was something of a restless soul; he had difficulties in adjusting himself to life and work in the big metropolis. In 1890, after almost a decade as journeyman and "goldworker" with Fabergé, he decided to return to Tampere, where he completed his master's examination in the same year.

In order to qualify as a master goldsmith, a candidate was expected to design and craft an item of jewellery – a so-called "masterpiece". This indication of the candidate's skills had to be approved by two specially appointed assessors, themselves experienced goldsmiths. The practice was a relic of the ancient guild system, which by this time had formally been abolished. Certain elements of the system were nevertheless preserved, primarily those concerning training and the supervision of proficiency.

Aarne was instructed to design and produce a gold bracelet. On its completion his two asses- sors, Kustaa Hiekka and Mats Andelin, were both surprised and delighted with the craftsmanship shown by their candidate. They awarded him a distinction for his work. Encouraged by the praise

*A photograph frame in its original fitted presentation case. Varicolour gold, gilt silver, and pale blue guilloché enamel. Fabergé, Viktor Aarne, St Petersburg, c. 1890. Scratched stock number 55882. The wooden case by Simo Käki is of common holly (Ilex aquifolium).*
COLLECTION OF PRINCESS KATHARINA HENCKEL VON DONNERSMARCK. PHOTO COURTESY OF CHRISTIE'S

he received in his home town, Aarne decided to stay on in Tampere to work as a gold-smith. However, owing to the lack of challenging commissions locally, his business foundered and he found himself returning to St Petersburg. Back in the great Russian metropolis, Aarne soon found suitable space for his workshop. The address was No. 58, Demidov Pereulok, today Grivkova Pereulok, from where he later moved to more spacious premises at No. 42, Ekaterininsky Kanal, today Griboyedova Kanal.

As a bonus, Aarne – the prodigal son of the House of Fabergé – was once again welcomed into the Fabergé team. One could never have too many skilled craftsmen…

### Aarne's Workshop and Production

In his memoirs, Hjalmar Armfelt provides a good picture of Aarne's workshop, and also of the master himself, mentioning that he was held in very high esteem by Carl Fabergé (see p. 220). Aarne oversaw the work of 20 journeymen and 3 apprentices. Of these, 15 were Russians and the remainder were Finns.

A fair amount of what Aarne produced has survived to this day, in museum collections as well as in private hands. This makes it possible to attempt some analysis of his output. Fabergé's commissions focused in large measure on luxurious table frames, intended for photographs or miniature portraits. These were the latest must-have fashion accessory in the fin de siècle interiors of the well-to-do, and were produced in all shapes and sizes, in vari-coloured gold or gilt silver with guilloché enamel and a plethora of décors and motifs, such as Louis XVI garlands of roses, wreaths, and festoons. There seems to have been no end to the imagination of Fabergé's designers concerning this specific article, and equally no end to the motivation at the workbenches to produce the objects.

In contrast to these exquisite table frames, designed often in the styles of the 18th century, Fabergé challenged Aarne with a diametrically opposite look: the contemporary Art Nouveau, which by this time had reached Russian shores in the wake

*Master Goldsmith Johan Viktor Aarne.*
COURTESY OF THE AARNE FAMILY

*Master Goldsmith Johan Viktor Aarne's atelier in Viipuri (now Vyborg). Aarne ended his collaboration with the House of Fabergé in 1904 and moved back to Finland, where he set up his own business. Aarne is standing facing the camera in the centre background.*
COURTESY OF THE AARNE FAMILY

▷ *A small picture frame in varicolour gold and pale blue guilloché enamel, with a miniature of Maximilian Hendrik van Gilse van der Pals at roughly age 10, painted by court miniaturist Johannes Zehngraf. Fabergé, Viktor Aarne, St Petersburg, c. 1895. Height 7.5 cm.*
PRIVATE COLLECTION. PHOTO BY KATJA HAGELSTAM

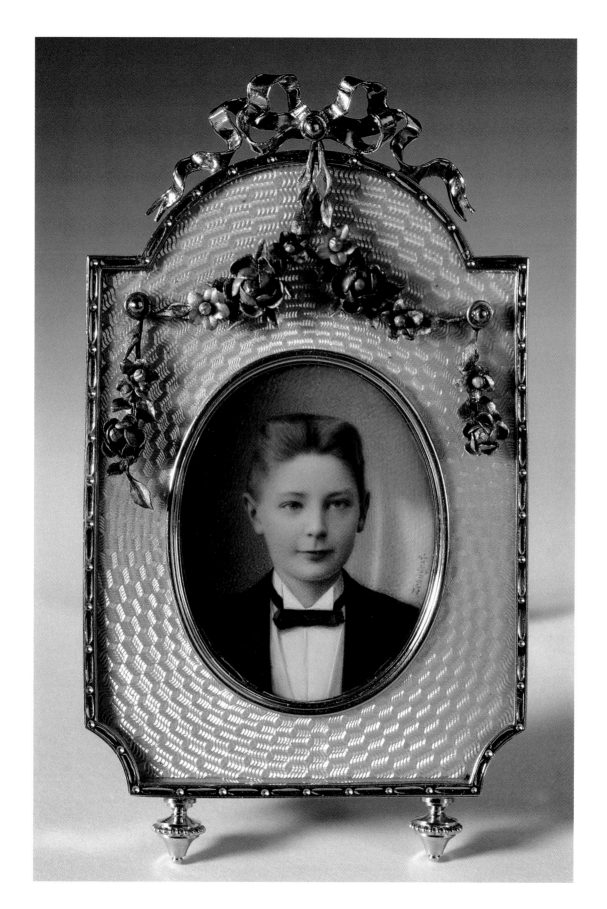

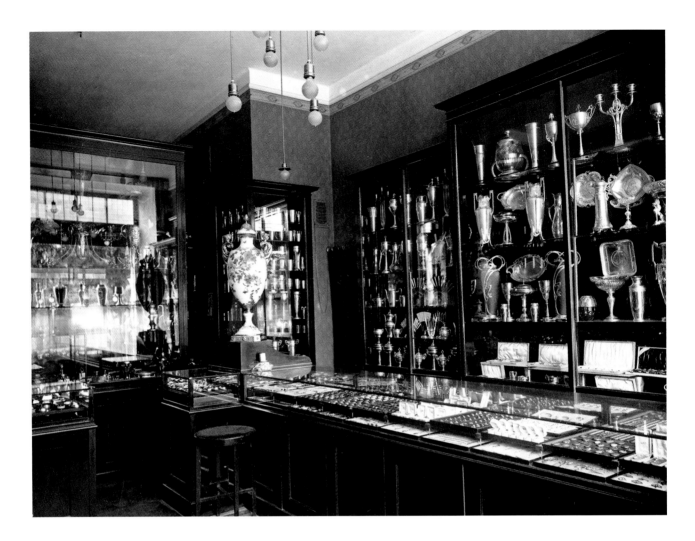

*Viktor Aarne's well-appointed shop
in Viipuri (now Vyborg), c. 1910. The
glass-topped counters and wall-cabinets
indicate an abundance of jewellery,
silverware, and crystal items for sale.*
COURTESY OF THE AARNE FAMILY

of the *Mir Iskusstva* (World of Art) magazine and art movement. For Aarne, this meant a complete about-turn in style and technique, and it must have been a stiff test for him, not only demanding re-thinking and adaptation on his own part, but also among his team of craftsmen.

Fabergé's assortment of objects in the style known in Russia as *Stil Modern* (a mélange of Art Nouveau and its German equivalent Jugend Stil) earned Aarne the nickname "Our Lalique" within the circle of his peers, after the great French jewellery designer René Lalique.

The collection consisted of silver-mounted vases and bowls in glass and pottery crafted by celebrated foreign names such as Tiffany & Co, Gallé, Royal Doulton, and Rörstrand. The *Stil Modern* silver mounts were crafted in Aarne's workshop. Many of these objects were purchased by Emperor Nicholas II as gifts for his wife, Empress Alexandra, who was a great admirer of the style, for instance in the decoration of the Mauve Room at the Alexander Palace.

One quite mundane article seemingly in great demand among Fabergé's clientele was the thermometer, used to measure room temperature. These were made by the dozens by Aarne's team, in gilt silver with guilloché enamel and neo-classical ornaments.

*A vase in gilt silver and porcelain. Fabergé, Viktor Aarne, St Petersburg, made between 1899 and 1904. Height 14.5 cm. The blue-glazed vase with white-glazed pansy flowers was made in the Rörstrand Porcelain Factory in Sweden. The vase belonged to Grand Duchess Xenia Alexandrovna and was kept in her salon at Gatchina Palace.*

COURTESY OF THE PAVLOVSK
STATE MUSEUM & PARK, PAVLOVSK, ST PETERSBURG

*An oval rhodonite bowl or vide-poche, with a gold rim and white opaque enamel stripes, set with eight cabochon emeralds. Fabergé, Viktor Aarne, St Petersburg, made between 1899 and 1904. Diameter 12 cm.*

COURTESY OF SOTHEBY'S

*A miniature photograph frame in four-colour gold, gilt silver, nephrite, cabochon rubies, rose-cut diamonds, and mother-of-pearl. Fabergé, Viktor Aarne, St Petersburg, made between 1899 and 1904. Height 5.8 cm.*

ROYAL COLLECTION TRUST / © HER MAJESTY QUEEN ELIZABETH II

*A Réamur-scale thermometer, in gilt silver and translucent royal blue enamel over banded engine-turning. Fabergé, Viktor Aarne, St Petersburg, made between 1899 and 1904. Scratched stock number 3063. Length 24.3 cm.*

COURTESY OF SOTHEBY'S

## MARRIAGE AND FAMILY

Viktor met his future wife in St Petersburg. She was Hilda Emilia Kosonen (1867–1954), a watchmaker's daughter from Joensuu in Northern Karelia. Their marriage took place on September 7th, 1886 at the Finnish Church of St Mary in St Petersburg. The groom surfaces in the parish register as Johan Viktor Aarne, indicating his change of name by deed poll took place on or before the day he married Hilda. Aarne's family has no idea where the idea for the new surname came from. It is actually rather more common as a first name. Amusing stories about their name abound in the Aarne family. For instance, Viktor's youngest son Eino, who had begun his education at a primary school, was apparently scolded by the teacher on his first day, and was summarily sent home and advised not to return before he was able to provide his correct surname.

Hilda and Viktor Aarne had a total of ten children, of whom three died in infancy. The father of the house had strict views about the education of his offspring. The two sons were to follow in their father's footsteps, and the five daughters had to acquire an occupation before they would be allowed to marry. Later generations of the family today look back with gratitude towards their far-sighted ancestor. He realised that education was the key to getting on.

## RELOCATION TO FINLAND

In spite of his successful career with Fabergé, Viktor Aarne decided to leave St Petersburg for good in 1904. According to his family, his departure was a direct result of the growing political unrest in Russia. Aarne sold his workshop interest to Hjalmar Armfelt (see p. 218) and established a new company in Vyborg (Viipuri to the Finns; it was the second-largest city in Finland between 1918 and 1940, and a very cosmopolitan place), where he continued to run a successful business as the city's leading goldsmith until his death in 1934.

Aarne's firm in Vyborg included a well-appointed retail salesroom and a workshop where he produced custom pieces and jewellery. However, not all the items he sold were his own creations. Aarne had maintained cordial contacts with his colleagues in St Petersburg and he purchased a substantial amount of silver from them, which he then sold in Vyborg.

▷ *A combination bellpush and wall thermometer, in varicolour gold, gilt silver, and oyster enamel, with a cabochon garnet for the pushpiece. Fabergé, Viktor Aarne, St Petersburg, made between 1899 and 1904. Scratched stock number 3192. Length 18 cm.*

COURTESY OF COLLECTION MIRABAUD

*A heart-shaped photograph frame in four-colour gold and translucent strawberry red sunburst guilloché enamel. Fabergé, Viktor Aarne, St Petersburg, c. 1890. Scratched stock number 1119. Height 7 cm.*
Courtesy of Christie's

*A rectangular frame in the form of four intersecting gold and enamel rods set with pearls and chased gold floral garlands, salmon pink guilloché enamel, and an oval bezel bordered with seed pearls, containing an image of Princess Louise, Duchess of Fife (1867–1931), the eldest daughter of King Edward VII. Fabergé, Viktor Aarne, St Petersburg, made between 1899 and 1904. Height 4.6 cm.*
Royal Collection Trust / © Her Majesty Queen Elizabeth II

*An oval frame in gilt silver and blue guilloché enamel, with a lily motif. Fabergé, Viktor Aarne, St Petersburg, Made between 1899 and 1904. Height 7 cm.*
COURTESY OF THE WOOLF FAMILY COLLECTION, LONDON

*A frame in gilt silver and lime green guilloché enamel. Fabergé, Viktor Aarne, St Petersburg, made between 1899 and 1904. Scratched stock number 62409. Height 6.2 cm.*
PRIVATE COLLECTION.
PHOTO BY KATJA HAGELSTAM

*A demilune table clock with circular dial, in two-colour gold and translucent lilac enamel over radiating guilloché. Fabergé, Viktor Aarne, St Petersburg, made between 1899 and 1904. Width c. 15 cm.*
COURTESY OF SOTHEBY'S

# Alfred Thielemann

Alfred Thielemann (1870–1910) was a master goldsmith and jeweller in the second genera-
tion.[61] His father Karl Rudolf (Rudolf Augustovich) Thielemann, of German stock, was the
owner of a workshop specialising in small jewellery items, badges, and jetons.

Alfred, the future heir to his father's workshop, was enrolled at the age of seven
in the renowned Petrischule. The school had a German curriculum and was partly financed by the
German Evangelical Lutheran Congregation of St Petersburg. At the age of twelve, in 1882, the boy
embarked on his apprenticeship in his father's workshop, which was located at Fabergé's former
address, No. 11, Bolshaya Morskaya.

Alfred earned his master's certificates in 1890, or possibly a few years later. Both he and his
brother Otto (d. 1914), also a goldsmith, remained loyal to the family business. After Rudolf's death,
around 1895, Alfred assumed responsibility for the workshop. In 1901 he moved into the workshop
wing of Fabergé's new headquarters at 24, Bolshaya Morskaya and was appointed second jeweller of
the firm.

The Thielemann workshop produced a mass of small jewellery items in gold or silver, set with
precious stones, often with guilloché enamel. Fabergé's lesser commissions from the Cabinet of His
Imperial Majesty, such as brooches, tie pins, cufflinks, and rings with the Imperial emblems – the
crown or the double-headed eagle – were produced in great numbers by Thielemann. The workshop
also made badges and jetons to a very high quality, for example those ordered by the Nobel compa-
nies. Miniature Easter egg pendants were also crafted by the hundreds in time for the Easter festival.

In 1893, Alfred married Elisabeth Emilie Olga (Olga Alexandrovna) Körtling. On the death of
Alfred Thielemann in April 1910,[62] his wife was granted permission by Fabergé to continue her late
husband's workshop. She acquired a "widow's mark" [ET], and was assisted in her work by a subor-
dinate of Alfred's, master goldsmith Vladimir Gavrilovich Nikolaev.[63]

*An Imperial presentation pair of cufflinks. Gold, silver, rose-cut diamonds, guilloché
enamel. Fabergé, Alfred Thielemann, St Petersburg, made between 1908 and 1910.*
© FABERGÉ MUSEUM, ST PETERSBURG. THE LINK OF TIMES CULTURAL AND HISTORICAL FOUNDATION. PHOTO BY ANDREY TEREBENIN

*The workshop of master goldsmith Alfred Thielemann (c. 1870-1910). Thielemann's atelier was
located on the top floor of the workshop wing in the courtyard of Fabergé's premises at No. 24,
Bolshaya Morskaya. The workmaster Thielemann stands in the left centre of the photograph.*
COURTESY OF WARTSKI, LONDON

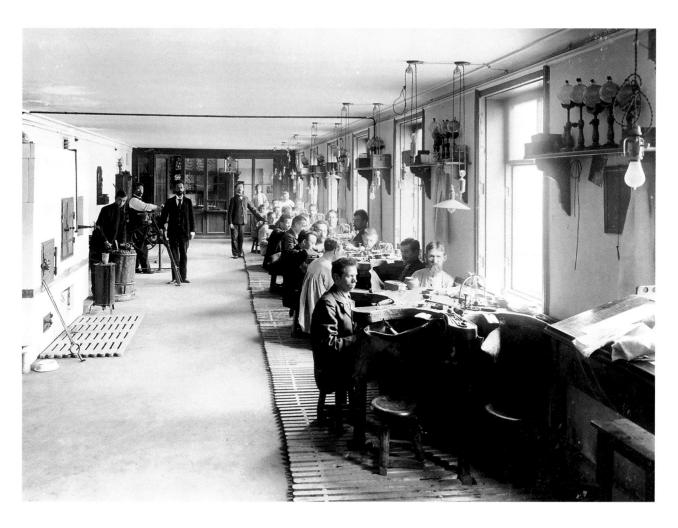

# Fedor Afanasiev

Fedor Alekseyevich Afanasiev (1870 - after 1927) was a skillful master goldsmith who worked for Fabergé as an independent workmaster.

By coincidence, the "Personal File" (*Lichnoye Delo*) relating to Afanasiev has been preserved at the Central State Archive in Moscow.[64] The file consists of a comprehensive questionnaire, which had to be completed under Soviet rule by all citizens who applied for work at either an institution or a commercial company. Afanasiev was employed by the Moscow Jewellery Company between October 1926 and June 1927. The file, which he filled in prior to starting his work, sheds light on his background, life, and career.

Afanasiev was born in Western Russia, in the village of Dubrovsky in the Smolensky District, in February 1870. He was of Russian peasant stock, his mother tongue was Russian, and he was born into the Orthodox faith. As a child he had attended courses at the school in his home village. To the question concerning his "citizen service before 1917", in other words his professional life, Afanasiev's replies are vague, possibly for political reasons. His answers do not match with information from other sources, or alternatively they were misinterpreted by the interrogator. The notes state that Afanasiev initially worked "in Fabergé's factory as a journeyman", then from 1903 to 1913 as "assistant of the head department", and between 1913 and 1917 with unspecified tasks at the "head department".

The Fabergé organisation did not, however, include a "head department" with positions suitable for employees with qualifications that corresponded to those of Afanasiev.

According to other sources,[65] Afanasiev left home in 1883 for St Petersburg, to find apprenticeship with a master goldsmith. He was 13 years old at the time, and he was accepted as an apprentice by the Finnish-born master goldsmith Enok Sistonen (active between 1870 and 1898). Sistonen had his workshop centrally in the city at No. 15, Nevsky Prospekt. Five years later, in 1888, Afanasiev continued his training in the atelier of Court Jeweller Carl Bock, whose well-known store was situated across the street from Fabergé in Bolshaya Morskaya, close to the corner of Nevsky Prospekt.[66] In 1903, Afanasiev qualified as a journeyman and in 1905 as a master goldsmith, while still working for Bock.

Shortly after having received his master's papers, Afanasiev opened his own workshop at No. 36, Voznesensky Periulok. Not long after this – probably in 1907 – he became a member of the Fabergé team of independent suppliers. The collaboration only ended when the House of Fabergé closed for business in November 1918.

Afanasiev's production for Fabergé was diverse and of surprisingly good quality. Small objects of vertu in gilt silver and guilloché enamelling were his specialty; he made pill boxes, dishes, parasol handles, seals, scent bottles, and taper-stick holders, as well as gem-set

*A unique taperstick holder. Gold, gilt silver, enamel. Fabergé, Fedor Afanasiev, St Petersburg, c. 1910. Height 6.1 cm.*
COURTESY OF BENTLEY & SKINNER, LONDON

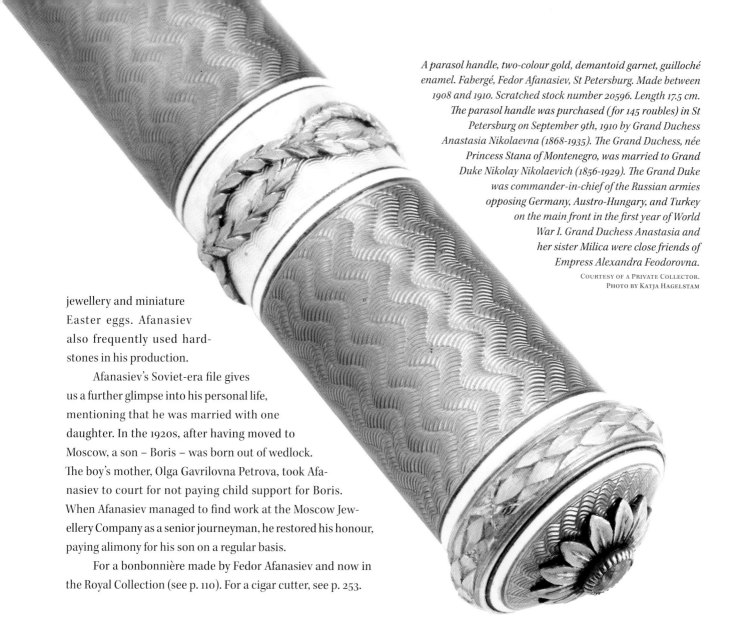

*A parasol handle, two-colour gold, demantoid garnet, guilloché enamel. Fabergé, Fedor Afanasiev, St Petersburg. Made between 1908 and 1910. Scratched stock number 20596. Length 17.5 cm. The parasol handle was purchased (for 145 roubles) in St Petersburg on September 9th, 1910 by Grand Duchess Anastasia Nikolaevna (1868-1935). The Grand Duchess, née Princess Stana of Montenegro, was married to Grand Duke Nikolay Nikolaevich (1856-1929). The Grand Duke was commander-in-chief of the Russian armies opposing Germany, Austro-Hungary, and Turkey on the main front in the first year of World War I. Grand Duchess Anastasia and her sister Milica were close friends of Empress Alexandra Feodorovna.*
COURTESY OF A PRIVATE COLLECTOR.
PHOTO BY KATJA HAGELSTAM

jewellery and miniature Easter eggs. Afanasiev also frequently used hardstones in his production.

Afanasiev's Soviet-era file gives us a further glimpse into his personal life, mentioning that he was married with one daughter. In the 1920s, after having moved to Moscow, a son – Boris – was born out of wedlock. The boy's mother, Olga Gavrilovna Petrova, took Afanasiev to court for not paying child support for Boris. When Afanasiev managed to find work at the Moscow Jewellery Company as a senior journeyman, he restored his honour, paying alimony for his son on a regular basis.

For a bonbonnière made by Fedor Afanasiev and now in the Royal Collection (see p. 110). For a cigar cutter, see p. 253.

# Hjalmar Armfelt

When he was already well into his eighties, Karl Gustav Hjalmar Armfelt (1873–1959) decided to write about his life. He was very much aware that his story was an exceptional one. The result was a handwritten document, to which he gave the title *One Man's Story*.[67]

The reminiscences were never meant to be published, nor to be read by anyone other than immediate family. His descendants, some sixty years after his passing, now consider it important to share what he wrote with a wider audience. Not only in homage to their beloved grandfather and great-grandfather, but because his reminiscences shed light on a historical chapter still largely unexplored. The author records his experiences with verve and in minute detail. The mosaic of these events wonderfully illustrates the world of the goldsmiths' trade of the day, how youngsters were trained as goldsmiths in St Petersburg, and how they worked and lived as journeymen and later as master gold- and silversmiths.

Armfelt goes on to describe life in St Petersburg during the turbulent years of the Revolution, and the ten gruelling months he spent in Bolshevik prisons and labour camps, both in Petrograd and Moscow. The return to Finland, the country of his birth, necessitated he start his professional life all over again. To make a living as a gold- and silversmith in circumstances far from the glamour of Imperial St Petersburg demanded both courage and resilience.

Armfelt's services during his country's wars with the Soviet Union[68] were much needed because of his fluent knowledge of the Russian language. At the age of 68, in 1941, he did not hesitate to enlist in the military to assist in intelligence-gathering at major prisoner-of-war camps.

The following chapter is based on these reminiscences, with many direct quotations from this unique document.

*An Empire style guéridon or small circular decorative table with a dished top. In richly decorated silver and Siberian nephrite, standing on three winged caryatid legs and pawed feet. Design by Franz Birbaum. Fabergé, Hjalmar Armfelt, St Petersburg, made between 1908 and 1917. Height 94 cm. The unique piece was commissioned by the Swedish oil magnate Emanuel Nobel. It is worth noting just how rare were furniture items in the Fabergé range.*
COURTESY OF CHRISTIE'S

## FAMILY BACKGROUND

Hjalmar Armfelt was a member of the Finnish nobility. The Armfelt family has provided many of Finland's most prominent military men and senior civil servants.[69]

Hjalmar himself did not make his appearance under the same lucky stars as many of his famous relatives. He was born on 6th April 1873, in Artjärvi, a relatively remote community in Southern Finland, where his father August Edvin Armfelt (1836–1905) worked as the village school teacher. August Edvin had been educated in the military, like most noblemen of the time, but interrupted his promising career at the age of twenty-one, serving for the rest of his life in modest positions throughout Finland, then a Grand Duchy of the Russian Empire. In addition to working as a primary school teacher, he gave piano lessons and tutored children in Russian and Swedish. In 1879, he was offered work at the liquor distillery on the Viurila estate. The sale of distilled beverages was an important source of income for the landowners, before the prohibition laws enacted during the first decades of the 20th century. August Edvin Armfelt remained there for the rest of his life. Viurila, one of the large Armfelt family estates owned by a distant relative, Count August Magnus Gustav Armfelt, is situated in Halikko, in Western Finland. By the time he was six, Hjalmar thus became acquainted with his noble roots and gradually learned why his own family had to live in very reduced circumstances.

His father's failure in life was the result of his first marriage to a young woman by the name of Amanda Lindh, with whom both he and his elder brother, the future Rear Admiral Alexander Johan Fredrik Armfelt, were infatuated. August Edvin was the quicker to propose, but the marriage was doomed from the start, since Amanda in fact preferred the older sibling.

Two years after their divorce in 1863, August Edvin Armfelt fortunately found a new love of his life. Johanna Matilda Ahlroos was the daughter of a crofter, and she was said to be the prettiest girl in her village. The marriage was a misalliance, but with her at his side, August made a fresh start. They had six children, Hjalmar being the fourth.

Count August Armfelt, the owner of Viurila, did what he could to help the less fortunate members of his vast family, such as financing the education of the children. The Count was incredibly wealthy: his estates consisted of 48,000 hectares (nearly 120,000 acres) of farmland and forests.

August Edvin Armfelt's three eldest children were assisted financially with their initial schooling and received a higher education in St Petersburg. However, when the question of Hjalmar's education arose, financial support was no longer forthcoming. Hjalmar's aunt Amalia came to the rescue, offering to underwrite his early schooling. She was married to a well-off vicar in a small community in Eastern Finland. The vicarage at Nurmes thus became Hjalmar's home for five years, until he obtained his primary school certificate at the age of twelve. The "family council" then gathered to consider whether Hjalmar should go on to secondary school or not. Since the boy had artistic talent, it was ultimately concluded that he should be trained as a craftsman of some kind. Hjalmar himself was not sure about this; he knew his best chances for future success would be to attend secondary school, but he acquiesced to the will of the older generation. The final decision was made by Hilda Armfelt, another of

*A large rectangular gilt silver and rhodonite desk clock with oyster guilloché enamel dial. Fabergé, Hjalmar Armfelt, St Petersburg, made between 1908 and 1917. Height 35.5 cm.*
COURTESY OF CHRISTIE'S

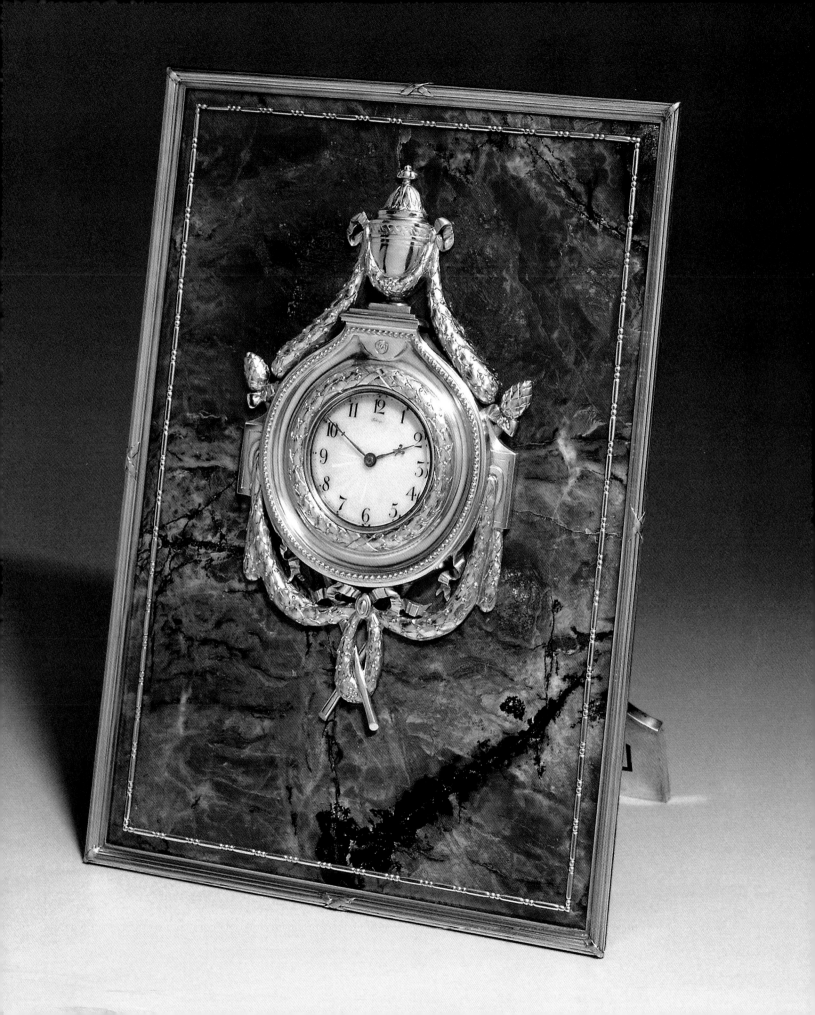

Hjalmar's aunts. She had received her education at the famous Smolny Institute in St Petersburg, an elite school for daughters of the nobility. Hilda had worked until her retirement as a lady's companion in the home of Minister State Secretary Count Alexander Armfelt.

Aunt Hilda knew of a distant relative, the gold- and silversmith Paul Sohlman,[70] who had a workshop in St Petersburg. She enquired whether Hjalmar could be apprenticed at his workshop. The proposition was also debated and discussed at Viurila. Count August Armfelt's comment was indelibly scored into the mind of young Hjalmar: "You were born poor; you will, therefore, have to forget you are a nobleman and that your name is Armfelt." This heartless yet utterly pragmatic remark shaped Hjalmar's entire outlook on life. He decided to bite the bullet and prove to his family he could become a skilled gold- and silversmith.

### TOWARDS AN UNKNOWN FATE IN ST PETERSBURG
On an icy cold day at the beginning of February 1886, thirteen-year-old Hjalmar Armfelt travelled by horse and sledge from his parents' home at Viurila to the nearest

*Karl Gustaf Hjalmar Armfelt as a young apprentice.*
COURTESY OF THE ARMFELT FAMILY

*Journeyman goldsmith
Hjalmar Armfelt.*
COURTESY OF THE ARMFELT FAMILY

train station at Riihimäki, some one hundred miles away. There he boarded the train to St Petersburg. His luggage consisted of a heavy trunk, one paper rouble, and a small slip of paper with a street address written in Russian. Aunt Hilda Armfelt was there to meet Hjalmar when the night train steamed into the Finland Station in St Petersburg the following morning.

Hjalmar describes in his own words the first encounter with his future life:

Auntie took an izvozchik,71 and brought me to Sohlman's. It was a Saturday morning. Things were in full swing in the workshop; approximately 15 men and apprentices were working on different tasks. All of it of course was interesting, but it seemed to me at the same time a disappointment. I had thought that goldsmiths' work was a fine and clean occupation. What I saw was that the work was more or less crude, in reality quite dirty. I thought to myself, is this my future, will I soon be a "soot-face", will I soon look like these sooty-faced brats or those journeymen, who toiled there with soldering lamps in their fists? The next morning was Sunday. I acquainted myself with the other apprentices. There were three of them, all Finns. Two brothers, Jussi and Bertil Saukkonen, and Mikko Virtanen.

The boys had a room next to the workshop; each had his own bed. A table and a few chairs completed the interior. I, who became the fourth of the apprentices, was not at first housed in this room: instead I had a bed in the home of the Sohlman family, situated in a different apartment, but also adjacent to the workshop. Then on Monday morning my apprenticeship as a goldsmith commenced. My apprenticeship lasted for five years.

My first task in the workshop was to try my hand at the making of chain work. I gradually started to understand a few sentences of the Russian language. Every day I learnt many new

The Rear Admiral had by this time retired from active service. Hjalmar had not yet been informed that Uncle Alexander's wife had in fact first been married to his own father. (As it happened, Amanda Lindh was not overly happy with her second husband, either, and she left Alexander in 1890 to marry his aide-de-camp, Vladimir Lavrov, later Vice Admiral Lavrov.)

Hjalmar continues:

Then came the Easter holidays. My Uncle Otto,72 stationed at Kronstadt, the naval base of St Petersburg, visited his brother Alexander. Both my uncles came to see me at the workshop. The visit of two high-ranking naval officers made a powerful impression on the rest of the workers, and this reflected on me. They asked me how it was possible that I – with such highly-placed members in my family – could have wound up in the position of an apprentice in a workshop? I remembered Count August's comment that when you are poor you must forget you are a nobleman. I replied that if I could become fluent in Russian, I would enrol in the cadet school – I had the right to this through my birth – but since it will take me a long time to learn sufficient Russian, I will be past the age for acceptance, and that will be my fate. Instead I will perhaps learn to be a good silversmith, if things go my way.

Hjalmar had developed a great deal, both mentally and physically, after a year of apprenticeship with Sohlman. He was already "fully grown" by the age of fourteen, and at the same time very much aware he had to further his studies in other disciplines if he was to become successful in his chosen profession. He purchased books of all kinds for self-study, and found out where he could obtain drawing lessons. He knew of a German drawing school promoting art studies for youngsters without means. It was located at No. 18, Maximilianovsky Pereulok and was called Zeichenschule der Palme (The Palme Drawing School). Hjalmar boldly knocked on the headmaster's door and showed him his designs and drawings. The headmaster, whose name was Zeidler, was impressed, and he welcomed Hjalmar as a student, although the school was intended only for German youngsters. From the time he came to St Petersburg, Hjalmar had received Russian lessons on Sunday mornings in the school run by the Evangelical Lutheran congregation. Because the drawing lessons were held at the same time, he had to discontinue his Russian lessons. He studied diligently in the evenings on his own: history, geography, arithmetic, physics, and "measurement studies". Hjalmar had a talent for learning long written passages by heart, and he taught himself poems in Russian – Pushkin and Lermontov. The self-discipline to study on his own and to get himself an all-round education was exceptional in one so young, and it was truly admirable, considering how long and arduous his working days were. Without over-analysing the boy's actions, one can understand that Count Armfelt's blunt words were never far from his mind – Hjalmar would show them he could succeed on his own!

Hjalmar's apprenticeship advanced:

*Hjalmar Armfelt, c. 1895.*
COURTESY OF THE ARMFELT FAMILY

My friend, the apprentice Jussi Saukkonen, had qualified as a journeyman. His brother Bertil left the workshop to try his luck elsewhere. Mikko Virtanen had also interrupted his apprenticeship; in his place there were now two new boys, Herman Janson and Emil Litmanen. Now I myself was some kind of a foreman in the boys' room.

I had advanced well in my skills in the craft, but I began to think that going on with this kind of work I would not develop much further. The tasks for the most part were so-called piece-work: tea-glass holders, cigarette cases, and so on. We did not produce any gold work or chasing or repoussé work. If we got that type of commission, we sub-contracted from elsewhere. In my opinion, my apprenticeship was thus incomplete. If I was to reach the top, I would have to find a new master with whom to train. I was permitted to do as much overtime work as I wished, but I wasn't very keen on that. It hindered my studying.

*Olga Armfelt, Hjalmar Armfelt's wife from 1895 until her death in 1932.*
COURTESY OF THE ARMFELT FAMILY

The teachers at the German drawing school encouraged Hjalmar to continue his studies at a school of arts and crafts. There were two in St Petersburg at the time: the Baron von Stieglitz Central School of Technical Drawing and the Drawing School of the Imperial Society for the Encouragement of the Arts. Upon graduating from the courses at either of these, a student could enter the St Petersburg Academy of Art. Hjalmar Armfelt applied to the Imperial Society school and was accepted. It was

*Hjalmar Armfelt and family, in 1908. Armfelt wished to give his children the sort of education he had not been able to enjoy. Unlike many of his fellow master goldsmiths at Fabergé, he did not harbour dreams of his son Viktor's taking up the helm in the "family business". He enrolled his daughter Nelly in the exclusive Smolny Institute and Viktor attended the Cadet School of the Imperial Navy. Rather later, Viktor – who showed considerable musical talent – applied to the Petrograd Conservatory and trained as an opera singer.*
<span style="font-variant: small-caps">Courtesy of The Armfelt Family</span>

situated at No. 38, Bolshaya Morskaya. The school had around five hundred pupils, divided among various disciplines.

In the spring of 1889, Sohlman sold his large workshop to the German-born goldsmith Wichmann, and in the autumn of the same year he opened a smaller workshop at No. 42, Gorokhovaya. Hjalmar (who according to his contract still had two years of his apprenticeship left) and the master's son Sasha Sohlman were the only apprentices in the new establishment.

Sohlman did not mind me taking time off from work for studies at the art school. His approach towards me was liberal. I think he secretly hoped to have me as his son-in-law; he had a daughter by the name of Aina.

Then the new year 1891 began. I had saved a bit of money as the end of my apprenticeship was approaching. From the first of February, I was a journeyman silversmith with an official certificate in my pocket. I received from Sohlman the 25 roubles we had agreed upon. Now I had to start a new life on my own.

My first wage was 14 kopecks per hour. That was truly a very small wage for a 10-hour working day. I still attended courses at the art school, although this very much troubled me because it reduced my wages: I obviously did not receive any payment for the hours spent at school.

With his journeyman certificate in hand, the now eighteen-year-old Hjalmar stood on his own two feet. He moved out from his master's household and was now free to do anything. He got a job with another goldsmith,[73] whose speciality was gold cigarette cases, a popular article at the time. The hourly wage in this workshop for the fledgling journeyman was 20 kopecks.

Hjalmar knew whom to choose as company in his leisure hours. He rented a room together with a young man a few years his senior, one Ivan Sergeyev. He, like Hjalmar, was eager to further his education. The roommate read aloud in the evening to Hjalmar from the Russian classics – Dostoyevsky, Tolstoy, Nemirovich-Danchenko, Danilevsky, Krestovsky, and Turgenev – and the boys had lively discussions on the way of life both in Russia and Finland.

In 1894, after five years at the art school, and with only two years left until graduation, Hjalmar Armfelt decided to interrupt his studies. He considered it futile to continue studying art, because an applicant to the Academy of Art had to have graduated from secondary school. To change course and to become an artist was no longer tempting for Hjalmar, now that he was on his way to becoming a skilled silversmith.

### YOUNG GIRLS AND LOVE

Hjalmar Armfelt, as photographs of him attest, was a handsome young man. He had good breeding and manners, and he was ambitious. He lived in two separate worlds: the first was that of his well-placed family members and the other comprised the artisans and craftspeople he worked with. Rear Admiral Alexander Armfelt was the centre of Hjalmar's family circle in St Petersburg. Alexander's children, Hjalmar's cousins, became his best friends, and among them was the first great love of his life, his cousin Frida.

Frida was the daughter of Amanda Lindh, the first wife of Hjalmar's father. History came close to repeating itself, but Hjalmar fortunately realised before it was too late that a marriage between the two of them was unacceptable in a society such as Russia's, with its rigid class divisions. A young craftsman, regardless of his noble birth, was not an acceptable husband for the daughter of an admiral.[74]

Hjalmar Armfelt had the good fortune of meeting a young girl at the Choral Society of the Finnish colony. She was Olga Josefina Lindroos (1875–1932). Hjalmar initially went out with Olga merely to drown his unrequited feelings for Frida, but before long he fell in love. The two married in 1895 and soon started a family. Hjalmar never stopped thinking about Frida, however, and he kept her photograph throughout his married life.[75]

Hjalmar and Olga had two children: Olga Nelly Alice, born in 1896, and Viktor Mauritz Hjalmar, born in 1897. At first the young family lived with Olga's parents, who had enough space in their home for the younger generation. Hjalmar's father-in-law, Isak Lindroos, was a workmaster in the leather factory of Rudolf Hübner.

*A bellpush in silver, gilt silver, enamel, and hardwood. Fabergé, Hjalmar Armfelt, St Petersburg, made between 1908 and 1917. The item has been in the family of Count Vladimir Borisovich Freedericksz (1838–1927), the Minister of the Imperial Court and Domains from 1897 to 1917.*
COURTESY OF UPPSALA AUKTIONSKAMMARE, UPPSALA, SWEDEN

*A domed bellpush in gilt silver and translucent peach guilloché enamel, with a moonstone for the pushpiece. Fabergé, Hjalmar Armfelt, St Petersburg, made between 1904 and 1908. Scratched stock number 14696. Height 7 cm.*
PRIVATE COLLECTION. PHOTO BY ANDRE RUZHNIKOV, LONDON

An oval silver-mounted wooden photograph frame bearing an Imperial Crown, with an image of prima ballerina assoluta Matilda Kshesinskaya (1872–1971), later to become Princess Romanovskaya-Krasinskaya on her marriage (in 1921) to the exiled Grand Duke Andrey Vladimirovich. Fabergé, Hjalmar Armfelt, St Petersburg, c. 1900. Height 24.7 cm.
COURTESY OF WARTSKI, LONDON

Around this time Hjalmar got a new job. His employer was Fabergé's master goldsmith Antti Nevalainen. Armfelt mentions in his reminiscences that at this point he had gained a great deal more skill in his profession, and his pay had been doubled. His monthly wage under Nevalainen was around eighty roubles.

In 1901, Nevalainen promoted Armfelt to be his closest assistant, and Armfelt consequently called himself Nevalainen's workmaster. He says this had a certain impact and importance, because through the promotion his name became known in trade circles. A year later, in 1902, Olga's father fell ill and had to leave his job with only a modest pension. Olga and Hjalmar moved into a home of their own, a three-roomed apartment with a kitchen, for which they paid 27 roubles in rent per month plus an additional five roubles for heating. Now the young family had to economise.

## THE OFFER OF HIS LIFE

Troubled times were on the way. The Russo-Japanese War broke out in 1904. There was unrest among the factory workers of St Petersburg. The entire working class was in a state of ferment. Armfelt describes the situation from his own standpoint:

The younger generation among the workers began to speak up at this time. The older craftsmen in the goldsmiths' workshops also now started seriously to work towards finally securing better conditions for themselves. I remained passive. A strike was declared, and the workers were granted an eight-hour working day without much struggle. As it happened, the employers had already agreed on this, so the strike was ultimately unnecessary.

Hjalmar Armfelt also qualified as a master gold- and silversmith in 1904, and more significantly, it was the year in he received the offer of his life. In his reminiscences, he relates how it came about:

> One day when I was at work I got a note from the goldsmith J. V. Aarne. He wrote to ask if I could drop by, as he had something important he wanted to discuss with me. I barely knew Aarne personally, but I thought he might want to offer me a job in his workshop, and perhaps was prepared to offer me a higher salary or something of the kind. I went to see him in the evening, after work. He told me he intended to open a shop in the country of his birth, in the town of Vyborg, and he asked me whether I would like to buy his workshop here in St Petersburg. He had 20 men on his payroll and a contract with the court jeweller Carl Fabergé, with sole rights in both directions. The price of the workshop would be 8,000 roubles. He said his first choice ( for buying the workshop) was me, as he knew I had the qualities necessary to satisfy the requirements of the firm.
>
> I answered that this offer interested me greatly, but I didn't have the money – in fact not even close to that sum. Aarne went on, saying half the purchase amount could remain as a written acknowledgement of my indebtedness, and perhaps Fabergé would be willing to assist with an advance payment, because he certainly would not agree to giving just anybody the right to head one of his production units. The workshops were important to Fabergé, as the firm was one of the world's foremost goldsmith companies. I said that I would think it over and would give my reply as soon as possible. "Alright", said Aarne. "Based on what I have heard about you and what I have seen of your work, I have no doubt this arrangement would be a successful one. But let's not rush things. I shall speak to Fabergé on your behalf."
>
> When I got home, I told Olga and her mother about Aarne's proposal. Their reaction was as anticipated: how on earth it could be possible, just like that, to become the owner of a large workshop? It was a Friday. On Sunday we went to the Smolny to see Aunt Hilda, and I told her about the proposal. I was uncertain what amount of money Fabergé would be willing to advance me. He didn't know me. I thought I would have to obtain a loan elsewhere, just to be on the safe side. Auntie said if I was sure this project would be successful, she would give me 1,000 roubles. I then turned to my cousin Karin[76] and received from her another 1,000 roubles against a bill of exchange without interest, and thus I had 2,000. I wrote to my brother-in-law Pastor Palmroth in Ruovesi, Finland, about the proposal, and from him I received a further 1,000 roubles.[77]

*A silver-mounted wooden lampstand on a plinth supported by four silver winged gryphons. Inscribed to Baron Emmanuel Julievich von Nolde as a commemorative gift from the Chancellery of the Council of the Empire. Fabergé, Hjalmar Armfelt, St Petersburg, made between 1904 and 1908. Height 31 cm.*
COURTESY OF SOTHEBY'S

After this I went back to Aarne, who said he agreed to my offer. "Well, let's go speak to Fabergé". We were received by Fabergé's son, Agathon Karlovich. He said: "You have been Nevalainen's right-hand man, but there is a great difference between Aarne and Nevalainen. We have become accustomed to the standard of work coming from Aarne's workshop. Can you guarantee you can produce the same quality?" I replied, saying that I have attended an arts and crafts school for five years, and as a goldsmith I am not afraid of any challenge in my own profession. "Well", he said, "Go speak to my father, but we have already made our decision."

In other words, the matter was settled. I received 1,000 roubles from the cashier. We went to see the notary. Aarne received the money from me and the acknowledgement of indebtedness in writing for 4,000 roubles, and I became the new owner of the workshop. Everything had to be handed over in the condition it was on the day of the transfer of ownership: the silver, the gold, and the semi-finished objects. We went together to the office director to transfer the lease of the workshop into my name. Aarne moved to Vyborg and I moved into his premises.

The workmen – 20 men and 3 apprentices – were almost all previously known to me. Several were Finns: Koponen, Arvila, Virkkunen, Niinimäki, Ojala, Leino, Långsjö, and the apprentice Kalle Kuula. The remainder were Russians. The workmen received me with salt and bread on a silver plate, according to the Russian tradition.

*A silver-mounted bellpush in nephrite with an almandine garnet pushpiece. Fabergé, Hjalmar Armfelt, St Petersburg, made between 1904 and 1908. Height 5.7 cm.*
Courtesy of Sotheby's

## TROUBLED YEARS

The years 1904–5 were difficult ones in the Russian Empire. The Russo-Japanese War concluded in a catastrophic defeat for Russia. At the end of 1904, massive workers' strikes took place within industries and factories across St Petersburg, and in January 1905, electricity was cut in the city and no newspapers were published. On the 9th of January, Father Georgy Gapon, an Orthodox priest, arranged a peaceful demonstration outside the Winter Palace in which striking workmen and their wives and children took part, as many as 200,000 persons by some estimates. The aim of the demonstration was to hand over a petition to the Emperor with the hope of more humane working conditions, shortened working hours, fairer wages, impartial wage-settlements, and reductions to the inhuman overtime work imposed on the working class. The Imperial Guard, which safeguarded the Winter Palace, opened fire on the unarmed demonstrators, and masses of innocent people lost their lives during this "Bloody Sunday" massacre. The tragic incident resulted in enormous bitterness towards the Emperor and his autocratic rule.

The tragedy also hit the Armfelt workshop:

Our apprentices, who were curious about what was happening, climbed the trees in the Alexander Park. The soldiers probably thought they were lookouts or "signallers", and therefore shot at them. Kalle Kuula was killed. The number of deaths that day was enormous, and shooting took place in many places in the city. The commander of the garrison, Trepov, had issued a day-order not to save ammunition. Next morning, I went to the places where the shooting had been most fierce. The snow was stained with blood. There were even bloodstains on the walls of the

*A gold-mounted rectangular nephrite photograph frame with a translucent pink enamel panel and the oval aperture set with seed pearls. Fabergé, Hjalmar Armfelt, St Petersburg, made after 1904. Scratched stock number 15683. Height 8 cm.*
COURTESY OF SOTHEBY'S

houses. After a lengthy search, we found the body of Kalle Kuula[78] in the mortuary of one hospital. A bullet had pierced his heart. Kalle's mother was the widow of a labourer; she was all alone and Kalle was her only child. He was just 15 years old.

The disorder and violence, which seemingly subsided after the difficult year of 1905, did not greatly affect the business activities of Fabergé. Armfelt's workshop was working at full stretch, and the new workmaster was able to start paying off his debts. Half of what he owed to Aarne was already signed off by 1905. During that same year, Armfelt had to look for new premises, both for his workshop and his home. The landlord at No. 42, Ekaterininsky Kanal[79] would not renew the rental contract. Armfelt's new address became 35, Kazanskaya. The place was already known to him, for it was where Antti Nevalainen had his workshop. Several other goldsmiths were on the same street, among them Gabriel Nykänen at No. 39. The new premises had eight rooms and a kitchen. Two walls were taken down to make the workshop more spacious and practical. New gas and electrical lines had to be installed. The family home was set up next to the workshop.

## AT THE TOP OF HIS CAREER

Armfelt's production consisted of a dizzying array of silver and gold objects, both decorative and for daily household use: boxes, table frames, desk accessories, table and mantel clocks, bell-pushes for the dining room, dishes and bowls. In addition, a significant number of large silver objects were commissioned by the Imperial Guard regiments for their various jubilees and anniversaries. In 1912, when the Russian Empire celebrated the 100th anniversary of the Patriotic War against Napoleon, Armfelt's workshop produced memorial pieces and gift objects for all the elite regiments. These items – among them silver boxes, étuis, *bratinas*, *kovshes*, beakers, and drinking cups – were displayed in the club rooms and messes of the various regiments in St Petersburg, Peterhof, and Tsarskoe Selo. An inventory of what has possibly survived in these collections is yet to be carried out.

Fabergé received enormous commissions of gift objects for the tercentenary of the Romanov dynasty. Armfelt relates that his workshop was working at capacity throughout the winter of 1912–13 on these sumptuous and costly *kovshes*, goblets, and ornate silver covers for congratulatory addresses. All these gifts were given to the Emperor by a bevy of government and private institutions. Objects of this type were, regrettably, among the first to be destroyed by the new regime after 1918. As far as we know, not one of the luxurious gift items Armfelt produced for the Romanov 300-year jubilee has survived.

Armfelt mentions in his reminiscences that his workshop had received important orders from the oil magnate Emanuel Nobel, who was one of Fabergé's most loyal customers, as well as from Prince Iusupov, from the Minister of the Imperial Court Baron (later Count) Vladimir Freedericksz, and from Grand Duke Vladimir Alexandrovich (the younger brother of Alexander III) and his wife Grand Duchess Maria Pavlovna. Unfortunately, Armfelt does not specify what his workshop delivered to these distinguished clients. By another source, we do know of one of the commissions, a fabulously expensive order placed by Emanuel Nobel, and we also know it has

survived to this day. The piece was noted in the memoirs of Fabergé's head designer Franz Birbaum as one of the most important orders the House of Fabergé ever received. It is a massive grey granite table clock in the shape of a temple of ancient fire worshippers, the symbol of the Nobel Brothers' Petroleum Company, Branobel. See illustration on page 231. The commission commemorates the company having extracted one billion *pud*[80] of crude oil between 1879 and 1906. The clock was completed for Branobel's 30th anniversary, in 1909.

Even during those sunny economic times, the clouds were forming on the horizon: a month-long strike within the goldsmith branch was called in 1912. Armfelt was a member of the employers' federation and hence received economic support from it. He himself was able to take an active part in the goldsmiths' work, production was not badly hit, and his workshop managed to pull through the stoppage without any substantial financial setback. The workers demanded a 20 per cent raise in general wages, a 50 per cent increase in overtime pay, and no work on Sundays. The strike ended with a mutual acceptance of the workers' demands.

## THE EDUCATION OF THE ARMFELT CHILDREN

It is understandable that Hjalmar Armfelt wanted to give his own children the education he had not himself been able to pursue. From the outset, he planned how he should go about schooling his children with the aim of returning them to the social class into which he was born. In other words, unlike most of Fabergé's workmasters, Hjalmar did not want his son Viktor to follow in his footsteps and continue his life's work.

He enrolled his daughter Nelly in the Smolny Institute, the elite academy for young ladies of noble birth, and his son Viktor in the Cadet School of the Imperial Navy. He then had to prepare them for the entrance exams. Nelly, aged ten, was already supposed to begin her education, so Armfelt arranged for a tutor to teach the girl the basics of French and German. Nelly passed her entrance exams without difficulty and entered the Smolny in 1906.[81] She graduated in 1917 and went on to the Bobrishchev-Pushkin Institute of Linguistics.

Viktor, at the age of ten, was granted the right to study at the First Cadet School, after which, at fourteen, he would automatically be entitled to continue at the Cadet School of the Imperial Navy. Hjalmar sought advice on this matter from his distant relative Count Carl Armfelt, assistant to the Minister State Secretary in St Petersburg. Count Armfelt said that the official application should state this was the first time a member of the Armfelt family was invoking their right to study at the Cadet School, and the first time a member of the family was applying for a grant. Hjalmar, who was all too aware of the rules of Russia's class-conscious society, deemed it necessary once more to make sure that his son's application was in accordance with the law. In his own words: "Your Excellency, you are no doubt aware that I am a craftsman, a silversmith? 'I know,' was his reply, '...and my recommendation is we keep it quiet. Bring your application to our chancellery and I will see to the matter.'"

In the autumn, Viktor became a cadet. The 11-year-old soldier looked so touchingly sweet in his new uniform. In 1915, Viktor's studies continued at the Naval Cadet School. He took part in a training squadron in Eastern Siberia that visited Japanese harbours and held joint exercises and manoeuvres. He was promoted to the rank of

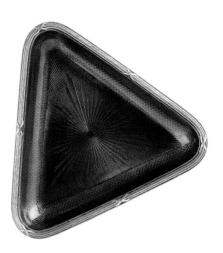

*A triangular vide-poche tray in silver, with violet translucent guilloché enamel on a sunburst ground. Fabergé, Hjalmar Armfelt, St Petersburg, made between 1904 and 1908. Scratched stock number 14429. Length of each side 10 cm.*
COURTESY OF COLLECTION MIRABAUD

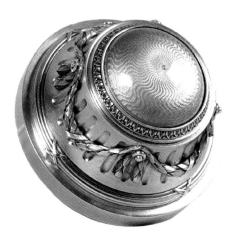

*A domed bellpush in silver and enamel. Fabergé, Hjalmar Armfelt, St Petersburg, made between 1908 and 1917.*

COURTESY OF JOHN ATZBACH, REDMOND, WASHINGTON

*gardemarin*, and in 1917 became a *michman* (Sub-Lieutenant) in the Russian Navy. In 1918, he enrolled in the Nikolayev Naval Academy, now renamed the Maritime Academy. Viktor soon realised, however, that military life was not for him, and that his true interest lay in music. He applied for a place at the Conservatory in Petrograd (the new name of St Petersburg), where he trained as an opera singer.

## THE GATHERING STORM

War broke out in the summer of 1914. Hjalmar Armfelt relates the problems from the vantage point of his own workshop:

> All age groups were mobilised. Also those in the second class of the reserves were called into service. Nine men were called up from our workshop. Initially the notion of continuing in the workshop seemed completely out of the question. For a short time, we worked four days a week, but since commissions were still coming in, we started working full-time. I employed several new men, most of them Finns. Miraculously, there was enough for us to do. I think the fear of inflation made people invest their money in objects made of precious metals. People had enough of both gold and silver roubles, the alloy of which was high. In addition, silver was easily available from England via Murmansk.[82]

The premises on the first floor of Fabergé's workshop wing were vacated in 1916. The master goldsmith August Hollming had died in 1913. His son Väinö had continued in his wake, but his contract with Fabergé was not renewed after 1914. Fabergé instead suggested Armfelt take over the space.

> Technically speaking, the premises were absolutely first-rate: nine windows in a row, all the conveniences in one place. But these premises did not have room for the workmaster's home. Our home had thus far been adjacent to my workshop. There was no way, however, that we could make the entire space [of the current workshop] our home, so I offered it to a goldsmith by the name of Antti Kajander for the sum of 500 roubles. I kept one of the rooms, into which we squeezed all our furniture; it turned into something resembling a furniture shop. I was convinced I would find a suitable home for us by fall. The family spent all summer in the countryside.

Armfelt moved into Fabergé's workshop wing at No. 24 Bolshaya Morskaya at the beginning of 1916. A year later, in early 1917, the February Revolution swept through St Petersburg. Armfelt takes up the story:

> The first sign of this was a lack of provisions, followed by endless queueing and a system of ration cards, which thus far was an unknown concept. There were demonstrations in the streets. Red signs demanded bread and the end of the war. The police tried to disperse the mob, but in vain; they [the police] were helpless. The military were called in, but the soldiers revolted and refused to obey orders. The revolution was upon us.

Initially the Socialists were in power. At the beginning, the bourgeoisie – in great measure – supported the change, but control gradually moved into the hands of the Communists. Kerensky, who came to power, was an unparalleled speaker but a poor politician. He made endless mistakes and squandered all his influence. By autumn, the October Revolution broke out. Now the situation became quite insane.

The workers, agitated by their leaders, seized all power in their hands. They started terrorising and eradicating every facet of society. Those who did not obey their absurd orders were crushed without mercy. Wherever resistance occurred, they brought in field guns and let them "sing" with "three inches"[83] until it was all over.

This was what happened all over the city. All banks and private houses were seized, and the valuables of the inhabitants were confiscated.

In our workshop, the men gathered every morning, but not to begin work, rather to hold their own meetings. Wages nevertheless had to be paid to them for the time they sat at their deliberations. I explained to them I could not afford to pay their wages if no work was done. If this continued, I would have to close the workshop. I received the answer that this would be fine, but in that case, I would have to pay their salaries for half a year in advance.

I thought things over and decided, since the value of money had in practice been reduced to dust, I was going to lose it anyway. I threw the money on the table and told them all to go to hell! When they were gone, I started to work on my own, but soon noticed that most of the workshop tools had disappeared.

An interesting incident took place a few weeks later. I happened to run into one of my workers, a man named Pavlov. He was carrying a leather briefcase under his arm. He was very well dressed and looked most important. He saluted me cordially and stopped for a chat. I asked what Mr Pavlov was doing nowadays. He replied that he was a civil servant at the Ministry of Justice, an attorney. I replied: "But you don't have a law degree". He burst out laughing, saying it was not necessary: "I am a member of the proletariat and that is enough. I naturally have deputies who are specialists". I told him a substantial quantity of the tools and appliances had disappeared from my workshop. He replied that those had been purchased with the sweat of the workers' brow, and the workers were therefore entitled to take what belonged to them.

When Fabergé finally closed its doors in 1918 and Armfelt's workshop was put under seal, Armfelt found himself out of work. The new regime started up study programmes in various occupations in each secondary school. Armfelt was employed as a teacher of craftsmanship in two different schools. The project never really got going, owing in part to the pupils' unwillingness to learn anything and in part to the disastrous lack of educational materials.

The general mayhem in the city gradually became too much for Armfelt. With the arrival of 1919, he concluded that it was necessary for him and his family to leave Russia at any cost. He found a prospective customer for their home and all their belongings – the household goods, the furniture, the piano, and the sewing machine.

*A jewelled desk barometer of carriage clock form. Two-colour gold, gilt silver, rose-cut diamonds, moonstone, white agate, guilloché and opaque enamel. Fabergé, Hjalmar Armfelt, St Petersburg, made between 1904 and 1908. Scratched stock number 15313. Height including handle 11.5 cm. In its original wooden case.*

*The instrument is inscribed in Russian: "Stormy/Rain/Change/Fair/Very Dry".*
Courtesy of Sotheby's, London

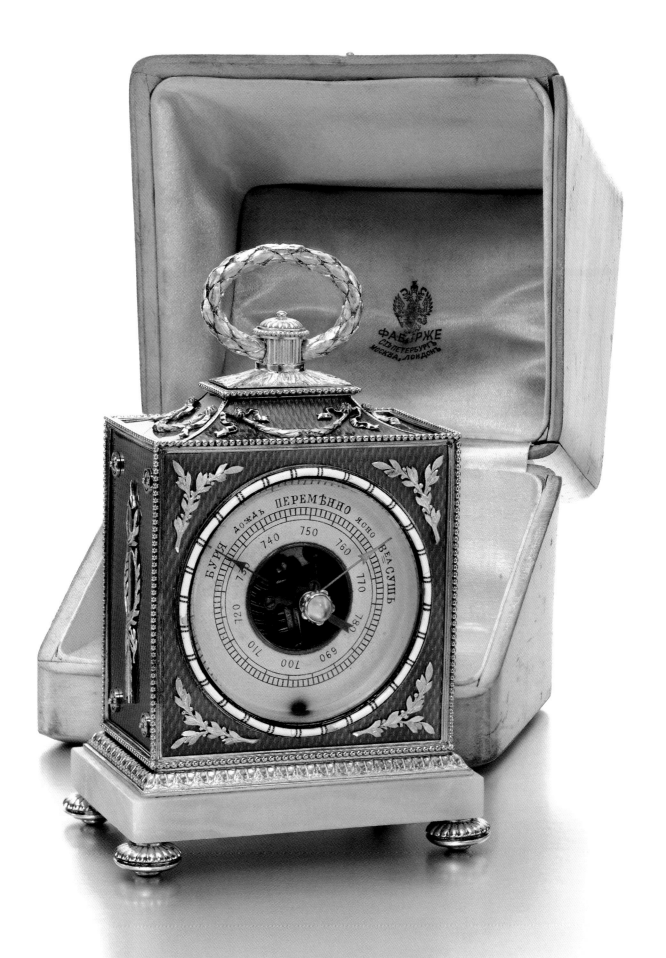

Armfelt's savings, which amounted to some 25,000 roubles, were lost as the banks had stopped paying out cash both to private clients and enterprises. He also lost a fortune in shares and obligations. Armfelt did have a substantial stock of precious metals: altogether about 16 kilogrammes of silver and one kilogramme of fine gold, which he hid in the ground underneath the woodshed of his home. In this way he prepared himself to leave the country with his wife Olga and daughter Nelly, filing an application with the relevant authorities.

Armfelt also had eight barrels of gold "debris" – dust and shavings – from his workshop in the cellar at No. 24, Bolshaya Morskaya, stored there from the time the workshop's refiner furnace had been shut down for the war. This waste material was also worth a fortune. He decided to go back to arrange for its transport to another location. Although his workshop had been put under seal, he was positive the Red Guards had no idea the debris had any value. This perfectly rational action was to change Hjalmar Armfelt's life in so many ways:

> I walked in through the gates, but did not see there was a Red Guard at the door with his rifle strapped across his shoulder. In the yard, the dvornik [janitor] Peter came towards me and whispered: "Why on earth are you here? You will not be allowed to leave. They arrest everybody who comes to this house". I didn't believe him. I asked him whether the barrels of scrap gold were still in place. "Yes, they are", he replied, "but you yourself, what about you now?" I tried to back out of the yard, but the Red Guard shouted at me to stop, and he reached for his rifle and ordered me to go up to the fourth floor, to be questioned by the Commissar...

And so begins a harrowing period, also fascinatingly documented in graphic detail in Armfelt's reminiscences, although it is largely outside the scope of this book.

He was thrown into a cell in the Shpalernaya Remand Prison, his case not helped at all by the fact that the Bolsheviks deemed him to be "a nobleman" (the irony of this is quite grotesque under the circumstances), nor by his Finnish background, which saw him associated with the commander of the Whites in the Finnish Civil War, Carl Gustaf Emil Mannerheim. To the Reds, Mannerheim and the Finnish Whites were little more than "butchers". Finns rounded up in St Petersburg following the Revolution were very much made aware of this.

Armfelt's son Viktor had also been arrested and imprisoned in Shpalernaya, and Hjalmar was able to make written contact with him through a prison guard, and to learn that the rest of the family knew of his plight, though visits were out of the question.

Many of the Finns were then transferred to Moscow by train. Hjalmar's wife Olga and his daughter Nelly managed a brief contact at the station, but then the cattle wagons departed, and Hjalmar's next weeks were spent in the Novopeskovsky Camp, an assembling point for all categories of political prisoners. His detention continued at the large Petrovsky Labour Camp, from which detachments of Red Guards would march the prisoners off to perform hard physical work around the city – carrying furniture, cleaning floors, tearing down old buildings, loading trains...

One morning Hjalmar's group went into an apartment on one of the most fashionable streets in Moscow. He immediately noticed two small silk flags on the

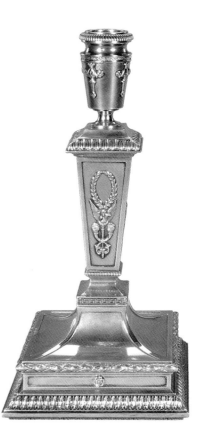

living-room mantelpiece: they were the official Swedish flag. In other words, it was a Swedish home they had been sent to empty and requisition. When left alone for a moment, Hjalmar crept into the kitchen, and encountered first a terrified kitchen maid and then the lady of the house, with whom he was of course able to converse. She told him her husband, the Swedish envoy[84] , had been arrested and the family's possessions were being carried out into the street. Hjalmar apologised for his role in the looting, but pointed out he, too, was a prisoner.

As the summer of 1919 moved towards autumn, Hjalmar was transferred to a Red Cross camp. On the positive side, he was able very briefly to meet with Olga and Nelly, who told him Viktor had been liberated and was working at the Naval Staff. A much more worrying development was that other Finnish prisoners left the camp, but that the Armfelt name indicated he was "dangerous", and Hjalmar was informed by his interrogators that he would be held as a hostage until peace had been signed with newly-independent Finland.

With dysentery, scurvy and lice all rife in the camp, and with only meagre rations, every additional day took its toll, and November brought both bitter cold and snow and an outbreak of typhoid. Firewood was scarce, and the prisoners were ordered into the forest with axes and saws to fetch their own logs.

In March 1920, the long ordeal was over, as suddenly and arbitrarily as it had begun. An order had arrived from St Petersburg "for the immediate release of political prisoner H. Armfelt".

Hjalmar took the night train to St Petersburg, finding the city in a wretched, broken state. He was reunited with his wife and children, but the first thing on his mind was to find a way to get out and get back to Finland. Here, his lengthy time in the labour camps finally worked in his favour: the Communist regime were now keen to get rid of former political prisoners. He merely had to prove he was a Finnish citizen, and the exit permit would be issued. Technically, the citizenship certificate required a clergyman's signed testimony, but in the post-revolutionary chaos, Armfelt and a friendly church janitor simply wrote and rubber-stamped the document themselves.

Some weeks later, in May 1920, Hjalmar, Olga, and Nelly took the train from Petrograd ( formerly St Petersburg) to the station of Valkeasaari (today Beloostrov) on the Soviet side of the border, before walking across the bridge to Finland and home. The three refugees were taken, in bad shape and seriously malnourished, to a quarantine hostel, where they stayed for two weeks.

## Back in Finland

Viktor Aarne, Fabergé's former workmaster, had heard about the return of Hjalmar Armfelt and sent him word to visit Vyborg, where Aarne had opened his new store and workshop after leaving Fabergé in 1904. Aarne, who knew Armfelt as a skilful and reliable craftsman, offered him a job in his firm, as well as financial help.

In this way, Armfelt started his life as an émigré in the country of his birth by working for Aarne. Since this was only a temporary arrangement, a year later Hjalmar accepted an offer to take over the management of the jewellery shop of Hjalmar Fager-roos in Helsinki. This, too, was a short-lived exercise, and in 1922 Armfelt was hired by the firm Oy Taito Ab. His extraordinary skills meant he quickly became a driving

*A pair of gilt silver candlesticks with square tapering stems. Fabergé, Hjalmar Armfelt, St Petersburg, made between 1908 and 1913. The candlesticks were sold at the Fabergé London store and bear London import marks for 1913. Height 20.5 cm.*
COURTESY OF SOTHEBY'S

force at Taito, which had been founded in 1918 with a view to renewing the art of the Finnish silversmiths. The firm produced arts and crafts in gold, silver, brass, and iron. Unfortunately, the time was not yet ripe in Finland for modern jewellery and objets d'art in precious metals. Armfelt left Oy Taito in 1925 to take over the position of technical director at Kultakeskus Oy. He continued working for them until his retirement in 1937. Kultakeskus Oy is today Finland's largest industrial enterprise in the field of precious metals.

An active and energetic man such as Hjalmar Armfelt did not find retirement very easy or fulfilling. He consequently started looking around for a new job, and was once again employed by Oy Taito Ab, where he had worked twelve years earlier. He now became head of Taito's silver production, but this project was blighted by the outbreak of the Winter War in 1939.[85] Taito was taken over for the war effort, and Armfelt's line of work was discontinued.

A peace treaty was signed between the Soviet Union and Finland in March 1940, but war broke out once more in June 1941. Armfelt was aware of the lack of Russian-speaking men in the Finnish armed forces. Despite his age (he was in his late sixties by this stage), he volunteered for military service and undertook a course for interrogators of prisoners of war. Soon he was back in a situation eerily similar to the one he had experienced himself in Moscow.

He was assigned to a POW camp on the Karelian Isthmus, close to Vyborg. Some 2,000 Red Army prisoners of war were registered in several camps in the area. Armfelt was tasked with questioning each prisoner and writing intelligence reports on them.

During the months of October and November, with his briefcase under his arm and a bagful of forms, he walked from place to place, often ten kilometres per day. This would not have been difficult for a younger man, but it was challenging for one approaching seventy, especially when there was snow on the ground.

*A silver presentation hunting horn, tapered, and with a curved terminal. Fabergé, Hjalmar Armfelt, St Petersburg, 1912. Length 58.5 cm. The item was a gift to Grand Duke Nikolay Nikolaevich (1856–1929) from fellow-hunters whom he had hosted at his large (3,000 hectares) estate of Perchino, close to the city of Tula. The Grand Duke was an avid hunter, with a famous kennel of borzoi dogs, bred for wolf-hunting. The names of the donors, some two dozen of them, are engraved on the horn.* COURTESY OF SOTHEBY'S

*A curved paper knife/letter opener in gilt silver and enamel. Fabergé, Hjalmar Armfelt, St Petersburg, made between 1904 and 1917. Length 17.4 cm.* COURTESY OF STOCKHOLMS AUKTIONVERK, STOCKHOLM

*Hjalmar Armfelt on his 60th birthday in 1933.*
COURTESY OF THE ARMFELT FAMILY

After the Moscow Armistice had been signed with the Soviets in 1944, Armfelt received several offers of work, among them from his earlier employer Oy Taito Ab, but he felt he was too old to take on yet another responsibility.

Armfelt was a craftsman of many talents. Not only did he master all the techniques of the gold- and silversmith, he also tried his hand at carpentry, sculpting in wax and clay, and oil painting. He made objects and ornaments in wood for his own amusement. In his old age, he enjoyed building miniature doll's houses for his grandchildren, fully furnished in the most minute detail. Hjalmar spent a lot of time painting in oils and watercolours. His motifs were frequently taken from nature – most often compositions with flowers and plants. His gifts of art to members of his family and friends were greatly appreciated.

At the very end of his life, Armfelt notes in his reminiscences:

> Whenever I am in good health, my greatest joy is in the arts. I review in detail in my thoughts all the beautiful objects of art which I had the chance to produce during my youth, when I was employed by Carl Fabergé.
>
> I also wish to point out that my memory is extremely sharp, especially when it concerns times long past.

Hjalmar Armfelt died on 22nd July 1959, at the age of eighty-six.[86]

The table clock was designed by Eugen Jakobson and produced in the workshop of Hjalmar Armfelt in 1909 and was the most important commission Fabergé ever received from Emanuel Nobel, the head of the Nobel Brothers' Petroleum Company (Branobel).

The silver plaque at the base, which is flanked with cast silver figures symbolising Industry and Trade, features a map of the Absheron Peninsula between bas-relief profile portraits of Ludvig (1831–1888) and Emanuel (1859–1932) Nobel. The inscription reads: "In commemoration of the extraction of one billion *puds* of crude oil by the Nobel Bros. Company, 1879–1906 (1 *pud* = 36.11 pounds or 16.38 kg). On the reverse side of the plinth is a silver plaque depicting the Nobel oil fields in Baku.

The body of the clock is of grey granite and is in the shape of the Baku Ateshgah, a 17th Century Hindu and Zoroastrian religious temple in Azerbaijan, also known as the Fire Temple of Baku. It was the symbol of the Branobel firm. The temple stands on a pedestal of red granite resting on low silver feet. Its four corners are crowned by flames of rhodonite. At the top is an angular finial of silver. A frieze of embossed silver with a swastika and fire-wheel motif runs around the upper walls. Below the clock dial is a glassed aperture, framed with silver latticework. Either side of it are applied geometric ornaments in silver.

*Fabergé, Hjalmar Armfelt, St Petersburg, 1909, 88 zolotnik. Height 65 cm. Width 44.5 cm.*
*The imposing clock, designed by Eugen Jakobson, came in a fitted oak case.*
COURTESY OF BUKOWSKIS, STOCKHOLM

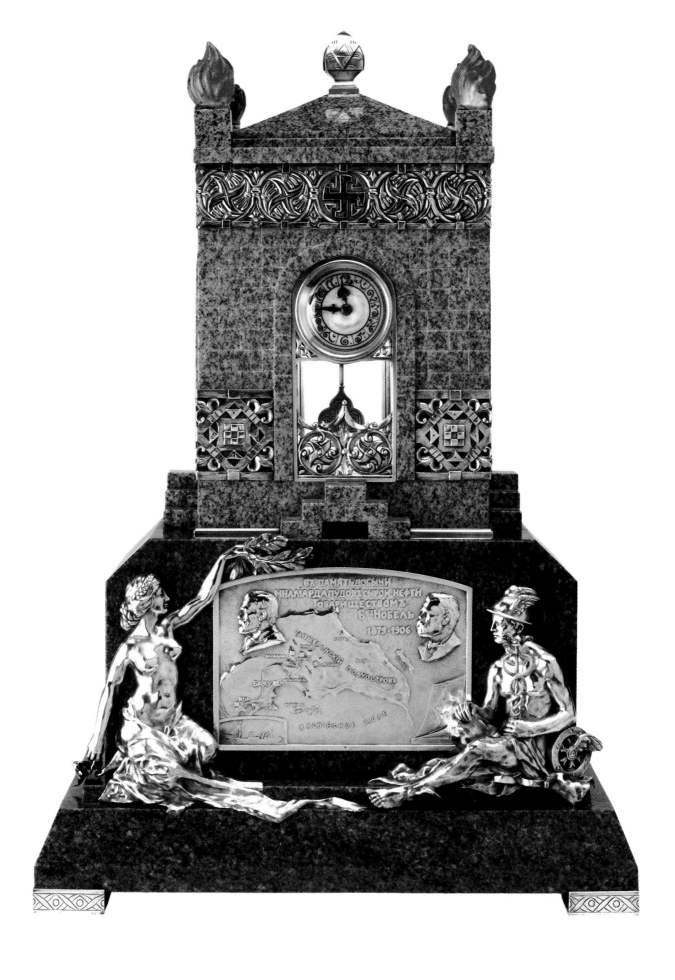

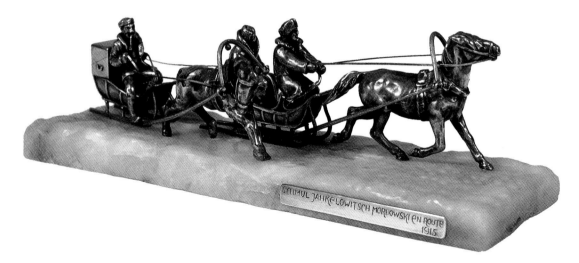

W hat DO we have here? Clearly a one-off item made for a special occasion, this silver statuette on a marble base depicts two horse-drawn sledges. A large packing case rests on the back of the first, and a fur-clad passenger is being driven in the second. The silver plate on the base reads: "Schmul Jahkelowitsch Mordowski en route 1915". It was made in the Fabergé workshop of Hjalmar Armfelt, and it has an amusing story associated with it. The St Petersburg industrialist Maximilian Othmar Neuscheller commissioned the piece to commemorate a delightful episode that occurred prior to the wedding of his godson Max Hendrik van Gilse van der Pals to Baroness Sara Stjernvall on 28 December 1915/9 January 1916. The groom writes in his memoirs:

*I was in fact surprised when I saw my godfather Max Neuscheller was among those who had arrived at Lindnäs (the Stjernvall estate) the day before my wedding, as he had explained to me a few days earlier that he unfortunately could not be present. His appearance thus pleased me very much. His arrival at Lindnäs is a story in itself, worth recounting because he had orchestrated it so cleverly.*

*From St Petersburg, he had arranged with the inn for two sleighs to be at the Lappila railway station at 9 o'clock in the morning, on the arrival of the local train from Lahti. He got off* *the Lahti sleeper, lest he arrive too early, and waited for the local train, sitting for a few hours at the station in Lahti.*

*His Lappila horses were ordered for him as had been arranged. He himself sat down in one sleigh and the luggage – two large wooden boxes – was loaded onto another. When the drivers pulled up in front of the main building at Lindnäs, a man swathed in a fur collar dismounted from the sleigh and introduced himself as the silver merchant Schmul Jankelowitsch Mordovsky of St Petersburg, and offered his wares for sale for the forthcoming wedding, which he had heard about.*

*My future mother-in-law had come to the veranda and she spoke to the merchant in French, as using German was forbidden during the war. She explained in a very firm and imperious tone that there was nothing they needed from the merchant, and asked him to leave. In a flash, he unwrapped his fur collar, and my mother-in-law instantly recognised him and bid him a warm welcome. The boxes contained a Fabergé silver coffee and tea service together with their associated stands from St Petersburg, and they were a wedding gift for us. All and sundry – not least my godfather himself – delighted in his invention of such an unusual and successful prank. In order to commemorate the incident, he had Fabergé create in miniature the arrival at Lindnäs. Neuscheller himself, the drivers, horses, sleighs, and boxes were fashioned in silver and attached to a marble base.*

*Silver and marble. Fabergé, Hjalmar Armfelt, St Petersburg, 1915.*
*Length of marble base 34 cm. Width 10.5 cm. Height of sleighs and horses 7 cm.*
PRIVATE COLLECTION. PHOTO BY HASSE PETTERSSON

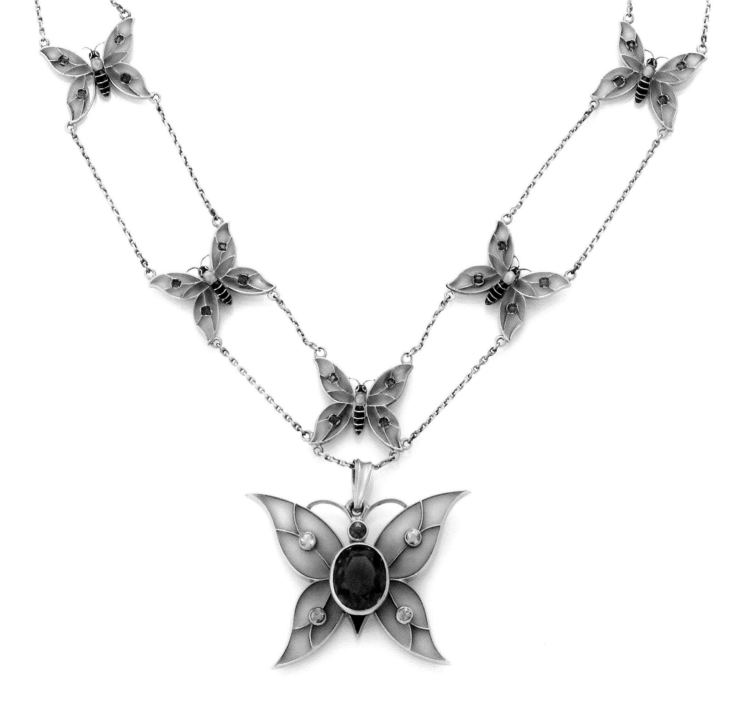

## FROM THE ARMFELT FAMILY JEWEL BOX

In 1895, at the age of twenty-two, Hjalmar Armfelt designed and crafted a romantic jewel for his future bride, Olga Lindroos, as a morning gift on their wedding day. The ethereal necklace composed of butterflies, symbols of conjugal bliss, is a perfect example of Armfelt's interest in trying his hand at new and varied techniques. The butterflies are enamelled using the plique-à-jour technique, one which demands special skill and is rarely seen in Fabergé's oeuvre.

*Gold, amethyst, garnets, and enamel. Hjalmar Armfelt, St Petersburg, 1895.*

PRIVATE COLLECTION. PHOTO BY KATJA HAGELSTAM

# Julius Rappoport

Julius Rappoport, originally Isaac Abramovich (1851–1917), was born in the small village of Dotnovo (Dotnuva), some 70 miles (110 km) north-west of the present-day Lithuanian capital Vilnius. At that time in the mid-19th century, the area was part of the Russian Empire. These regions had active Jewish communities, *shtetls*; the population engaged in commerce and shopkeeping, but also in various crafts such as tanning and metalwork.

The modest circumstances of Dotnovo did not offer young Isaac Abramovich much of a future and he therefore left home to seek an apprenticeship in a craft. His first place of training was Berlin, the capital of Prussia, a city undergoing great expansion and with some 800,000 inhabitants. In 1864, at the age of 13, Isaac was training with the silversmith Scheff in the city, and he stayed with him until he had earned proficiency in the craft. In 1884, twenty years later, Rappoport took the step of qualifying for his master's certificate as a silversmith. This took place in St Petersburg. Now he was ready to open his own workshop, and he found suitable premises at 65, Ekaterininsky Kanal.[87] His skills were soon discovered by Fabergé and within a few years he was the head silversmith of the firm in St Petersburg.

In the 1890s, Isaac Abramovich converted to Protestantism and became a member of the German Evangelical Lutheran Church in St Petersburg. In the process he changed his given name to Julius.

Rappoport was a well-versed and gifted master silversmith with an impressive production. This included large dinner services, incorporating centrepieces, terrines, and candelabras. He produced a breathtaking number of oversized and custom-made presentation *kovshes* and *bratinas,* gifts and prizes for important anniversaries of meritorious men in state service or for organisations and elite regiments of the Imperial Russian Army. Rappoport was also entrusted with the important commission of creating parts of the dowries for Grand Duchesses Xenia Alexandrovna and Olga Alexandrovna, the daughters of Alexander III.

In addition, he produced objects for interior decoration such as lamps, tables, and desk sets in silver, combined with hardstone or wood.

A wide range of smaller objects in cast silver were also part of Rappoport's production repertoire. His animal figures were hugely popular, either as purely decorative pieces or fashioned as table lighters or match holders. There were endearing monkeys in amusing positions, elephants, frogs, pigs, rhinos, alligators, ostriches, dolphins, rabbits, and yet more elephants - it seemed there was no end to the master's imagination! The animal figures were produced applying the lost-wax casting process (*cire perdue* in French). The figures were realistically sculpted in wax prior to being cast in silver. For some of the most popular models, especially those of the monkeys, long series of identical pieces were made.

*"Big Bad Wolf" cigar lighter. Silver, glazed earthenware, wick. Fabergé, Julius Rappoport, St Petersburg. Made between 1899 and 1908. Scratched stock numbers 4571 and 5327. Height 16.5 cm. The design of the object is inspired by the classic European fairy tale "Little Red Riding Hood".*

© Fabergé Museum, St Petersburg. The Link of Times Cultural and Historical Foundation. Photo by Andrey Terebenin

*A silver table lighter, modelled in the form of a seated frog, with cabochon garnets for eyes. The design of the piece is consciously light-hearted, with the frog posed as if singing bel canto, one "hand" clasped theatrically to its chest while the other rests on its knee. The animal's back is crusted with warts, and the movable tongue is pierced to accommodate the lighter's wick. Fabergé, Julius Rappoport, St Petersburg, 1899-1908. Height 10.5 cm.*

Courtesy of The Woolf Family Collection, London

## THE FIRST SILVER ARTEL

When he retired in 1909, Rappoport rewarded his workmen for their long and faithful service by leaving his workshop and all its equipment to them. The First Silver Artel was thus formed.

This Artel remained at the same address and was active until 1911, continuing to work for Fabergé, at the outset successfully and with approximately the same production programme as under Rappoport.

The Artel was wound up in 1912–1913, following internal conflicts and unexpected rises in costs. When the workshop closed, Hjalmar Armfelt took over its orders for the House of Fabergé.

# Stefan Väkevä

Stefan Väkevä (1833–1910), was born in the parish of Säkkijärvi on November 4th, 1833. Säkkijärvi, roughly 120 miles or 200 km from St Petersburg, was one of the coastal communities in the Karelian Isthmus ceded to the Soviet Union after World War II, and some 90% of the old Säkkijärvi is now Kondratjevo in the Russian Federation.

Väkevä's forefathers were deeply rooted in the Säkkijärvi village of Väkevälä. The village was mentioned for the first time in the tax registers at the beginning of the 1540s. The original settler owned 1,573 hectares of land. He must have been a robust individual, because he was nicknamed *Väkevä*, which translates as 'sturdy' or 'strong'. The first Väkevä gave his name to his homestead, and gradually the entire village and its inhabitants bore that name for generation after generation. The village of Väkevälä consisted of two homesteads at the beginning of the seventeenth century. In one there were twenty adult inhabitants, and in the other there were fourteen. The children were not registered, since infant mortality was so high at that time. One of these unlisted children was Stefan's grandfather, Mikko Väkevä (1759–1809), the youngest of six brothers. All six remained on the homestead and all had families of their own. The land thus divided was no longer sufficient to provide a living for the next generation, so they had to seek their fortune elsewhere. Stefan's father, Erkki Väkevä (1805–1834), went to sea as a young boy.

Erkki Väkevä was shipwrecked and tragically drowned in September 1834. His wife, Kristina 'Stina' was left a widow at the age of just twenty-four. Baby Stefan was less than a year old.

By the time Stefan reached the age of nine, Stina's situation had become so dire that she had no other choice than to apply for a permit for her son to be sent to St Petersburg to be apprenticed.

According to family tradition, one day in January 1843, Stina stopped a farmer on the road to Vyborg, making his way to St Petersburg with provisions.[88] The decision to do this was obviously not an easy one, but St Petersburg was the city of opportunity, whereas the villages locally had nothing to offer a young person. The boy would not be all on his own, however. Stina's own godmother had moved there, as had two female cousins of Stefan's father, and Stefan's own cousin David Outinen. There were four boys from Säkkijärvi in St Petersburg at this time, all of whom either apprenticed to or working for silversmiths. Of them, Anton Harju (b.1824) had only begun his apprenticeship, whereas Elias Junnola (b. 1816), Stefan Räikkönen (b. 1825), and Isak Falkenberg (b. 1828) already

*A two-handled silver sugar bowl and cover. Fabergé, Stefan Väkevä,*
*St Petersburg, made between 1908 and 1910.*
COURTESY OF THE VÄKEVÄ FAMILY. PHOTO BY KATJA HAGELSTAM

served as journeymen. The Finnish colony in St Petersburg was not all that large at this time, so it can be assumed all the boys were acquainted with one other. The youngsters from Säkkijärvi were without exception members of the Finnish Lutheran congregation of St Mary's, and thus met each other at church services, Sunday school, and on religious holidays.

Social life centred around the church and the congregation. The reason for this was partly that it was compulsory to register at a congregation if permanent residence was taken up in St Petersburg, and partly because the church and its pastors were the only ones offering an education to these young émigrés. The churches also provided various leisure activities, such as choirs, and later gymnastics and sports. These religious communities thus gave the youngsters a chance to meet others in the same situation and even to find a future spouse, which happened quite frequently.

A look at the careers of the quintet of boys from Säkkijärvi shows us that Stefan Väkevä was the most successful of them. He passed through his years of apprenticeship more quickly than the other four and received his master's papers before all of his older friends. Perhaps he was more eager to learn, and more diligent and talented than the others. Nevertheless, a great deal also depended on the master to whom a boy was apprenticed. If the workshop was busy with various types of work, an apprentice learned faster and attained proficiency earlier. The other boys from Säkkijärvi did all receive their masters' papers in due course, but their life's work did not measure up to that of Stefan Väkevä.

According to the registers at St Mary's, Väkevä started his apprenticeship with the Finnish master silversmith Olof Fredrik Wennerström, a second-generation craftsman. Wennerström became a master silversmith in 1830.[89] Not much is known about him other than that he produced coffee and tea services as well as other hollowware. He ran his workshop with the help of a number of apprentices.

Stefan qualified as a journeyman after four years, at the tender age of fourteen. It normally took roughly seven years. He practiced the trade for nine years before becoming a master silversmith, around 1856. Now he had the right to establish a workshop of his own. He had enough savings by this time to buy a workbench and other necessities, such as precious metals, for his production. Before long, he also found suitable premises. They were situated east of the immediate centre of St Petersburg, at No. 41, 5-ia Rozhdestvenskaya (today 5-ia Sovetskaya). Väkevä's workshop was located in the inner courtyard of the building at number 41, and remained at this address to the very end, until the business had to close in 1918. His home was here as well, as was the custom.

## MARRIAGE AND FAMILY

Stefan met his future wife, Lovisa Wilhelmina Ekström, at the home of a colleague and friend. She was the daughter of a Helsinki-based carpenter and had come to St Petersburg to look for work. Lovisa and Stefan were married in 1856, shortly after Stefan had qualified as a master silversmith. The bride was only eighteen at the time, and the groom five years her senior. Lovisa's mother tongue was Swedish, and she spoke only Swedish with her children, whereas Stefan spoke to them in Finnish. They learnt Russian while playing outside with the neighbourhood children.

*A chased silver beaker. Fabergé, Stefan Väkevä, St Petersburg, c. 1891. The model for the decoration comes from 18th century Russia. Set in the base of the cup is a silver rouble from the reign of Empress Anna of Russia, between 1730 and 1740. The item was a gift to the Finnish officer Colonel Gabriel Edvard Krogius (1850–1933). Krogius served from 1889–1891 as a battalion commander in the crack Izmaylovsky Lifeguard Regiment (established in the time of Empress Anna). Krogius received the cup from his fellow officers on his resignation and return to Finland in 1891.*
<small>COURTESY OF THE KROGIUS FAMILY. PHOTO BY KATJA HAGELSTAM</small>

*Master Silversmith Stefan Väkevä and his wife Lovisa (née Ekström). The photograph is from 1866, when the couple celebrated their 10th wedding anniversary.*
<small>COURTESY OF THE VÄKEVÄ FAMILY</small>

The tenth and last child in the family was born when Lovisa was forty-one. Six of the children died young. Of those that survived into adulthood, the eldest was a boy baptised as Stefan Erik after his father; he was born in 1862. Konstantin "Kostia" and Alexander "Sasha" were born in 1868 and 1870 respectively. After them came a daughter, Olga, in 1873. The children more or less grew up in the workshop, and it is only natural that from an early age they were assisting their father in his daily work, as the offspring of craftsmen have done since time immemorial.

According to family lore, Lovisa and Stefan were determined to give their children the possibility of a better start in life than the one they themselves had enjoyed. During the 1870s, when the Väkevä sons reached school age – in those days it was at nine – they were enrolled in a three-year primary school programme available to the children of craftsmen.

The boys' younger sister Olga commenced her education in the 1880s, also at the age of nine. Upon completing school, she married the master silversmith Adam Herttuainen, who was twenty years her senior. Herttuainen was born in Sulkava in Finland. He had apprenticed for Stefan Väkevä and worked for him until he qualified as a master silversmith. He founded his own workshop soon after at No. 31, 6-ia

Rozhdestvenskaya. He specialised in silver cutlery and gradually became very successful, with a large production. He worked as a sub-contractor for the purveyor to the court I. E. Morozov, for whom he produced with exclusive rights.

*A four-piece silver tea set in matte finish. Fabergé, Alexander Väkevä, St Petersburg, made between 1908 and 1917.*
COURTESY OF SOTHEBY'S

### VÄKEVÄ'S WORKSHOP

Hardly anything is known about the first decades of Väkevä's career. A young master silversmith setting up his own workshop obviously had to have a plan of what he intended to produce. Stefan Väkevä knew from the start that he was going to specialise in making good quality coffee and tea services. These were much in demand at the time in Russia amongst the prosperous middle class. And Stefan himself was his best salesman. When a small collection was ready to be sold, he took it in person to show the retailers. This simple way of offering objects for sale was typical of the time, as evidenced in the reminiscences of many a young master.

The oldest son Stefan Erik chose a career in the postal service, but the younger sons, Konstantin and Alexander, were both keen on following in their father's footsteps and began their apprenticeship with him in the early 1880s. By this time, Väkevä was already a successful silversmith, whose entire production was channelled through Fabergé. Based on the scope of his output, he probably employed some fifteen to twenty craftsmen.

As soon as the two sons had qualified as master silversmiths, their father gave them the right to mark part of the production with their own master's mark, perhaps as an incentive (it was otherwise very unusual for a workshop to use several different master's marks). Hence one might come across a silver service made by the Väkevä workshop that confusingly bears two or even three of the family's marks. There is for instance a coffee service in the Moscow Kremlin Armoury Museum for which the coffee pot and sugar bowl have Stefan's mark and the creamer bears Konstantin's.[90]

*A silver sugar urn and cream jug in neo-classical style, with winged lion-head gryphon decoration. Fabergé, Alexander Väkevä, St Petersburg, made between 1899 and 1908. Scratched stock numbers 13870 (sugar urn) and 13871 (cream jug). Height of sugar urn 21.5 cm.*
COURTESY OF SOTHEBY'S

# Konstantin & Jenny Väkevä

K onstantin Väkevä (1868–1902) worked for his father Stefan for more than twenty years. Upon completion of his schooling in 1880, he was apprenticed to his father, then qualified as a journeyman, and finally as a master silversmith around 1891. For eleven years, he had a responsible role in the family business. However, Konstantin's constitution was weak, and he sadly died at the age of thirty-four, leaving his young wife Jenny Alexandra, née Rosenberg (1878–1971) and two small children, Bertha Lovisa (*b*. 1896) and Yrjö Reinhold (*b*. 1900).

According to family stories, Konstantin's mother Lovisa had asked Jenny why she chose him as a prospective husband: "Take Sasha instead, he is healthy and strong". Stefan and Lovisa took care of the grandchildren, as the young widow had to train in a profession in order to be able to support herself and her children. She took a midwifery course and gradually became very proficient in her vocation. She worked as a private midwife to wealthy families, who paid her generously. After the Russian Revolution, Jenny moved with her children to Finland, where she continued her work as a midwife.

Following Konstantin's death, an application for a so-called "widow's mark" was made for Jenny. The right to have part of the workshop's production so marked entitled her to an income from the workshop, which served as a kind of pension. Her mark was [JW], in a similar typeface to those of her husband and brother-in-law. The system of allowing the widows and surviving daughters of master gold- and silversmiths to have a "widow's mark" (and thus the right to maintain a workshop and its production with the assistance of an experienced master) was quite common in many Western European countries under the guild system. In Russia, where the system was also adopted, it remained in use until the fall of the Empire.

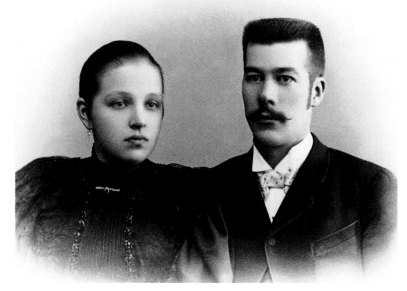

*Master Silversmith*
*Konstantin Väkevä*
*and his wife Jenny, in a*
*photograph from c. 1900.*
COURTESY OF THE VÄKEVÄ FAMILY

# Alexander Väkevä

Alexander Väkevä (1870–1957) qualified as a master silversmith soon after his elder brother Konstantin. He took over the responsibility of his father's workshop around 1905, and on the death of his father in 1910 he ran it alone. The family business prospered, and production increased during the nearly ten years that Alexander was in charge.

As we have read so many times elsewhere in these pages, the Russian Revolution brought an abrupt end to the flourishing business and career of Alexander Väkevä. He was forty-seven years old at the time, a man in his prime.

Like his colleagues in the trade, Alexander could not believe that the new Bolshevik rulers were up to the task of creating a viable government for the long term. Consequently, he stayed on in Petrograd (later Leningrad) and took a temporary job as a janitor at 26, Nevsky Prospekt, which housed the

Finnish Consulate for some fifteen years after the Revolution. His work consisted of collecting the rent, overseeing repairs, and keeping general order in the house. It was here that he met his future wife, Maria "Masha" Henriette Norlin, born in Sweden. She was the consulate's cook. Väkevä was sixty and his bride forty-five when they married in 1930.

Alexander Väkevä was able to continue working as the janitor at the Finnish Consulate until 1937, when the powers that be refused to renew his residence permit, thus forcing him to leave the country.[91] Sasha and Masha Väkevä moved to Vyborg, "leaving all their belongings and furniture to the poor" as the story goes.

Väkevä earned his living in Vyborg by selling merchandise he had brought from Russia in the shop established by Viktor Aarne. At this point in his life, Väkevä felt he was too old to continue in his own field. Aarne's son Eino did offer him a

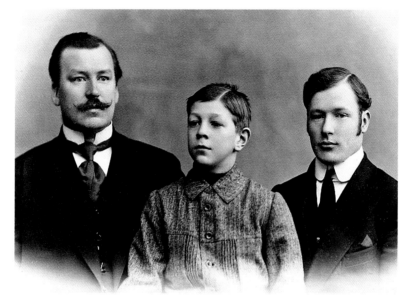

*Master Silversmith Alexander Väkevä (left), with his nephews Yrjö Reinhold (centre, son of Konstantin Väkevä) and Väinö Stefan (son of Stefan Erik, the eldest of the three Väkevä boys, who did not enter the family business).*
Courtesy of
The Väkevä Family

workbench in the atelier, and pushed work his way, at least periodically. During times of inspiration, Alexander Väkevä actually produced quite a few coffee and tea services while in Vyborg, as gifts for family members and friends. These pieces were all marked with the workshop mark of Aarne [JVA] (Aarne's master's mark in Finland, 1904–40).

Alexander Väkevä spent his last years in Helsinki in the home of his sister-in-law Jenny and her daughter Bertha. He died in 1957.

### THE PRODUCTION OF THE VÄKEVÄ WORKSHOP

The Väkevä workshop was active for sixty-one years in total, and worked throughout for the House of Fabergé. Under the older generation, the output of the workshop consisted mainly of tea- and coffee services, trays, dishes, bread-baskets, samovars, and the like. By the time Alexander Väkevä took over, the production had somewhat moved up in the market. Fabergé gave the workshop more important commissions, including luxurious objects to be presented at state visits, and large banqueting pieces such as soup terrines, platters, sauce boats, cruets, candelabras, and so on.

In keeping with the origins of the family name, Väkevä objects are in general very solid: material was never spared in the making, and one can feel that one really has something of substance in the hand. Trays were produced of silver plate thick enough to support a dozen coffee cups, plates, and liqueur glasses. Designs vary between the conspicuous Väkevä "Louis XIV style" and an equally ubiquitous "Empire style". Sometimes Väkevä springs a surprise with a Rococo coffee service or by decorating objects with winged mythical creatures. Favourite motifs include decorative bands of silver "beads", stylised palmettes, acanthus, laurel leaves, and meander patterns. Historical Russian silver coins, sometimes enamelled, frequently make an appearance.

The "Old Russian style" was also not unfamiliar to the Väkevä workshop. Its forms are derived from medieval arts and crafts, the revival of which had taken place in the 1840s and had become the ideal and the model for modern Russian design in the first decades of the 20th century. The tercentenary of the Romanov dynasty in 1913 was the perfect occasion to showcase this style, and this is reflected in the lush engravings and chased decorations in Väkevä's production from around this time.

Occasionally one encounters a piece free of any ornamentation, one in which the aesthetics of the form itself become the main attraction. These objects are forerunners of modernism that Western Europe only explores decades after the Second World War.

It is highly probable that most of Väkevä's designs were handed down from Fabergé's ateliers. There is, however, no formal documentation for this. It was common practice during the last decades before the Revolution for apprentices and journeymen to take courses in drawing and design. When the Central School of Technical Drawing backed by Baron A. L. von Stieglitz opened in November 1879, courses at the School became a compulsory part of the training of gold- and silversmiths.[92]

Workmasters frequently purchased designs directly from graduates of the von Stieglitz School. The master goldsmith Olli Koistinen (1851–1919), who had his own workshop in St Petersburg in the 1870s, states in his reminiscences (1916) that this was the most common way of obtaining designs for their production.[93] Not all workmasters were able to employ their own designers, nor did all have the required artistic talent, regardless of their other skills.

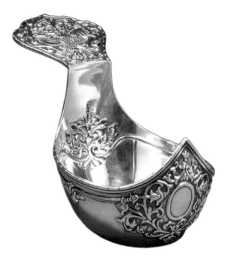

*A silver kovsh with handle decorated with the Imperial double-headed eagle. Fabergé, Alexander Väkevä, St Petersburg, made between 1899 and 1908. Scratched stock number 13392. Length 22 cm.*
COURTESY OF SOTHEBY'S

*A silver bowl, gilt silver on the inside, with the engraved monogram "АП" (Cyrillic script) of the original owner. Fabergé, Alexander Väkevä, St Petersburg, c. 1911.*
COURTESY OF COLLECTION MIRABAUD

*A silver napkin ring. Fabergé, Stefan Väkevä, St Petersburg, c. 1890.*
COURTESY OF JOHN ATZBACH, REDMOND, WASHINGTON

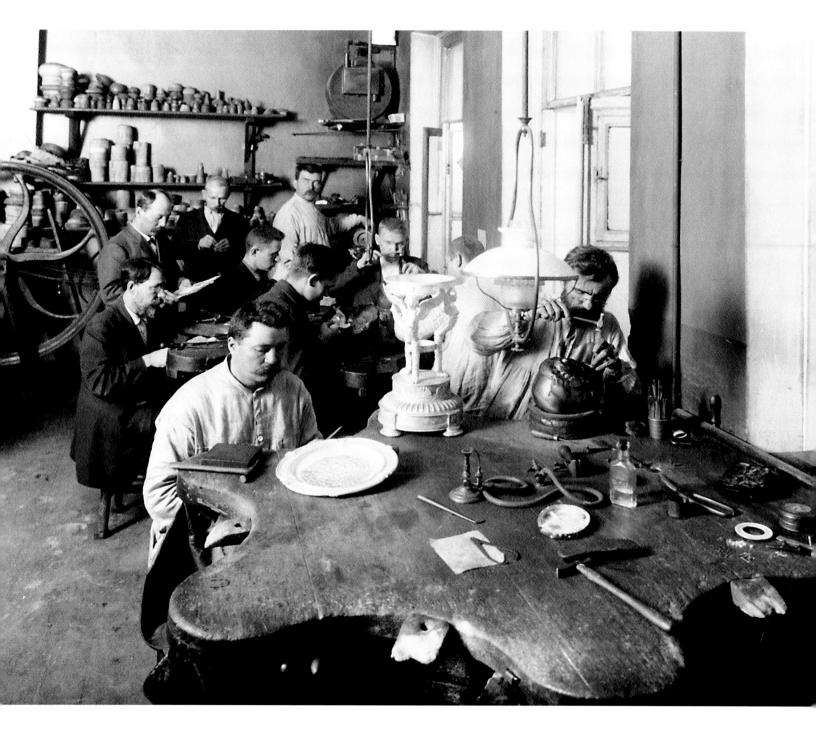

*One of Fabergé's silversmiths' workshops;*
*regrettably it is not known which of them.*

COURTESY OF THE ALEXANDER FERSMAN
MINERALOGICAL MUSEUM IN MOSCOW,
UNDER THE RUSSIAN ACADEMY OF SCIENCES.

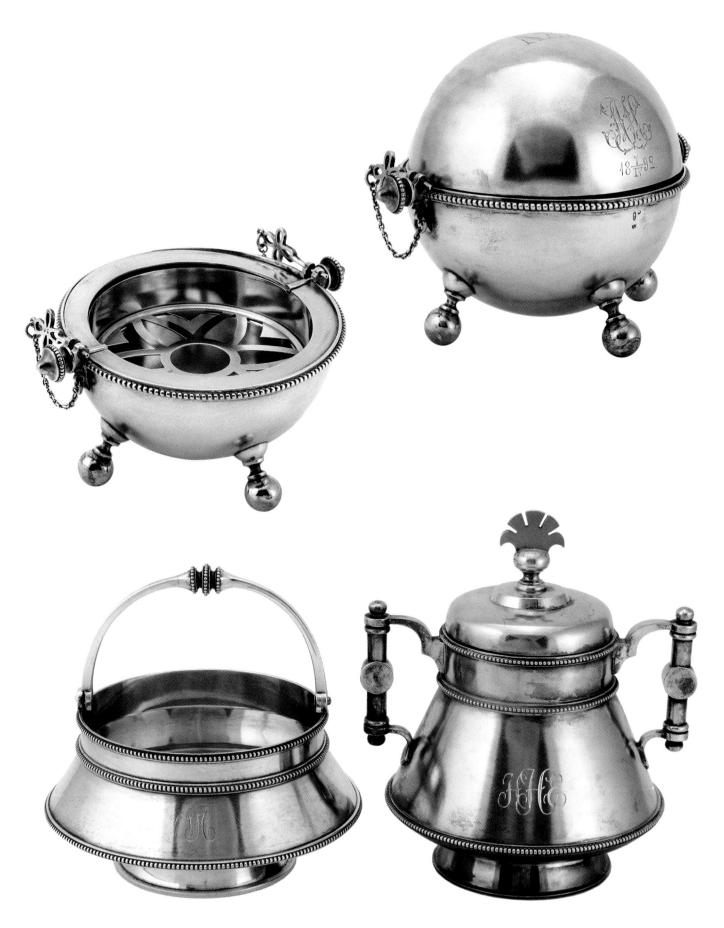

◁ *A spherical caviar server with hinged cover, on ball feet. Silver, marked "JW" for Jenny Väkevä, St Petersburg, 1912. Diameter 13.8 cm.*

*The picture at left shows the lid removed to reveal the gilded interior, with a grille, under which would be placed crushed ice to keep the caviar cool.*

*The item was a gift from the family to Olga and Adam Herttuainen, Stefan Väkevä's daughter and son-in-law, on their 20th wedding anniversary, April 7th 1912.*
COURTESY OF THE HERTTUAINEN FAMILY.
PHOTO BY KATJA HAGELSTAM

▷ *A large silver tankard on ball feet, mounted with 18th and 19th century coins and medallions, with an Imperial double-headed eagle as the finial on the hinged lid. Fabergé, Stefan Väkevä, St Petersburg, c. 1890. Scratched stock number 3212. Height 36.3 cm.*
COURTESY OF SOTHEBY'S

◁ *Two silver sugar bowls, one covered. Fabergé, Stefan Väkevä, St Petersburg, c. 1890. The bowl on the left is engraved "OH" for Olga Herttuainen, the one on the right has a later engraving.*
COURTESY OF THE HERTTUAINEN FAMILY

*A set of six hammered beakers in a surprisingly
modernist style, much resembling designs by
Scandinavian silversmiths of the 1960s. Silver,
Fabergé, Alexander Väkevä, St Petersburg,
made between 1905 and 1908. Height 10 cm.*
COURTESY OF WARTSKI, LONDON

The family of Stefan Väkevä was and still is large, and it is only natural there are many anecdotes – some more fanciful than others – that have been told and retold down the generations. One of these stories recounts how Stefan, as a young master silversmith, offered to gild the weathervane cast in the shape of an angel that spins atop the Peter and Paul Cathedral.

Stefan apparently decided to take on the task as nobody else dared do it. The work took place between 1856 and 1858, when the spire was being restored. The sculptor Robert Salemann was commissioned to craft a new angel, identical to the old one. The two brothers Ivan and Vasily Korotkov also took part in the work. The angel turns in the wind at a height of 394 feet (over 120 metres) above the ground, is 10 feet (3 metres) high, and holds a cross measuring 21 feet (6 metres). The total weight, including the cross, is 551 pounds, or roughly 250 kilos.

The weathervane's body is of copper plate, with artistically chased garments and wings. All this magnificence was gilded using the technique of fire-gilding. In this process, an amalgam of mercury and gold is applied to the object, which is then heated, causing most of the volatile mercury to evaporate. It can be deadly if the fumes are inhaled. Fire-gilding had been outlawed in Western Europe by this time, but the ban only came into force in Russia at the end of the 19th century. Stefan guaranteed his work for fifty years. In recognition of his efforts, Emperor Alexander III subsequently awarded him the Silver Medal for Useful Works, mounted on the red and yellow ribbon of the Order of Saint Anna.

The tale of Stefan's heroic deed has been the most tenacious of the Väkevä family anecdotes. Stefan's daughter-in-law Jenny Väkevä, who knew her father-in-law very well, repeated it over and over. Happily, his "Medal for Useful Works" has survived to this day.

*The Alexander III Silver Medal "For Useful Works", awarded to Stefan Väkevä, with the ribbon of the Order of St Anna. This medal was awarded to citizens primarily for their useful support to the Imperial Russian State in the fields of trade, production, and agriculture.*
COURTESY OF THE HERTTUAINEN FAMILY. P
HOTO BY KATJA HAGELSTAM

*The gilded copper weathervane, a winged angel bearing a cross, stands at the top of the 123-metre spire of the Peter and Paul Cathedral. It is a powerful symbol of St Petersburg.*
COURTESY OF THE STATE MUSEUM OF THE HISTORY OF ST PETERSBURG

# Franz Birbaum

Franz (François) Birbaum, (1872–1947), was Fabergé's chief designer between 1895 and 1918. He headed the designers' and modellers' ateliers in the House of Fabergé, but also worked actively as a designer in his own right.

Birbaum had come to St Petersburg from his native Fribourg in Switzerland at the age of 14 to study applied arts and crafts at the two major institutions for these studies: the Drawing School of the Imperial Society for the Encouragement of the Arts and the Baron von Stieglitz Central School of Technical Drawing. In 1893, the talented young man was employed by Fabergé, first as a draughtsman, later as assistant designer.

Carl Fabergé's younger sibling Agathon Fabergé (1862–1895) had joined the family firm in 1882, with the aim of assisting his brother in developing the artistic strategies of the House. By this stage, Carl Fabergé had already launched the widely-acclaimed "archeological revival" jewellery collection, based on the Scythian finds on the Kerch Peninsula, between the Sea of Azov and the Black Sea (see the chapter on Erik Kollin). It was now time to create a new concept. This was already in full swing when Agathon Fabergé sadly died of lung disease at just 33 years of age (see the chapter on Mikhail Perkhin). Following the loss of his gifted younger brother, Carl Fabergé decided to appoint Birbaum chief designer and the supervisor of his designers' studios.

Fortuitously for later scholars, Birbaum was urged by his friend and mentor Alexander Fersman, the eminent Russian mineralogist and academician, to record his recollections on his time at the House of Fabergé. Birbaum wrote them up in 1919, a year before he decided to return to Switzerland. The manuscript was discovered in 1990 by Dr Valentin Skurlov among the papers of Alexander Fersman.[94] Although never completed, Birbaum's recollections have significantly added to our knowledge of how work at the House of Fabergé was organised. The author of the memoirs, however, regrettably does not provide much detail of his own work.

Some twenty full-time designers – divided between St Petersburg and Moscow – are listed in Birbaum's manuscript, unfortunately without any information on the type of work they were engaged in.[95] Many of them were graduates of Baron von Stieglitz's Central School of Technical Drawing in St Petersburg and/or the Stroganov School for Technical Drawing in Moscow. For Fabergé, that educational background was a guarantee of high proficiency. The list of the designers is supplemented with the names of a few architects, called upon for design work on significant commissions.

The research on Fabergé's designers is far from being concluded. Artists' drawings and sketches made at Fabergé are rarely signed, and the majority of designers listed by Birbaum below have so far remained as names and nothing more.

Nevertheless, by pure coincidence information has surfaced on a few designers of spectacular objects. One such chance occurrence has shone the spotlight on the young in-house artist Alma Pihl, working at the Holmström atelier. See the chapter on Alma Pihl. No doubt more information will come to light in the future.

| DESIGNERS IN ST PETERSBURG AS LISTED BY BIRBAUM: | |
| --- | --- |
| Carl Gustavovich Fabergé | Oscar May |
| Agathon Gustavovich Fabergé (1882–1895) | L.L. Mattei |
| V.A. Kritsky (1888–1894) | G.G. Eber |
| Franz Birbaum (1893–1918) | M.D. Rakov (1915–1918) |
| Alexander Ivashov (1895–1918) | M.I. Ivanov |
| Eugen Jakobson | Herman Kurtz (1900–1918) |
| | Ivan Komalenkov (1908–1918) |

| DESIGNERS IN MOSCOW AS LISTED BY BIRBAUM: | |
| --- | --- |
| Ivanov | Sheverdiaiev |
| The Klodt brothers | Jan Liberg, chief designer at the Silver Factory, (1909–1918) |
| Balashov | |
| Borisov | Obradushkin |
| Petz | Sergey Andrianov[96] |
| Lozhkin | |

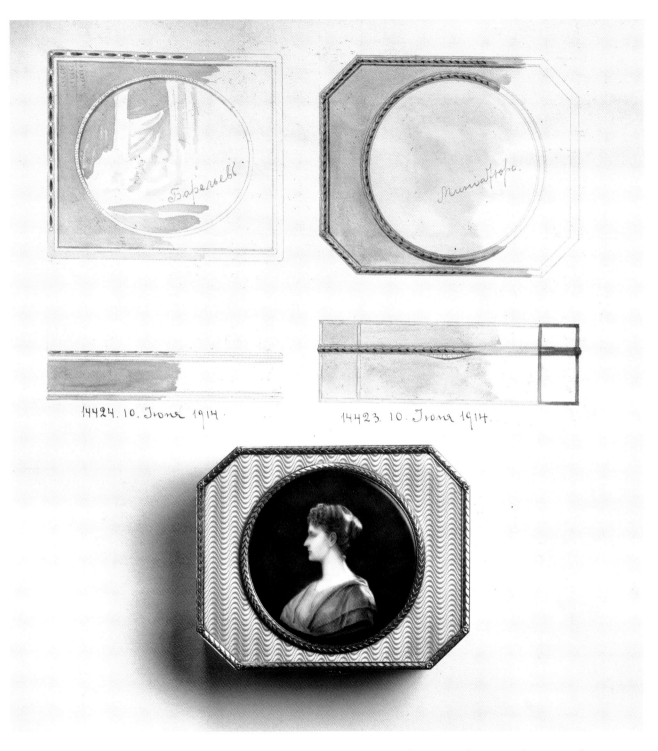

*An Imperial presentation snuffbox, the cover set with a porcelain portrait plaque painted in sepia with an image of Empress Alexandra Feodorovna, simulating a cameo. The box is photographed on Plate 13 of Henrik Wigström's first stock book, next to its working drawings. Guilloché enamel, gilt silver, vari-coloured gold, rose-cut diamonds. Fabergé, Henrik Wigström, St Petersburg. Completion date of the box is June 10th, 1914. According to the sketch, the item has Wigström's internal production number 14423, and is scratched with the stock number 4744. Width 11 cm.*
*The working drawing on the left shows a similar snuffbox set with a cameo. This box has also survived, and is now in the collections of the Cincinnati Art Museum, Ohio. It is not known who designed these two boxes.*

PRIVATE COLLECTION. PHOTO BY KATJA HAGELSTAM

As related in the chapter "Formative Years", during his years of study Carl Fabergé was blessed with wonderful opportunities to familiarise himself with the collections of the most important treasuries of Europe, above all those of the Green Vaults in Dresden and the Hermitage in St Petersburg. The latter became especially well known to him as he voluntarily assisted with restoration work in the Treasury for a total of 15 years. The collections of Empresses Elizabeth Petrovna and Catherine the Great, with their superb examples of French 18th century enamelling techniques, became models and exemplars for Fabergé's own work. Fabergé's use of translucent enamelling over a guilloché ground came to attain a level of perfection well beyond the possibilities of his predecessors.

Franz Birbaum names two craftsmen with whom Fabergé worked in his initial stages of experimenting with the art of enamelling. They were a master by the name of Killender (his first name is not known), who worked for Fabergé between 1870 and 1885, and Vasily Vasilievich Boitsov, who was active between 1890 and 1905.[97]

Little is known about Killender's fifteen-year collaboration with Fabergé. There is no documentation of what level of skill Killender attained. Hardly any enamelled objects have survived from these years. Boitsov came to work for Fabergé soon after the House had completed two major pieces that show off guilloché enamelling. One was Alexander III's 1889 gift to Germany's Iron Chancellor Prince Otto von Bismarck, a gold and jewelled snuffbox with a miniature portrait of the Emperor. The body of the box heralds the sunburst guilloché enamelled surfaces that were to become such a striking feature of Fabergé's future work. The other pioneering object was the "Danish Palaces" Imperial Easter Egg of 1890, the shell of which is exquisitely guilloché enamelled in opalescent pink-mauve.[98] Whether these objects were enamelled in either Killender's or Boitsov's workshops is not known to us. As an alternative theory, it has been suggested that the work was carried out abroad.

*Silver and guilloché enamel kovsh. Enamelled translucent raspberry red over a wavy ground, handle in silver. Fabergé, Antti Nevalainen, St Petersburg, made between 1899 and 1908, stock number 11967. Length 8.5 cm.*
COURTESY OF COLLECTION MIRABAUD

The real breakthrough in Fabergé's enamelling came, however, in 1895. Fabergé unearthed a prodigious talent in the shape of the master enameller Alexander Fedorovich Petrov (d.1904). He was employed by the House of Fabergé as chief enameller. Petrov had two sons, Dmitry and Nikolay, who trained with their father and continued working for him.

On the death of Alexander Fedorovich Petrov in 1904, his son Nikolay Alexandrovich Petrov (d. 1918) succeeded him as Fabergé's chief enameller. Birbaum gives a vivid description of the younger Petrov:

> Enamelling was assigned to a special workshop run by N.A. Petrov, to whom the firm is greatly obliged for his fine work. He was the son of the enameller A. P. Petrov, and from his early childhood he became acquainted with this complex craft, which is so subject to sudden failures, owing to the metal, the baking process, or the enamel itself. With his knowledge of all the technical details, he was able to overcome difficulties that presented obstacles even for foreign enamellers, many of whom he could certainly have surpassed if he had received a proper artistic education. Work was his natural element, and unlike other masters he made all his pieces himself, frequently spending nights poring over a task in which he was interested. Sometimes when the firm received very important commissions, the management sent the order abroad in order to prevent possible failures, but it was very seldom that the foreign-made article was preferable. After the workshop was closed, Petrov was invited to the Mint to enamel badges for the Red Army. He carried out this totally uninteresting work just to earn a living, but a scanty diet and overstrain killed him: Petrograd lost its best enameller – most probably the best enameller in all Russia – and we lost a good, honest man and a toiler.99

*Cigar cutter. Gilt silver, varicoloured gold, guilloché enamel under a sunburst ground. At the top of the blade, a gold-mounted cabochon moonstone. Fabergé, Fedor Afanasiev, St Petersburg, made between 1907 and 1908. Scratched stock number 16105. Diameter 4.9 cm.*
Courtesy Collection Mirabaud

The deep-seated love felt by Russians for their country's vast wealth of beautiful hardstones was a creative call to arms for Fabergé, spurring him to seek out new means of expression. His use of semi-precious stones extracted from the Urals, from Siberia, and the Caucasus – nephrite, bowenite, chalcedony, agates, jasper, rhodonite, quartzes, aventurine, and others – went hand in glove with his credo of shunning costly materials.

The briefest of glances at the illustrations in this book spotlights the significance of hardstones in Fabergé's work.

From the mid-1880s, objects combining hardstone and precious metal mountings start to surface in Fabergé's production. The novelties were a result of his teaming up with the Imperial Peterhof Lapidary Works. The factory, created by decree of Peter the Great in 1721, had a long tradition of fine lapidary work. Since their early days, Peterhof were major suppliers to the Court, delivering impressive display objects in hardstone, such as urns, vases, and large stemmed bowls or dishes (*tazzas*) that were commissioned to embellish the grand halls of the Imperial palaces.

In 1886, Andrey Gun was appointed head of the Peterhof Lapidary Works. The zealous new director saw the opportunity of broadening the factory's range of production. This led him into close collaboration with the best jewellers of St Petersburg, among them Fabergé. Hardstone artefacts of various kinds made at Peterhof were designed to be mounted in gold or silver. For Fabergé, this soon turned into a two-way process. In his turn, the jeweller began to commission Peterhof to produce specific items according to his own designs.[100] Among these were animal figurines. Initially, Fabergé's menagerie was limited to elephants in various hardstones. The success of these, however, saw the assortment expand with all manner of different animals.

One of Fabergé's first truly important objects in hardstone was the Imperial Easter Egg of 1891: the *Pamiat Azova* Egg, fashioned from a solid piece of heliotrope jasper (also known as bloodstone). This was the year's Easter gift from Alexander III to his wife Maria Feodorovna.[101] The 1891 offering was followed twelve months later by the Diamond Trellis Egg, carved in bowenite (see p. 50). It is not known whether the shells of the two early hardstone eggs were cut at Peterhof. By the early 1890s, Fabergé was already testing the skills of the lapidarians Carl Woerffel and Moritz Stern.

This is backed up by Franz Birbaum, who notes in his memoirs: "Practically all lapidary work was at this time [before 1908] carried out at the workshop of Carl Woerffel in

*A decorative box. Nephrite, gold, rose-cut diamonds, enamel. Fabergé, Mikhail Perkhin, St Petersburg, made before 1899. Height 3.2 cm, diameter at base 4.5 cm.*
COURTESY OF THE WOOLF FAMILY
COLLECTION, LONDON

St Petersburg and the ateliers of Moritz Stern in Idar-Oberstein, Germany, according to designs and models produced by Fabergé. Hardstone objects were sometimes purchased from craftsmen in Ekaterinburg and passed on to Woerffel and Stern for correction of imperfections, or to improve the polish."[102]

Carl Woerffel (1846-after 1917) was a lapidarian in the second generation. His father had a bronze and hardstone business, established in St Petersburg in 1842. In 1873, he took over the works from his father. Woerffel produced bronze work, which incorporated semi-precious stones from Siberia, the Caucasus, Altai Krai, and other regions. By 1881, the company employed 80 workers.

The cooperation with Fabergé was not successful in the long run, as the quality of Woerffel's work did not meet with Fabergé's exacting standards.

In 1908, Fabergé was able to take over Woerffel's workshop and to reorganise it. He employed two young and very talented stone carvers, under whom things took a very good turn. Woerffel remained titular head of the workshops, but Fabergé oversaw the operations. In this way the House of Fabergé began to produce its own hardstone pieces, following the arrival of Peter Mikhailovich Kremlev and Peter Mikhailovich Derbyshev.

Peter Mikhailovch Kremlev (1888-after 1938) hailed from the Perm Governorate, straddling the Ural Mountains. He was educated at the Ekaterinburg School of Art and Industry. In 1915, he was appointed head of the Fabergé lapidary workshop.

Birbaum writes in his memoirs: "...the artistic level of the output immediately improved considerably, beginning with the disappearance of the mediocre dryness characteristic of works by Woerffel and those produced in Idar-Oberstein."[103]

Kremlev made many articles himself: he specialised in flowers. He is known to have worked on the 1913 Winter Egg. At its peak period from 1912 to 1914, the workshop employed 20 craftsmen. Demand was so great they had to work overtime more or less constantly.

Peter Mikhailovich Derbyshev (1888–1914) was born in Ekaterinburg. Like Kremlev, he was educated at the Ekaterinburg School of Art and Industry. He arrived in 1908 in St Petersburg and was immediately employed by Fabergé, working for a year at the Woerffel workshop. Fabergé then sent him to Idar-Oberstein to study stone carving, and after that to Lalique in Paris. He was an extraordinary talent, the best stonecutter in the entire company. He returned to Russia in 1914 but was killed in action in World War I in the same year.

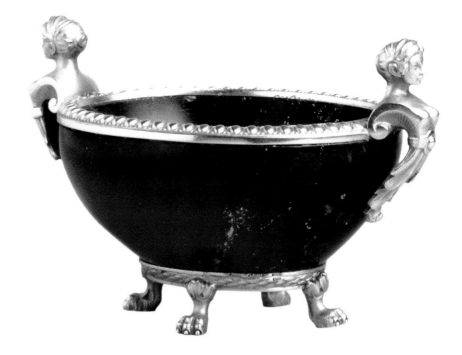

*A lapis lazuli bowl on four gold paw feet with handles in the form of mythical female busts. Fabergé, Henrik Wigström, St Petersburg, completed in January, 1912 with the production number 12609. The design of the bowl is depicted in the first stock book of Wigström on Plate 257. Fabergé's stock number 22104. Height 4.4 cm, width 6,8 cm.*
COURTESY OF THE WOOLF FAMILY COLLECTION, LONDON

In the mid-1880s, Fabergé recognised the advantages of expanding his business to the old Russian capital of Moscow. Here the customer base consisted of wealthy businessmen and textile industrialists. There was, in other words, a plentiful supply of immensely rich people in the city, with an appetite for luxury articles. Fabergé obviously saw the potential in Moscow. And he was right.

By the 1910s, the Moscow end of the House of Fabergé had over 300 on its payroll and was exceptionally profitable. The greater part of the turnover for the entire Fabergé emporium came from this source.

Fabergé's Moscow business was established in 1887 and given the name "C. Fabergé, Moscow". At this stage, Fabergé had his hands rather full in St Petersburg, so he decided to go into partnership on this project with a South African-born British subject living in Moscow, one Henry "Allan" Talbot Bowe. Fabergé entrusted the operations in Moscow entirely to Bowe, who had extensive retailing experience via the jewellery and silver department of the city's high-end outfitters, the Magasin Anglais. In 1901, Carl Fabergé and Allan Bowe entered into a full partnership, i.e. the pair co-owned the enterprise from this point. Bowe, known to the employees as "Allan Andreevich", worked as managing director for the Moscow business until 1906, when he returned to the UK.

In 1887, Fabergé and his partner opened a first showroom at Kuznetsky Most ("Blacksmith's Bridge"), in a house owned by the industrialist Franz San-Galli,[104] with whom Fabergé had had previous business dealings.

Fabergé's showroom was a regular jewellery store, selling gold and diamond jewellery, silver items, and enamelled pieces. Much of this obviously came from the St Petersburg workshops.

In 1890, additional showrooms were opened in an adjacent space, focusing on silver pieces.

In 1895, Fabergé & Bowe moved the retail outlet to the corner building at No. 4, Kuznetsky Most and Neglinnaya, as shown in the photograph opposite. Simultaneously with their establishing the Moscow company (in 1887), Fabergé and Bowe started to look for premises for the planned "production unit" (later to become a factory). Fabergé once again negotiated with his business associate San-Galli about acquiring space in another of San-Galli's premises, this time at No. 4, Bolshoy Kiselney Pereulok. This was an industrial building in three storeys.

The first unit to open was a jewellery workshop, headed by Oscar Pihl (see p. 259). The silver workshop opened in 1890 and was led by Mikhail Moiseyevich Chepurnov. There were soon some 50 craftsmen at work in this facility. Fabergé was now in direct competition with the large and long-established silver manufacturers of Moscow – Ovchinnikov, Sazikov, and Klebnikov, as well as W. A. Bolin – and making a success of it, selling silver hollow ware and cutlery.

Business was booming, and things expanded rapidly. By the turn of the century, the Moscow production unit had grown into a full-blown factory with no fewer than four departments: one produced silver hollow ware and flatware, the second made fine jewellery, the third was described as a "mechanical department", and the fourth was a lapidarian workshop.[105]

Objects of vertu and fantasy, Fabergé's bestsellers in St Petersburg, were also in demand in Moscow. During the early years, the Moscow retail store was supplied with an assortment of this genre of objects from the workshops in St Petersburg. In 1895, Fabergé was successful in discovering Gustav Heinrich Jahr, a Baltic German working as an independent craftsman in Moscow. In Jahr, Fabergé found a skilled master goldsmith totally on a par with his Petersburg workmasters. Over the course of a decade and more, until 1908, Jahr supplied Fabergé's retail outlet in Moscow with high quality objects of fantasy and function as well as the ubiquitous cigarette cases. These were all made to designs supplied by Fabergé's St Petersburg studios. Jahr worked simultaneously for Cartier in Paris with the same types of objects designed by the artists of Cartier.[106]

In contrast to the St Petersburg masters and Oscar Pihl, head of the Moscow jewellery workshop, Jahr's production for Fabergé was not marked with his master's mark.

*Fabergé's Moscow retail store moved to the premises at No. 4, Kuznetsky Most in 1895.*
COURTESY OF WARTSKI, LONDON

# Oskar Pihl

A workmaster was required for the Moscow jewellery workshop, and the task was given in 1887 to Knut Oscar Pihl (1860–1897), son-in-law of the Petersburg chief jeweller August Holmström.

Oscar Pihl was born in the small hamlet of Bollstad, part of the municipality of Pohja, some 80 kilometres west of Helsinki, as the son of the village tailor Gustaf Johan Pihl. There were eleven children in all, three of whom died young. Money was tight, so Oscar was sent to St Petersburg at the age of six, to his uncle Anders Viktor Pihl (1835–1883), a prosperous watchmaker. The uncle gladly adopted the boy, as he had no children of his own and wanted an heir for his business. Back home in Finland, however, Oscar's mother Lovisa regretted her decision to send him away. She travelled by barge to St Petersburg to fetch the boy back to Bollstad, but Oscar found Finnish village life woefully dull after his stay in the great metropolis, and he was allowed to return to his uncle.

According to Max Engman, who has studied the Pihl family in depth, altogether four of Oscar's uncles had left home for St Petersburg. Three of them became watchmakers and one a goldsmith. The first to leave was Bernhard Wilhelm Pihl (1817–1860), who trained at the Pulkovo Observatory, in the office of the chronometer maker Haut. He completed his studies in London, where he was employed by the famed watchmaker Edward John Dent. After returning to St Petersburg, he continued at the Haut office. Anders Viktor Pihl (who became Oscar's adoptive father) started his own company after having studied both in England and in France. He worked almost exclusively for the Pulkovo Observatory and the Admiralty in St Petersburg. Oscar would undoubtedly have enjoyed a brilliant future with Anders Viktor, and would in time have inherited his workshop, but his mind was set on the art of the jewellers.

Oscar found his métier the very moment he was taken on as an apprentice by August Holmström. Ten years later, in 1887, he qualified as a master jeweller. That same year, Carl Fabergé asked Holmström if he could recommend a young and talented master for the planned Moscow jewellery workshop. Holmström suggested Oscar Pihl (his prospective son-in-law) for the job. As it happened,

*A large triangular jewelled brooch, more accurately a plastron, also known as a devant de corsage, in diamond-set gold and silver, with five large rectangular cabochon Colombian emeralds in loosely tied bows. Part of a parure (a tiara and necklace were included, the tiara made by Court Jeweller C.E. Bolin) in the Louis XVI style, ordered as a gift for Empress Alexandra Feodorovna by close relatives, in connection with the coronation in 1896. By Fabergé, Knut Oscar Pihl, Moscow, 1896. The piece's current whereabouts are unknown.* REPRINTED FROM A.E. FERSMAN, RUSSIA'S TREASURE OF DIAMONDS AND PRECIOUS STONES, 1925, PLATE LXX.

◁ *Master Goldsmith Knut Oscar Pihl.*
FROM THE COLLECTION OF LYDIA PIHL

▷ *Fanny Pihl, Knut Oscar Pihl's wife,
the daughter of August Holmström.*
FROM THE COLLECTION OF LYDIA PIHL

*Carl Fabergé's letter to Fanny Pihl, Oscar's
widow, on October 20th, 1897: "I hereby
affirm that Mrs Fanny Florentina
Pihl, née Holmström, has this day
sold me the workshop belonging to her
late husband, and that she makes no
further financial demands of me. Carl
Fabergé, Merchant of the 2nd Guild".*
NATIONAL ARCHIVES OF FINLAND, HELSINKI

Téléphone 304.

C. FABERGÉ
Joaillier de la Cour.
ORFÈVRERIE, ARGENTERIE.
St. Pétersbourg. ☙ Moscou.

St. Pétersbourg, 20 Okт. 189 7

Симъ удостовѣряю что Госпожа
фанни флорентина Пиль
урожденная Хольмстремъ
продала мнѣ всю мастерскую
покойнаго мужа ея и ника-
кихъ претензій болѣе не
имѣетъ.

С.Птрб. 2й гильдіи купецъ

К. Фаберже

▷ *A miniature frame in gilt silver, four-
coloured gold, guilloché enamel, and ivory.
Fabergé, Moscow, possibly by Gustav Jahr.
Marks: Fabergé's Imperial Warrant, assay
mark of Moscow 1896, 84 zolotnik. Height
13.2 cm. The miniature portrait on ivory
shows the celebrated Parisian dancer
and Belle Époque beauty Cléo de Mérode
(1875-1966). The painting is of exceptionally
high quality, but the artist is not known.*
COURTESY OF THE WOOLF FAMILY COLLECTION, LONDON

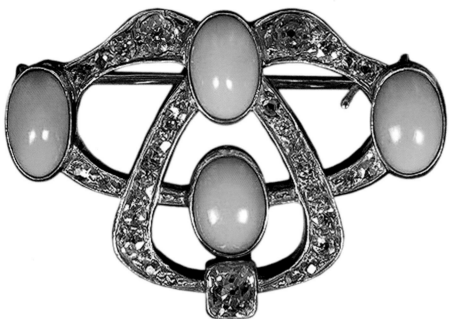

A jewelled gold brooch, set with diamonds and four cabochon turquoises. Fabergé, Knut Oscar Pihl, Moscow, 1890s.
PRIVATE COLLECTION. PHOTO COURTESY OF JOHN ATZBACH, REDMOND, WASHINGTON

Oscar had found his future bride in the daughter of his employer. She was Fanny Florentina Holmström (1869–1949). The couple were married in St Petersburg in 1887.

Fabergé loaned young Oscar 2,000 roubles to set up his workshop in Moscow. In accordance with the old guild tradition, the newly-weds furnished their own home in the back of the workshop.

Fanny and Oscar had five children. Of them, Alma Theresia (1888–1976) became a jewellery designer (see her own chapter), and Oskar Woldemar (1890–1959) became a jeweller like his father. After the Revolution, Oskar Jr. worked for A. Tillander's in Helsinki as the company's chief designer.

Oscar Pihl, assisted by the master goldsmith Oskar Sewon (another Finn), worked successfully in Moscow for ten years. Pihl had some 40 craftsmen on his staff in the year 1896.

In addition to small gem-set jewellery in the latest fashion, which was the main production, the Pihl workshop produced elegant cigarette cases, various custom-made badges and insignia, as well as miniature Easter eggs.

An impressive Louis XVI-style plastron ornament for Empress Alexandra Feodorovna bears witness to the skills of the workshop. The plastron is illustrated at the beginning of the present chapter. Made of gold and silver, it was set with five rectangular Colombian cabochon emeralds, the largest of which was 45 carats, and 228 diamonds weighing a total of 85 carats. The plastron was part of a *parure* consisting of a tiara and necklace in addition to the plastron. The tiara and necklace were made by the Court Jeweller C.E. Bolin in St Petersburg. The House of Bolin had been Russia's foremost maker of fine jewellery since the reign of Nicholas I. It was thus a considerable badge of honour for the young master jeweller Oscar Pihl to be commissioned to supply the third item of the set. It has been suggested it was Grand Duchess Elizabeth

A pair of cufflinks in varicolour gold with off-set cabochon sapphires. Fabergé, Knut Oscar Pihl, Moscow, after 1887. The cufflinks are similar in style to the cylindrical cigarette case shown on the opposite page.
COURTESY OF THE STATE HISTORICAL AND CULTURAL MUSEUM IN THE KREMLIN, MOSCOW

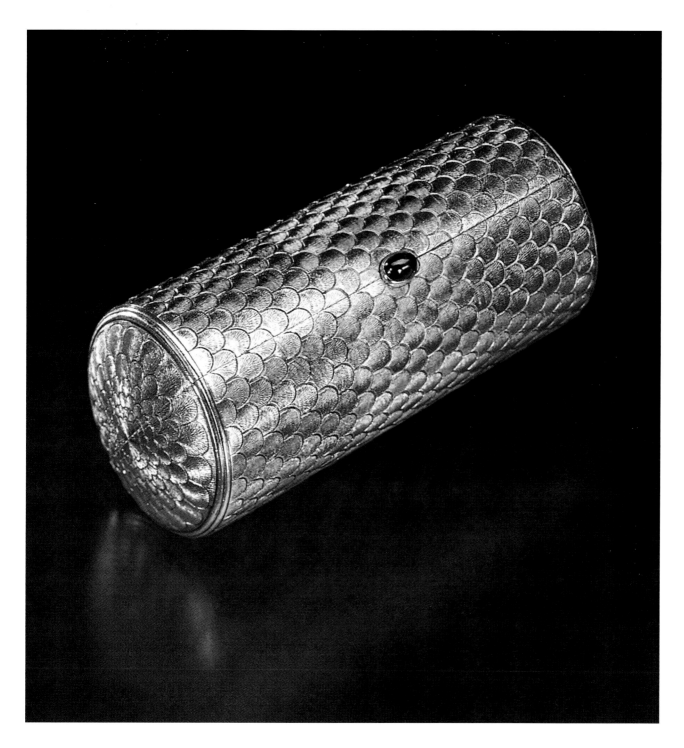

*A cylindrical cigarette case in varicolour gold, with fish-scale chasing and a sapphire thumbpiece. Fabergé, Knut Oscar Pihl, Moscow, after 1887. Length 8.6 cm.*
©FABERGÉ MUSEUM, ST PETERSBURG. THE LINK OF TIMES CULTURAL AND HISTORICAL FOUNDATION

Feodorovna, older sister of the future Empress Alexandra, who placed the order in Fabergé's Moscow branch.

In the summer of 1897, at the age of just thirty-eight, Oscar Pihl died tragically of blood poisoning in his foot. He had accidentally stepped on a rusty nail while doing repairs in the family dacha. Fanny Pihl moved back to St Petersburg and sold Fabergé her interest in her husband's workshop. A letter from Carl Fabergé has survived, dated October 20th, 1897 and verifying his acquisition of the Pihl workshop.

# Simo & Matilda Käki

arl Fabergé realised early on that an elegant and well-made case, specially crafted for its contents, would enhance the value of the piece itself. The package worked as a "calling card" both for the object it contained and for the firm whose name was stamped inside.

The long-serving and leading case maker of the House of Faberge was Simo Käki (1819–1896), born in Löytömäki, near the city of Vyborg. In 1833, at the age of fourteen, he left home for St Petersburg to learn a trade. He found apprenticeship with a master case maker in the city. As soon as Simo had

qualified as a master in the mid-1850s, he opened a workshop of his own and embarked on his collaboration with Fabergé – at this stage with Carl's father, Gustav Fabergé.

Simo Käki was also fortunate to find himself an able and accomplished wife. She was Matilda Olivia Orädd. Born in Finland in 1835, she was the daughter of a village tailor. Orädd is an old soldier's name, which translates as "fearless". It suited Matilda down to the ground. She was a key figure in her husband's work, and after he died in 1896, the indomitable Matilda took over the management of the workshop.

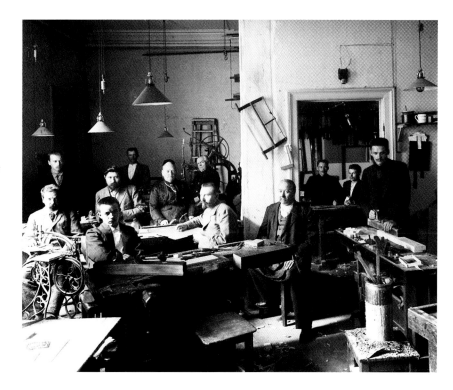

▷ *Master Casemaker Simo Käki's atelier, when his widow Matilda Käki was running the business. The workshop was on the ground floor of the courtyard building at the House of Fabergé premises in St Petersburg. The picture dates from 1902, and Matilda is seated left of centre in the middle ground.*
COURTESY OF THE ALEXANDER FERSMAN MINERALOGICAL MUSEUM IN MOSCOW, UNDER THE RUSSIAN ACADEMY OF SCIENCES.

◁ *A gilt silver and translucent violet guilloché enamel kovsh in its original fitted case. Fabergé, Antti Nevalainen, St Petersburg, made between 1899 and 1908. Scratched stock number 14410. Length of the item 9.5 cm.*
COURTESY OF SOTHEBY'S

When Fabergé moved to his new premises on the Bolshaya Morskaya in 1901, the Käki workshop was installed in the back courtyard, on the ground floor of the wing where the goldsmiths' workshops were located. It was essential for the case makers to be adjacent to the production units, as they had to spend considerable time on the spot, measuring the objects and jewels for which the cases were being made.

Fabergé cases were completely redesigned at the end of the 19th century – the forms, material, and colour scheme. A light holly wood, uniform in colour and polished with beeswax, was the material of choice. The wood was not covered as it had been before: it was beautiful in and of itself. For large objects, such as silver trays, coffee services, samovars, and sets of flatware, sturdy boxes were made of pine wood, oak, and occasionally elm. These new cases became emblematic of Fabergé's production.

The cases were in perfect harmony with their valuable contents, simple in form and totally functional. They are always closely fitted for the object inside, so as not to put it at risk of falling out when the case is opened. The hinges are hidden, barely visible. At the front of each case is a small clasp of a white metal, with the flap turned upwards. The interiors of the case lids are upholstered with cream-coloured silk on which the name and address of Fabergé is printed in gold. The fitted base is lined with ivory-coloured velvet.

The Cabinet of His Imperial Majesty reserved a special type of case for Imperial awards and presentations. Also fitted for their contents, they were covered in bright red Morocco leather. An Imperial double-headed eagle was imprinted in gold on the centre of the lid. Occasionally these boxes were covered with blue or even sometimes green leather. A reason (if there indeed *was* one) for the variation in colour has not been found.

Albert Ampuja was the case maker for the jeweller Alexander Tillander. It can be seen from Tillander's accounts that Ampuja's invoices for cases were by no means modest, a reflection of the fact that case-making was recognised as a demanding craft.

Fabergé also made use of Käki's fine carpentry skills for his wooden art objects: picture frames, cigarette cases, and various types of table-top boxes. The photograph of the Käki workshop taken in 1902 shows several designs for wooden table frames ready to be taken into production.

Simo Käki's nephew Antti Käki was another case maker. He had his workshop at No. 18, Nevsky Prospekt. It is not known whether the two ateliers collaborated.

At the age of seventy-six, after 56 years in Fabergé's service, including fifteen years of managing the atelier herself, Matilda Käki retired and the workshop was closed. The year was 1911.

In looking back on the lives and careers of the workmasters and others in the Fabergé world, one feature that is striking and heartwarming is the apparent lack of any envy or cut-throat competition between the various arms and ateliers. Relations were cordial; the wives and children of the workmasters regularly met socially.

This short passage from Hjalmar Armfelt's reminiscences illustrates the sense of community:

> Among the employees of the Fabergé firm a society was formed. It came about on the employees' own initiative and was called the Saturday Club. The club had approximately twenty members. It met every Saturday evening in turn at the house of one of the members; those who had families. The evenings were spent in a joyous way. This tied the group of colleagues together and cemented our relations, and it helped create a good collegial ambiance within the entire Fabergé operation.

Armfelt's "collegial ambience" was not limited to the masters themselves, but permeated down to the employees on the workshop floor. We have already seen examples of a very modern "team spirit" ethos within Fabergé – the proud displaying of prestige items from the workshop to the journeymen and apprentices who crafted them, just before they were delivered to the customer – and the anecdote that follows suggests that loyalty to the firm was intense and was appreciated at all levels.

Agathon Karlovich Fabergé, Carl's second oldest son, gave an interview to a Finnish journal in 1935.[107] Agathon Fabergé lived in Finland from 1926, from the time of his escape from Russia, until his death in 1951. This is what he had to say about the culture in one of the ateliers:

> I clearly remember our Finnish masters and workers... Holmström served us for 48 years... and the case maker Kämärä for 52 years. Kämärä, whom we called 'Komar', did not smoke, but he was an avid taker of snuff. When he was celebrating his fiftieth anniversary in our service, his fellow workers made him a snuffbox in gold. It was identical to the ragged cellulose case from which for decades he had filled his nostrils. When it was opened, inside was a mosquito, exquisitely fashioned in gold and enamel – a komar. Комар is the word for mosquito in Russian.

To my mind, this goes beyond the traditional retirement gold watch: the item was lovingly crafted by the man's peers and carried with it a clear-cut personal investment. It seems an apt example with which to express that for all the hard labour, for all the gruelling nature of apprenticeships entered into at a very tender age, for all the distance from home and family, those who served the House of Fabergé felt a commonality and saw it as a very good place to work. They respected and honoured the rules and traditions, even after the business closed down and they were forced into exile and often difficult circumstances.

Beside all the beautiful pieces that we marvel at in their display cases, the House of Fabergé created something less tangible but no less valuable, and no less marvellous in its way: a working milieu – in an archly-conservative and class-conscious Imperial St Petersburg – that was both strongly "inclusive" and often conspicuously ahead of its time.

I hope that in its small way this book has helped to bring out this aspect of Carl Fabergé's genius and the genius of his artisans.

Fabergé objects were marked according to precise rules

- Fabergé's name mark (with a few exceptions)
- Master's mark (often, but not in all cases)
- Gold and silver standards
- Mark of the city of manufacture
- Assayer's Mark

## FABERGÉ'S NAME MARK

ФАБЕРЖЕ — Items made in St Petersburg

КФ — Small objects, on which the full name stamp would not fit

К.ФАБЕРЖЕ — Items made in the Moscow, Odessa, and Kiev branches

FABERGE   CF — Articles made for export

## MASTERS' MARK

АН — AUGUST and ALBERT HOLMSTRÖM

М.П  М.П — MIKHAIL PERKHIN 1886-c.1895, c.1895–1903

H.W. — HENRIK WIGSTRÖM

A•H — AUGUST and VÄINÖ HOLLMING

A.N — ANTTI NEVALAINEN

BA — VIKTOR AARNE

ЯA — HJALMAR ARMFELT

S.W — STEFAN VÄKEVÄ

K.W. — KONSTANTIN VÄKEVÄ

J.W. — Widow JENNY VÄKEVÄ (1902–17)

A.W — ALEXANDER VÄKEVÄ

AT — ALFRED THIELEMANN

ET — Widow ELISABETH THIELEMANN (née Körtling) (after 1909)

ФА — FEDOR AFANASIEV

I.P. — JULIUS RAPPOPORT

ICA — First Silver Artel

The marks of Fabergé's St Petersburg workmasters of foreign origin are mostly in Latin characters, whereas those of the Russian workmasters are in Cyrillic. This is because foreign masters belonged to the foreigners' gold- and silversmith guild, the working language of which was German. The Russian masters belonged to the Russian guild. Of the Finnish goldsmiths, only Viktor Aarne and Hjalmar Armfelt used Cyrillic lettering in their marks.

The mark of Aarne in Vyborg (after 1904) was J.V.A.

On the products of Antti Nevalainen (c. 1890-c. 1910) the master's mark A.N. and the gold or silver standard mark of St Petersburg, were punched next to the Fabergé mark either without the initial K, i.e. ФАБЕРЖЕ or with the initial K, i.e. К.ФАБЕРЖЕ. After 1896 the Fabergé mark with the initial K is sometimes combined with the separately punched state arms (the double-headed eagle) in a round cartouche.

On the products of Julius Rappoport (late 1880s-1909) and the First Silver Artel (1909–11), the masters' marks I.P. and ICA and the silver standard mark of St Petersburg, were struck next to the Fabergé mark without the initial K, i.e. ФАБЕРЖЕ. After 1896 this mark is always combined with the separately punched state arms (the double-headed eagle) in a round cartouche. Only a few Rappoport pieces have been found with the initial K, i.e. К.ФАБЕРЖЕ.

The products of the Väkevä family between the late 1850s and c. 1895 do not have Fabergé marks. From c. 1895 the masters' marks of Stefan Väkevä, S.W., (c. 1895–1910), Konstantin Väkevä, K.W., (c. 1895–1902), Jenny Väkevä, widow's mark, J.W., (1902–1917) and Alexander Väkevä, A.W., (c. 1895–1917) and the silver standard mark of St Petersburg, were punched next to the Fabergé mark with the initial K., i.e. К.ФАБЕРЖЕ, seemingly joined to the state arms (the double-headed eagle), thus very similar to Fabergé's Moscow mark.

The products of Erik Kollin, Gabriel Nykänen, and Knut Oscar Pihl were stamped with their master's mark only.

EK — ERIK KOLLIN

GN — GABRIEL NYKÄNEN

OP — KNUT OSCAR PIHL

AM — ANDERS MICKELSSON

(Oval or square cartouche) Mickelsson's mark was also sometimes used in conjunction with Fabergé's name mark (К.)ФАБЕРЖЕ.

## INDEPENDENT MASTERS

Workmasters employed as sub-contractors at Fabergé but who also sold their products to other jewellery stores, did not have the Fabergé mark on their products. Items they have made must be in the original Fabergé case if they are to be reliably attributed to Fabergé.

**T.R**  THEODOR RINGE

**AR**  ANNA RINGE (Anna Ringe's widow's mark was sometimes used in conjunction with Fabergé's mark with the initial K., i.e. К.ФАБЕРЖЕ).

**BC**  VLADIMIR SOLOVIEV

**ES**  EDWARD SCHRAMM

**W.R**  WILHELM REIMER

**АГ**  ANDREY GURIANOV

**Ф.Р.**  FRIEDRICH (FEDOR) RÜCKERT

Among Fabergé's sub-contractors are some unknown workmasters, but their marks have not been dealt with in this context.

### GOLD AND SILVER STANDARDS

Gold objects were usually made of 56 zolotnik (14 karat) or 72 zolotnik (18 karat) gold.

Silver articles were usually made of silver 84 zolotnik (875/000), 88 zolotnik (916/000) or 91 zolotnik (947/000).

### CITY MARKS

1860–1875, gold and silver articles were stamped with the marks of the gold or silver standard and the manufacturing city. 1875–1899 brought the addition of the assayer's signature and the year of production to the mark.

ST PETERSBURG

MOSCOW

ODESSA

At the end of 1898, Russia ratified a new law on marking precious metals applicable to the entire Empire. The law took immediate effect, but in practice articles were not stamped until January 1899. The new mark consisted of a profile of a woman's head with a kokoshnik.

Between 1899 and 1908 the head is facing left. The mark incorporated the gold or silver standard and the initials of the assayer.

Between 1908 and 1917 the head is facing right. The mark incorporates the gold or silver standard and the city of manufacture.

The city of manufacture is indicated with a small Greek letter:

**α**  ST PETERSBURG

**Δ**  MOSCOW

**κ**  ODESSA

**ν**  KIEV

### ASSAYERS 1899–1917

The assayer's mark consisted of his initials.

ST PETERSBURG

**ЯЛ**  Iakov Liapunov (1898/9–1903)
**АР**  Alexander Romanov (April 1904–12)
**КС**  Konstantin Soloviev (1913–17)

MOSCOW

**ИЛ**  Ivan Lebedkin (1898/9–1914)
**ЛО**  Lev Olex (1915–17)

ODESSA

**ИС**  Ilya Sorokin (1898/9–1910)
**МФ**  Mikhail Faleyev (1911–17)

KIEV

**АВ**  Alexander Vyrzhikovsky (1898/9–1904)
**ЛО**  Lev Olex (1905–14)
**АА**  Anatoly Artsybashev (1915–17)

The list should be regarded as indicative only; it is not a comprehensive inventory of Fabergé's collaborators and contemporaries

Beilin & Son, St Petersburg. The firm was founded by Abram Solomonovich Beilin-Levkov and was active between the 1890s and 1918. Beilin produced cigarette cases, snuffboxes, and gold and diamond jewellery. The firm supplied many of the important retail jewellers, among them Fabergé and Tillander, for whom substantial quantities of cigarette cases in silver were made. Beilin was also a sub-contractor to Paul Buhré, making chains for pocket watches commissioned by the Cabinet of His Imperial Majesty. As special orders for the Cabinet, Beilin produced diamond-set crowns and double-headed eagles, possibly to be used for Imperial presentation boxes.

Carl Blank (1857–1924, Finland), St Petersburg. Son of a Finnish blacksmith, he was apprenticed in St Petersburg and was a master for Carl Hahn, for whom he worked from 1882 to 1909. He established his own workshop in 1894 and was so successful that he was made a Merchant of the 2nd Guild. He was in partnership with Hahn from 1909 until the closure of the firm in 1911, after which (until 1917) he became an independent contractor supplying the Imperial Cabinet.

Blank produced diamond insignia for the various Russian orders, field-marshal batons, enamelled cigarette cases, and gem-set ecclesiastical awards. He was appointed Official Appraiser of the Cabinet of His Imperial Majesty in 1915, and two years later received hereditary honorary citizenship. Blank moved with his family to Finland following the Russian Revolution.

Carl Bock (1851–1916?), St Petersburg. Proprietor of a well-known goldsmith's company from 1874 to 1916. The company was founded by J. Eckhardt in 1840. Following Eckhardt's death, the firm was acquired by F. Bühler, from whom Bock purchased it. He began manufacturing gold ornaments, decorative objects, and jewellery for the Cabinet of His Imperial Majesty in 1901. He employed about twenty-five workmasters and two to three apprentices. His son Alexander Bock took over the firm in 1916.

C. E. Bolin, St Petersburg. The company was founded in the 1790s by Andreas Römpler, who soon became a purveyor to the Imperial Court. Swedish-born Carl Edvard Bolin married Römpler's daughter in 1834 and inherited the firm on the death of his father-in-law.

The House of Bolin continued to be the most important manufacturer of fine jewellery up to 1917, serving seven consecutive Russian monarchs. The firm supplied the Cabinet of His Imperial Majesty with diamond insignia of the Imperial orders, jewellery, and ecclesiastical awards.

The last two members of the Bolin family, Edvard and Gustaf, received numerous official honours. In 1912 they were granted hereditary nobility by letters patent of Nicholas II.

Bolin's main workshops at No. 55, Moyka River were headed by the master goldsmiths and jewellers Vladimir Iakovlevich Finikov, *active* 1880–1908, who himself employed fifteen workers; Nikolay Andreyevich Chernokov, *active* early 1900s-1917?; Alexander Robert Friedrich Schwan, *active* ?-1895, followed by his widow Sophie Schwan (Sofia Ivanovna) and son Robert Schwan (Roman Robertovich), *active* 1895–1917.

Wilhelm A. Bolin opened a branch in Moscow in 1888. This continued its operations in Stockholm following the Revolution, making it the oldest Russian goldsmith's firm still in existence.

Ivan Savelevich Britsyn, (1870–1952), St Petersburg. Master gold- and silversmith. The son of a peasant from the Moscow region, he trained at Fabergé. Britsyn established himself as an independent master in 1903 and specialised in enamelled products, mostly cigarette cases, but also jewellery. His tools and workbench are preserved at Peterhof. Workshop on Spasskaya, then from 1910 at No. 12, Malaya Konyushennaya.

Paul Eduard Buhré, St Petersburg. He supplied the Cabinet of His Imperial Majesty with pocket watches – the largest category of official gift items – and was succeeded by his son Paul Leopold Buhré (d.1897?). Jean Pfund continued the business following the latter's death.

Friedrich Daniel Butz, St Petersburg. A goldsmith and jeweller who established his firm during Nicholas I's reign. The business became one of St Petersburg's finest jewellery stores. During Fabergé's time, it was headed by Alexander Butz, and later by his son Julius Agathon Butz (1847–1912), a good friend of Carl Fabergé.

The company produced jewellery, gold objects, and diamond insignia. The Finnish master Tuomas Polvinen joined the firm during Julius's tenure. Following Butz's death, Polvinen returned to Finland, taking with him all his design books. These contain excellent examples of the firm's production from the 1850s onwards.

Alexey Kuzmich Denisov-Uralsky (1864–1926, Finland), St Petersburg. He specialised in hardstones from the Ural Mountains, producing a variety of decorative items and miniature animals in the same style as Fabergé. His retail shop was opposite Fabergé's on the Bolshaya Morskaya.

Fraget Argent, St Petersburg. The brothers Alfons and Józef Fraget founded this well-known silver workshop in Warsaw in 1824 under the name Bracia Fraget. Józef (1797–1867) later took over the entire company, which was inherited by his son Julian Fraget (1841–1906). There were branch offices in many cities, including Moscow, Kharkov, Kiev, Tbilisi, Odessa, and Vilnius. Julian's daughter Maria Fraget Swiatopołk-Mirska (1869–1938) subsequently headed the firm, which continued the production of base metals and decorations through Soviet times, until 1939.

Brothers Grachev, St Petersburg. Gavril Petrovich Grachev founded the firm in 1866. On his death in 1873, his sons took over under the name Brothers Grachev. They worked in gold, silver, and enamel, and also supplied objects to the Cabinet of His Imperial Majesty. In 1896 Brothers Grachev received the Imperial Warrant.

Carl August Ferdinand Hahn (1836–1899), St Petersburg. His jewellery firm, founded in 1873, was one of Fabergé's major competitors. He became a purveyor to the Imperial Court during the reign of Alexander III, the same honour being accorded his son Dmitry Hahn in 1903.

Hahn's production was extensive and varied. The company produced jewellery, objects, and diamond-set insignia and swords for the Imperial Cabinet. For the coronation of Nicholas II, the firm created the diamond crown for Empress Alexandra Feodorovna.

Hahn worked with two master goldsmiths: the Finn Carl Blank (*see above*) and the Baltic German Alexander Treyden (*see below*).

The business was closed following Dmitry's death in 1911. Alexander Tillander bought the lease to the premises, which were located at 26, Nevsky Prospekt, and moved his own retail business there. Both Blank and Treyden continued as independent entrepreneurs.

Alexander Dementevich Ivanov (d. 1907), St Petersburg, was a successful jeweller and goldsmith. He was a Merchant of the 3rd Guild 1856–63, then of the 1st Guild. Hereditary honorary citizen, 1888. Produced snuffboxes and jewellery for the Cabinet of His Imperial Majesty, 1894–1907. His widow Xenia Tarsovna continued the business until 1911.

Otto Samuel Keibel (1768–1809), St Petersburg. The German-born Keibel opened his firm in 1797. His son Johann Wilhelm Keibel, together with the goldsmith Wilhelm Kämmerer, was charged in 1836 with producing all Russia's official orders and decorations. Prior to WWI, the company was headed by the fourth-generation Albert Konstantin Keibel (1854–1910). The firm also produced diamond-set swords and field-marshal batons.

Ivan Petrovich Khlebnikov (1819–1881), Moscow. Founder of a gold- and silversmith workshop in St Petersburg in 1867. In 1871, the business was moved to Moscow. The

firm, a Purveyor of the Court, became one of the leading industrial companies in the Russian Empire. On the founder's death, the business was inherited by his four sons.

**GUSTAV GUSTAVOVICH KLINGERT,** Moscow. He opened his own silversmith's workshop in Moscow in 1865 and was active until 1917, specialising in cloisonné-enamelled objects in the Russian national style. During the first decade of the new century, the firm employed up to fifty-five workers. Klingert exhibited at the 1893 Chicago World's Fair.

**FRÉDÉRIC CHRISTIAN KOECHLY** (1838–1906), St Petersburg, was a goldsmith and jeweller with roots in Switzerland. He was an important supplier of presentation objects to the Cabinet of His Imperial Majesty and was a Merchant of the 2nd Guild. Koechly won the competition in 1894 for a parure in sapphires and diamonds for Empress Alexandra Feodorovna. He was granted the title of Court Jeweller in 1898 and was a member of the jury at the Paris Exposition Universelle in 1900. He was also a member of the St Petersburg administration of foreign trade. Finnish-born master jeweller Adolf Wist was Koechly's head workmaster.

**EDVARD JOHAN KORTMAN,** St Petersburg. A silversmith from Finland, he bought G. Bostel's business in 1848. His firm produced silverware, regimental jewellery, jetons, medals, insignia, enamelled and galvanised objects, and guilloché work. He also made fine gold objects for the Cabinet of His Imperial Majesty.

**FEDOR ANATOLEVICH LORIÉ,** Moscow. His goldsmith's workshop, founded in 1871, was in operation up until the Revolution. He employed twenty to thirty craftsmen, manufacturing both gold and silver jewellery and ornaments. Art Nouveau and modern Russian-style jewellery were his speciality.

**IVAN EKIMOVICH MOROZOV** (1825–1885), St Petersburg. His company, founded in 1849, was inherited by his son Vladimir Ivanovich Morozov.

The firm created a range of silver and gold objects and had an extensive production of gold jewellery. Morozov employed many independent masters, including several Finns. One of them was Stefan Väkevä's son-in-law, the master silversmith Adam Herttuainen, who produced a considerable amount of silverware for Morozov. Another was the master jeweller Johan Passonen, who made gold jewellery for the retail store and by order of the Cabinet of His Imperial Majesty. The silversmith Antti Seppänen and jeweller Juhani Seppänen also collaborated with Morozov.

**PAVEL AKIMOVICH OVCHINNIKOV** (1830–1888), Moscow. Ovchinnikov was a serf by origin, who founded a large-scale industrial company in 1853. He became an important supplier to the Cabinet of His Imperial Majesty. He also had a branch and workshop in St Petersburg. In 1881, the firm employed 300 workmen. The Ovchinnikov company was the first to devote itself entirely to the manufacture of articles in the Russian national style. Its enamelware was outstanding and won first prizes in all important Russian exhibitions. Ovchinnikov also exhibited at every world's fair and earned honourable mentions both in Chicago (1893) and Paris (1900). On the death of the founder, his son Alexander took over the business.

**FRIEDRICH KONRAD RUTSCH,** St Petersburg. A German-born master from Heidelberg, he produced chains, lockets, and other pieces of jewellery, as well as evening bags of gold mesh for which the workshops of Fabergé supplied decorative closures.

**FRIEDRICH MORITZ RÜCKERT** (Fedor Ivanovich) (1851–1918), Moscow. Of Prussian origin, Rückert was, according to family tradition, "brought to Russia at the age of 14 by a member of a Russian princely family". Rückert's years of training are not documented, but by 1886 he had qualified as a master silversmith and set up a workshop of his own, specialising in painted enamel. By 1898 he had 4 journeymen working for him; in 1900 the number had risen to 14. Rückert was an outstanding craftsman with a very personal style. His works are celebrated as some of the most significant pieces of the Russian national movement. Rückert did not have a retail outlet of his own. He preferred to collaborate – as an independent supplier – with the well-known silver manufacturers of Moscow. He worked with Ovchinnikov, with Orest Kurliokov, and very successfully with Fabergé's Moscow outlet. In 1914, the First World War put an end to Rückert's career. German subjects between the ages of 18 and 45 were declared prisoners of war. Although Rückert was past the age for imprisonment, he was not allowed to continue his business, which was declared state property.

Rückert's life and work has been presented in a magnum opus by Tatiana Muntian in 2016. See the *References*. See also Atzbach, John. "Workmaster Feodor Rückert" in McFerrin, 2013, pages 274–283.

**IVAN DMITRIEVICH SALTYKOV,** Moscow. Owner of a silversmith's workshop in 1884. The firm had twenty-three workmasters and eight apprentices in 1897. The company specialised in objects decorated with cloisonné enamel.

**PAVEL FEDOROVICH SAZIKOV,** Moscow. Sazikov founded his workshop in 1793. From 1810 the workshop was called a factory, which indicated it had grown substantially. In 1842, a branch was opened in St Petersburg. From 1846, the firm had the Imperial Warrant. After the founder's death, the business passed to his son, and thereafter to his grandsons. The firm of Sazikov is known for high-quality silverware and for silver sculptures and cloisonné enamels.

**MARIA VASILEVNA SEMENOVA,** Moscow. Maria Semenova inherited the silversmith's workshop established in 1852 by her father, Vasily Semenovich Semenov. There were one hundred craftsmen in her employ in 1905, producing high-quality cloisonné enamel pieces.

**AVENIR IVANOVICH SUMIN,** St Petersburg. Purveyor of the Court of Empress Alexandra Feodorovna, 1913. Decorative objects and miniature figurines made of hardstones were his speciality, making him a Fabergé competitor. The company had been founded in 1869 by his father, Ivan Sumin.

**THIRD ARTEL,** St Petersburg, was a group of more than ten craftsmen, former members of the Fabergé firm. This independent co-operative produced guilloché enamel objects in the style of Fabergé, such as desk clocks, frames, miniature Easter eggs, small bowls and dishes, most often in pastel colours,

**ALEXANDER EDVARD TILLANDER** (1837–1918), St Petersburg. Born in Helsinki, Tillander was apprenticed to the Finnish master Fredrik Adolf Holstenius in Tsarskoe Selo in 1848. He obtained his master's certificate in 1860 and began to work independently.

He opened a retail business with its own workforce in the 1870s, specialising in jewellery, but also making gold – often enamelled – ornaments, as well as jetons and miniature pendants. Between 1896 and 1911, the firm supplied the Cabinet of His Imperial Majesty with gold and silver cigarette cases and numerous jewels with Imperial emblems, such as tie-pins, cufflinks, pendants, and brooches.

**ALEXANDER THEODOR TILLANDER** (1870–1943). Son of Alexander Edvard Tillander (*see above*). He began his training at the age of fifteen in his father's workshop. He furthered his studies in London and Paris. He returned in 1892 to help his father and assumed the management of the family firm in 1910. Tillander was the representative in Russia of French jeweller Boucheron. From 1911 to 1917, the Tillander workshop was owned and led by the German-born master jeweller Theodor Weibel, who had worked for Tillander since his years of training.

# COLLABORATORS AND CONTEMPORARIES
## IN ST PETERSBURG AND MOSCOW

Alexander Theodor continued operations in Helsinki after the Russian Revolution, successfully adapting to conditions in a small city like Helsinki, with its very limited market. While in St Petersburg, he had maintained relations with his countrymen and sold items through the Helsinki-based jeweller Viktor Lindman. When Lindman retired, Tillander purchased his business.

Tillander had already transferred a sizeable part of his stock across the border before the Revolution. In the early stages of his operations in Helsinki, he bought large quantities of precious jewellery from Russian émigrés in Finland, selling them on in Paris and London. He also succeeded in recruiting talented goldsmiths fleeing the new Soviet Russia, who brought with them their skills and experience. The master's mark of A. Tillander was **AT** in an oval cartouche, 1860-c.1890 and **AT** in a lozenge-shaped cartouche, c.1890–1917. Tillander's marks are often confused with those of Alfred Thielemann and Alexander Treyden.

Alexander Adolf Treyden was a Baltic German. It is not known where Treyden apprenticed and qualified as a master goldsmith and jeweller. From the early 1880s until 1911 he worked for the jeweller Carl Hahn in St Petersburg, producing guilloché enamelled and jewelled items, among them important presentation pieces commissioned by the Cabinet of His Imperial Majesty. Treyden is also known for a series of decorative gold and gilt silver bowls and *charkas* with plique à jour enamel. In 1911, Treyden became an independent entrepreneur on purchasing the retail shop and atelier of the jeweller Johansson at 42, Nevsky Prospekt. He was elected treasurer of the Society of Jewellers, Goldsmiths, Silversmiths, and Merchants in 1912. The master's mark of Alexander Treyden was **AT** in an oval cartouche.

# ORTHOGRAPHY AND DATES

Russian names have been transliterated with the primary aim of being accessible to a general readership. A modified version of the Library of Congress system has been employed.

Surnames of Western origin are rendered in their original language. Given names appear in their Russian form – for instance Nikolay and Ekaterina, rather than Nicholas and Catherine. The only exception to this is for monarchs and their consorts, for whom English equivalents have been used.

Dates in the text are given according to both the Julian calendar, used in Imperial Russia, and the Gregorian calendar, used in Western Europe. The former was twelve days behind the latter in the 19th century, and thirteen days behind in the 20th century. The abbreviations *o.s.* (old style, Julian) and *n.s.* (new style, Gregorian) have also been used for clarification where necessary.

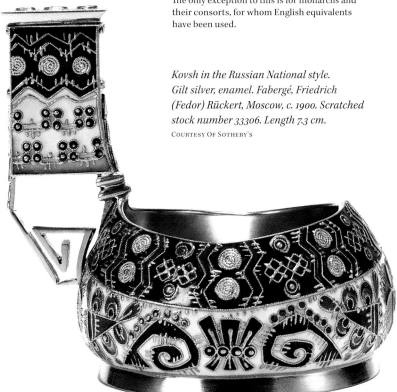

*Kovsh in the Russian National style. Gilt silver, enamel. Fabergé, Friedrich (Fedor) Rückert, Moscow, c. 1900. Scratched stock number 33306. Length 7.3 cm.*
COURTESY OF SOTHEBY'S

1 Snowman, 1953, pp. 28–29.

2 Fabergé, 1992, p. 35.

3 Joseph Friedman (b. 1811) swore his burgher's oath in Frankfurt in 1849, and settled in the city as a goldsmith and jeweller. From 1864, his brother Adolph Friedman became a co-owner of the business. See Habsburg, 1987, p. 40.

4 These personal details were recounted by Carl Fabergé's eldest son Eugène to A. Kenneth Snowman in the early 1950s.

5 For an excellent source of information on the Campana Collection see Munn, 1984, pp. 87–104.

6 After the demise of the Empire, the regalia and part of the jewels were transferred to the Moscow Kremlin. See Fersman, 1926. Passim. A substantial part of the collection was sold abroad. See Christie, Manson & Woods, 1927.

7 Russian State Historical Archives (RGIA), Fond 472, Opis 38, Delo 7, pp. 41–44. Habsburg-Lopato, 1993, p. 55. As early as in 1830, the first large finds of Greek artefacts and jewels were made at the Scythian burial tumulus of Kul-Oba, on the Kerch Peninsula at the eastern end of the Crimea, close to the strait that connects the Black Sea and the Sea of Azov. Between 1864 and 1868, another burial kurgan – Bolshaya Bliznitsa – was discovered and excavated on the Taman Peninsula, just across this strait to the east.

8 Léon Grinberg's notes on his interviews with Andrey Plotnitsky, dated September 28th, 1951. Hillwood Estate, Museum & Gardens, Washington DC. See the References.

9 Bainbridge 1949, p. 130. The reference is to the Pamiat Azova ("Memory of Azov") Easter Egg from 1891, now in the Moscow Kremlin Armoury Museum.

10 The reappearance of the Third Imperial Egg is one of the most remarkable and quirky stories in the entire Fabergé-hunters' canon. Briefly, the quest began in earnest from a chance discovery in 2011, by Anna and Vincent Palmade, that a piece auctioned (not as Fabergé) by Parke Bernet, New York in 1967 bore a striking resemblance to an egg seen in the photos of the 1902 von Derwies Palace Exhibition (see p. xxx) This was widely reported in the media at the time, but not until 2012 did the egg's owner – a scrap dealer in the U.S. Mid West – catch up with an article that suggested the item he had bought for USD 13,000 a decade earlier ("to sell on to a buyer who would melt it down") was worth a king's ransom. The owner contacted Kieran McCarthy of Wartski, London, with photographs that instantly indicated the egg was very much the real thing. It is hard to know which of the two men were more flabbergasted – the owner or McCarthy himself. Wartski bought the egg on behalf of a private collector, and the piece was exhibited, for the first time in more than a century, in April 2014.

11 There is only scanty information on these two missing eggs. See Fabergé et al, 1997, pp. 100–101. The 1888 Egg is described as "A cherub pulling a two-wheeled chariot containing an egg". It is possible that this object was among those sold by Armand Hammer in New York in 1934. The Nécessaire Egg of 1889 is known to have been sold by Wartski, London in the early 1950s to "A Stranger". Its present whereabouts are being researched by Kieran McCarthy of Wartski.

12 The research on the crown brooches was carried out by Dr Galina Korneva, St Petersburg. For Fabergé's invoice, see RGIA, fond 268, opis 8, delo 195, pp. 65–67.

13 Bowenite is the official state mineral of Rhode Island, USA.

14 Anna Vyrubova (ed. Irmeli Viherjuuri), 1987. Anna Virubova, Keisarinnan hovineiti (Anna Vyrubova: Maid-of-Honour to the Empress). Otava, Helsinki, p. 60.

15 Lowes & McCanless, 2001, p. 231.

16 ВЕСЪ ПЕТЕРБУРГЪ, 1895 (Address Directory of St Petersburg).

17 Erik-Amburger-Datenbank. Ausländer im vorrevolutionären Russland.

18 Bäcksbacka, 1951, p. 449.

19 Erik-Amburger-Datenbank. Ausländer im vorrevolutionären Russland.

20 Research of William Lowes and Christel McCanless.

21 Erik-Amburger- Datenbank. Ausländer im vorrevolutionären Russland.

22 For the information on how the tradition of the series of Imperial Easter eggs came about, see Fabergé et al., 1997, pp. 15–17.

23 Vorres, 1964, p. 41.

24 Communication with Valentin Skurlov, St Petersburg.

25 Fabergé, 1992, p. 5.

26 The State Hermitage Museum inventory numbers are Э-2165, Э-2169, Э-2171.

27 The figurine is illustrated in Hill, Gerard (ed.) Fabergé and the Russian Master Goldsmiths. New York: Wing Books. Plate 19. p. 65.

28 Ekenäs in Swedish, which was and still is the dominant local tongue of the town.

29 Jalmari Haikonen had worked for the well-known engravers A. Jaggard, initially as an apprentice, and he subsequently took his journeyman's examination in this firm.

30 Princess Cécile Murat, née d'Elchingen (1867–1960) presented her paramour Charles Antoine Roger Luzarche d'Azay with cigarette cases produced by the House of Fabergé. In all, 18 of them were made by Fabergé. They are now in the Musée des Arts Décoratifs in Paris. Luzarche d'Azay had been a French secret service officer early in the 20th century.

31 Haikonen's account is given verbatim. Grand Duke Nikolay Nikolaevich (1856–1929), the recipient of the platinum cigarette box, was actually Nicholas II's first cousin once removed, and not his uncle. He was appointed Commander of the Russian forces fighting against Germany, Turkey, and Austro-Hungary in the initial stages of World War One, but by 1916 he had been dismissed and was instead C-in-C and Viceroy in the Caucasus. Grand Duke Nikolay Nikolaevich was also briefly the nominal Emperor of Russia in 1922, after the Revolution. It is also perhaps worth noting that the young journeymen's assessment of the value of the cigarette box was wildly overstated: the most expensive of all the Fabergé cigarette cases was priced at perhaps 4,000 roubles, and even one of the costliest Imperial Easter Eggs (the 'Catherine the Great Egg') cost no more than 26 800 roubles when it was first delivered. Grand Duke Nikolay turned 60 in 1916: the cigarette case was probably a 60th birthday gift.

32 Alexander Tillander wrote detailed annual reports on his business between the years 1901 and 1917.

33 Marvin C. Ross, chief curator of Hillwood 1958–1965, corresponded with Léon Grinberg in the early 1970s on the subject of Grinberg's interviews with Eugène Fabergé and Andrey Plotnitsky. Grinberg's notes on his interviews with Andrey Plotnitsky are dated September 28th, 1951. Hillwood Estate, Museum & Gardens, Washington DC.

34 Snowman, 1953, p. 81.

35 See Tillander-Godenhielm et al., 2000, for the first stock book of Henrik Wigström, and Tillander-Godenhielm, 2008, for the second stock book.

36 Mannerheim 1951, p. 28.

37 Georg Alphonse Stein, a native of Courland, was employed by Fabergé in 1896. Interviewed in Paris by Léon Grinberg, Eugène Fabergé said: "He (Stein) had been a 'master carriage builder', but became with us one of the most skilled engravers". Grinberg's interviews with Eugène Fabergé were made in the late 1940s and early 1950s. Extracts of these are included in correspondence between Marvin C. Ross, chief curator of Hillwood, and Léon Grinberg in Paris. Grinberg was the nephew of Jacques Zolotnitsky, who re-established his grandfather's antique store A La Vieille Russie in Paris, c.1920. The firm was originally founded in Kiev in 1851. When A La Vieille Russie was re-located to New York, Grinberg remained in Paris working as an independent antique dealer. Hillwood Estate, Museum & Garden, Washington DC.

38 For more information on Kortman, see page 270.

39 Baron Freedericksz was created count at the tercentenary of the Romanov dynasty in 1913.

40 Snowman, 1977, p. 56.

41 Numismatic Chronicle and Journal of The Numismatic Society (Great Britain), 1902, p. 76.

42 Fabergé scholar Alexander von Solodkoff quotes Maria Feodorovna's letter dated April 8th, 1914 in his book The Art of Carl Fabergé, 1988, p.24. The quotation is a translation from Danish, the maternal language of Empress Maria Feodorovna and her sister Queen Alexandra.

43 Léon Grinberg's interview with Andrey Plotnitsky, September 28th, 1951. Hillwood Estate, Museum & Gardens, Washington DC.

44 Fabergé, 1997, p. 247.

45 The photograph was pointed out to Ms Wintraecken by her colleague. See the website Fabergé's Imperial Easter Eggs, hosted by Annemiek Wintraecken.

46 Fabergé, 1997, p. 160 and the website Fabergé's Imperial Easter Eggs, hosted by Annemiek Wintraecken.

47 Bainbridge, 1949, p. 130.

48 The marriage between Albert and Sara Marshak took place in 1900. Their daughter Sofia was born in 1899.

49 A letter to the author, dated August 14th, 1996, from Edgar Holmström, Västerås, Sweden.

50 Maxim Maximovich Litvinov (1876–1951) was in charge of emigration applications. In 1930 he was appointed Minister of Foreign Affairs of the Soviet Union. He later served as the Soviet Ambassador to the United States.

51 The story of how the frost-flower designs came about was originally recounted first-hand by Alma to her niece Lydia Pihl. Alma had no children of her own, and she was very close to Lydia.

52 Communication from the descendants of Mrs Edla Nobel.

53 The jewellers A. Tillander made use of a number of sub-contractors with various specialities. These are listed in his annual business reports kept between 1901 and 1917.

54 Siltanen, 1999, passim. This book, based on reminiscenses of the Silventoinen family, (Petter "Pekka" Silventoinen was an important producer of silverware in St Petersburg), describes the social life of the Finnish gold- and silversmiths in St Petersburg. Parents and children of the Hollming, Wigström, Nykänen, Nevalainen, and Silventoinen families were close friends and met frequently for family events and holidays.

55 Siltanen, 1999, p. 97.

56 Siltanen, Pentti, 1999. Dr. Siltanen's book tells the story of the St Petersburg master silversmith Pekka Silventoinen, a close family relative. Silventoinen was an important manufacturer of silverware. He employed more than 70 workers during the latter part of the 19th century. The Silventoinen family were close friends of the Nykänens.

57 Recipients of these objects were meritorious individuals in state service, or persons, either at home or abroad, who had rendered the sovereign some special service. For details on the Imperial Award System, see Tillander-Godenhielm, 2005.

58 Snowman, 1952, page 121. The author mentions that 'Niukkanen' (no Christian name mentioned) was manager of Fabergé's Odessa branch after Karl Gustav Lundell. Lundell has never been identified. The only goldsmith with this name never qualified as a master goldsmith. 'Niukkanen' is an early (and persistent) misunderstanding of the spelling of Nykänen's name. The error occurred at the transliteration of his name from the Cyrillic Нюкяненъ into Latin script.

59 Gabriel Nykänen's older brother, master goldsmith Matts Nykänen, had a workshop at the address No. 3, Kaznacheiskaya. He was a sub-contractor to retail jewellers, among them A.Tillander, specialising in the production of cigarette cases. His two sons Frans and Adam Nykänen were also goldsmiths, but they worked independently from their father Matts.

60 Bäcksbacka, p. 262.

61 Erik-Amburger-Datenbank. Ausländer im vorrevolutionären Russland.

62 Ibid.

63 Lowes and McCanless, 2001, p. 239.

64 Центральный Государственный Архив Москвы (Central State Archive of Moscow), Fond 1204, opis 2, delo 68. I am most grateful to historian and independent researcher Dmitry Krivoshey, Moscow, for finding this file and for sharing it with me.

65 Communication with Dr Valentin Skurlov, St Petersburg.

66 Fabergé's store was located at No. 16, Bolshaya Morskaya until 1901, when the firm moved to No. 24, Bolshaya Morskaya.

67 Hjalmar Armfelt. Erään ihmisen tarina. Handwritten in the Finnish language, early 1950s.

68 The Winter War, 1939–40 and the Continuation War, 1941–44.

69 The most prominent member of this family was Gustav Mauritz Armfelt (1757–1814), a favourite of both King Gustav III of Sweden and Emperor Alexander I of Russia. He was a Knight of the Order of the Seraphim of Sweden and of St Andrew of Russia. He was granted the title of count in 1812 by Alexander I. His son Count Alexander Armfelt was the most decorated Finnish civil servant in the history of the Grand Duchy of Finland. His highest post was that of Minister State Secretary. There were several generals and admirals, as well as a number of high-ranking civil servants, in the baronial branch. Hjalmar Armfelt belonged to the untitled branch of the family.

70 The silversmith Paul Sohlman, born at Kangasala in Finland, was a prolific craftsman. He specialised in the production of handmade silver services and objects. Bäcksbacka, 1951, p. 260.

71 A St Petersburg coachman with a horse.

72 Captain 2nd Rank Otto Armfelt (1847–1904), later Captain 1st Rank.

73 Armfelt does not mention the name of the goldsmith.

74 It is interesting to compare this with the position of Armfelt's colleague, Albert Holmström, who married the daughter of a Russian general some ten years later.

75 Frida Armfelt (1874–1909), married Sergei von Wittenburg, a physician in the Russian Navy, in 1899. She died in childbirth at Kronstadt.

76 Karin Anna Armfelt (1872–1920) married Lieutenant Leonid Borodovsky († 1905), and then in 1912 Sergei von Wittenberg, the widowed husband of her sister Frida Armfelt.

77 The vicar of the Hauho congregation Vilhelm Palmroth was married to Hjalmar's oldest sister Olga Armfelt (1866–1936).

78 Kalle Kuula's real name was Karl, he was nicknamed "Kalle". In a tragic twist, the Finnish kuula translates as "bullet".

79 Known from 1923 as Griboyedova Kanal.

80 A pud or pood is an old Russian unit of weight. 1 pud = 36.11 pounds or 16.38 kilograms.

81 From 1809 onwards, when Finland became a Grand Duchy of the Russian Empire, the Finnish nobility had fourteen places reserved for them at the Smolny Institute, and from that year on, that precise number of Finnish girls were enrolled. A total of 176 Finnish girls graduated from the Smolny. The school was founded by Catherine the Great, with the idea that girls should receive the same education as boys in comparative institutes. However, the idea was not realised as such. The subjects taught were history, geography, mathematics, physics, and heraldry. The school emphasised languages. The girls were also taught singing, music, and dancing. Practical subjects were not included in the curriculum, as it was taken for granted that the girls would have servants in their future homes.

82 Murmansk is an important seaport on the north coast of the Kola Peninsula, facing the Barents Sea. Although north of the Arctic Circle, the winters are relatively mild, owing to the effects of the Gulf Stream current.

83 A reference to the 76 mm M1902 divisional field gun, colloquially known as the "three-incher". Many different factions used this weapon after the collapse of the Russian Empire in 1917.

84 Clas August Asker (1883–1919) was Sweden's Consul General in Moscow from 1916. The Soviets took possession of the consulate and the official residence at Brussovsky Pereulok, a few blocks away from the Kremlin, just as Armfelt reported. Asker, his wife Brita, and their children managed to escape Russia, making the last leg (across the Gulf of Finland to Sweden) in a fisherman's boat. All the non-Communist countries were regarded as enemies of the Soviet Union, and hence all their offices and residences were expropriated.

85 The Winter War was a military conflict between the Soviet Union and Finland, lasting 105 days in 1939–40. It began with the attempted Soviet invasion of Finland. The Soviet Union staked claim to parts of Finnish territory on security grounds, primarily the protection of Leningrad, which was only 20 miles (c. 30 km) from the Finnish border.

86 At the very end of his reminiscences, Hjalmar Armfelt brings up the tragic fate of his son Viktor. The family lost all contact with Viktor after their return to Finland. Following the death of Joseph Stalin in 1953, at the time Nikita Khrushchev came to power, there was a brief political thaw in relations between the Soviet Union and the outside world. International contacts became possible to some extent. The Armfelt family learned that Viktor had been arrested on trumped-up charges and sentenced to forced labour for ten years. When released, he attended the funeral of a friend, where he was spotted by a KGB agent, who arrested him once more. He was sentenced to another ten years of hard labour. Viktor was finally released in 1956. The years in the Gulags had completely shattered his health, despite certain privileges he enjoyed as part of the camp's entertainment troupe. Viktor's niece and nephew were permitted to visit their uncle in Moscow, but not before 1960. At the time of their last visit, Viktor was paralysed and wheelchair-bound. He died during the late winter of 1970; the precise date is not known. His ashes were brought to Finland and were buried in the family grave in the town of Hämeenlinna.

87 Known from 1923 as Griboyedova Kanal.

88 The migration application can be found in the Säkkijärvi parish register and is dated January 28th, 1843 (register of children born in Säkkijärvi during the years 1817–1838).

89 Bäcksbacka, p. 336.

90 See: Saloniemi, 2006, Catalogue No. 136. Coffee pot, marked SW, MP-11532, stock number 13442; sugar bowl, marked SW, MP-11533, stock number 13443; creamer, marked KW, MP-11534, stock number 10394. See also Gusarova, E.B. et al. (1996) The World of Fabergé. Moscow: "Moscow Kremlin" State Museum-Preserve of History and Culture, pp. 134–5.

91 Archives of the Finnish Ministry of Foreign Affairs. The relevant section head at the Finnish Foreign Ministry, Paavo Pajunen, signed Väkevä's employer's reference in Helsinki on December 2nd, 1937.

92 The school was founded in 1876, but opened only four years later.

93 The reminiscences are today in the collection of Koistinen's descendants.

94 Fabergé, 1992, p. 1. The papers of Academician A.E. Fersman are held at the Archive of Russian Academy of Sciences. Fond 544, opis 7, delo 63.

95 Fabergé, 1992, pp. 21–23.

96 An album with Andrianov's designs of jewellery and objects of vertu from 1915 has survived. The album was acquired in 1990 by The Moscow Kremlin State Museum Preserve of History and Culture.

97 Fabergé, 1992, p. 22.

98 The presentation gift to Prince von Bismarck is in the McFerrin Collection, Houston, Texas. The Danish Palaces Imperial Easter Egg is part of the Matilda Geddings Gray Foundation Collection, New Orleans, Louisiana. The Easter Egg is on long-term loan at The Metropolitan Museum of Art in New York, NY.

99 Fabergé, 1992, p. 9.

100 Habsburg, 2000. pp. 298–300. Research of Dr Marina Lopato.

101 The Pamiat Azova Egg is part of the collection of The State Historical and Cultural Museum in the Kremlin, Moscow.

102 Fabergé, 1992, p. 38. The text is a translation from the Russian language and has been slightly amended to follow more closely the original Russian.

103 Fabergé, 1992, p. 45.

104 San-Galli was of Prussian descent, the owner of an iron foundry and mechanical factories both in Moscow and St Petersburg producing, art castings and other things,

105 Muntian, 2016, pp. 67–75.

106 Habsburg, 2003, pp. 441–447.

107 Joensuu, Väinö, No.18, May 4th, 1935. So far no further information has been found on the case maker Kämärä.

# REFERENCES

**PUBLISHED SOURCES**

ADAMS, TIMOTHY "A gift from the czar and a puzzle solved" in *The Magazine ANTIQUES*, July/August 2017, pp. 46–48.

ADAMS, TIMOTHY AND MCCANLESS CHRISTEL LUDEWIG "Fabergé Cossack Figures Created from Russian Gemstones" in *Gems & Gemology*, Volume 52, Summer 2016, No.2, pp. 132–143.

BAINBRIDGE, HENRY C. (1949). *Peter Carl Fabergé. His Life and Works*. London: B.T.Batsford Ltd.

BORG, TYRA (1972). *Guld- och silversmeder i Finland, 1373–1873*. (Gold- and Silversmiths in Finland) Malmö: Malmö Grafiska.

BÄCKSBACKA, LEONARD (1951). *St. Petersburgs Juvelerare, Guld och silversmeder, 1714–1870*. (St Petersburg Jewellers, Gold- and Silversmiths 1714–1870). Helsinki: Published privately.

CHRISTIE'S *Auction Catalogues, 1970s-2017*.

CHRISTIE, MANSON & WOODS (1927). *Catalogue of an Important Assemblage of Magnificent Jewellery mostly dating from the 18th Century which Formed Part of the Russian State Jewels*. London.

ENGMAN, MAX (1980). "Finnish goldsmiths in St Petersburg during two centuries" in *Carl Fabergé and his Contemporaries*. Helsinki: A. Tillander.

ENGMAN, MAX (1983). *St Petersburg och Finland migration och influens, 1703–1917*. (St Petersburg and Finland. Migration and Influence, 1703–1917). Bidrag till kännedom om Finlands natur och folk. Helsinki: Societetas scientiarum Fennica.

ENGMAN, MAX (2004). *Pietarin suomalaiset*. (The Finns in St Petersburg). Helsinki: WSOY.

FABERGÉ, TATIANA AND SKURLOV, VALENTIN (1992). *History of the Fabergé Firm: According to the Recollections of the Head Designer of the Firm Franz P. Birbaum*. St Petersburg: Published privately.

FABERGÈ, TATIANA, PROLER, LYNETTE AND SKURLOV, VALENTIN (1997). *The Fabergé Imperial Easter Eggs*. London: Christie's Books.

FABERGÉ, TATIANA, KOHLER, ERIC-ALAIN AND SKURLOV, VALENTIN (2012). *Fabergé. A Comprehensive Reference Book*. Geneva: Slatkine.

FERSMAN, ALEXANDER, ED. (1926). *Russia's Treasure of Diamonds and Precious Stones*. Moscow: People's Commissariat for Finance.

FORBES, CHRISTOPHER AND TROMEUR-BRENNER, ROBYN (1999). *Fabergé. The Forbes Collection*. New York: Hugh Lauter Levin Associates.

GAFIFULLIN, R. R. (2014). Том IX. Изделия Фирмы Фаберже конца XIX – начала XX века в собрании ГМЗ Павловск. (Fabergé Items of Late XIX – Early XX Century in the Collection of the State Museum of Pavlovsk). State Museum of Pavlovsk.

GUITAUT, CAROLINE DE (2003). *Fabergé in the Royal Collection*. London: Royal Collection Enterprises.

HABSBURG-LOTHRINGEN, GÉZA VON (1986). *Fabergé: Hofjuwelier der Zaren*. München: Hirmer Verlag.

HABSBURG, GÉZA VON AND LOPATO, MARINA (1993). *Fabergé. Imperial Jeweller*. London: A. Zwemmer.

HABSBURG, GÉZA VON, ET AL. (2000). *Fabergé. Imperial Craftsman and His World*. London: Booth-Clibborn Editions.

HABSBURG, GÉZA VON (2003). *Fabergé – Cartier. Rivalen am Zarenhof*. München: Hirmer Verlag.

HABSBURG, GÉZA VON (2011). *Fabergé Revealed At the Virginia Museum of Fine Arts*. Richmond and New York: Virginia Museum of Fine Arts and Skira Rizzoli.

HABSBURG, GÉZA VON AND MUNTYAN, TATIANA (2018). *Fabergé. Treasures of Imperial Russia*. Fabergé Museum, St Petersburg and Skira Rizzoli.

ILICH, ALICE MILICA (2007). *A Gentleman's Obsession. A Collection of Russian Art by Fabergé and his Contemporaries*. Geneva: Published privately.

IVANOV, A.N. 2002. *Gold- and Silversmiths in Russia [1600–1926]*. 2 vols. Moscow: Russian National Museum.

JANGFELDT, BENGT (1998). *Svenska vägar till S:t Petersburg*. (Swedish Trails to St Petersburg) Stockholm: Wahlström & Widstrand.

JOENSUU, VÄINÖ (1935). "Kultainen joutsen ui akvamariinilaineilla". (A Golden Swan on Acquamarine Waves). In *Suomen Kuvalehti* No.18, May 4th, 1935.

KANKAANPÄÄ, PAULA, ED. (2000). *Fabergén kisälli. Kultaseppä Jalmari Haikosen muistelmat*. (Fabergé's Journeyman. The Memoirs of Master Goldsmith Jalmari Haikonen). Lappenranta: Lappeenrannan Kilta.

KOHLER, ERIC-ALAIN (1997). *François Birbaum. Premier Maître du joaillier Fabergé 1872–1947*. Aigle: Association des Amis de François Birbaum.

KORNEVA, GALINA AND CHEBOKSAROVA, TATIANA (2006). *Empress Maria Feodorovna's Favorite Residences in Russia and Denmark*. St Petersburg: Liki Rossii.

KORNEVA, GALINA AND CHEBOKSAROVA, TATIANA (2012). *Russia and Europe: Dynastic Ties, Second Half of the Nineteenth to the Beginning of the Twentieth Century*. St Petersburg: Liki Rossii.

KUZNETSOVA, LILIA (2016). Петербургские ювелиры XIX-начала XX века. (Jewellers of St Petersburg of the 19th and 20th Centuries) Moscow-St Petersburg:Tsentrpoligraf.

LOPATO, MARINA N. (2006). Ювелиры старого Петербурга. (The Jewellers of Old St Petersburg). St Petersburg: The State Hermitage Museum.

LOWES, WILL AND MCCANLESS, CHRISTEL LUDEWIG (2001). *Fabergé Eggs: A Retrospective Encyclopedia*. Lanham, Maryland & London: Scarecrow Press.

MANNERHEIM, CARL GUSTAV (1951) *Minnen. Del I. 1882–1930*. (Reminiscences. Part I, 1882–1930). Helsinki-Stockholm: Schildt-Norstedt.

MCCANLESS, CHRISTEL LUDEWIG (1994). *Fabergé and His Works. An Annotated Bibliography of the First Century of his Art*. Scarecrow Press.

MCCARTHY, KIERAN (2017). *Fabergé in London. The British Branch of the Imperial Russian Goldsmith*. Woodbridge, Suffolk, England: ACC Art Books Ltd.

MCFERRIN, DOROTHY, ET AL. (2013). *From a Snowflake to an Iceberg*. Houston: McFerrin Foundation.

MCFERRIN FOUNDATION (2016). *Fabergé. The McFerrin Collection. The Opulence Continues...* Houston, Texas: McFerrin Foundation.

MENZHAUSEN, JOACHIM (1968). *Das Grüne Gewölbe*. Leipzig: Veb. E.A. Seemann Verlag.

MOEHRKE, MARK, ED. (2016). *Unknown Fabergé. New Finds and Re-Discoveries*. Minneapolis, Minnesota: The Museum of Russian Art.

MOREL, BERNHARD (1988). *Les Joyaux de la Couronne de France*. Antwerp: Fond Mercator.

MUNN, GEOFFREY C. (1984). *Castellani and Giuliano. Revivalist Jewellers of the Nineteenth Century*. London: Trefoil Books.

MUNN, GEOFFREY C. (2001). *Tiaras: Past & Present*. London: V & A. Publications.

MUNN, GEOFFREY C. (2015). *Wartski. The First One Hundred and Fifty Years*. London: Antique Collectors' Club.

MUNTIAN, TATIANA (2016). *Feodor Rückert & Carl Fabergé*. Moscow: Maxim Revyakin.

MUNTIAN, TATIANA WITH V.S. VORONCHENKO (2014, reprint in 2016). *Fabergé Masterpieces from the Collection of the Link of Times Foundation*. St Petersburg.

PFEIFER SWEZEY, MARILYN (2004). *Fabergé Flowers*. New York: Harry N. Abrams.

PURCELL, KATHERINE (2006). *Fabergé and the Russian Jewellers*. London: Wartski.

SALONIEMI, MARJO-RIITTA, ED. (2006). *The Era of Fabergé*. Tampere: Vapriikki.

SILTANEN, PENTTI (1999). *Hopeaa ja säveliä. Pietarinsuomalaisen perheen kronikka*. (Silver and Music. The Story of a Finnish family in St Petersburg) Helsinki: Otava.

SKURLOV, VALENTIN V., ET AL. (2011). Михаил Перхин. Ювелир фирмы Фаберже. (Mikhail Perkhin. Jeweller of Fabergé) St Petersburg: Published privately.

SKURLOV, VALENTIN V., ET AL. (2016). Фраиц Бирбаум. Главный Мастер Фирмы Фаберже. (Franz Birbaum. Head Master of the Fabergé Firm). St Petersburg: Published privately.

SKURLOV, VALENTIN V. (2017). Василий Иванович Зуев – художник фирмы Фаберже и «Придворный миниатюрист». (Vasily Ivanovich Zuev – Artist of Fabergé and Court Miniaturist"). St Petersburg: NP-Print.

SNOWMAN, A. KENNETH (1953, revised and enlarged edition with new information 1962). *The Art of Carl Fabergé*. Boston: Boston Book and Art Shop.

SNOWMAN, A. KENNETH (1979). *Carl Fabergé. Goldsmith to the Imperial Court of Russia*. London: Debrett´s Peerage.

SNOWMAN, A. KENNETH (1993). *Fabergé: Lost and Found. The Recently Discovered Jewelry Designs from the St. Petersburg Archives*. London: Thames & Hudson.

SOLODKOFF, ALEXANDER VON (1981). *Russian Gold and Silver*. London: Trefoil Books.

SOLODKOFF, ALEXANDER VON (1988). *Art of Carl Fabergé*. London: Ermitage Ltd.

SOLODKOFF, ALEXANDER VON (1997). *The Jewel Album of Tsar Nicholas II and A Collection of Private Photographs of the Russian Imperial Family*. London: Ermitage Ltd.

SOTHEBY'S *Auction Catalogues 1970s-2017*.

SPARKE, CYNTHIA COLEMAN (2014). *Russian Decorative Arts*. London: Antique Collectors' Club.

TILLANDER-GODENHIELM, ULLA (1980). "Personal and Historical Notes on Fabergé's Workmasters and Designers". In *Carl Fabergé and His Contemporaries*. Helsinki: A. Tillander.

TILLANDER-GODENHIELM, ULLA (1996). *Smycken från det kejserliga St Petersburg*. (St Petersburg Jewellery) Helsinki: Hagelstam.

# References

Tillander-Godenhielm, Ulla, et al. (2000). *The Golden Years of Fabergé. Drawings and Objects from the Wigström Workshops*. New York & Paris: A la Vieille Russie & Alain de Gourcuff Èditeur.

Tillander-Godenhielm, Ulla (2005). *The Russian Imperial Award System 1894–1917*. Helsinki: *Journal of the Finnish Antiquarian Society*, Vol. 113.

Tillander-Godenhielm, Ulla (2008). *Fabergé ja hänen suomalaiset mestarinsa*. (Fabergé and His Finnish Masters) Helsinki: Tammi.

Tillander-Godenhielm, Ulla (2012). *Jewels from Imperial St. Petersburg*. St Petersburg: Liki Rossii/ Images de Russie/Unicorn Press Limited.

Traina, John (1998). *The Fabergé Case. From the Private Collection of John Traina*. New York: Harry N. Abrams.

Trombly, Margaret Kelly, et al. (2017). *Fabergé and the Russian Crafts Tradition. An Empire's Legacy*. London: Thames & Hudson and The Walters Art Museum, Baltimore.

Tuomi-Nikula, Jorma and Päivi (2002). *Keisarit kesälomalla Suomessa*. (The Emperors on Vacation in Finland) Jyväskylä: Ateena Kustannus.

Viherjuuri, Irmeli, ed. (1987). *Anna Virubova. Keisarinnan hovineiti*. (Anna Virubova. The Empress's Maid-of-Honour) Helsinki: Otava.

Williams, Haydn (2009). *Enamels of the World 1700–2000. The Khalili Collections*. London: The Khalili Family Trust.

Villumsen, Ole Krog (1997). *Kejserinde Dagmar. Maria Fjodorovna. En udstilling om den danske prinsesse som blev kejserinde af Rusland*. (Empress Dagmar/ Maria Feodorovna. An Exhibition on the Danish Princess who became Empress of Russia). København: Christiansborg Slot.

Vorres, Ian (1964). *The Last Grand Duchess. Her Imperial Highness Grand Duchess Olga Alexandrovna*. London: Hutchinson.

Zeisler, Wilfried (2014). *L'Objet d'Art et de Luxe Français en Russie (1881–1917). Fournisseurs, Clients, Collections et Influences*. Paris: Mare & Martin.

Zeisler, Wilfried (2018). *Fabergé Rediscovered*. London: GILES, and Washington DC: Hillwood Estate, Museum & Gardens Foundation.

Åsbrink, Brita (2001). *Ludvig Nobel. Petroleum har en lysande framtid!* (Ludvig Nobel. Petroleum has a Glorious Future!) Stockholm: Wahlström & Widstrand.

ВЕСЪ ПЕТЕРБУРГЪ 1907–1918 (All St Petersburg, Address Directories), St Petersburg.

## Archives

Kansallisarkisto (National Archives of Finland)

Pyhän Marian Seurakunnan kirkonkirjat (St Mary's Parish Registers [St Petersburg])

S:ta Katarinaförsamlingen i S:t Petersburg kyrkböcker (St Catherine's Parish Registers [St Petersburg])

Suomen Passivirasto Pietarissa (The Finnish Passport Office [in St Petersburg]

RGIA (Russian State Historical Archive)

Fond 468, Archives of the Cabinet of His Imperial Majesty), St Petersburg.

## Unpublished Sources

Amburger-Datenbank-Ios Regensburg. (Ausländer im vorrevolutionären Russland)

Armfelt, Hjalmar (1950s). "Erään ihmisen elämä" (One Man's Story), MS. Collection of the Armfelt family.

Grinberg, Léon (1940s-early 1950s) Interviews with Eugène Fabergé and Andrey Plotnitsky. Hillwood Estate, Museum & Gardens, Washington DC.

Koistinen, Olli (1916). "Kultasepän muistelmat" (A Goldsmith's Reminiscences). MS. Private Collection.

Tillander, Alexander, Business Reports, 1901–17. Collection of the author's family.

Tillander, Alexander, Stock Books, 1918–36. Collection of the author's family.

Weissenberg, Axel von, Personal Notes. Collection of the von Weissenberg family.

Wigström, Henrik, First Stock Book. Private Collection.

Wigström, Henrik, Second Stock Book. National Archives of Finland.

## Web Sites

*Fabergé's Imperial Easter Eggs* http://www.wintraecken.nl/mieks/faberge/index.html web site in Dutch and English with current research, hosted by Annemiek Wintraecken.

*Fabergé Research Site* http://fabergeresearch.com/ edited and published by Christel Ludewig McCanless, includes ongoing research in its quarterly *Fabergé Research Newsletter*

http://fabergeresearch.com/current-newsletter/

The Imperial Egg Chronology http://faberesearch.com/eggs-faberge-imperial-egg-chronology web page is an update of the eggs by Will Lowes from *Fabergé Eggs: A Retrospective Encyclopedia*, first published in 2001.

## Correspondence & Interviews

Airila, Jukka, Vantaa, Finland

Backström, Ragnar, Kotka, Finland

Bonsdorff, Eeva, Espoo, Finland

Brüninghaus, Günter, Halikko, Finland

Engman, Max, Helsinki, Finland

Haikonen, Jalmari †

Herttuainen, Mauri, Vantaa, Finland

Holmström, Edgar, Västerås, Sweden

Hurme, Riitta, Espoo, Finland

Joukamo, Eila, †

Juntunen, Marja-Riitta, Kuopio, Finland

Karikoski, Raili, Kuopio, Finland

Kuznetsova, Lilia †

Käki, Kirsti, Viiala, Finland

Lopato, Marina, St Petersburg, Russia

Luukkainen, Kalevi and Marja-Leena, Helsinki, Finland

McCanless, Christel Ludewig, Huntsville, Alabama, Usa

Nobel family, Helsinki, Finland

Palmade, Anna and Vincent, Bethesda, Maryland, Usa

Pihl, Lydia †

Polvinen, Helmi †

Rönnqvist, Ronny, Espoo, Finland

Salvèn, Kurt, Espoo, Finland

Sarvi, Anni †

Skurlov, Valentin, St Petersburg, Russia

Virmakoski, Matti, Kotka, Finland

Wigström, Lyyli †

Wintraecken, Annemiek, Venray, Holland

# ACKNOWLEDGEMENTS

For allowing me to publish the photographic material – of the greatest importance for this book – my warmest thanks go out to the following prestigious museums, institutions, foundations, auctions houses, and collections:

The Royal Collection Trust, London; The State Hermitage Museum, St Petersburg; The State Historical and Cultural Museum in the Kremlin, Moscow; The Fabergé Museum, St Petersburg; The State Museum "Pavlovsk", Pavlovsk; The Alexander Fersman Mineralogical Museum in Moscow, under the Russian Academy of Sciences, Moscow; The National Archives of Finland, Helsinki; The National Museum of Finland, Helsinki; Hillwood Estate, Museum & Gardens, Washington DC; the Walters Art Museum, Baltimore; Cheekwood Botanical Gardens & Museum of Art, Nashville, Tennessee; Cleveland Museum of Arts, Cleveland, Ohio; Virginia Museum of Fine Arts, Richmond, Virginia; Matilda Geddings Gray Foundation Collection, New Orleans; McFerrin Collection, Houston, Texas; Christie's, London; Sotheby's, London; Bonhams, London; Bukowskis, Stockholm; Fondation Eduard & Maurice Sandoz, Pully, Switzerland; Pierre Mirabaud, Geneva, Switzerland.

Special thanks to Christopher Forbes, New York, for allowing me to show the splendid images of Imperial Easter Eggs, formerly in the Forbes Magazine Collection.

I am grateful for the kindness and support of Geoffrey Munn, Katherine Purcell, and Kieran McCarthy of Wartski, London; the Schaffer family of A La Vieille Russie, New York; Alexis Tiesenhausen, London; Helen Culver Smith, London; Darin Bloomquist, London; Harry Woolf and Nita Sowerbutts, London; Alexander von Solodkoff, Hemmelmark; Caroline de Guitaut, London; Dorothy McFerrin, the late Artie McFerrin, Jennifer McFerrin-Bohner, Houston, Texas; John Atzbach, Redmond, Washington and Géza von Habsburg, New York.

This book could not have been written without the unfailing enthusiasm and most valuable assistance of many friends and colleagues. My heartfelt thanks to:

The descendants of the Fabergé masters; Christel McCanless, Huntsville, Alabama; Galina Korneva and Tatiana Cheboksarova, St Petersburg; Valentin Skurlov, St Petersburg; Dmitry Krivoshey, Moscow; Annemiek Wintraecken, Venray, Holland; Anna and Vincent Palmade, Bethesda, Maryland; Timothy Adams, San Diego, California; Will Lowes, Adelaide, Australia; Timothy F. Boettger, Ottawa, Canada; Mark Moehrke, New York; Wilfried Zeisler, Washington, DC; Johanna Puisto, London; Marilyn Pfeifer Swezey, Washington DC; Margaret Kelly Trombly, New York; Mikhail Ovchinnikov, St Petersburg; Karina Pronicheva, St Petersburg, and Alexey Pomigaloff, St Petersburg.

I must also reach out to thank the 'team' of the book, above all William Moore of Helsinki, who took upon himself the immense task of translating and editing my text. My thanks also go to Jukka Aalto of Armadillo Graphics and to the Publishers Tammi, of Helsinki, for granting me the right to publish this book in English.

14043.    15.XI.1913 13808      13978. 5.XI.1913.      13849. 22. Ноябрь 1913.

~~25 Ноябрь 1913.~~
12 Дек. 1913      14042. 27. Янв. 1914.      14149. 28. Фев. 1914.

Cartié